FOR PEOPLE, NOT FOR PROFIT

Nate,

May we all age as
gracefully – and as
prosperously – as Fenway
Health.

all the best,

To

FOR PEOPLE, NOT FOR PROFIT

A History of Fenway Health's First Forty Years

Thomas Martorelli

authorHOUSE®

AuthorHouse™
1663 Liberty Drive
Bloomington, IN 47403
www.authorhouse.com
Phone: 1-800-839-8640

Published by AuthorHouse 06/06/2012

ISBN: 978-1-4772-1701-6 (sc)
ISBN: 978-1-4772-1700-9 (hc)
ISBN: 978-1-4772-1699-6 (e)

Library of Congress Control Number: 2012910225

CONTENTS

DEDICATION

Former Fenway board Chair, Dan Cirelli (*Photographer unknown*)

This book is dedicated to Dan Cirelli. He was a man who embodied the deep commitment, determination, and community pride that have enabled Fenway Health to become a powerful model for community care for, among others, a large LGBT community. Daniel L. Cirelli (b.1945 d. 2004) served on the Board of Directors of Fenway Community Health Center from 1978-81, and chaired the board from 1980-81. Dan served on the board as the AIDS crisis both stunned the gay community and inspired an urgent need to expand and improve health care, and research, aimed at the needs of LGBT people.

Dan had his own style of leadership. He had to; at the time, he was responsible for organizing a diverse, civic-minded group of volunteers (and staff), who believed they could create a viable community health center that would be a center of excellence. And, of course, it needed to serve the needs of all: the neighborhood's largely aging population, gay men, sexually active women, and students. Through the efforts of countless volunteers and professionals just like Dan, Fenway has not only flourished, it has become a high quality community health center as well as a world-renowned research center.

Like so many others of his generation, Dan was inspired by his American patriotism. He believed in equal treatment, opportunities for all, and the power of science. As an old-fashioned Republican, he believed in individual civic responsibility

as the best way to protect the freedoms essential to our Democracy. Raised in a proud, hard-working Italian family, Dan dreamed of being a physician, and maintained his interest in health care throughout his life, even as he developed a very successful career, bringing his own innovations to the food import-export business that spanned from the United States to Japan and Italy. But that would be another story about Dan.

He was also a true founding member of the Stonewall generation, actively pushing for expanded rights and freedoms for the LGBT community, even as he continued to protect his sexual identity from his parents, extended family, and business associates. Assuming a prominent position at Fenway risked revealing that identity, but Dan knew his business skills, his firm voice, and those powers of gentlemanly persuasion were important to the success of the organization, especially as it navigated the difficult waters of the early 1980's. Setting the standard for all the Board Members who followed him, Dan stepped up when things tipped downhill, never losing his commitment, resourcefulness, and firm belief that Fenway could achieve its goals.

I am forever grateful for the opportunity Dan provided me, when, as chair of the board, he hired me to serve as Executive Director of Fenway Health at the eager but naïve age of 32. I am even more grateful for his enduring friendship, which extended over decades and included my occasional role as his girlfriend at many business and family events.

As I drove Dan's mother to the train station from his memorial in 2004, she asked me why we had never married. I breathed a sign of relief that her question confirmed his wish that she would never know that he was gay, or that I was lesbian. Yet, I sensed her sadness that Dan never fathered her grandchildren. I simply told her that we were each independent people, too ambitious to do justice to a marriage. I looked her straight in the eye, saying, "We respected each other too much to marry." And that was the heartfelt truth.

Sally Deane
Executive Director,
Fenway Community Health Center, 1980–1984
Provincetown, Massachusetts
August 14, 2011

ACKNOWLEDGMENTS

First of all, I would like to thank you for actually reading this page. If you're at all like me, you may have read other pages like this, and wondered why writers always emphasize their appreciation for their editors. Trust me, now I know. Dale Orlando came to this project as one of the people to be interviewed, having served as Fenway's Executive Director in the late 1980s. When I arrived at her house in Lynnfield with Fenway's video camera and my list of questions, she greeted me with an impressive pile of documents and videos of her own to embellish her story. Our subject matter required more than a single conversation, and our meetings graduated to collaboration on the story, and then in each of our respective kitchens and barbecue grills. When it came time for Fenway to hire an editor for the entire book—not just the part of the story that Dale knew—she volunteered. Fenway accepted. Then the real fun began. At a time when deadlines loomed and stories needed telling, she was always there. I'm not sure it's truly a first, but she has to be one of the only editors in the world who actually added pages during her review. She's made great judgment calls on subjects including how to improve the organization of the book by chapters, and how to properly tell the stories she lived without missing the point of how and why things happened—all of it with the emotional honesty only someone who was there can convey. She kept me focused on work when I could easily have strayed, and constantly pitched in to transcribe interviews, pick photographs, search through her personal files for information that made the story real, and edit, write, and re-write. It's been more than fun, and Dale, I can never thank you enough.

Sally Deane is another collaborator, and working with her on this book has renewed an old friendship in a truly wonderful way. She has an incredible memory, a love for the organization, and a uniquely philosophical perspective that sparks imagination and insight just by telling a story. Sally encouraged me in those times when a blank computer screen tried to stare me into submission, and both introduced and re-introduced me to people who were there at critical times in Fenway's history. Read her dedication of the book to our friend Dan Cirelli, or any of her quotes throughout the story, and you'll get to know her well. Sally, working

with you on this book reminds me of what a great decision we made when our Dan, myself, and the rest of our Board of Directors voted to hire you in 1979.

Nan Dumas actually helped me realize my long-term dream of writing this book, after she and Judy Bradford brought me into the Leadership Circle and Fenway's Board of Visitors, of course. In early 2010, we discussed the idea that a history of Fenway Health might be a great way to celebrate its 40th anniversary this year. She invited me to 1340 Boylston Street to talk about it with herself, Phil Finch, and Chris Viveiros. By September, the project had begun. Today, 24 interviews and many pages of writing later, here is that history. Thank you, Nan, for helping make my dream come true.

Phil Finch and Chris Viveiros also deserve many thanks, for their constant support and encouragement throughout the past year. Early on, Phil remarked that there would be many ways to do this project correctly, and expressed his confidence that I would find one of those right paths, giving me great creative freedom along with his support. Chris has a rare combination of patience and enthusiasm that has always made me feel welcome at Fenway's offices, even when I needed too many lessons in how to operate the camera, or needed to talk through ideas about the book with someone who was willing to listen. Chris always was, and still is.

There are at least a couple of dozen other people to thank, mostly those who agreed to be interviewed during the research portion of this project, contributing their time, insights, and stories to help make the book real. Stephen Boswell, Henia Handler, Ken Mayer, David Scondras, Harvey Makadon, Rodney VanDerwarker, Phyllis Dixon, Judy Bradford, Ron Ansin, Jerry Feuer, Charlene Metrano, Tony Knopp, Vincent Perrelli, Harry Collings, Joanne Herman, and Denise Bentley are all telling their stories in the pages that follow. Ruben Hopwood and Jon Vincent have given me hope that, as Fenway moves forward into the future, there are capable young leaders like them who will continue to guide its success. Allison Salke actually introduced me to Nan Dumas, which deserves special mention. And my friend Cameron Kirkpatrick is someone who not only encouraged me to write the book when I first mentioned it to him, but was willing to share his memories as a participant in one of Fenway's vaccine research trials once the book became real.

I could go on, of course. But, if you're like me, you have limited patience for acknowledgment pages. Thank you again for allowing me to introduce you to people worth meeting, first in the pages of this book, and maybe someday in person.

FOREWORD

Most people recognize their duty in time to avoid it. How lucky we are that for forty years the founders and builders of Fenway did not avoid their duty but actively sought it out and still do.

For People, Not for Profit brings to life those forty years. Fenway Health started as a dream, a castle in the air and then people put the foundation under it. This book doesn't shy away from the painful decisions, the different personalities, the politics and the money struggles. I don't want to give any of that history away but it can serve as a primer for organizers today.

The original idea that gay people, women and the elderly were underserved by the medical profession grew to encompass other groups underserved or ignored. Fenway's victories are manifest in everyone who passes through the door.

The AIDS crisis, the breast cancer realizations are vividly covered. So many young people were lost but their willingness to participate in various health programs eventually enabled doctors, nurses and other workers to extend life, to save life. Even sorrows carry treasures.

For People, Not for Profit couldn't come at a better time. As a people we are disillusioned, distrustful and often cynical about government and business given the massive corruption. Read *For People, Not for Profit* and you will have your hope rekindled. You can change the world just as Fenway has changed the world. When you make a commitment, when you find like-minded people and work for the common good, things happen. Things get done.

Spending time at Fenway whether in book form or in person makes you think. I look at the transgender people who look pretty darn good. I have to ask should I become a handsome man? Would I have better luck? That may not be what crosses your mind but what I've seen there in all respects, people overcoming addictions, people battling disease, people finally able to be who they truly are just picks you right up.

Fenway has also made me realize that the old Southern mother's cure for what ails you, bourbon, while still much in use, pales beside Fenway's wisdom.

My first contact with this remarkable place came in 1972. I was impressed then and am even more impressed now. Fenway makes me glad to be an American. When we put our hearts and minds to a problem, we solve it.

Tom Martorelli has given us a labor of love about a place fueled by love. He deserves a big kiss for writing *For People, Not for Profit*. Oh well, he deserves a big kiss anyway. Turn the page. Begin your journey. God Speed.

Always and ever,

Rita Mae Brown, PhD., MFH
Alton, VA
September 4, 2011

INTRODUCTION

There is a place in Boston where the words "doctor," "patient," and "dialogue" have always meant more than you'd think. The people there have been engaged in a forty-year conversation about health care on every imaginable level. They have debated the rights of all people to quality health care, and how to make sure these rights came with access, to ensure that they would be real. Some of the same people, along with others, have collaborated on the design of new medical services for people in the "community," which may have begun as a synonym for "neighborhood," but has come to mean so much more. At every level, these dialogues, no matter how many doctors, patients, administrators, volunteers, and others are involved, have always revolved around a central question: "What is the essence of community health care?"

Is it the delivery of good medical services? Is it the collective political act of a unique population claiming the right to create its own model of health care? Is it to study the condition of a unique community and then design a program of care based on what these studies tell us? Which is more valuable: health care provided by a professional, or education programs that teach consumers how to keep themselves healthy? Does the way an organization responds to an overwhelming epidemic define it in a way that limits its future growth? How do you deliver of the most difficult news imaginable to an anxious human being waiting for you in the next room?

Many of these conversations happened behind the closed door of a medical office. Others endured through long evenings over cold pizza in the waiting room of a tiny basement health center that was, this place for twenty years. These same conversations are happening now in the medical, research, education, and policy-development departments of an organization, that now includes several places serving different neighborhoods. Taken together, these doctor-patient dialogues, policy debates, practical discussions, and philosophical musings define a unique and enduring health care resource in the city of Boston.

No organization succeeds without providing solid answers to questions about its mission and how to achieve it. This is an organization that began by offering free health care for all, insisting that "health care is a right, not a privilege." To fulfill this promise, it relied on donated services by doctors and other volunteers. Today, Fenway Health is one of Boston's largest community health centers. Diverse people have always come to this place, many of them consuming and designing health care that they believed was truly theirs for the first time in their lives. Together, these people found ways to collaborate at a medical facility that works for all. They responded to a crisis, partially prepared, but always completely focused, and succeeded in impressive fashion. In a variety of ways, these people and this place give us insight into how national human service programs move from the President's pen to neighborhood reality. And it gives us an education by real example of the answers to a series of unique questions that were at times highly predictable, and at others, completely unexpected.

Fenway Health—incorporated as the Fenway Community Health Center, a 501(c)(3) nonprofit organization on November 4, 1972—has faced all of these questions and more since its founding by a group of Northeastern graduate students and community organizers. A narrative that tries to tell the story of those forty-and-more years must address large, sweeping questions while also answering those that are more specific. What were the reasons why Fenway was founded? On what day did the center see its first patient? Where was its first clinic located? How did it evolve from a clinic for women, gay men, and the elderly into a community health center that serves lesbian, gay, bisexual, and transgender (LGBT) people, while also providing care to individuals who identify with none of these groups? Why does it have a dental and eye care clinic? What organizations have grown from Fenway Health over the years, and what other agencies has Fenway acquired? Why has it always been a leader in understanding and treating people with AIDS? What drives the organization today?

The answers to these questions—or at least the search for them—are important both inside and beyond the walls of 236A Huntington Avenue, 7 Haviland Street, 1340 Boylston Street, or any other building Fenway Health volunteers and employees have occupied, or will. They give the many people who have left us the chance to tell their stories, so that we may learn from them while remembering

how human they were in their day. They remind us how similar we are today with those who were part of Fenway Health in 1974, or 1981, or 1987, or any other year in the health center's history. And they provide a framework of knowledge, perspective, and action to guide us in facing the challenges to come.

Many people have helped write this history, telling stories about themselves and others who made key contributions at times of great change. These individuals have answered questions we all have about an organization that long ago established its standing beyond Boston, New England, or even the United States. And while many of these questions are specific to a time or place, there is one larger question every one of us can answer. Why is it that Fenway Health has succeeded over these four decades, when there are so many reasons why it might not have survived? Are there consistent institutional strengths that have guided Fenway's leaders, enabling them to make choices that have been proven to be correct, and allowing them to avoid mistakes or learn from those they made, even in the face of uncertainty, crisis, and the unexpected?

Throughout this book, many contributors' answers to this question are quoted verbatim; so each reader may assemble his or her own conclusions about the reasons for Fenway's success. But one answer stands out—not necessarily as the definitive answer, but as a framework for telling Fenway's story in a way that allows the other answers to resonate and grow together. It was offered by Stephen Boswell, president and CEO of Fenway Health, in an article written by Fred Kuhr for the March/April, 2009 edition of *Boston Spirit* magazine: "Fenway's Great Big International Success Story." Dr. Boswell cites four reasons for the organization's success: quality care, research, education, and policy. His brief description of each reason helps explain why these four organizational themes have been combined with a timeline of Fenway's four decades to give structure to this book.

Health care. "First, we want to serve as a model site...We want to show others how to set up, build, and run a health care center that serves their (LGBT) community."

Research. "We want people to be able to do the research into issues affecting the LGBT community. This is all about broadening the knowledge of LGBT people, no matter where they live."

Education. "We want to train future and current heath care providers."

Policy. "We are here to help people around the world articulate policy as it affects our community."[1]

These four themes resonate through Fenway's forty years. The story broadens its themes of education and advocacy to include education of consumers as well as those who work as health care providers. Advocacy promotes individual patients within the health care system as well as bolstering success by influencing policy decisions of officials in government and other health care institutions.

As we will see in the chapter about Fenway in the 1970's, nearly everything its early leaders did was associated with one or more policy matters. "Health care is a right, not a privilege," the Center's original mission statement, only begins to describe this emphasis on larger social issues. Other examples of Fenway's commitment to quality care, research, education, and policy advocacy can be seen throughout its history. At times, these seem almost prescient. Dr. Ken Mayer's proposal for "Venereal Disease Research" in December, 1980, and then-Executive Director Sally Deane's commitment to support this research with practice standards to ensure its validity, led to the establishment of an infrastructure for proper epidemiological research. With these resources in place, Fenway was able to contribute real knowledge about HIV at a time when little was understood about its source, nature, or outcome—in fact, in the days when it didn't even have a name. This knowledge established Fenway as a leader in the field of AIDS care, research, education, and policy—a role that has continued ever since.

In the late 1970's, Fenway Health wrestled with a growing disparity between its original mission and health care model—free care for all, and provision of this care by volunteers—with increasing government regulations and requirements. If providers were licensed, the Center could become eligible for third-party payments that would allow for free care in a different, if more limited form. Intense debates split Fenway's original ideological founders from other leaders who believed that integration with Boston's established health care system would provide more opportunities for growth and success. Decisions in the late 1970s and early 1980s set Fenway on a path toward full licensure as a community health

center, making it eligible for many grants and programs that would be essential for its role as a national leader in the AIDS crisis since 1981.

With Fenway's growth into a larger organization came more deliberate ventures into new fields of research and care—all with their associated education and policy programs. As early as 1983, when much of the Center was engaged with the AIDS epidemic, Fenway Health became one of the country's first providers of alternative insemination, a field in which Fenway still leads. The hiring of Dr. Judith Bradford in 2000, and the establishment of The Fenway Institute in 2001, allowed for the expansion of research studies to include LGBT health issues in the U.S. Department of Health and Human Service plan, "Healthy People 2010" (and now 2020), addressing health disparities among diverse populations across the nation. Today, Fenway's influence on LGBT health is international, with formal research studies in two locations in India, and collaboration with health professionals in least seven other countries to establish research programs, health centers, and education programs.

Programs to address domestic violence, anti-smoking education aimed at gay men and women (bolstered by research findings that lesbians are nearly four times as likely to smoke as heterosexual women), one of Boston's earliest alternative insemination programs, AIDS prevention programs aimed at men of color, and a significant behavioral health program are all part of Fenway's four decades of commitment and care. The center's behavioral health programs have changed and grown over time as well, providing psychological care and counseling to address crystal methamphetamine abuse, depression, and other concerns that disproportionately affect Fenway's target populations. The expansion of these services led the organization to outgrow two health center "homes" and several additional rented locations until March of 2009, when it moved into 1340 Boylston Street, with its ten floors of medical, research, education, and conference space.

Looking at the four themes again—care, research, education, policy—I also believe there is a fifth theme that needs to be added: management, or to be more accurate, leadership. Over time, the choices Fenway made to add programs, or end programs; to spin off committees of its Board into independent nonprofit organizations, or absorb other nonprofit organizations into its corporate structure; to create

new coalitions; to reach out to new target populations with care, research, education, and policy advocacy all required the contributions of its Board of Directors, its management staff, and allied individuals in other positions of leadership throughout Boston's health care community. Stephen Boswell's four reasons for Fenway's success required his actions and the actions of Executive Directors before him to be responsible for the success we celebrate in looking back on Fenway's forty years of history. For better or worse—thankfully, mostly for better—the hard work of Fenway's leaders was equally responsible for the health center's progress as any of the four themes Dr. Boswell cited in Boston *Spirit* Magazine.

This progress may not have always been in a straight line. In its earliest days, the Health Center weathered a number of external threats, including opposition from the Christian Science Church, which, as owner of its first location at 236A Huntington Avenue, was unpleasantly surprised to find a health center as one if its tenants. Throughout the 1970s and 1980s, a number of Boston's leading hospitals and state health officials challenged Fenway's provision of care—first because it was not formally licensed, and later because it was providing outpatient care and nontraditional treatments to AIDS patients. The organization twice fell upon difficult financial times—once in 1980, and again in 1985. The dominance of the AIDS epidemic on Fenway's program development in the 1980's and 1990's at times caused strains with other key constituencies. It took a surprisingly long time for the organization to embrace transgender people, despite an early commitment to their care by a few individual staff members in the 1980's. The remarkable combination of medical planning, organizational focus, fundraising success, and creative real estate financing that led to the opening of 1340 Boylston Street in 2009 may have created an unintended unwillingness among closeted gay men, or perhaps closeted gay men of color, to use such a visibly "gay" health care facility for their HIV and other sexually-transmitted disease screening and treatment. As a result, Fenway Health and its Fenway Institute have founded Fenway: Sixteen, a re-established walk-in facility offering services tailored for these individuals at Fenway's historic 16 Haviland Street headquarters, with its more discreet, community-based location. The health center's efforts to expand access to its services has also led it to operate South End Associates, located at 142 Berkeley Street, in 1992; and to acquire the Sidney Borum, Jr. Health Center, which serves gay and lesbian youth, in 2010.

But even without a straight line from its roots in the Nixon Administration to international leadership today, Fenway Health's progress is remarkable—from a first-floor office furnished with medical equipment from a retired general practitioner and waiting-room chairs from a defunct movie theater across the street to a ten-story, $57 million building; from an all-volunteer staff of fewer than 20 people to a current staff of over 300; from three evening clinics a week to five and one-half days of medical, behavioral health, dental, and eye care tailored to the LGBT community but welcoming to all; and from 9,000 patient visits per year in 1979 to 80,000 such visits in 2010. The details of this progress make for a great story, one that is a joy to share with anyone interested in community health, organizational development, and the rich diversity of the city of Boston. The three Mayors of Boston since 1971 have been staunch supporters of Fenway Health. "I could never have gotten to first base without the real friends we had in the city of Boston," remembers Sally Deane. She also remembers the people on Mayor White's staff who have gone on to make important contributions in their own right: Elaine Noble, Barney Frank, Brian McNaught, and Harry Collings, to name a few.

Finally, there is the personal relationship so many of us have with Fenway Health, a love story which comes across in so many of the tales included here. Mine has its most memorable moment in 1979, when, as Chair of the Fenway Health Center's board of directors, I participated in a debate about continuing to offer free care by volunteers vs. requiring all of Fenway's providers to be licensed, so we would be eligible for third-party payments and other government support. At the time, our board struggled with serious financial problems that threatened the organization's survival. Many of the staff and board members who were part of this debate did not survive the AIDS epidemic. This book is dedicated to one of them in particular, and it is also a tribute to them all.

But the moment that stands out, and holds so much personal meaning, is the night when we made our most difficult choice of the year—one that was most likely correct, but which filled us with regret; and one that would soon be dwarfed by other, far more wrenching choices. That night in the spring, we were faced with the knowledge that the Women's Health Collective—the last bastion of free care by volunteer providers—was standing between our organization and its eligibility for state licensure, third-party insurance and Medicare/Medicaid payments. Seeking those

credentials, reliable sources of revenue, and increased participation in Boston's health care system, I presided over our vote to eliminate volunteer reproductive and health counseling by Fenway's Women's Health Collective. Good, dedicated people, many of whom had been volunteering tirelessly for a decade, watched as we decided that they would be replaced by paid professionals, all in the name of progress. It was an event we all believed had great importance, and we feared it might cost Fenway as much in alienation from our original mission and community as it might help us gain in increased organizational security and stature.

Luckily, our fears were unwarranted. Within two years, new Executive Director Sally Deane and Board Chairman Dan Cirelli had rebuilt the bridges we thought had been burned, and people dedicated to the provision of women's health care were back at Fenway, working within the Center's new "professional" system almost as if nothing had happened. The fact that so few of us remember this story is testimony to how short-lived a crisis it really was. It is also only one story in four decades of stories, one night in almost 15,000 nights that something happened at Fenway Health. Many other stories, many other days and nights, many other individuals have far more to do with where the organization is today.

But for me, that evening meeting has left a longstanding need to make amends, to acknowledge that I was in fact there and supported the end of volunteer health counseling by and for women who had been part of Fenway's programs since its founding. I'm sorry, Women's Health Collective, for the way you felt unappreciated and paid for our organization's growth. I hope that, by telling the history of Fenway Health's great accomplishments—including yours—that we can unite in honoring all that we have been in the past, in celebrating what we are today, and in creating what Fenway Health will be in the future.

I hope you enjoy the read.

Winthrop, Massachusetts
August 8, 2011

Chapter One
THE 1970S

1970S OVERVIEW

"The Health Center didn't have one parent, or one anything. It's like the Mississippi River. It had a lot of different people doing a lot of different things all over the place, which ended up being a river. But the river has a lot of tributaries from places you really would never expect, exactly."

—David Scondras, a Fenway Community Health Center founder

In its earliest days, Fenway Health was more a project than an organization. A group of Fenway residents, students, medical professionals, political activists, and a Catholic nun were in charge. Today we might call them the original Board of Directors, if only to help us impose a sense of orderly progress on a time when no such structure existed or was even desired. Beginning in the late 1960s, this group, almost all of them under the age of 25, volunteered to take on the task of creating a local response to a number of local residents' needs, looking for problems that demanded solutions, and injustices that cried out for remedies. Consistent with a national rebellion against authority that was then called "the movement," they created a neighborhood safety net to change things for the better. They were innocent enough to believe that they could accomplish their goals through their own collective action. They saw the struggle for social change as a battle against the "establishment," which they defined as anyone over 30, and believed that poverty, hunger, war, and sickness were caused as much by oppression as anything else. By their logic, if the neighborhood's, or the country's problems all had a common cause, the challenge of solving them would be a common struggle. Solving things one at time was missing the point. Collective action was their method of choice, and collective decision-making was the way they governed themselves.

They formed FIG, or the Fenway Interagency Group, as an umbrella organization where collective decision-making could be made, with representation of the many smaller groups that were active in the neighborhood at the time. These organizations included: the Tenants Action Group (TAG) to fight for tenants' rights and affordable rent; the Fenway Civic Association (FCA), to clean local streets,

2

maintain parks, and protect residents from crime; the Edgerly Street Playground Association, to build and manage this resource for local children; *The Fenway Free Life*, a community newspaper; the Boston Center for Older Americans (BCOA), to improve the lives of older neighbors; and a local chapter of the American Friends Service (AFS), a national Quaker organization open to people of all faiths "devoted to service, development, and peace programs throughout the world." [2] The Fenway Community Health Center, as a member of FIG, had roots in the neighborhood while it was also affiliated with the fledgling social movements of gay liberation and feminism.

Many of the same individual community activists were involved in all of these organizations. They would simply meet and move from one project to the next, planning and then acting on their plans. Initially, there was no selection process for service. Once someone showed up for three meetings, he or she was a member, and could participate fully in governance. But showing up meant more than just debating and brainstorming. The same people who planned the playground went out and brought in sand, swings, and slides. After they decided to start the food coop, they staffed it, buying and distributing canned goods and staples to their neighbors. Some of these individuals also provided lunches to the elderly through the BCOA's Meals on Wheels program.

Together, the Fenway Interagency Group started and re-started a food cooperative, succeeding on the third try, and launched a newspaper, *The Fenway Free Life*, which took only two. They formed a tenants' rights organization and opened a playground on a vacant lot across the street from the Health Center's second location at 16 Haviland Street. On weekend evenings, they hung sheets from an adjacent wall to show children's movies they checked out from the Boston Public Library. They hosted social programs for seniors at the Boston Center for Older Americans (BCOA), whose 236A Huntington Avenue headquarters were located in office space rented from the Christian Science Church. They held many of their meetings in the Westland Avenue Community Center, a neighborhood haven for the movement. There, in 1970, Fenway neighborhood activists began a medical referral program using the Center's telephones. They collaborated with the fledgling Homophile Community Health Services, perhaps Boston's first gay health organization, and with the Boston Women's Health Book Collective, which had

FOR PEOPLE NOT FOR PROFIT

produced a mimeographed health education program called *Our Bodies, Ourselves.* When they determined that local residents were experiencing roadblocks to health care, such as gay people seeking respectful, confidential care; young college women seeking medical services without the risk of having it reported to their parents; or the elderly having difficulty navigating the streets to get to one of the city's hospitals, they launched a free medical clinic. Across the city of Boston, other community health centers were forming in response to their own issues regarding access to care, whether they were language barriers, cultural mores, the mental health needs of people in the neighborhood, or the problem of drugs on the streets.

When it came to the Health Center, Fenway's volunteers solicited equipment from an elderly doctor in the Back Bay, who willed the contents of his office to them when he died, and moved it into the clinic's original location at the BCOA's 236A Huntington Avenue offices in 1971. They recruited volunteer doctors and nurses to staff the clinic one night per week (on Thursdays) and served without pay as intake workers. Fenway Health's founders acquired the clinic's 16 Haviland Street location shortly thereafter, readying it for its opening in 1973 by volunteering their own labor to construct a number of features—the flooring, front door, and raised basement window bars—that still exist today. The clinic's waiting area was furnished with seats salvaged from the old Fenway Theater on Boylston Street, an historic movie theater that had fallen on hard times and had been purchased by the Berklee School of Music to become today's Berklee Performance Center.

Technically, both before its incorporation in 1972 and throughout the 1970s, Fenway Community Health Center was not only a sub-group of Fenway's larger collective of neighborhood volunteers; it was also a loose confederation of three of its own internal collectives. The Women's Health Collective, Gay Health Collective, and the Elderly Health Collective were "autonomous, volunteer units operating out of the Fenway center," as Ronald Vachon, a Physician Assistant and one of Fenway Health's first paid employees, stated in a Boston Globe article about the organization in February of 1978.[3] Each Collective took one night per week to operate a free walk-in clinic, and each of them met independently to plan programs, recruit volunteers, and debate policy and management issues. Each had ties to other organizations in Boston growing from the nascent social movements sweeping the country, which brought talented people and vibrant ideas to

Fenway's Board of Directors. Their sense of independence from each other and allegiance to broader political ideals from outside the neighborhood eventually caused problems as the center grew and choices had to be made on behalf of Fenway Community Health Center as a whole. This was particularly true when one of these decisions went against the interests of another collective. But in the early days, everyone went to everyone else's meetings, so the only real impact was the time it took for any individual meeting to end.

Many other tributaries, from near and far away, brought big ideas and opportunities to Fenway's founders. Some were national trends that swept Fenway along in changes to America's health care system, like health care free clinics and women's self-help. Others were city government innovations designed to decentralize city services and health care delivery in Boston. There were advances in education—medicine and music—that opened doors for its founders to create Fenway's role as a health center in Boston's system of care, and in the neighborhood. Through it all, in the early days, there were politics, lots and lots of politics. Sometimes Fenway Community Health Center's founders would side with fellow neighborhood activists, and sometimes they would side with the establishment. Sharing patients' names or medical information with government funding sources would remain a political challenge throughout the 1970s and even into the 1980s, as organizers grappled with demands from the gay and women's liberation movements for the right to anonymous care, while placating the establishment's demands for uniformity of care and record-keeping. Ironically, the experiences of these early struggles and decisions prepared Fenway for its future leadership role in HIV/AIDS research and clinical care. Its work on issues of self-help, privacy, and anonymity (i.e. no named medical records at all, just aggregated information) vs. confidentiality (keeping physical records but not revealing names to outside organizations) enabled Boston's smallest community health center to guide the city's large hospitals and government agencies in developing protective patient care systems for those with secrets.

In 1970, an organization called the Boston Women's Health Book Collective, published *Women and Their Bodies*, a 193-page stapled course booklet that was republished a year later by the New England Free Press as the first edition of *Our Bodies, Ourselves*, to advance its beliefs that:

"Women, as informed health consumers, are catalysts for social change.

"Women can become their own health experts, particularly through discussing issues of health and sexuality with each other.

"Health consumers have a right to know about controversies surrounding medical practices and about where consensus among medical experts may be forming.

"Women comprise the largest segment of health workers, health consumers, and health decision-makers for their families and communities, but are under-represented in positions of influence and policy making.

"A pathology/disease approach to normal life events (birthing, menopause, aging, death) is not an effective way in which to consider health or structure a health system."[4]

The idea that women ought to be in control of their own health care was new and inspiring at the time, as was the emphasis on education and prevention in health care, the demand for increased dialogue with "medical experts," and the challenge to the prevailing health system.

There are many anecdotes but little written documentation of Fenway's philosophical struggles in its evolution from a free clinic to a licensed community health center. But an analogy can be made from The Cambridge Women's Community Health Center (CWCHC), which was incorporated in 1974 as "a feminist institution which seeks radical social change by implementing the concept of self-help; the sharing of skills and information so that women can regain control of our health and our lives." This organization was founded in 1971 by feminist women, who occupied Harvard's Architectural Technology Workshop, at 888 Memorial Drive, on International Women's Day, March 6, 1971.[5] The CWCHC began offering the same type of self-help health education programs and gynecological services that Fenway's Women's Health Collective provided, including education of paramedics, lesbian health groups, natural birth control, and information on herbal self help therapies. By 1975, the Cambridge Women's Community Health Center was performing first trimester abortions, a service Fenway never offered. Consistent with the values of the Boston Women's Health Book Collaborative and Fenway, CWCHC provided patients with printed information on women's health topics. Its staff gave presentations on "well-woman healthcare" and slide

presentations on the components of a good gynecological exam and women-controlled abortions. In 1976, the center operated a pelvic teaching program for the Harvard Medical School in which CWCHC staff acted as instructors and patients for medical students learning to perform gynecological exams. The program broke down, however, because "CWCHC staff felt that they were only valued by the medical school in their role as informed patients while their ideas on self-help and women-controlled exams were being ignored."[6] Ultimately, the Cambridge Women's Health Center ceased operations in 1981 and the medical records of its patients were incorporated into Fenway Community Health Center that same year.

Following is a section from the April, 1978, edition of *On Our Way*, the newsletter published by the Cambridge Women's Community Health Center, providing an insight into the struggles of an organization trying to remain true to its founders' original mission while grappling with the requirements of clinic licensure:

"Dear Sisters,

"The Massachusetts Department of Public Health (DPH) has issued an ultimatum to Women's Community Health, the state's only feminist health center offering abortion care. In a letter dated March 2, the DPH threatened to deny the Center's application for a clinic license and take legal action to close Women's Community Health, if various certificates pertaining to clinic licensure are not in the hands of DPH officials by May 31, 1978.

"Women's Community Health, which offers a variety of health care services under physicians' licenses as well as educational self-help programs, is currently renovating office space in Central Square in order to satisfy extensive physical plant requirements for clinic licensure. The DPH has notified the Center that 'relocating' before obtaining a clinic license will be considered a criminal offense. All of the required certificates, however, must be obtained for new location before licensure. Again it is unclear what the DPH is requiring of Women's Community Health (WCH). WCH is investigating the meaning of the seeming 'catch 22s.'

"...Specific attempts to harass abortion providers, especially Women's Community Health, have been escalating since Nov., when State Representative Flynn persuaded the Post Audit Committee of the legislature to ask the Attorney

General to rule on the legality of health facilities operating while in process of obtaining a clinic license.

"Although the Attorney General decided it would be improper to make a ruling on the specific questions posed by the Committee, he has pressured the DPH to take action against unlicensed facilities, especially abortion facilities. The DPH has responded by reversing their policies to operate while in process of becoming licensed. In the future, any facility seeking clinic licensure will be required to obtain the license before offering health care services. This is a severe blow to all small, community or consumer based groups. Only those with access to large amounts of money will be able to open clinics, making it even harder for people to have control over their own health care.

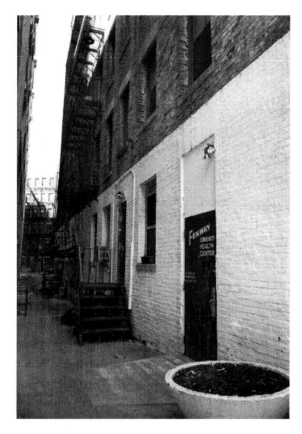

The original door to Fenway Community Health Center in the alleyway at 16 Haviland Street (*Northeastern University Archives*)

"Women at WCH see the campaign to deny abortion rights as a spearhead in a much broader political movement against women, Black and other Third World people, homosexuals, and other oppressed groups who have been organizing to take more control over their lives."

"...It is vital that women demonstrate our determination to fight for our right to control our own bodies and our health care. We must not allow the state to close feminist health centers like Women's Community Health!" [7]

Several insights into the state of community health services in Boston in 1978 can be found in this letter. First of all, there is the fact that, until the late 1970s, a practicing health center could continue to provide medical services without its own license, using the individual credentials of its professional medical staff. Fenway Community Health Center did so for nearly ten years, until its application for a license as a medical clinic was submitted in 1978 and ultimately approved in 1981. The Massachusetts Department of Public Health would charge Fenway and CWCHC with operating an unlicensed health center, but chose to allow them to apply for a license instead of shutting them down. Note that, like Fenway, CWCHC provided "a variety of health care services under physicians' licenses as well as educational self-help programs." It's likely from the wording of this sentence that CWCHC, like Fenway, provided educational self-help programs using volunteers without medical credentials, a major hurdle in the way of licensure. Without that license, health clinics like Fenway or CWCHC could not directly bill insurance companies, Medicare, or Medicaid, and they could not claim to provide medical care as part of their self- help services.

Another insight into the difficulties surrounding fledgling health clinics in Boston in the 1970s was the confusion and resistance expressed by Women's Community Health about DPH licensing procedures, particularly those pertaining to the center's physical plant. As the letter indicates, the center's staff proposed to relocate from its original location at 173 Hampshire Street to new facilities at 639 Massachusetts Avenue in order to comply with DPH requirements. But in the midst of this process, the Massachusetts Committee on Post Audit and Oversight (a committee of the state legislature) launched an investigation of DPH procedures on abortion, pressuring the DPH to take a stronger stance against any health centers

providing this service. Nationally, anti-abortionists, led by the Catholic Church, Christian fundamentalists, and other groups, began campaigns against abortion that would lead Congress to pass the Hyde Amendment in 1976, which prohibited Medicaid funding for abortions unless the mother's life was in danger.[8]

Besides denying nearly 300,000 American women access to abortion (the estimated number of abortions paid by Medicaid in the year before the Hyde Amendment was passed), the "right to life" movement also created an atmosphere of political pressure, regulatory harassment, and violence against health care facilities providing abortion services. Conservatives in the Massachusetts state legislature found CWCHC to be an easy target, questioned its legal right to provide abortions while it was applying for its license, and demanded that these services stop, even as the DPH was proceeding with its more supportive policy of giving the clinic time to complete its application. It isn't difficult to see why CWCHC saw competing policy statements from the DPH and the Massachusetts Legislature as the "catch 22" mentioned in the letter's second paragraph, or as a political attack on the center's feminist approach to education and provision of abortion services.

In fact, the CWCHC was successful in obtaining a clinic license once it moved to its Massachusetts Avenue location in April of 1978, where it continued to operate for another three years. However, it was plagued by continued financial difficulties and organizational turmoil related to its difficult transition from a "collective" organization to one with management systems able to comply with the requirements of a state-licensed clinic. For example, in its collective structure, "staff were expected to participate in the administrative, educational, and medical programs of the center; they rotated jobs, served on committees, and attended the weekly business meeting where major decisions about the center were made by consensus. The CWCHC operated on a suggested fee system of payment, and funding often depended on contributions from supporters. The CWCHC did receive small grants from local organizations, including the Boston Women's Health Book Collective, but strove to fund the center through fees from medical services and honoraria from self-help presentations and groups."[9] Despite several reorganizations and the abandonment of its collective operating model, the Women's Community Health Center filed for bankruptcy and closed later in 1981, relinquishing according to law its medical records to Fenway Community Health Center.

The above-quoted excerpts from the April, 1978 edition of *On Our Way* include an extensive public airing of grievances against the Massachusetts DPH "harassment" of Women's Community Health, and arguments linking the DPH actions to a "broader political movement" or "campaign by anti-abortionists." As written elsewhere in this book, Fenway's early leaders held long meetings with similar philosophical and political arguments against "the system" and its treatment of women, gay people, poor people, and minorities. If some of Fenway's board members had their way, the Center would have continued to fight for free health care and the provision of health educa- tion "self-help" programs for women, and for gay people, despite pressure from the state to become a licensed clinic. After all, Fenway had existed without its own license since its earliest days, relying on the personal credentials of its physicians and nurses— volunteer or paid—to provide care to its patients.

Another Fenway tributary flowed from the Civil Rights Movement. In 1969, the Black Panther Party opened a free health clinic near the corner of Columbus Avenue and Ruggles Street in Roxbury, on land that was being cleared for Interstate 95, a highway that ultimately was never built due to protests from local residents. The sixth of the Black Panthers' Ten Point Plan shows some of the common political ground among people who wanted to expand access to health care at the time:

"WE WANT COMPLETELY FREE HEALTH CARE FOR ALL BLACK AND OPPRESSED PEOPLE. We believe that the government must provide, free of charge, for the people, health facilities which will not only treat our illnesses, most of which have come about as a result of our oppression, but which will also develop preventive medical programs to guarantee our future survival. We believe that mass health education and research programs must be developed to give all Black and oppressed people access to advanced scientific and medical information, so we may provide our selves with proper medical attention and care."[10]

By opening a free health clinic a few blocks away, the Panthers showed Fenway's founders that it was possible to express political ideas about health

care with a real organization providing the services they advocated. But they also reached out to women and gay people in a welcome and unexpected way. The August 21, 1970, edition of the *Black Panther Newsletter* included "A Letter from Huey Newton to the Revolutionary Brothers and Sisters about the Women's Liberation and Gay Liberation Movements," which expressed his views on the solidarity of black people, women, and homosexuals.

"During the past few years strong movements have developed among women and among homosexuals seeking their liberation. There has been some uncertainty about how to relate to these movements...We must gain security in ourselves and therefore have respect and feelings for all oppressed people...I do not remember our ever constituting any value that said that a revolutionary must say offensive things towards homosexuals, or that a revolutionary should make sure that women do not speak out about their own particular kind of oppression. As a matter of fact, it is just the opposite: we say that we recognize the women's right to be free.

"We have not said much about the homosexual at all, but we must relate to the homosexual movement because it is a real thing. And I know through reading, and through my life experience and observations that homosexuals are not given freedom and liberty by anyone in the society. They might be the most oppressed people in the society...

"When we have revolutionary conferences, rallies, and demonstrations, there should be full participation of the gay liberation movement and the women's liberation movement."

The Black Panther Clinic provided more than just inspiration to Fenway's early leaders. Some of them volunteered their time to work there, including Dr. Vincent Perrelli, Fenway's first Medical Director. His memories of the times carry the calm commitment of a doctor doing his work. "When you're in a room with a patient doing medicine, the experience is always the same. It doesn't matter whether it's in a trailer or in a brand-new surgical suite in a modern hospital. Once that door is closed, you treat the patient." He also recalls Fenway's early meetings. "They were interminable. People could say whatever they wanted for however long they wanted. They could repeat themselves over and over if they wanted to. Sometimes I wonder how we got anything done." But he also remembers that,

when it came to making decisions about medical matters, like what cultures to use for bacterial testing, or how many blood pressure cuffs they needed, decisions were made quickly and on advice of the medical professionals on hand. "No one ever questioned us on those issues, and remember, back then I had hair down to my waist, a beard, and wore sandals and beads. But I was there to practice medicine. I left the politics to David Scondras and the others, who were quite good at it, as it turns out."

In addition to Fenway's local activists and the national women's and civil rights movements, another tributary was flowing. The gay liberation movement had been developing gradually throughout America for several years, even if only in the country's larger cities. Many date its beginning to the nights of June 27 and 28, 1969, at the Stonewall Inn in New York City's Greenwich Village, when gay, lesbian, bisexual, and transgender patrons unexpectedly fought back against a "routine" police raid with beer cans, bricks, "and anything else they could get their hands on." Why this spontaneous rebellion happened on that particular night might be explained as the result of the broader challenge against authority in the name of civil rights at the time. Or, as some say, it might have happened then because emotions were particularly raw in the wake of the death of gay icon Judy Garland five days earlier. Whatever the reason, the gay rights movement gained momentum and attention from that day forward. Other pioneering gay organizations in Boston at the time included Homophile Community Health Services, the weekly *Gay Community News*, and the Gay Academic Union of New England. In 1971, WBUR-FM, Boston University's radio station, launched a new show, "The Gay Way," hosted by Elaine Noble, who would become the first openly lesbian candidate elected to the Massachusetts House of Representatives in 1975. [11]

It's tempting to view the founding of Fenway Community Health Center as a grass-roots, counter-culture, even radical effort made by local activists, women, gays, lesbians, and others committed to civil rights, cobbling together whatever it took to create a free medical clinic in their shared belief that everyone deserves health care. And in many ways this story is correct. The volunteers who created

Fenway saw inequality and injustices in their neighborhood and sought to correct them, whether they were building a free medical clinic, or a food cooperative, or a tenants' rights organization, or a children's playground. They believed they could change the world, at least at their community level, and they accomplished much with a minimum of resources. Creating Fenway Community Health Center through the contributions of volunteers made them unique. But they were not alone.

"Sickness and poverty reinforce each other. The poor usually live in conditions which undermine physical and mental health—malnutrition, crowded and unclean housing, inadequate heating and sanitary facilities, substandard working conditions, poor provisions for personal hygiene. Illness generated or exacerbated by these conditions prevents or handicaps many of the poor from making use of the education, training and employment opportunities which could lift them out of poverty." [12]

At first glance, this paragraph could have been written by any number of Fenway's early volunteers, or by men and women who belonged to one of the other organizations advocating for social change in the 1960s and '70s. The fact that these words were official federal government policy at the time helps us understand the world in which Fenway began. President Lyndon Johnson declared a "War on Poverty" in 1964. That August, Congress passed the Economic Opportunity Act, which created a government agency, the Office of Economic Opportunity "to mobilize the human and financial resources of the nation to combat poverty in the United States."[13] This agency, which lasted until President Nixon dismantled it in 1974, sponsored twenty-two social programs, including Head Start, Family Planning, and the Community Economic Development Corporation. While its initial activities didn't include health care, in 1965, two physicians at Tufts School of Medicine—Drs. H. Jack Geiger and Count Gibson—used funding from OEO to start the nation's first community health center at Columbia Point.[14] These two Boston physicians were world-renown for their commitment to human rights: H. Jack Geiger is a founding member and past president of Physicians for Human Rights, a founding member and past president of Physicians for Social Responsibility, a founding member and past president of the Committee for Health in South Africa, and a founding member and national program coordinator of the Medical Committee for Human Rights. Count Gibson was the first Director of the Columbia Point Health Center, and throughout his life was active in civil rights—he

participated in the 1965 march from Selma to Montgomery, Alabama, he was a supporter of Cesar Chavez and his farm workers' movement in California in the 1970s, and pioneered the use of simultaneous translation between doctors and patients as a way of breaking down barriers to care among non-English speaking patients.[15]

The work of Drs. Geiger and Gibson inspired the development of community health centers throughout the United States, but their work had a particularly strong effect on Boston. Mayor Kevin White's administration was concerned with the decline of practicing physicians in the city and a concurrent rise in the number of doctors based in its large hospitals. In *A Promise Kept: Boston's Neighborhood Health Centers* (1981), Dale Young writes that, between 1940 and 1961, the ratio of general practitioners per 100,000 Boston residents had fallen from 132 to 67. At the same time, the ratio of hospital-based physicians rose from 119 to 289. And while in 1940, 65% of Boston's physicians were based in the community, by 1961, 60% of them had their offices in hospitals.

"As a consequence, there were few locally available family physicians and patients sought care at hospital emergency rooms. Yet, these services were known to provide inappropriate and inadequate primary care. Many of the services needed to ameliorate conditions of low-income people were entirely absent in such settings. Long waits, the absence of evening clinics and unscheduled appointments were mere symptoms of the system's inability to offer personalized care. Fragmentation of service characterized the services provided. Sick children were cared for in one clinic, well children in another clinic on another day. Potentially valuable services went unutilized."[16]

Federal dollars were being awarded to develop primary medical care facilities through the OEO, and the city of Boston saw the opportunity to develop a system of community health centers based on the success of the country's first such center at Columbia Point. Mayor White and his Department of Health and Hospitals would create a plan that would put the city in charge of receiving these funds and distributing them to local hospitals and community groups to form a citywide network of primary care clinics. On October 24, 1969, Commissioner Sackett launched the "Districting Plan" at a meeting of the directors of Boston's teaching hospitals and the heads of local, state, and federal government agencies. Residents

of the communities where health centers were to be located would serve on the new health centers' boards, and hospitals would provide the resources needed to address the health needs of communities deemed to be within their geographic area.

As Dale Young reports, "the city encouraged compliance with its objective by reminding the hospitals of their charitable purposes and their tax exempt status. The city also suggested that 'being a partner in the enterprise...would substantially enhance the chances of success for any application they may submit for funding.' Finally, the city proposed to match any financial or in-kind contribution made by a hospital, provided funds were restricted to the delivery of primary health care services in a community or neighborhood setting."[17] The links between health care development and politics weren't limited to the Fenway neighborhood. With matching grants of up to $50,000 from the city of Boston for each new clinic, the Department of Health and Hospitals and eight teaching hospitals launched twenty-four community health centers between 1965 and 1976. As shown in the chart on page 22, Fenway began services in 1971 without any funding from the city of Boston or any local hospital.

Ironically, 1971 was also the year that OEO funding for community health centers was eliminated nationwide—partially because of the Nixon Administration's commitment to scale back much of the Johnson Administration's funding of social programs, but also because other federal agencies saw OEO as a competitor for Congressional funding. The Department of Health, Education, and Welfare wanted to be the leading federal agency concerned with health care, and successfully brought a number of OEO programs under its management that year. Later, the Department of Labor would absorb the Job Corps and other OEO programs, and the Department of Housing and Urban Development took over emergency housing and programs aiding the homeless from OEO as the agency was dismantled.[18]

As noted above, federal funds the city of Boston used to help build its network of community health centers in the 1960s and '70s shifted from the Office of Economic Opportunity to HEW (now HHS) and the Department of Housing and Urban Development (HUD). Both before and during this shift, Boston's city government and some of the city's hospitals were able to apply federal funds to meet needs outside the original program guidelines promulgated by OEO, HEW,

and HUD. One example was the original application of OEO funds to the creation of the country's first community health center at Columbia Point in 1965. But in addition to this pioneering effort, the city of Boston worked in other ways to create a uniquely supportive environment for the development of Fenway and the city's other 23 community health centers. Examples of these adaptations of federal program standards include:

- OEO's original intent was to fund services for the poorest of the poor, seeking small, defined areas of poverty. Boston looked to develop a system that would deliver health care to all city residents.

- Boston's city government believed that a shortage of physicians was a primary cause of inadequate access to health care. As noted earlier, doctors had become more concentrated in hospitals instead of practicing medicine in the community.

- Boston's Districting Plan would engage its hospitals as partners, giving them incentives to contribute some of their enormous resources to a new system that would distribute these resources more equitably in the city's neighborhoods.

- OEO funds were not applied in this way in other parts of the United States. OEO believed that poverty needed to be addressed directly through programs aimed at the general disenfranchisement of poor people. In OEO's view, the creation of services that would be made available for all, without specific efforts to reach the poor, wouldn't work. In its final years before being dismantled, OEO allocated increasing funds to "community groups and neo-political organizations" tasked with creating awareness of, and demand for, needed services, rather than on the development of service programs themselves.

- Boston saw its role as the developer of a system that would sustain itself in the future by obtaining funds from new sources, rather than on continuing financial support from city and federal grants. The city's goal was to use Medicare and Medicaid funding to subsidize its community health centers going forward.[19]

Boston's officials used OEO funding as a broad means to increase community care, not only from the giant hospital systems affiliated with Harvard but also through the city's own system of clinics linked to Boston City Hospital (now Boston Medical Center). Of Boston's twenty-four health centers, eight of them were affiliated with Boston City Hospital. Harvard teaching hospitals used OEO funding to establish eight more neighborhood outpatient clinics that remained under their budgetary control. Finally, there were eight clinics that, like Fenway, were independent from any hospital and were formed by community organizers to serve various minorities in solidarity with the "free care" movement. With assistance from Senator Kennedy, these unsponsored health centers would eventually receive federal funding, but, for a while, Fenway and the other clinics would play catch-up. Today, thanks in no small part to the tireless work of Massachusetts's Senator Edward Kennedy, Fenway has grown from the smallest of Boston's community health centers to one of the city's largest.

Parallel to the creation of community health centers with funding via the Office of Economic Opportunity and President Johnson's 1964 War on Poverty was another, much larger, and longer-lasting national response to American's needs for health care. On July 30, 1965, the President signed the Social Security Act of 1965, which authorized Medicare (Title XVIII; extending health coverage to almost all Americans over the age of 65) and Medicaid (Title XIX; granting access to health care to certain low-income individuals and expanding the collaboration of federal and state governments in providing additional services to these same people). There is no way to overstate the importance of this legislation in modern American history, and the entire story is too large to tell in this book. The changes these two programs brought took decades to be realized, but a brief look at the "before" and "after" are worth noting. Today, Medicare and Medicaid are the largest funders of medical services in the United States. Their expansion contributed to the eventual division of the Department of Health Education and Welfare (HEW) into the Department of Health and Human Services (HHS) and the Department of Education (DOE) in 1980. Medicare is the second-largest federal program, behind Social Security, with over 45 million Americans enrolled. Another 45 to 50 million Americans receive assistance through Medicaid. Together, these programs support nearly 1/3 of all United States citizens. In 1964,

the year before Medicare was passed, only 56% of Americans over the age of 65 had health insurance, and almost none of those in poverty did. Uninsured elderly and poor people received medical care through charity programs offered by individual doctors, hospitals, and other mostly local organizations.[20]

Statistics, agency budgets, and legislative history tell one side of the story. Changes in neighborhoods like the Fenway remind us of the others. In the 1960s, Boston's poorest neighborhoods included the Fenway, the South End, Roxbury, Mission Hill, and Dorchester. Slums included run-down apartment buildings and old hotels whose guest rooms had been converted into one-room apartments with rudimentary kitchens, known at the time as "poor houses." People who lived there included the oppressed people cited by the Black Panthers and other anti-poverty groups, and the elderly residents Fenway Community Health Center was founded to serve. In 1970, changes were coming, but not all the benefits of Medicare and Medicaid had made their way to people living in Boston's poorest neighborhoods. Over time, for a variety of reasons, the South End's slums were transformed into a neighborhood of well-kept townhouses, and poor houses such as the Sherry Biltmore Hotel at 150 Massachusetts Avenue became the new headquarters of the Berklee School of Music. Fenway's patients came from these addresses in 1970, when they were homes for the poor and disadvantaged, and they come from them today, when these same addresses are home to many of the city's current and future leading citizens. If, as Dr. Perrelli observed, the nature of the doctor–patient relationship is constant, Fenway's ability to serve the needs of its community has remained constant, even in the face of great change.

Increased access to health care also brought an influx of revenue to doctors, hospitals, and health care institutions throughout the United States. Boston, always a leader in medical care, research, and education, received a large share of these new federal and state dollars. The story of how Boston's city government and its major teaching hospitals developed a way for these funds to make their way to community health centers like Fenway is another key element in this story—not just for Fenway, but for Columbia Point, Whittier Street, Dimock, East Boston, and other health centers throughout Boston's neighborhoods that pioneered the community health center model of health care. Federal funds couldn't have come to Boston to the extent that they did (and still do) without the established

excellence of Massachusetts General Hospital, Brigham and Women's Hospital, Tufts/New England Medical Center or Beth Israel/Deaconess Medical Center and the tireless insistence on health care for the people by Senator Edward Kennedy. Under the leadership of Mayor Kevin White, Andrew Sackett, his Commissioner of Public Health, and Board Chair Herbert Gleason, Esq., the city initiated a program to create community health centers with the support of Boston's hospitals through the "districting plan" in 1969, assuring that these funds would be allocated to primary care for Boston's residents. It was their decision to require that each of Boston's major hospitals receiving these funds establish a partnership with a local community health center to provide medical care to the residents of Boston's neighborhoods.

This chapter tells the story of Fenway Community Health Center's first ten years, a time of trial and error, a time of volunteers and free care, and a time of local and national innovations making their way to a small Boston neighborhood, some of them "from places you would never expect." Fenway saw patients for a year or two before it was formally incorporated on November 4, 1972, and it didn't receive its first license as a medical clinic until 1981. It struggled to fulfill its original goal of providing medical care to elderly local residents, while its growing popularity among women and gay men led to three different evening clinics per week—one for the elderly, another for women, and a third for gay men. Those who were there remember a lengthy debate on what to do if patients from one of these groups showed up on the wrong night. When the Berklee School of Music made Fenway the "official" health center for its students in 1973, another lengthy debate began because these students didn't volunteer to participate in the Center's lengthy debates, as did representatives of other patient populations. After exploring many options, in 1973, Fenway's Board of Directors decided for the first time to charge for care—fifty cents per patient visit, although this fee would still be waived if a patient agreed to provide volunteer work instead of paying cash.

These debates underscore how young the health center was at the time, and also how young its founders were. Few were over the age of 25, and if they were, it wasn't by much. They wanted to make a difference, to change the world. "We were so young," David Scondras remembers. "We didn't know you needed a license to open a medical clinic. We didn't have any money. When we discovered that we

needed something, we found it, or we built it, or we demanded it." Today's strong partnerships with Boston's hospitals began with demonstrations and sit-ins outside administrators' offices. "I think they were more amused than angry at us," Scondras recalls. It is no less of a tribute to Fenway's founders that Mayor Kevin White's commitment to develop community health centers throughout Boston also played a role in convincing administrators at the New England Deaconess, Beth Israel Hospital, and Boston City Hospital, to collaborate with them. The result was a confluence of youthful idealism and like-minded older officials in Boston's hospitals and city government, combining to solve a problem they both recognized—a growing lack of access to quality health care among Boston's less affluent citizens. Together, they created a facility that was uniquely positioned to serve the Fenway community in the way its founders envisioned, while also becoming part of Boston's growing community health care system. Evidence of Fenway's unique origins can be found in the chart on the following page from *A Promise Kept*, a 1982 book written by Dale Young about Boston's pioneering work to create a network of 24 community health centers from 1965 through 1982. Note that, in the column showing "Major Source of Initial Funding," Fenway is alone in listing "volunteers."

During the decade ending in 1981, Fenway grew from a temporary evening health clinic whose medical equipment was stored under tarpaulins during the day to a licensed medical clinic. By 1974, the health center received its first federal funding; in 1975, it hired the first of three executive directors that decade; throughout the 1970s, Fenway expanded its medical services, first with volunteers and eventually used paid providers. The Fenway Institute Co-Director Ken Mayer, then at Brigham and Women's Hospital on a three-year fellowship at Harvard Medical School studying infectious diseases, successfully proposed the center's first research programs in 1980, in response to Fenway's strategic planning process that had begun a short time earlier. It was a decision that would have unexpected and profound effects on the health center in the years ahead. Gradually, in the long process leading to Fenway's medical clinic license in 1981, painful choices were made in order to qualify for third-party payments from Medicaid, Medicare, and private insurance companies. By its tenth anniversary, Fenway Community Health Center became an "arms-length" affiliate of Boston's

health care system, with linkages to Deaconess Hospital, and medical residents or interns from Beth Israel Hospital—tentative initial ties that would grow in strength and depth throughout its history.

Table 2

SOURCES OF INITIAL FUNDING FOR BOSTON'S HEALTH CENTERS AND DATE SERVICES BEGAN

HEALTH CENTER	MAJOR SOURCE OF INITIAL FUNDING	DATE SERVICES BEGAN
BOWDOIN STREET	Carney/DHH	1973
BROOKSIDE	Model Cities (HUD)	1970
BUNKER HILL	MGH, Title V	1968
COLUMBIA POINT	OEO/Tufts University, College of Medicine	1965
DIMOCK	Beth Israel, Title V	1969
DORCHESTER HOUSE	DHH	1969
EAST BOSTON	DHH	1970
FENWAY	Volunteers	1971
HARVARD STREET	Title V, DHH	1969
JOSEPH M. SMITH	St. Elizabeth's, Title V/DHH	1974
LITTLE HOUSE	Carney, NEMC, St. Margaret's	1973
MARTHA MAY ELIOT	OEO/Harvard Medical School	1966
MATTAPAN	Boston Family Planning, Carney/DHH	1974
NEPONSET	HEW "330"	1970
NORTH END	MGH/DHH, Tri-State Regional Medical Program	1971
GREATER ROSLINDALE	Carney, Deaconess/DHH	1976
ROXBURY COMPRE-HENSIVE	OEO/Boston University Medical School	1969
ROXBURY DENTAL & MEDICAL GROUP	Deaconess Hospital	1969
SOUTH BOSTON	DHH	1971
SOUTH COVE	HEW "330"	1972
SOUTH END	Trustees of Health and Hospitals, TB Association	1969
SOUTHERN JAMAICA PLAIN	Children's/DHH	1971
UPHAM'S CORNER	DHH	1973
WHITTIER STREET	Title V, DHH	1967

21

22

Within the organization, its first comprehensive strategic plan, begun with Sally Deane's arrival in early 1980, helped lay the groundwork for Fenway's future success. The planning process began with discussions among Sally Deane, medical staff including Ken Mayer, Lenny Alberts, and Jay Goldfarb; and members of the Board, including its Tom Hurley, Larry Doucette, Fred Mandell, and chairman Dan Cirelli. They started with the normal sorts of strategic planning exercises—questions about who uses the center; why they come, where else they could go; focus groups; and data on awareness of the center's services, satisfaction with them, types of care delivered or desired, etc.

The results of the study told them that people were coming to Fenway for episodic care for specialized needs—mostly gay men coming for STD screenings and treatment. In Sally Deane's words, "Our patients told us that they were coming in for the clap. But, because their hearts and lungs were just like other people, they would go elsewhere for the rest of their care. We knew that this wasn't entirely true—gay people's livers weren't the same, they had different infectious diseases, and in some cases they suffered from a lack of regular medical care. Most important, though, we learned that Fenway wasn't taking care of them as whole people, because they didn't trust us to. Why?"

The planning team agreed that "internalized homophobia," was the reason. Sally Deane summarized it as follows. "Our patients thought the care they received at Fenway was second-class care, because it was administered by second-class medical professionals in a second-class facility. And the primary reason for this conclusion was because the professionals were gay, and were therefore second-class like our patients saw themselves to be, for the same reason."

Phyllis Dixon, Fenway's Director of Behavioral Health, is emphatic that this is no longer the case; perhaps, she believes, it never was. "The way I've always seen it is that we are blessed to attract smart people even with low salaries. The salaries at most health centers are not high, so that's not why people come to work here. People who come to work at Fenway from the lesbian, gay, bisexual or transgender communities just have such commitment and such passion for their work. So I've never seen it as internalized homophobia." She asserts it's quite the opposite, "I do think that when we have job openings, we get people who apply because

23

they have strong LGBT political leanings, and they think they are qualified for the job because they have strong feelings about their community, but we tend to hire based upon their clinical skills first and then a professional attitude about work. It's the opposite of internalized homophobia. I tend to think of internalized homophobia as hiring people just because they are gay or lesbian without them having the skills for the job."

The next logical strategic question was, of course, how to change this. Phyllis Dixon remembers their collective "aha" experience well. "We decided to use the model of specialized care that was becoming more prevalent throughout Boston. We would become the leading research center on gay health, and in doing so, we'd gain the knowledge base we needed to deliver quality health care to our target population. This quality would earn us the credibility to encourage them to come to us for all of their medical needs. At the time, Brigham and Women's Hospital was the place to go for kidney transplants and dialysis. People went to Joslin Medical Center for Diabetes. If we became the place that was most knowledgeable about gay health care—all gay health care, not just STDs—people would come to us." It was an idea that would be incorporated into Fenway Community Health Center's mission then, and it would remain a central part of the organization's mission.

But through all these debates, professionalization, and strategic plans, silently in the background, a health crisis was spreading among one of Fenway's target populations. It would eventually morph from mystery to tragedy and fear, bringing medical, emotional, and intellectual challenges to Fenway far beyond what its founders and early leaders ever imagined. It would test the organization's medical and research staff, its administrators, its board of directors, and its patients for decades. But it would validate this early strategic decision to become Boston's leading resource for gay health care, over and over again.

"I've always believed that community organizing is to community health care as epidemiology is to medical care. Epidemiology is the science of public health. It helps us look at the nature and causes of illness and disability. I think community organizing, when done well, can engage all the diverse segments of the community—not just racial or sexual minorities, but all the diverse groups in our population—in a way that allows their real health barriers and needs to be better understood, and therefore better addressed. It's the same with epidemiology—when public health is better understood, it is better addressed. I'm a big believer in community organizing. It's an essential part of an effective community health center."

—Sally Deane, Fenway Community Health Center Executive Director, 1980-1984

1970S CARE

"And the young gay people...who are coming out and hear [anti-gay crusader] Anita Bryant on television...The only thing they have to look forward to is hope. And you have to give them hope...hope that all will be right. Without hope, not only gays, but the black(s), the seniors, the handicapped, the us'es, the us'es will give up."

—Harvey Milk, the Hope Speech, 1977[22]

At the time its articles of incorporation were filed, Fenway Community Health Center had been serving the community for over a year, at its initial location in the Boston Center for Older Americans offices at 236A Huntington Avenue. Medical equipment was kept under tarpaulins in the back of the office during the day, and was brought out and set up for each of Fenway's initial free evening clinics—one for women, a second for the elderly, and a third for gay men. Each of these three sessions was managed by a committee of Fenway's board—the Women's Health Collective, the Elderly Health Collective, and the Gay Health Collective. Volunteer doctors and nurses served as the first medical staff, and, through Fenway's three Health Collectives, the same local residents who served on many other neighborhood organizations provided administrative support and neighborhood outreach. Until Fenway was fully licensed as a health clinic in 1981, actual medical care was provided using the credentials of Fenway's providers themselves. Original services included testing for sexually transmitted diseases and pregnancies, basic obstetric and gynecological services, and mental health counseling. Within a few years, pediatrics, podiatry, and primary care were added. By 1979, Fenway offered a senior adult day program, and a children's outreach program that included after-school activities and assistance with part-time job placement for high-school students.[23] Patients in need of care that couldn't be given on an outpatient basis were referred to Beth Israel Hospital, but not by referral from the health center as an organization; in these cases, one of Fenway's medical staff was designated as the "physician of record." There was no billing

system; all of Fenway's initial health care services were free. Medical records were mainly service statistics, since Fenway would only track individual patients with their permission, offering most of its services on an anonymous basis.

In 1974, Fenway received its first funding from Boston's Matching Grant Program in conjunction with the New England Deaconess Hospital. Under this program, the city contributed funds from the federal Department of Health, Education, and Welfare (now the Department of Health and Human Services) to local hospitals for their use in supporting community health centers, so long as the hospitals contributed an equal amount of their own funds for this purpose. The Fenway Community Health Center's affiliation with the Deaconess continues today with Beth Israel Deaconess Medical Center (BIDMC); Fenway is one of seven community health centers in the BIDMC's Community Care Alliance (CCA), a group of independent health centers that affiliated with the hospital during the 1980s and 90s. It is worth noting here that Fenway and the other members of CCA still receive federal support from other agencies, among them the Health Resources Services Administration (HRSA), part of the Department of Health and Human Services. Recent HRSA funding includes grants for direct medical services to disadvantaged populations, and for improvements to CCA members' managerial resources, such as electronic medical records. Balancing the financial requirements of running a community health center with periodic shifts in government priorities, changes to regulations and grant programs, and transfers of responsibility from one agency to another, has always been a challenge for Fenway and other organizations like it.

When Fenway Community Health Center's volunteers were building a neighborhood clinic with volunteers and donations, gradually transforming the Center from a project of community activists into a self-sustaining health care facility, they were to some extent fulfilling the goals of federal and city officials interested in increasing access to medical services as part of their anti-poverty programs. "We believe health care is a right, not a privilege," Fenway's original slogan, was more than the radical proclamation of a collection of neighborhood activists intent on changing the world. It was also official government policy, put into practice by political leaders in Boston and Washington, administrators of the eight hospitals participating in Boston's Districting Plan, and the health care

professionals and community representatives who managed community health centers throughout the city.

Still, this collaboration was not always smooth, or well understood. Many of Boston's community health centers had direct relationships with one or more hospitals or government agencies. Beginning in 1974, when it was financially "linked" to New England Deaconess Hospital, Fenway had an "arms length" hospital relationship, which was strengthened into real partnership under Sally Deane's leadership in 1980. It would be 1989 before Fenway providers actually had admitting privileges at the Beth Israel Hospital to provide continuity of care to their patients. Where these relationships existed, the need to provide health care and education services as a professionally licensed medical clinic, in order to comply with qualification standards for Medicare and Medicaid funding, could be communicated. In these cases, collaborating managers at the city government, hospital managers, and community health center board members were all on the same team. "Being on the same team" was no trivial matter, since official licensing of health centers was the responsibility of the Massachusetts Department of Public Health (DPH), not the city or the federal government. At the time, the DPH was not a collaborator in the creation of Boston's community health center network. Officially, it would grant licenses to health centers only after strict standards were met. However, the DPH did provide Fenway with important and substantial donations of supplies for the treatment of STD's throughout the 1970s, even as it contracted with all local hospitals for their STD clinics.[24] For a long time, Fenway got supplies, while the hospitals received funding. This was particularly ironic, because, by 1980, Fenway's STD screenings at Boston's gay bathhouses accounted for 50% of all syphilis cases identified in the state.

Individuals on Fenway's board in the 1970s recall city officials and administrators at New England Deaconess and Beth Israel Hospitals urging them to take steps to comply with the DPH, because this was the only way to get reimbursed for services rendered from Medicare and Medicaid, and from private health insurance companies, to go directly to the Fenway Community Health Center, instead of being written to the individual doctors and nurses who worked there. But this process was introduced to Fenway more because of the financial benefits of third-party billing than it was presented as a strategy for long-term survival of Boston's community

health care system. Fenway's board took a number of steps toward the city's goals in the 1970s, including the initial filing of an application for a license from the Massachusetts Department of Public Health in 1978. But it took three years and the efforts of Sally Deane, Fenway's third Executive Director, and her Medical Director, Natalie Mariano, to obtain that license in 1981. Rhonda Linde would follow soon thereafter with a second license to provide mental health services at Fenway as its programs expanded following the organization's first strategic plan.

Throughout the 1970s, Fenway's program of medical care was a work in progress. It seems hard to believe that its evening clinics began in 1971, not only before there was a state license, but before the organization was even formally incorporated. Until moving to 16 Haviland Street in early 1973, Fenway was still delivering free medical care in office space owned by the Christian Science Church. Volunteer doctors, free office space, donated medical equipment and supplies, and the support or benign neglect of many Boston political, medical, and community leaders were all elements in the survival of Fenway Community Health Center. The question of what would happen if a woman showed up on Gay Health Night, or a gay man on Women's Health Night, was important, because the Board of Directors at the time was comprised of people primarily dedicated to one of these three groups, and not necessarily to the Center as a whole. As discussed earlier, the next-higher level of organization was a group of community activists who saw the health center as one of the Fenway neighborhood's many programs to fight poverty, advocate for tenants rights, run a food coop, or publish a newspaper. The core of an independent, mission-driven organization we now know as Fenway Health was still evolving. But once Fenway Community Health Center was incorporated in 1972, and established its headquarters at 16 Haviland Street, the institutional doors were opened at least wide enough for the city of Boston to include it in the city's comprehensive system of neighborhood health centers, which was evolving in its own manner at the same time. Support from the city of Boston, even if it was delivered in ways that were not always clearly in line with the goals of Fenway's three health collectives, brought resources that allowed the

clinic to expand beyond its initial three-evening program and begin to operate as a free-standing health center. But it also changed the Health Center from a loose confederation of volunteers taking on all challenges to an organization more specifically focused on the provision of health care services—as these services were defined by a medical establishment including local hospitals, the city of Boston, the state, and the federal government.

Fenway Community Health Center Staff and Volunteers, circa 1980 (*Northeastern University Archives*)

Two of Fenway's three Health Collectives found early success by developing programs aimed directly at the needs of their target populations. Women's health advocates brought the philosophy of *Our Bodies, Ourselves* to Fenway, and several members of the Center's original Women's Health Collective, including Norma Gaye Martin, one of Fenway's original founders, were in fact closely affiliated with the Boston Women's Health Book Collective itself. Counseling and education programs for women expanded beyond the initial Women's Health Night, and Fenway's offices were full of literature from other women's organizations, some of it for sale at a discount as part of Fenway's early health education programs (the Gay Health Collective borrowed this idea and began selling *The Advocate's Guide to Gay Men's Health* at the discounted price of $7). Women came to Fenway not only seeking treatment; they came to volunteer and collaborate with other women in the development of a new, alternative system of health care for women, managed by women. Similarly, Fenway's commitment to providing anonymous screening and treatment for sexually transmitted diseases became well known among Boston's gay men. These consumers became such a large part of the center's early patient population that Fenway became known as a gay men's clinic—not just by Boston's gay community, but by the city's medical establishment and later the press and the public at large. In hindsight, the interplay of such broad social forces as homophobia, women's rights, the free clinic movement, and government anti-poverty programs is fascinating, and worthy of serious reflection. But from the perspective of those who were there at the time, things could be seen in far simpler terms. One of Fenway's founders describes the reason for Fenway's initial success with women and gay men in simple terms: "We just became popular."

Becoming popular wasn't the result of simply being open to gay men every Wednesday evening, then also by appointment on Mondays, and gradually throughout the week as Fenway's patient population grew. J.B. Molaghan, a nurse who staffed Fenway's Gay Health Nights, recalled the center's philosophy of teaching people to be healthy, not to simply treat their diseases. "We encouraged patients to seek VD tests every six months, and to try to avoid disease by washing and urinating after sex. We were trying to teach safe sex, although we didn't know it then." In 1976, Fenway expanded its unique combination of care, outreach, and education by collaborating with the Massachusetts Department of Public Health

(DPH) to conduct free, anonymous STD screenings at Boston's gay bathhouses, which were also popular in the time before AIDS. DPH staff conducted the tests, and participants were given Fenway's phone number to call for results. They could use their own names, an alias, or simply a number. Jerry Feuer, a physician assistant who has worked at Fenway since 1978, recalls the program, which remained in place until the bathhouses were closed in the mid 1980s. "It was effective in the sense that people who might not come to the clinic were able to get tested, but it was flawed. In many cases, we had positive results for people who never called for them, and we had no way of contacting them so they could come in for treatment."

Results from Fenway's third target population weren't as promising. The elderly came to Fenway as patients, but in smaller numbers than women or gay men. They didn't join Fenway's Board of Directors or the Elderly Health Collective to help manage the organization's development with the same energy as the other two groups. There are a number of possible reasons why Fenway didn't succeed with its elderly patients as well as it did with women and gay men. First of all, and perhaps ironically, the elderly were the only target population with many people who actually lived in the neighborhood. Fenway's women and gay men patients came from all over Boston, Massachusetts and later from throughout New England because other health centers didn't offer them the programs Fenway did. These other health centers, and indeed doctor's offices and hospitals throughout the city, provided accessible, quality health care to "their" local elderly. So, even though Fenway's relationship with its elderly patients was based on its location nearby and was one of the primary reasons behind Boston's Citywide Districting Plan of 1968, there were fewer elderly residents seeking Fenway services than women or gay men were.

A second reason for Fenway's lower utilization by the elderly was the fact that its early office space—first its temporary evening clinics at the Boston Center for Older Americans at 236A Huntington Avenue, and then its 16 Haviland Street location—were not as well-equipped as other health care facilities in town. The 16 Haviland Street offices were in the building's basement, and weren't yet handicapped-accessible. Exam rooms were small and cramped, walls were paper-thin, and equipment was second-hand. Ken Mayer remembers it fondly as "our grubby little health center," a fine environment for developing revolutionary health care

for women and gay men, but not as inviting to the elderly. Medicare and Medicaid were evolving to offer more universal health care for the elderly, who preferred other, more professional-looking medical facilities. While Fenway might have been an extreme example of this problem, other neighborhood health centers in Boston at the time had similar experiences. They weren't traditional doctor's offices, and made do with less in order to offer care to their communities. By 1979, when statistics were gathered on utilization for all 24 clinics, Medicare visits comprised only 9% of the total population for all the health centers, a disappointment to many of the community boards which operated each center, and to the city of Boston's Department of Health and Hospitals. Eight of Boston's neighborhood health centers averaged a relatively strong 17% Medicare utilization, among them East Boston, the North End, Charlestown, and Upham's Corner; Fenway was roughly consistent with the city-wide average, reporting 8% of its FY 1979 income from Medicare reimbursements. The larger number of Medicare visits at Upham's Corner and East Boston can be attributed to these centers' operation of home health care programs.[25]

A third reason for Fenway's difficulties in reaching the elderly may have been more cultural. Fenway's success in reaching women and gay men brought many patients and volunteers to the clinic, and its waiting room was often filled with people who were young, maybe "radical," and definitely comfortable being themselves. Fenway Community Health Center wanted to be a place where all its patients felt at home, but may not have realized how its popularity with two of its target populations might get in the way of similar success with its third. In fact, one of the reasons Fenway moved from the Boston Center for Older Americans to its 16 Haviland Street offices in 1973 was due to complaints from elderly Fenway residents that so many young people were invading their community center. To satisfy the service needs of the elderly, Fenway would later send a podiatrist on regular visits to elder housing in the area instead of seeing elderly patients at the health center.

In retrospect, Fenway's difficulties in reaching out to the elderly residents of its neighborhood may have always been a problem of governance, since most of its early leaders were so young. Women and gay men could advocate for their own needs in the organization's early, interminable meetings. The elderly were

represented by the wishes of Fenway's volunteers to provide health care to the disadvantaged, but not by themselves—at least not directly, in large enough numbers. The elderly would turn out for community meetings—nearly 400 of them did so in 1972 when the Christian Science Church's Board of Directors considered evicting the Health Center from its BCOA location—but they didn't participate as regularly in the "interminable meetings" that were so much a part of the organization's early management structure. Looking back at Fenway's difficulties reaching the elderly, one member of the Board of Directors recalls how mysterious this problem seemed at the time, "We couldn't imagine why a 72 year old woman wouldn't walk on an icy road on a long winter night, and then down the stairs into a tiny cramped clinic, instead of being driven or taking one T stop to a bright, new hospital clinic open at 10 AM."

Given its success in reaching women and gay men, how did Fenway's health services develop in the 1970s? Few documents from this decade exist; apparently, many of the center's official records were discarded by the mid-1980s, for reasons that might be related to protection of patient confidentiality during the early AIDS epidemic (at that time, some government and hospital officials were suggesting quarantine as a policy response to the disease). This loss also might be related to the physical space constraints of Fenway's tiny headquarters. The medical records were stored according to law in cold storage facilities because the health center had such cramped quarters that maintaining medical records except for active patients was untenable. By the late '80s these patient records along with active patient files were all purged with the exception of active patients. Many people in the 1970s and early 80s were using false identities to get care and generating a new medical record under a new identity with each visit. However, we can draw a number of conclusions from data reported by Dale Young in *A Promise Kept*, which gathered service statistics from all 24 community health centers in Boston for 1979. That year, Fenway reported 9,014 total patient encounters, categorizing them into the following three types of care:

Pediatrics .2%180

OB/GYN, Family Planning 13% 1,172

Adult Medicine 85%7,662 [26]

We also know from this same report that Fenway Health's FY 1979 income totaled $223,670, and were summarized in three major categories:

From grants . 26% $58,154

Patient fees. 49% 109,598

Donated Services 25% 55,918

Fenway's 1979 grants income came from the following sources:

City .44% $25,297

State. .0%0

Federal . 10%5,815

Private . 47% 27,042

Total . $58,154

Within the "patient fees" category, Fenway's sources of payment for medical care were:

Self pay . 83% $90,418

Medicaid .6% 6,028

Medicare .8% 8,769

Private insurance4% 4,383

Total. $109,598 [27]

There is no information about what was included under "donated services." This figure may have included supplies donated by the Massachusetts DPH for treatment of venereal diseases, or it may represent the volunteer health education services contributed by Fenway's Women's Health Collective, the last of Fenway's three collectives to provide free care by individuals who were not professionally licensed.

These figures contrast sharply with the average for all 24 neighborhood health centers participating in Young's 1980 study. Overall, the average income was just under $1 million per center, with 48% coming from grants, 44% from patient fees, 6% from donated services, and 3% from other sources. Average grant revenue by source for all centers shows 21% from the city, 2% from the state, 69% from the federal government, and 8% from private sources. By any measure, Fenway did not conform to the image of a neighborhood health center that served women and their children with their largest departments being OB/GYN and pediatrics. The other health centers survived on federal government funding, or hospital funding for infrastructure and administration, or third-party billing and Medicaid payments. Fenway barely got by on an unusually high amount (83%) of self-payers, largely from people who wanted anonymous services, like gay men, or those who rejected the types of services paid by insurance companies, like feminist lesbians. These self-payments were usually nominal and totally unrelated to the actual cost of care.

By these standards, Fenway was the smallest of all 24 health centers in total annual income, about 1/5 the size of Boston's citywide average. Its reliance on grants for 26% of its total income ranked fifth lowest in this category. Looking at the types of grants that sustained Fenway in 1979, its 44% of grant revenue coming from the city of Boston ranked eighth-highest, while Fenway's 10% reliance on the federal government for its grants was fourth-lowest. It is also worth noting that Fenway received no financial support from the state in 1979 (although the Massachusetts Department of Health did contribute medical supplies for Fenway's STD screening programs). The 47% of its grant income that came from private (non-government) sources ranked Fenway as the third-highest among all of Boston's neighborhood health centers in 1979. Fenway's reliance on grants was a highly local phenomenon, with over 90% of these dollars coming from the city of Boston and private sources.

Patient fees for all centers averaged 44% of total income, roughly in line with Fenway's 49% of total income from these sources. Citywide, 36% of patient fees were from self-paying individuals without government or private insurance, 42% from Medicaid, 9% Medicare, and 14% private insurance. Fenway was second highest in percentage of patient fees coming from self-payers, at 83%. (Joseph M. Smith Health Center, formerly the Allston-Brighton Community Health Center, saw 86% self-payers, largely because it provided dental services, which were not covered by any government or private insurance). Fenway's 6% reliance on Medicaid funding for patient fees was lowest among all reporting centers, while its 8% in Medicare patient fees tied with three other health centers at eleventh overall, more or less the median for all centers. The 4% of Fenway's patient fee income that came from private insurance ranked seventh lowest. Finally, Fenway's reliance on donated services for 25% of its total income ranked highest among all of Boston's community health centers in 1979.[28]

What might these numbers mean? It isn't surprising that Fenway was the smallest of all of Boston's community health centers in 1979, given its tiny basement location at 16 Haviland Street and its founding by neighborhood volunteers as compared to the larger government agency and hospital support that launched many other clinics in the city. Fenway also reported the lowest percentage of patient fees from Medicaid, which is partly the result of not being licensed by the State of Massachusetts until two years later, in 1981. The 8% of Fenway's patient fee revenue that came from Medicare is disappointing, but not very different from the figure for many other health centers in Boston at the time. A few figures in Dale Young's study may reveal key aspects of Fenway's medical services in 1979. First, there is the 83% of its patient fee income coming from self-paying individuals without insurance. The reason given for this in *A Promise Kept* is quoted verbatim: "Sally Deane, the Executive Director, explained that while many of that Center's clients did carry insurance, many clients chose not to use their insurance policies for reasons of privacy."[29] In fact, this is evidence of how popular Fenway had become among gay men by the end of the 1970s. Patients from all over Boston or even farther away could go there, give a false name, get tested, call back or wait for results, get treated, and pay cash for all of it. No questions asked. As many as 7,500 of Fenway's reported 9,000 patient visits in 1979 may have gone just about

like that. People didn't trust the government or their insurance companies with information about their sexuality, and Fenway was one place gay and bisexual men knew they could trust to keep it confidential. Those who didn't even trust Fenway staff could get effective medical care anonymously as "John Doe."

Boston resident Douglas Hughes, who, with his partner Terry Keane, donated funds for today's Behavioral Health Program's lobby at 1340 Boylston Street, recalls his first visit to 16 Haviland Street in 1981. "I was nervous, looking both ways to see if anyone was watching as I entered the side door. Once inside, the very friendly receptionist told me I could give a fake name if I didn't want to use my real identity. I did, and took a magazine to read while waiting to be seen. I got so engrossed in the story I was reading that I forgot the name I had given the receptionist, who eventually had to come over to tell me, 'sir, I believe you've forgotten your name.'"

Another insight can be found in the details about Fenway's federal funding. Its 1979 grant of $5,815 for family planning was that year's share of the first direct federal dollars awarded to the Center—a significant milestone given the organization's long history of federal funding ever since. It's also a bit ironic, given Fenway's focus on gay men and lesbian health services throughout its history. This grant, authorized by the Family Planning Services and Population Research Act of 1970, funded "family planning counseling, gynecological exams, diagnosis and treatment for infertility, and contraceptive supplies," and was administered by the Department of Health, Education, and Welfare (now HHS).[30] Family planning was part of Fenway's 1970s women's and family health programs, along with support for individuals in applying for Women, Infants, and Children's (WIC) funding from the Massachusetts DPH. The construction of a playground on the parking lot across the street from Fenway's 16 Haviland Street location (which would eventually become the site of the health center's new building at 7 Haviland Street), and its after-school activities programs for children and teenagers in the late 1970s, were also funded in this manner.

A third figure in Young's study is also revealing, if through a bit more of a stretch. Twenty-five percent of Fenway's total income, or almost $56,000, was categorized as "donated services." Other neighborhood health centers used this category to place

a value on medical services provided at their clinic by staff on the payroll of their affiliated hospitals.[31] As noted above, Fenway had no such arrangement at the time. However, Fenway did still maintain an active program of free health services run by its Women's Health Collective, based on the self-help philosophy championed by the Boston Women's Health Book Collective in *Our Bodies, Ourselves*. Throughout the 1970s, Fenway offered free reproductive health counseling appointments, education in how to conduct self-examinations for breast cancer, and demonstrations on how women could perform their own cervical exams.

Absent further study, it is possible, maybe even likely, that much of the 25% of Fenway's total 1979 income reported as "donated services" was the value of the Women's Health Collective's free, volunteer-provided services that year. The energy that these volunteers contributed, and the importance they placed on their own work, had been a part of Fenway Health Center since its founding. Women, after all, were one of the three groups who were there at the beginning; Norma Gaye Martin, one of the three signers of Fenway's Articles of Organization in November of 1972, was also a founder of the Women's Health Collective.

In Board meetings at the time, Fenway's Women's Health Collective argued that their commitment to teaching other women how to manage their day-to-day health offered better medical care than services provided by male doctors who were essentially untrained in anything beyond traditional obstetrics and gynecology. From today's perspective, the idea of a health center providing medical care through unlicensed volunteers seems unimaginable. But at a time when neighborhood health centers were developing a system of care to fill the void left by doctors who had abandoned their communities to join the growing ranks of specialists in Boston's enormous teaching hospitals, the concept was not so shocking. Or maybe it was not as shocking as this:

"Medical research was conducted almost exclusively by male physicians, and because most research scientists believed that effects of the reproductive cycle of women might lead to unreliable research results, most supported the belief that research should be conducted on men and then applied to women. Even most medical research on rats during this period was conducted using male rats."

"However, by the 1980s, women's health advocates had realized that because women were being excluded from research studies, knowledge about the diagnosis and treatment of a wide variety of common diseases in women lagged far behind knowledge of diseases in men. A major focus of the women's health movement in the 1980s and 1990s was improving knowledge about disease in women by promoting the inclusion of women in research studies, mainly through mandating inclusion of women in federally funded research studies."[32]

In the 1970s, large hospitals and the doctors who worked within them were not necessarily viewed as trusted health providers by many of Fenway's patients, and certainly not by its founders. The Center was a viable alternative for gay men seeking confidential health care. It was also a place where women who understood the shortcomings of traditional health care facilities could not only receive health care services designed for them. At Fenway, they could help design them. Today, the publication of *Our Bodies, Ourselves* in 1970 is widely considered as a revolutionary leap for women's health care. But at the time, when women actually confronted a medical system that didn't conduct research on women's health by studying actual women, the word "revolutionary" had more immediate import. It was a call to action—inspiring, invigorating, promising, and exciting. For many women, it stirred a demand for better health care. When they believed their advocacy for improvements in women's health care fell on the deaf ears of a male-dominated medical research and health delivery system, they engaged themselves in providing these services directly, and used their experience to teach each other about women's health. It was difficult to argue against women who stridently claimed that their preventive and self-help health programs were superior to what could be found anywhere else in Boston.

At the end of a decade that saw support from the city of Boston, and even the federal government's interest in community health as an anti-poverty program, Fenway was evolving into a neighborhood health center that was equal to similar organizations in twenty-three other parts of the city. Its unique programs were becoming more health-centered and less community-action oriented. Women

made up the majority of its professional staff, and a woman was about to be hired as the Center's new Executive Director—one who would help transform Fenway into a professional health care organization that would become a leader in the struggle against one of the greatest epidemics the world has ever seen.

But, in a different way, the year 1979 was an important milestone for Fenway Community Health Center. Maybe it was the end of its innocence, one of the last years when it could be described as the smallest of all of the city's health centers. It served a unique population of gay men; it had a high percentage of self-paying patients; and it was a place where women provided medical services in a way that was truly self-help. 1979 was a year when Fenway learned that its struggle to reach the elderly was a challenge shared with so many other health centers in Boston, and was one of the last years before it would receive its license as a health clinic and its first state funding. Fenway Community Health Center, headquartered in a basement office its volunteers had built out only six years earlier, remained almost exclusively a product of its own neighborhood. The people on its Board of Directors were neighbors. They made decisions in interminable meetings with philosophical arguments and a commitment to let everyone speak on every issue— politics, health care, research, education, and advocacy. The pizza was always cold long before the end of the agenda.

Then, one night in 1979, weighing the choice of continuing the longstanding contributions of one of its founding three Collectives vs. joining Boston's growing system of neighborhood health centers, Fenway's Board chose the system. With eligibility for third party Medicaid and health insurance payments as the prize, Board members took a "counsel or cancel" vote. Fenway would either continue to provide women's health counseling services for free, by volunteers who were screened by other center volunteers but not professionally trained, or it would cancel these programs as they were conducted by its Women's Health Collective. The vote was to cancel.

So much changed that night: Fenway would continue to professionalize its health care services. Choices between providing health care vs. operating programs that were not strictly health care would consistently be made in the interests of providing quality health care. Just one year later, a similar vote would be taken

against the passionate arguments of the Gay Health Collective, who believed that it was more important to hire gay male staff, even if they weren't as competent as women or heterosexual professionals who wanted to work at the center. The center chose the more competent woman as its new Executive Director, and she, in turn, hired medical and administrative staff based solely on ability and credentials. Struggles among Fenway's leaders would continue, of course—how to balance the needs of its different constituencies; how to respond to unanticipated crises; what to do in times of scarce resources; and how to deal with homophobia, misogyny, racial prejudice, or other threats. Some of these struggles were real and required wise leadership to resolve. Others seemed important at the time, but eventually receded in the face of larger challenges. But a choice of competence and professionalism over political activism had been made, and Fenway would be profoundly different from that night forward.

In other ways, very little changed that night. The next day, Fenway opened for business as usual and provided the same health care services it had offered the day before. Women came for family planning counseling and WIC education services the following Tuesday, gay men came for STD screenings and treatments on Wednesday, and elderly residents came for appointments with one of Fenway's doctors or nurses on schedule. The same characters arrived at 16 Haviland Street and sat in the old movie theater chairs, interacting with each other while waiting for their turn in one of the tiny exam rooms. Action continued on the center's application for a license from the Massachusetts DPH. Officials at the city of Boston Department of Health and Hospitals and administrators at the Deaconess held meetings with Fenway's staff and board members to develop a collaboration that would expand health care services for consumers. Students at Berklee Performance Center called to learn more about the medical care their school had arranged for them at their official health care facility. Daily dramas among staff members alternately offered entertaining or annoying distractions, and the next interminable meeting, complete with political and philosophical commentary, was always a short time away. There were laughs, lots of them. Most of the medical issues that visited Fenway were routine, even if a small percentage were heartbreaking. And the Women's Health Collective didn't go away—there was too much energy associated with their mission for that. Within months, they were bringing health

counseling and education services back to Fenway, this time with the qualified professionals the state and Fenway's board wanted. It was still the 1970s, and innocence hadn't really been lost, after all.

...

I think that we will continue to expand our research into other areas besides HIV, so we will expand research into lesbians and other members of the community. We are already looked at nationally as a resource for information on LGBT health care. We're moving into clinical areas on transgender people and we are seeing trans folks now the way we were with gays and lesbians 30 years ago, far ahead of other clinicians in being willing to treat, knowing how to care for transgender people.

I see our services as expanding to eye care, dental and we will probably expand to geriatrics, perhaps pediatrics. I see us moving more toward geriatric care for LGBT people growing with our patients who have been with us for over 30 years. We can offer many supports to Sydney Borum Health so that we can assist their stability and growth. We have many more clinicians now who are women so we can serve many more women, and we are.

—Jerry Feuer, Physician Assistant, Fenway Health

1970S EDUCATION

"We learned that we were capable of collecting, understanding, and evaluating medical information; that we could open up to one another and find strength and comfort through sharing some of our most private experiences; that what we learned from one another was every bit as important as what we read in medical texts; and that our experiences frequently contradicted medical pronouncements."

—*The Boston Women's Health Book Collective and Our Bodies, Ourselves: A Brief History and Reflection*[33]

Fenway's concept of care included education from the very beginning. "Educate the people in the Fenway...and assist these residents in improving the quality of health care in this area," is one of the two stated purposes in its 1972 articles of incorporation. The October, 1970 survey that Fenway's founders circulated around the neighborhood included questions about residents' knowledge of Medicare and Medicaid, and their interest in learning more about how to obtain health care. While Fenway was evolving during its first decade, a number of programs began based on the enthusiasm and commitment of individuals who shared the belief that "health care is a right, not a privilege," and who saw a need for medical services that weren't being provided to key groups in Boston. Among these groups were the women who formed Fenway's Women's Health Collective, the same people who sponsored Women's Health Night at Fenway's 236A Huntington Avenue, an occasional clinic in 1971. With strong ties to the Boston Women's Health Book Collective (BWHBC), the women of Fenway shared their perspective on health care for women at the time: "We discovered that every one of us had a 'doctor story,' that we had all experienced feelings of frustration and anger toward the medical maze in general, and toward those doctors who were condescending, paternalistic, judgmental, and uninformative in particular. As we talked and shared our experiences, we realized just how much we had to learn about our bodies, that simply finding a 'good doctor' was not the solution to whatever problems we might have."[34] And so they set about creating health care

services that, in their view, would be at least as good, if not better, than the care found from traditional doctors in Boston. They would do it themselves.

With this mission, Fenway's Women's Health Collective developed the Center's first comprehensive health education program. As noted elsewhere in this book, Fenway's first federal grant was from the Department of Health, Education, and Welfare for family planning services. Congress created this funding program "to enable public and nonprofit private entities to plan and develop comprehensive programs of family planning services; (and) to develop and make readily available information (including educational materials) on family planning and population growth to all persons desiring such information."[35] Fenway gave its women patients information and advice on how to obtain Women, Infants, and Children (WIC) funding from the Massachusetts Department of Public Health, and it provided counseling services for women seeking advice on reproductive health, birth control, and abortion. Stapled copies of "Women and Their Bodies," the results of the BWHBC 1969 summer project that would later be reprinted as *Our Bodies, Ourselves* in 1973, were available in Fenway's clinic on Women's Health Night, along with other books that, in the opinion of many women at the time, offered health information that was superior to anything found in Boston's hospitals and doctor's offices.

While this self-help health education model assisted Fenway's consumers, there came a time when it no longer assisted the organization's growth. For much of the 1970s, Fenway's women's health programs were a standard element in its growing collection of programs, and in fact were the largest health education program available at the center. These services were free of charge, and there were plenty of volunteers willing to provide them. Medical staff was not involved in most of these health education services, but Fenway's physicians and nurses could be brought in when the needs of a particular woman would warrant their attention. Providers could provide formal medical care in the same way it was done at Fenway and many other health centers at the time—they would practice at Fenway's offices using their own professional licenses. But later in the decade, when the city, state, and federal governments expanded their support for health centers with programs that required these clinics to be formally licensed, some of these "educational" services would become a source of conflict and confrontation.

Specifically, women at Fenway and other clinics were offering reproductive health counseling, and even basic medical examinations. While these women volunteers believed they were not only culturally but medically competent to offer such care, government agencies determined these services could only be provided by licensed medical professionals.

In most neighborhood health centers in Boston, being affiliated with, or owned and operated by a hospital with its large medical staff prevented these licensing requirements from becoming a threat. Doctors and nurses from these hospitals offered health care at their neighborhood health centers, while non-medical staff and volunteers ran community outreach programs, scheduled education programs conducted by professionals, maintained a stock of health information pamphlets and books, and helped women fill out applications for WIC and other available services. At a few health centers, including Fenway, things were very different. There was no official hospital or large medical staff, and in fact the people running Fenway's programs believed they had a better idea for providing health care than the care provided by licensed physicians from Boston's large hospitals.

By 1978 though, many of its leaders realized that Fenway's health care business model was unsustainable. A growing number of them also became aware of the city of Boston's long-term plans for its community health center system, and how state licensure would be a central part of any health center's continued existence. A clinic license would not only bring Medicaid and Medicare funding directly to Fenway to pay for free care to the poor and elderly, it would also cement the bond between Fenway and its affiliated hospital, the NE Deaconess. With a license, Fenway could refer patients directly to the hospital instead of relying on the personal credentials of its providers. But, in order to get a license, Fenway had to renovate its offices to comply with DPH standards, and it had to require that all its providers be professionally qualified. Financial survival was required to secure a future for Fenway's mission. Optimism dictated that there must be a way to be licensed, while at the same time making sure the organization's mission was fulfilled.

The choice was a profound one, and in the late 1970s there was no clear answer on which was the correct course. Should Fenway comply with state licensing requirements

to become part of a developing health care system that would subsidize professional care for the poor and disadvantaged, or stay true to the organization's original model of free care for all? Throughout its first decade, Fenway's staff included doctors and nurses from inside the health care system, and non-medical educators and counselors from the women's movement and the gay community. These volunteers provided free medical care, education, and counseling along with such non-medical services as senior day care and after-school programs for students. In some ways, Fenway's priorities grew to include not only the needs of its patients for care, but also the interests of its volunteers in contributing to society. They believed that health services to gay people could best be provided by gay people, who best understood the unique needs of their community for non-judgmental, confidential care. Or they believed that health care for women ought to be provided by women, in a way that included education about unique aspects of women's health that had never been offered before.

Lost in the political activities of the early 1970s were the unique needs of lesbians, often an afterthought for gay men concerned with their own well being or deliberately overlooked by other women who feared being stereotyped as "man-haters" if lesbians were visible in their movement. Fenway's Gay Men's Health Collective went into the gay baths to educate, and its Women's Health Collective lived the lessons of *Our Bodies, Ourselves.* Along with *Gay Community News,* Fenway was one of the rare organizations where gay men and lesbians worked together, in fact helping to make Boston the first city in the nation that had a united gay and lesbian community. Nationally, this would not change for several decades, until the Year of the Lesbian in 1993.

During the early 1970s, pioneers had already created new organizations like Fenway, or the Cambridge Women's Center or the Boston Women's Health Book Collective. Why not go further with the revolutionary changes they had already brought about? Gay men had created a place where anyone could be tested and treated anonymously, because Fenway didn't rely on health insurance, Medicare, or Medicaid funds to pay for these services. Patients either paid cash or received free, anonymous care. Much of it was for the diagnosis and treatment of sexually-transmitted diseases, which in many cases would be revealed at other health facilities with significant adverse effects on their careers and personal lives. Women could come to a clinic where they could obtain health services from

other women, and could learn from—and teach—each other in the process. They saw the information in books like *Our Bodies, Ourselves* to be better than what was available from male physicians, and saw nothing wrong with using it as the basis for "self-help" education that would enable women to take control of their health care for the first time in their lives. Exchanges of information like these didn't require money; why should they? Male doctors didn't know or care about women's health as much as women did; why should a woman go to a licensed physician when better information and care could be found among women who were far more dedicated to these subjects? Fenway's progressive emphasis on self-help education and its unique adherence to strict anonymity in STD screening and education for gay men would become invaluable assets over the next decades. The health center became the place where large numbers of gay men and other people with AIDS sought the comfort of anonymity in care, and lesbian women sought to help themselves create families through Fenway's alternative insemination program instead of struggling with the obstacles they normally encountered in the foster care system.

Ultimately, with its 1979 vote to end health care services provided by unlicensed volunteers or staff, Fenway made the choice to comply with government licensing standards, and to distinguish professional health care services from community-based health education services and neighborhood outreach programs that could be operated by non-medical personnel. This distinction had already been developed within Fenway's health programs for the elderly. The people on Fenway Community Health Center's Board of Directors had ceased to be involved in the newspaper business, or the food coop business, or tenants' rights activism. Its application for a state license had been submitted a year earlier, and the Board understood the license would not be granted until it complied with DPH requirements. Within a short time, doctors and nurses were hired to provide women's health services. But the shelves of Fenway's waiting room were never without copies of *Our Bodies, Ourselves*. Women's health services continued to be pioneered at Fenway, even as they moved to 7 Haviland Street and 1340 Boylston Street.

Ironically, the Cambridge Women's Center and its Women's Community Health program continued to fight "the system" through the late 1970s.

Ultimately, plagued by funding shortfalls and ongoing struggles with government agencies, it closed in 1981, when its programs were incorporated into the growing women's health services of the Fenway Community Health Center. By the mid 1970s there were divisions within the feminist movement that resulted in lesbians seeking their own health care services separately from heterosexual women. While feminists struggled to assure their own personal choice of abortion in the context of their relationships with men, lesbians clamored for rights to procreate and raise families with each other, with no male involvement beyond the initial donation of sperm. With Fenway's alternative insemination program, women's choices about pregnancy expanded from the reactive "how to prevent or terminate a pregnancy" to the creative "how to become pregnant and have a baby."

Fenway's Gay Health Collective adopted the educational program model the center's Women's Health Collective had created—it sold books printed by other organizations, most notably *The Advocate Guide to Gay Health*, first published in 1978.

Fenway Physician Assistant Ron Vachon also began writing a medical advice column in *Gay Community News* in 1979. Amy Hoffman, who worked at GCN and was proud of her role in getting Vachon to start his column, remembers his first topic, "Anal pleasure and health," as one of the main reasons she and her parents never discussed the newspaper again.[36] With its confidential STD testing program at Boston's gay bath houses and provision of health information to patients at the health center itself, Fenway's Gay Health Collective was providing educational services within the health center's unique delivery system of one-to-one conversations that would be a hallmark of these programs throughout its history.

Today, Fenway's education programs have grown in number and subject matter. Fenway produces a wide array of booklets, pamphlets, and brochures on dozens of health issues that are important to the LGBT community. It has published frequent and influential research reports from The Fenway Institute; its April, 2010, bibliography includes 632 citations. And, with the publication of *The Fenway Guide to Lesbian, Gay, Bisexual, and Transgender Health* in 2008, a textbook designed to teach medical professionals about how to care for the LGBT community, Fenway has literally moved from selling health educational books to writing them.

In the future, I can imagine Fenway being a little less gay-centric. Look at places like the South End. It used to be a very gay place, but, like everywhere, it's sort of gentrified now and the South End serves everyone. I can see Fenway Health doing the same thing, where it expands beyond health care for gay men and women to include everyone. The essence is, that's what we want. We don't want healthy isolated pods of people. We want a healthy world. That's what health wants. Even if you're totally healthy and the person next to you is dying of tuberculosis, you're probably going to get it. So the idea is to expand that reach to cover everyone. I don't know if it's in Fenway's mission statement or not, but I can see them becoming more of a model for the type of health care that people need regardless of their community, whether it's a gay community, a black community, or Boston, or the world.

Fenway World Health. I can see it. Seriously. Imagine, if this model works here, why can't it work in India? What I know about Fenway Health is that it provides low-cost, high-quality health care. But they're becoming much more comprehensive than just care for gay men, or for women, or for people in Boston. Why can't that model expand to other countries, like Haiti? There's a country where HIV rates are very high, where homosexuality is stigmatized. If Fenway could provide low-cost health care in a country like that it helps make the western hemisphere the community. Let's make the western hemisphere as healthy as possible. And once that's covered, maybe expand again. Over the next forty years, maybe we'll see Fenway Global.

—Cameron Kirkpatrick, Participant, Fenway HIV Vaccine Trials

1970S ADVOCACY

"It's a costume party, for gays and straights alike. Sometimes it's come as you are, but most often it's come as you aren't."

—Robin MacCormack, Boston Mayor White's liaison with the Gay Community, quoted in "Gay Boston is a Reality. But It's a Paradox of Liberalism and Puritanism," *Boston Globe*, February 18, 1979[37]

A strong case can be made that by simply offering health care services to its original three communities—the elderly, women, and gay men—Fenway Community Health Center was making the strongest statement possible in advocating for their rights. Fenway's three evening clinics per week expanded throughout the decade until its annual patient visits totaled over 9,000. The 1970s were a time when Fenway and several other organizations mixed medicine with politics, particularly when it came to gay men, lesbians, and women of all ages and sexual preference. By the time Fenway opened its 16 Haviland Street offices in 1973, its philosophy had found new words, but kept the same spirit, on a plaque that hung in its waiting room throughout the decade. "Health care is a right, not a privilege" was replaced with "Health Care for people, not for profit."[38]

The politics surrounding Fenway Community Health Center's early growth included internal struggles about how to address the needs of its patients, and whether it was morally possible to separate the provision of medical care from efforts to combat hunger, poverty, the ignorance and errors of the "establishment," or oppression. Women were not receiving adequate health care because many doctors didn't understand how to promote the health of the female body well enough to answer questions raised by patients who had read *Our Bodies, Ourselves*. Gay men were afraid to seek care because they couldn't trust most medical personnel to keep their identity confidential. Elderly people were suffering not only from a lack of ready access to care, but were also hungry and living in substandard housing. At a time when its board meetings were really gatherings of community activists who were also running food banks, newspapers, tenants' rights groups, and anti-war demonstrations, the idea that everyone and everything were connected was hard

to ignore. Any topic was fair game for debate and commentary. Despite the Fenway neighborhood's 1970s tradition of tackling multiple social, economic, and political issues at the same time, a focus on health care gradually emerged at Fenway Community Health Center, partly because it was becoming "popular" with women and gay men, partly because the city of Boston was developing its plan for a network of health centers serving all its neighborhoods, and partly because decisions about medical care and the resources necessary to provide it had to be made, as Vincent Perrelli recalls. Finding the money to purchase blood pressure cuffs wasn't a problem that could be solved by talking all night, and a waiting room full of patients had a way of crowding out board meetings that would otherwise occupy the same space in 16 Haviland Street's cramped basement.

These same forces also led to the growth of Fenway's other organizations in their own spaces: *The Fenway Free Life* needed its own space to publish a newspaper, and the Food Bank had to find somewhere to receive and distribute the canned goods, bags of grain and rice, and loaves of bread that were part of its growing operations. People who were more inclined to write stories and editorials gravitated to the newspaper, as volunteers interested in fighting hunger spent increasing amounts of time at the Food Bank. Demonstrations against the city government about the need for affordable housing, or in neighborhoods slated for demolition to make room for an interstate highway, or on the Boston Common to protest the Vietnam War, would still rally everyone from time to time. But they would be planned by others, and Fenway's leaders could lend their support by simply showing up. When it came time to occupy the administrative offices of a local hospital to demand better health care for the poor, Fenway's leaders could take their turn planning the demonstration and depend on their colleagues from other organizations to lend their support. By the end of the decade, an era of specialization would come to the neighborhood, replacing the collective Fenway Interagency Group with smaller, more focused organizations intent on solving the problems of the world in more modest and manageable ways.

Even as these separate organizations turned to the drafting of articles of incorporation, the writing of grant proposals, and the development of managerial structures and systems beyond the initial model of collective self-governance, the 1970s were still a great time for political debate about health care and the liberation of gay men and women. The exuberance women felt about taking control of their bodies, and the

energy Stonewall had given to the gay community led to a growing interest in challenging attitudes and prejudices that stood between these two groups and their rights. Progress came in the form of many small battles—some won, others lost—and the rise of new common enemies who fought against the expansion of rights and tolerance, on local and national levels. By the mid-1970s, the Nixon Administration and competing federal agencies had dismantled the Office of Economic Opportunity, which had been instrumental in funding the community health center movement. In a speech on November 3, 1969, calling for support of his Vietnam War policies in the face of rising anti-war protests, Nixon coined a term that would come to define a growing backlash against anti-war activists, but the women's movement, the civil rights movement, and gay liberation:

"I know it may not be fashionable to speak of patriotism or national destiny these days. But I feel it is appropriate to do so on this occasion...the wheel of destiny has turned so that any hope the world has for the survival of peace and freedom will be determined by whether the American people have the moral stamina and the courage to meet the challenge of free world leadership. Let historians not record that when America was the most powerful nation in the world we passed on the other side of the road and allowed the last hopes for peace and freedom of millions of people to be suffocated by the forces of totalitarianism.

"And so tonight—to you, the great silent majority of my fellow Americans—I ask for your support. I pledged in my campaign for the Presidency to end the war in a way that we could win the peace. I have initiated a plan of action, which will enable me to keep that pledge. The more support I can have from the American people, the sooner that pledge can be redeemed; for the more divided we are at home, the less likely the enemy is to negotiate at Paris. Let us be united for peace. Let us also be united against defeat. Because let us understand: North Vietnam cannot defeat or humiliate the United States. Only Americans can do that."[39]

It was the most successful speech of Nixon's presidency, and the "silent majority" term he invented would be come to define the constituency that elected him in both 1968 and 1972: those "hardworking Americans who paid taxes, did not demonstrate, and desired a restoration of 'law and order.' Nixon vowed to restore respect for the rule of law, reconstitute the dignity and stature of America, dispose

of ineffectual social welfare programs, and provide strong leadership to end the turmoil of the 1960's."[40] The silent majority was not an organized movement; it was more of a theoretical audience to which Nixon and a range of social conservatives and religious leaders played in their quest to gain political power. By 1979, it would be superseded by the "Moral Majority," a political coalition led by Rev. Jerry Falwell, to promote its "pro-life, pro-traditional family, pro-national defense and pro-Israel platform."[41] Falwell would go on to gain national attention by calling AIDS the "gay plague" in 1983, along with many other homophobic comments from his very public platform until he died in May, 2007.

The national and local gay rights movements of the 1970s saw similar steps forward and back. In 1971 "anti-closet" legislation called Intro 475 was drafted to add the words "sexual orientation" to the provisions of New York City's Human rights law. It was defeated. Gay Activist Alliance (GAA) founder Marty Robinson noted that the legislation could be a tool to "...underline how the threat of loss of employment had been used to keep Gays in silent submission...Gay Liberationists ...saw Intro 475 as the best way of getting a message to the community: the closet is built in fear, not shame."[42] The next year, in 1972, San Francisco, California, and Lansing and Ann Arbor, Michigan, passed laws banning discrimination in housing, employment, and public accommodation based on sexual orientation. That same year, leaders of America's gay movement addressed a major national political convention for the first time at the Democratic National Convention in Miami, Florida. Democratic candidate for President George McGovern included gay rights in the party's platform—another first for a major US political party. In 1975, California decriminalized all sex acts between consenting adults. Also in 1975, Elaine Noble became the first openly gay person to be elected to the Massachusetts Legislature and the first recognized lesbian to be elected to public office in the United States. The United States Civil Service Commission announced that homosexuality would no longer be a barrier to government employment. [43]

Believing that health care was not a place for closets or secrets, Fenway's early commitment to what is now called culturally competent care included respect for total patient confidentiality. Anonymous screenings and treatment for all diseases proved highly popular with gay men and college students, who knew that Fenway would not report them to the Massachusetts Department of Public Health, which for

years had been documenting sexually-transmitted diseases and tracking down the partners of those who were infected. This was important for students who didn't want their parents to know about their sexual practices, or for women who wanted to practice birth control without anyone else knowing. It was even more meaningful to gay men at the time, who could receive medical services at Fenway when anonymity as an institutional policy was nothing short of revolutionary.

Anonymity meant that partner notification of transmittable diseases was a decision properly left to those infected and their physician. While less than desirable for public health surveillance, these policies set a precedent for creating New England's largest HIV Counseling and Testing center in the mid 1980s. Fenway providers traditionally asked people who tested positive for a disease to notify their sexual partners or to ask partners to come in for testing, but did not include their names while reporting the incident of the infection to the DPH. In the mid 1980s the HIV testing center staff provided information, soothed concerns about HIV infection, held hands with those infected, and taught partners how to tell lovers about their HIV. Fenway replaced a cold knock on the door by DPH notification agents with a friendly face—actually two friendly faces, for the longest time: Jennifer Walters and Gail Beverly.

Gail Beverly served at Fenway from 1980 through 2010, first as a volunteer, and then as its HIV Counselor. (*Northeastern University Archives*)

In 1977, Dade County, Florida, passed its own gay anti-discrimination ordinance, provoking an odd backlash that would arrive in Boston the following year. A campaign against the ordinance was led by Florida's Anita Bryant, who was Miss Oklahoma in 1958, and a top-forty music star in 1959 and 1960 with such hits as " 'Til There Was You," and "Paper Roses." Bryant was also a Christian activist, an author (*Bless This Food: The Anita Bryant Family Cookbook*, Doubleday 1975), and official spokesperson for the Florida Citrus Commission from 1969 through 1977. She introduced their slogan, "Breakfast without orange juice is like a day without sunshine," in a national advertising campaign. Beginning in 1977, for about three years, she became the symbolic leader of a national campaign to repeal gay-rights legislation in states where it had recently been enacted, and to pass new laws banning gay people from teaching in public schools. These efforts were successful in Dade County in 1977, and in Oklahoma and Arkansas in 1978; however, they failed in California. One of her more famous quotes at the time was, "as a mother, I know that homosexuals cannot biologically reproduce children; therefore, they must recruit our children."[44]

In 1978, the Boston Public Library was the site of a highly publicized police "sting" operation in which plainclothes policemen arrested over 100 men for "open and gross lewdness" in the library's men's room and General Fiction area. This provoked several protests by the city's gay community, and corresponding political counter-attacks by local Christian and right-wing activists, as the story unfolded and the defendants went to trial. Late in the summer of 1978, supporters of conservative Democratic senatorial candidate Howard Phillips invited Anita Bryant to sing her trademark "Battle Hymn of the Republic" at a "Pro-Life, Pro-Family" rally at the Hynes Auditorium on September 1. Gay and women's organizations quickly formed the "September 1 Coalition" to protest her show, and organized street protests outside the Hynes Auditorium to coincide with the performance, followed by a rally at Copley Square. The Coalition encouraged people to buy tickets for the show and "bring oranges." Boston's *Gay Community News* ran a full-page edition with a Anita Bryant's picture under the headline, "Wanted for Crimes Against Humanity." Ultimately, only 78 tickets were sold, many to people intent on disrupting the event, and it was canceled. The Phillips campaign cited bomb threats and accused *Gay Community News* of inciting a riot. Anita Bryant sang her anthem on September 1, but at a cocktail party for only 25 people. Later, she returned to her

hotel, overlooking the Coalition's Copley Square rally, which 2,000 people attended. Howard Phillips lost his primary to Paul Tsongas, the eventual winner of the election for US Senate. Two days later, on September 3, the offices of *Gay Community News* were ransacked and vandalized. The perpetrators were never found.[45]

Perhaps the best description of the climate for gay men and lesbians in Boston was an article in the February 18, 1979, Boston *Globe*, which "introduced" the idea of gay life in Boston in recognition of Mayor Kevin White's appointment of Robin MacCormack as the city's first liaison with the gay community. MacCormack's comments about himself open the article "Clearly, I don't have to worry about my boss finding out I'm gay. But I am just one very fortunate person. In those buildings and all around the city there are people who go to work every day wondering, 'is this the day I'm going to let something slip? Is this the day I'm going to lose my career chances or even my job?'"

A "middle-management woman who works downtown and lives on Beacon Hill," but declined to give her name, stated, "The word 'community' is accurate in every sense of the word—we have our own newspaper, clinics, associations, and dozens of other institutions. But it's also a fact that if you name me, the kind of business I work for, or even my age, the odds go up against my advancing in my career—that's Boston too. Hell, I'm brighter and more productive than many of the men I work for. It's hard enough being a woman, much less a lesbian in the marketplace."

The *Globe* article, "Gay Boston is a Reality," is also one of the first mainstream press articles about Fenway:

"The Fenway Community Health Center, the Gay Health Collective, and the Homophile Community Health Service, all in Boston, are among the most important health providers to the gay community. State and city funds help keep them going, but patient fees and above all, volunteer labor from gay and sympathetic straight professionals are the critical elements.

"Venereal disease and hepatitis are the most serious problems encountered by the Fenway center staff. Physician Assistant Ron Vachon said, 'most physicians are not trained to deal with problems where sexuality may be an issue. Few take or know how to take a complete sexual history upon first interview, for example. And on the other hand,

many gay people are woefully ignorant about health issues. We provide service and education in a setting where gays can be comfortable.

"The Gay Health Collective, an autonomous, volunteer unit operating out of the Fenway center, sponsors a walk-in 'Gay Health Night' every Wednesday, and a by-appointment health treatment service every Monday evening. Confidentiality is assured, and even anonymity is acceptable. Volunteer physicians, therapists, and clinicians staff the organization.

"'But it is not just in direct service that we're valuable,' said Vachon. 'Increasingly, as other health agencies become aware of the quality of care we provide, they are referring patients to us. We represent a link between many agencies and gay health professionals, many of whom are not able to be open about their gayness.

"The Fenway operation now sees about 200 patients a week, most, but not all gay. 'We remain a community-oriented organization,' said Vachon, "and we provide services to many elderly people who are not gay, for example.'

"But it is in the area of health education for gays that Vachon sees the biggest challenge. 'Sex education for heterosexuals is a joke, so you can imagine what it is for the average gay person,' he said. 'We are buying a good book, *The Advocate's Guide to Gay Health*, at a 40 percent discount, and hope to sell copies for $7 to as many members of the community as we can.'" [46]

Robin McCormack would soon move on from his position as Mayor White's Liaison to the Gay Community, to be replaced by Brian McNaught, who held that position at the beginning of the HIV epidemic, and, according to Sally Deane, "was a real difference maker."

By the end of the 1970s, Fenway had come a long way, and still had a long way to go. Born as one of its neighborhood activists programs to make the world a better place, it benefited from help provided by the city of Boston, some local hospitals, and federal programs targeting health care as part of a larger "war on poverty." It was opposed by other local hospitals, politicians speaking on behalf of the "silent majority," and religious leaders who considered gay men and lesbians to be immoral. Fenway's founders sometimes attacked the "grownups" in the city's political and medical establishments even as some of these leaders were paving

the path for its early successes. They also were successful in convincing their first landlord, the Christian Science Church, that the health care services they provided should not be grounds for their eviction, based on the Church's tenets that everyone has a right to self expression, and Fenway's founders were exercising this human right in founding their health center for the disadvantaged.

Fenway's founders were naive enough to create a medical clinic that relied on volunteer labor and collected no fees. Yet they were sophisticated enough to find the allies they needed in Boston's medical community and city government, to build coalitions, and make deals that gave Fenway the opportunity to grow. Two of Fenway's original founders—David Scondras and Rosaria Salerno—went on to successful careers as Boston City Councilors. Fenway was, and is, the only one of 24 neighborhood health centers to rely solely on volunteer energy in its formative years. The center survived internal debates and financial challenges that doomed many similar organizations at the time. As Fenway grew from a clinic that came out from under tarpaulins for three free evening clinics per week to a licensed neighborhood health center, its leaders never stopped mixing politics with medical care, and made the most of it. Forty years later, in a much larger building, with 300 professional staff, and an annual budget that is 200 times larger than it was in 1979, Fenway Health is still a leader, not only in the provision of health care, but in advocating for the right of its patients and people like them throughout the United States and the world.

...

Fenway Health's future success will continue to depend upon finding excellent leaders who are finely tuned in listening to what the community wants for health care.

—Holly Ladd, former Chair, Fenway Health Board of Directors

1970S LEADERSHIP

So these do-gooder hippies walk into a neighborhood. The neighbors give them the once-over, check out their long hair, beads, and sandals. Their leader walks up to these strangers, looks them all up and down, and can't help but ask, "So, why are you here?" The head volunteer jumps up, very excited, and hugs him, shouting, "We thought you'd never ask!"

— Old Community Organizing Joke, unknown origin.

It may be only natural for us to view the early days of Fenway Community Health Center as a smaller version of today's organization, or in terms of nonprofit organizations as they exist today. Maybe it was a little more political, maybe its board meetings were long and argumentative. Sometimes we wonder how a medical clinic could operate in the cramped basement space at 16 Haviland Street, or marvel at its reliance on volunteer providers. But on closer examination, the way Fenway was managed in the 1970s reminds us how different the center was from its current organization—not just in scale and resources, but in how it operated every day.

For starters, much of what it did was borderline, if not outright, illegal. Providing free medical care in an unlicensed medical clinic violated several city, state, and federal laws. Instead of closing the center, the city of Boston and the State of Massachusetts chose to encourage its growth into a licensed clinic, and tolerated its existence as Fenway took a series of steps toward this goal. When Fenway's board voted to charge for medical services, it didn't bill patients but instead asked them to contribute fifty cents, or whatever they could afford, per visit. They could volunteer at the center if they didn't have the money. As Jerry Feuer, a Physician Assistant at Fenway since 1978, recalls, Fenway's "Medical Director" was often the only doctor among its volunteer staff. Vincent Perrelli, Fenway's first Medical Director, held the same title at other community health centers because no other doctor wanted the job. David Scondras recalls that, even as he and his colleagues on Fenway's early board advocated for free care by volunteers in a facility they built with donated equipment, they all knew that this model was unsustainable.

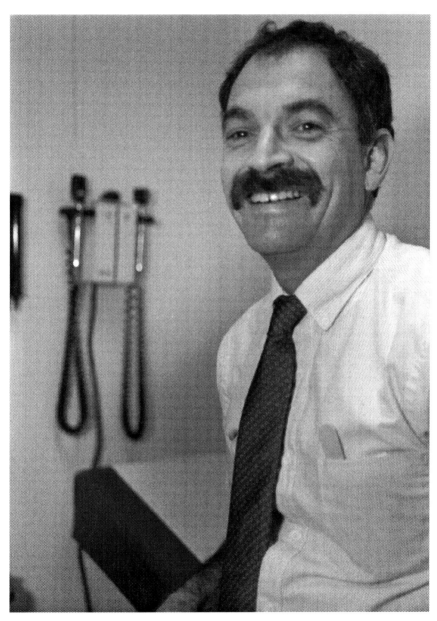

Jerry Feuer, Physician Assistant, Fenway Community Health Center, in 1978. Jerry is the oldest continuing staff person at Fenway Health today. (*Northeastern University Archives*)

61

By the middle of the decade, the outside world was changing in a way that invited Fenway to become a more professional organization. Medicare and Medicaid grew as alternatives to charity and volunteer care, in major hospitals and at grassroots clinics like Fenway. Federal dollars were available for care to the elderly and the poor, but standards for facilities and medical staff came with them. Boston wanted Fenway to be part of its citywide network of neighborhood health centers, and it, too, had both dollars to share and standards to meet. Fenway was being encouraged to join a growing sector of the health care "system" it had long criticized from the outside. Gradually, a number of initial steps were taken. Patients could be seen by doctors at Fenway, and these visits could be covered by health insurance, Medicare, and Medicaid—but only indirectly, through the doctors themselves, not by Fenway. Until its license was granted in 1981, Fenway didn't receive payment for these services; its individual doctors did. Fenway's operating budget was covered by grants and donations, sometimes in-kind contributions of supplies and equipment from sympathetic hospitals, even if the center's budget was artificially low because it wasn't paying providers who were being paid directly by insurance companies and government programs.

FENWAY AT A GLANCE: 1979

Fenway Health Center Annual Budget $250,000

Annual Patient Visits . 9,000

Number of Professional Staff12

One of the strangest aspects of Fenway's early organization was its reliance on the "collective" form of governance. We hear this term today and think it is more or less interchangeable with "committee." Fenway had its three collectives—one for women, a second for the elderly, and a third for gay men—and we might assume that these were simply three committees of Fenway's board, meeting separately to manage parts of the center's overall programs, and reporting back to the board as a whole—much like a modern board's finance or marketing committee might. In fact, this wasn't true until the late 1970s; for much of the decade these three

collectives were considered to be autonomous, and Fenway's board was itself a larger collective where all three groups hammered out issues of resources and fairness among them. The collective form of governance requires decisions to be made by consensus, not by vote, and it is based on the idea that everyone in the organization is equally responsible for meeting the day-to-day challengers of its operations. Even after Fenway's board decided to exercise its legal right to make decisions for the organization as a whole, some individuals on each of the three collectives would periodically challenge this right, or simply ignore the board and continue to operate autonomously. It would take fifteen years for the last bastions of those who believed in Fenway's collectives to accept the health center's modern organizational structure.

The collective model explains why many of Fenway's leaders saw the organization as a loose confederation of its three "real" constituency-based health care programs, and how Fenway was also one of the organizations in the larger Fenway Interagency Group. Everyone's opinion needed to be heard, because, ultimately, everyone was responsible to each other for fulfilling the organization's mission. Nothing could be done until everyone agreed to do it. Further, once Fenway grew to the point where it had paid staff, they too were part of the collective, along with the volunteers who served on the board. It was nearly impossible to meet the challenges of a growing organization with this form of governance, as was seen in the final struggles of the Cambridge Women's Health Center, which ultimately failed in the effort to abandon its collective organizational structure in order to be licensed by the Massachusetts Department of Public Health.

How did Fenway manage to survive its first decade with this form of governance? The answers are (1) it almost didn't, but, (2) when it did, Fenway began to succeed by relying on the leadership of Sally Deane, the first in a series of strong Executive Directors. Shortly after the 1979 "counsel or cancel" vote that required all medical services to be provided by professionally-licensed individuals, Fenway Health faced one of its most serious organizational crises. Its then-Executive Director suddenly resigned and moved away from Boston, leaving a void that needed to be filled. By this time, Fenway was in the middle of its application for a medical clinic license from the Massachusetts Department of Public Health, which the board believed would bring access to third-party payments for patient

care from Medicare, Medicaid, and private insurance companies. Fenway was also becoming more integrated in Boston's network of community health centers and hospitals, moving closer to being eligible for grants from the city of Boston through the New England Deaconess Hospital, the institution that would become its partner in that network. The unexpected loss of its director was a shock, even as many of the center's goals seemed almost within reach. But it would take strong management to get there.

The search was national, with a classified advertisement in the *New York Times*, quite a stretch for an organization that could still barely make ends meet. It was also a controversial effort, since a number of board members and staff wanted to hire from within. They had a strong candidate—Ron Vachon, the organization's charismatic and committed Physician's Assistant, and leader of the Gay Men's Health Collective. He and his supporters believed that Fenway's future lay in its identity as Boston's leading provider of care to the gay community, strengthening its collaboration with other gay organizations in the city, and continued reliance on the private donations and foundation grants that had sustained the center through its early years. Members of the other two collectives were concerned about his leadership and what it would mean to their interests. Others were wary of Vachon's preference for political activity instead of a focus on professional medical care, particularly after the difficult decision to require its Women's Health Collective to rely on professional providers instead of its more political self-help philosophy. The Fenway board was deeply divided when the search for a new director began, to the point that interviews were held off-site at Morville House, where many of Fenway's elderly residents lived, in order to keep some members of the board and staff from attending and scaring off possible outside candidates for the position. Sally Deane, who quickly became the leading candidate, recalls how strange it was that she was being interviewed in one of the community rooms at Morville House instead of Fenway's 16 Haviland Street offices.

After the interviews were completed in late 1979, at one of its most tumultuous meetings ever, Fenway's board voted to hire Sally Deane, and she accepted the job. New Board Chair Dan Cirelli, to whom this book is dedicated, took on the responsibility of working closely with Sally Deane to orient her to the center's

current and future challenges, and to restore harmony among board members and staff who had struggled with the choice of who would lead Fenway into the future. Sally Deane began her tenure at Fenway in February of 1980. Ron Vachon remained a member of the center's staff until he was successfully recruited by the Gay Men's Health Crisis in New York in late 1981, after the AIDS epidemic had begun. One thing that didn't go according to plan was a visit the IRS paid to Sally Deane and her new staff within weeks of her arrival. They told her that the center had failed to pay employee withholding taxes to the federal government for many months, apparently in a misguided effort to fund the center's ongoing operations. To Sally's credit, she stayed on, managing both her initial shock and the short-term crisis. She negotiated an advance on that year's grant from New England Deaconess Hospital as part of Boston's city-wide community health center program, allowing her to pay the center's back taxes in full. More important, she bought the time she needed to begin laying the groundwork for the Fenway Health organization we know today.

..

Everyone wants to be here. We're excited to be here every day. Our tasks may be mundane at times—paperwork and insurance claims are part of the job after all. But I love my job. My colleagues are exciting to work with. It's hard to find an organization that openly takes suggestions from staff and acts on them. "I came up with that question on the survey," or "I hung that disco ball at our party." It's very rare, and it keeps Fenway Health strong. People, when they're away from work, are happy to talk about where they work and what they do. We're proud of it. I want people to know I'm part of it.

There are so many people who have been here for 20, 25, 30 years, or more. Everyone else hears about our history from them—the things they witnessed. Gail Beverly, a 70-year old counselor, just retired. Ken Mayer has been here 30 years; Jerry Feuer has been here 30 years; Rhonda Linde has been here 29 years; and there are so many more. We've gone from 16 Haviland to 7 Haviland to the fourth floor of the Prudential Center, and now to 1340 Boylston Street. There are stories of being in these places, moving out into new spaces, and then moving again. I don't know if people at hospitals talk about moving into their new wings. It's not what you'd expect in these big places but we

have that here. I can see myself here in 5 years or even 25 years and that's not limiting. Actually I believe I'll have more of an effect by staying here than going anywhere else. I'm actually delaying the completion of my PhD degree by two years in order to stay at Fenway and continue to help build this organization.

— Ruben Hopwood, Coordinator, Transgender Health Program, Fenway Health

Chapter Two
1980–1996

1980—1996 OVERVIEW

"Thank God Fenway was birthing babies at the same time it was burying brothers. It's a significant statement for the community about the continuum of life."

—Holly Ladd, Chair of Fenway Community Health Center Board, 1983, commenting on the beginning of Fenway's Alternative Insemination (AI) program, founded that year.

Fenway Community Health Center began the 1980s with a series of challenges that were vital to its growth, if not its survival. They were dramatic, particularly if you were a new Executive Director facing the challenges of a new job at a health center that was on the brink of bankruptcy, and operating without a license. But they were, at least conceptually, the sorts of internal trials one would expect from a young nonprofit organization: leadership transition, funding shortfalls, debates about the center's mission among constituencies on its board and in the community, regulatory requirements, and relationships with allied organizations. Though they were no different in kind from those facing many other health centers, taken as a whole, they were formidable. Sally Deane recalls what she found when she took the job in early 1980:

"The annual budget, just over $200,000 for just under 9,000 annual visits or about 3,000 patients, didn't cover expenses. Within ten days, the accountant/consultant I had brought in uncovered a $35,000 deficit, much of it owed to the federal and state governments for taxes withheld from employees but never paid. Licensure was due for inspection...in three months. It would require renovations.

"Whenever it rained, the facilities flooded with sewage from plumbing problems occurring in the 100+ year-old building that housed us. There was no central heat, ventilation, or air conditioning. Privacy for patients was limited to three unsound proofed exam rooms and one unisex bathroom.

"A contentious staff wanted self rule and had successfully acted to drive the medical director to resign. There were no written standards for employment,

personnel policies, quality assurance standards, or management reports. Services ranged from a grant-sponsored rat control program, surgical wart removal, some general medicine and podiatry and flu shots for the elderly, to local resident adolescent outreach, and gay and women's health care service nights." [47]

Fenway's collective organizational structure remained in place, even as it took key votes to require professional medical providers on Women's Health Night, or to hire Sally Deane over Ron Vachon as its new director. Anyone—elected board members, staff, and members of the community who used the center for care—could attend a meeting and vote. Politically motivated decisions were always one packed meeting away from becoming a reality. Another aspect of Fenway's collective organization was its salary structure: in 1980, all staff were paid the same $12,000, except for doctors, who earned $17,000—substantially lower than the going rate at other health centers in Boston. People then as now worked at Fenway because they were dedicated to its mission, but without the organizational structure, financial resources, and leadership in place to channel this dedication, Fenway was at risk of moving in so many different directions at the same time that it would effectively go nowhere.

One surprising Board meeting at the time was called by Ron Vachon, who believed the health center's concern with the gay community should be made more explicit. After he tried and failed to win enough board votes to be hired as Fenway's Executive Director, he asked for a new vote to recognize the importance of the health center's services for gay men. This may seem odd, given Fenway's long-standing leadership in providing medical services to gay people, but there were internal and external reasons for his actions. Internally, Fenway had never identified itself as a gay organization, or as a women's organization, or even as an elderly organization. Jerry Feuer, who was in fact a classmate of Ron Vachon's in graduate school, remembers this time in Fenway's history. "We didn't actively seek to include anyone in providing our services, instead we made sure we didn't exclude anyone." The organic growth of gay people and women as two of Fenway's main constituencies was a result of this openness and commitment to serving those who couldn't get competent medical care anywhere else. By the late 1970s, as the health center grew and sought financial and organizational support from sources in Boston's government, foundation, and medical communities, Ron

Vachon and his supporters became concerned that the Board might be consciously downplaying Fenway's gay clientele in the interests of gaining stature and grant money. Given the fragile state of gay rights at the time, he was not entirely wrong. Sally Deane remembers, "In applying for the job in late 1979, I was told by insiders to deflect my own gay identity because it could be used against my candidacy. The Board that hired me had among its membership many gay people, but they often deferred on strengthening the gay-oriented health programs for fear of challenging the 'neighborhood' mission of the center."[48]

Beyond the doors of 16 Haviland Street, Boston saw the growth of other organizations serving the gay and lesbian community, including Homophile Health Services, a mental health counseling organization affiliated with Boston University, which opened in 1971 at 419 Boylston Street, a few blocks away from Fenway's headquarters. *Gay Community News*, "the closest the early (gay) movement came to a (national) newspaper of record," was founded in 1973 at the Charles Street Meeting House at the foot of Beacon Hill in Boston.[49] GLAD, Gay and Lesbian Advocates and Defenders, was founded in 1978 by John Ward, the lawyer who successfully defended the 100 gay men arrested in the Boston Public Library sting operation that year (over 25 years later, GLAD would argue and win the case for gay marriage before the Massachusetts Supreme Court). BAGLY, the Boston Association of Gay and Lesbian Youth, was founded in 1980 at the Arlington Street Church, and hosted America's first gay high-school prom a year later.[50] For the first time, a reasonable argument could be made that Boston's gay organizations could take advantage of their strength in numbers.

Similar clusters of gay and lesbian organizations were emerging in a number of other American cities. But the strength of Boston's organizations lay not just in the number of these groups. From their beginnings, several of Boston's fledgling gay and lesbian organizations shared a trait that was uncommon in similar LGBT organizations across the United States. Their volunteers, and whatever staff they employed, included both men and women, and they worked together to address common challenges. Not all of the city's gay and lesbian organizations were "integrated" in this manner; there were leading women's organizations, like Our Bodies, Ourselves (formerly the Boston Women's Health Book Collective), and the Cambridge Women's Community Health Center, although these groups

represented all women, not just lesbians. But, including a newspaper, legal rights groups, and health care organizations, Boston's LGBT organizations followed a similar model of addressing a primary issue—publishing news and opinion, or advocating for the rights of young gays and lesbians—and building on their strong local achievements to gain a national reputation. Ron Vachon and his colleagues were suggesting a more deliberate path. By declaring it to be a "gay health center," they would link with other Boston gay organizations and, together, align with a growing national network of gay men's organization, instead of simply doing good work in Boston and letting these national ties develop more organically. These men saw benefits to be gained by joining forces with other gay organizations in Boston to establish the city as a place of national political leadership within the gay movement. The idea that Fenway might gain from following this path was not without merit. A choice was about to be made that, like many others in Fenway's history, would pit those who believed in a focus on medical care against those who saw the organization's mission to be more political in nature.

However, Ron Vachon and his supporters failed to pack the Board meeting with enough of their supporters that night, and they lost the vote. Fenway's new age of professionalization would continue, although Executive Directors from Sally Deane through Stephen Boswell would continue to deal with difficult choices about Fenway's mission and how to balance the needs of its constituencies for medical care and political support. With the help of a Board run by new Chair Dan Cirelli, Sally Deane began Fenway's first strategic planning process in 1980. This helped the center set priorities, reconcile the demands of its different constituencies, and find its place in balance with the needs of its local community, its unique patient population, and Boston's larger health care system. Ironically, the process led to a conclusion not far from what Ron Vachon had tried to enact by collective vote:

"We recognized our strength was in prioritizing services to those who needed us most and who we were best positioned to serve—the gay community. We did so without abandoning our commitment to continuing services for local elderly patients. We aimed to be the center of excellence for care and to do more than just be 'gay sensitive.' In order to do so, we felt we needed to invest in developing our opportunities by establishing a research program, focusing on a broad range

71

of major gay health care problems. We felt we needed adequate facilities, and proceeded not only to renovate what we had to meet minimum standards, but we began the long process of looking for a permanent new home." [51]

Philosophical reconciliation, facility renovation, and financial efficiencies were important early accomplishments of Sally Deane's new administration. But there would be more. The Board agreed to end Fenway's collective structure and allow Sally Deane oversight over expenditures and the hiring of new staff as a unified health center. A new accounting and billing system was installed, improving Fenway's ability to collect third party payments from Medicare, Medicaid, and private insurers. Staff who were hired had licenses, professional skills, and a commitment to improving the center's ability to provide the medical services it promised to its patients. A new Medical Director, Natalie Mariano, helped set the expectation that existing staff would have to be board-certified if they were to stay on. She established clinical supervision and quality assurance practices for the first time. She was proud that, despite all these improvements, some things about Fenway's model of care didn't change. "The medicine the health center practiced was as good as academic medicine, but the caring was better, and the education that patients received about their own health care was much better than at the large teaching hospitals." [52]

New programs were instituted, including alternative insemination for lesbian, bisexual, and heterosexual women, through the efforts of Fenway's Women's Health Collective. Mental health services were added with a grant from the Mass Department of Mental Health in 1980. Rhonda Linde, PhD. was hired to in 1981. In response to the board's and staff's strategic plan from earlier that year, Ken Mayer, MD, proposed a research program in December of 1980, agreeing to her conditions that it be done with the same standards as would be required at any large teaching hospital. Fenway's episodic agreements with local colleges and universities to provide health care for their students were formalized into contractual programs in 1980. Its much-sought-after license as a medical clinic was approved by the Massachusetts Department of Public Health in 1981. An amazing amount of progress was made in an incredibly short number of months. And, as it turned out, just in time.

Like other health centers in the United States, Fenway saw men with swollen glands, fatigue, and thrush in 1980 and early 1981. It would take an article in the Center for Disease Control's *Morbidity and Mortality Weekly Reports*, in June of 1981, to announce for the first time that these symptoms might be related, and five years later, would become known as AIDS. As Ken Mayer, still Fenway's Director of Research, says, "Nothing was ever the same again for any of us who worked at the Health Center."[53] Fenway became a leader in the provision of care to people with HIV over the next decade—first in New England, and over the next twenty years, in the world. Its research program, begun with a part-time commitment from Ken Mayer and Sally Deane's strict requirements for professional standards, has become the largest community-based research facility in the United States, widely recognized for its innovation and contributions in the fight against AIDS. No one knew it at the time, but in the short months between Sally Deane's arrival and the first diagnosis of AIDS (then "GRID," or gay-related immunodeficiency) in late 1981, these organizational improvements and research initiatives would enable Fenway to respond to the crisis as well as any organization.

Many other critical moments of choice would arrive at Fenway's doorstep, but, unlike all the choices Fenway had made before June of 1981, these decisions would be made in the context of national events that could not be ignored. In 1984, under the leadership of Board Member Larry Kessler, Fenway founded and then in 1986 spun off the AIDS Action Committee, with its "Buddy Program" to provide advocacy and support for patients wherever they received care. In the mid 1980s, under Ken Mayer. Fenway advanced the successful culture of HIV from blood and semen with Harvard Medical School; and, using samples from Ken Mayer's previous Hepatitis B research studies, worked with Dr. Jerome Groopman of New England Deaconess Hospital to confirm how HIV spread among men having sex with men. By 1987, under executive director Dale Orlando (1986-1990), Fenway became the largest provider of care to AIDS patients in New England with the region's largest HIV Counseling and Testing Center. During the first decade of care in the epidemic, HIV counseling and testing services were not only a bridge to the larger community, but the primary method of introducing Fenway's medical service to the LGBT community beyond the neighborhood.

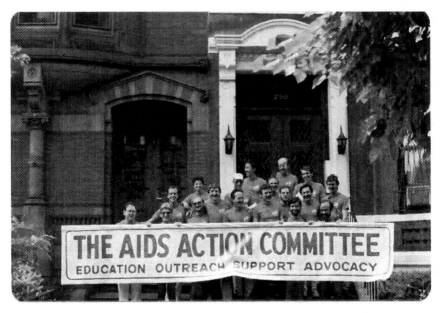

AIDS Action Committee, Fenway staff, and volunteers at Gay Pride, circa 1985
(*Northeastern University Archives*)

Fenway led the nation in community-based clinical trials in the late 1980s, experimenting with aerosolized pentamidine to treat a life-threatening form of pneumonia contracted by some people with AIDS; and then creating and spinning off the Community Research Initiative of New England (CRINE) in 1989 to carry on with this work. As one of twelve national treatment model sites under the earliest Federal AIDS Service Demonstration Grants, Fenway gained national attention in 1988 for its pentamidine experiment in part because Dale Orlando worked with the State of Massachusetts to obtain reimbursement for treatment from Medicaid, and, because of this authorization, from private insurers as well. This unprecedented source of revenue for AIDS treatment prompted calls for assistance with protocol development from across the city, including Harvard's teaching hospitals, and also from across the country, including none other than Johns Hopkins Hospital in Baltimore, MD. Fenway began tests of pre- and post-exposure prophylaxis with AIDS drugs in the early 1990s; and led in the search for an AIDS vaccine through clinical trials in collaboration with other community health centers.

Wayne Wright, Executive Director of the Multicultural AIDS Project, Larry Kessler, founding Director of AIDS Action, and Michael Savage, Executive Director of Fenway Community Health, at the Opening New Doors reception at the Harvard Club (*Ellen Shub*)

Still, with all this activity and efforts to find the cause, treatment, and possible cure for AIDS, for a long time, there was no treatment, and there still is no cure. Ken Mayer describes the time from AIDS was first discovered through the introduction of multiple-drug treatment in 1996 as the "long HIV wasteland," a time when doctors at Fenway and elsewhere could only watch patients sicken and die, or treat them with a therapy that was at best a bridge to keep them alive until some better therapy might be discovered and prolong their lives a little further. The toll this would take on Boston's gay community was devastating, and the impact on Fenway's staff of doctors, nurses, researchers, and other workers was almost as terrible. For a long time, all Fenway could offer was time with its staff—time to talk with patients about their fears, their concerns, and their questions about what the future might hold, however bleak their answers might be. Even so, as Dr. Harvey Makadon put it, "listening to patients and simply spending time with them to talk about their fears and concerns is medical treatment."

"But it wasn't treatment, according to most payer systems. The 'wasteland' described by Ken Mayer was in part the result of years of isolation of the gay and lesbian community by the medical establishment," according to Dale Orlando. While Fenway's physicians and counselors held anxious and desperate hands, trying every new treatment that might promise to build a bridge of time, "the larger gay and lesbian community burst out of their closets in record numbers to help build different bridges to funding sources, and also built the service infrastructure to propel Fenway, other LGBT health providers and other still-struggling political organizations onto the national and international stage. What began as the fight against AIDS has in fact continued as a broader struggle for LGBT rights—for quality health care, the right to marry, and serve in the military—and this fight expanded from Boston to the rest of the country and the world. In many ways, the acceptance of Fenway's leadership in AIDS care and research by Boston's medical establishment in those early, desperate years was a metaphor for the larger recognition of us as fellow citizens that continues today," she believes.

Beyond care and research, Fenway's education efforts, at least those aimed at prevention of the spread of the epidemic, were successful in slowing the pace of infections. Education was also a means of marketing Fenway's health services to people at high risk for HIV and the "worried well," a term that describes not only the large number of gay men who feared the disease, but others—particularly medical providers at major hospitals throughout Boston. Once Fenway helped determine how AIDS spread, the challenge of encouraging men having sex with men to practice safe sex was something that could achieve the intended results of slowing the speed with which the disease spread. The fear prevalent in the first few years of HIV—that any contact with an infected person might infect someone else, even medical providers—gave way to clearer understanding of how it was more likely to spread, and what sorts of contact were not dangerous. This knowledge gave health professionals at Fenway and other clinics treating AIDS patients the opportunity to educate health professionals less familiar with the disease that they need not take extraordinary precautions such as leaving food trays outside the door of a patient's room, wearing protective gowns, gloves, and masks, or avoiding contact of any kind. These were small achievements to be sure, but they

were important at the time, given the risk that AIDS patients and maybe even all gay people might remain isolated from society at large.

Education about safe sex was important as an intervention in the spread of AIDS, and Fenway did its share, along with AIDS Action Committee, government public health agencies, and other organizations. What set Fenway apart in the time of AIDS was its emphasis on educating other health care providers on the importance of their role—not only in the treatment of disease, but in establishing a relationship with the patient, and in the importance of their role in the community at large. An excerpt from *The Fenway Guide to Lesbian, Gay, Bisexual, and Transgender Health*, authored in 2008 by Fenway providers Harvey Makadon, Ken Mayer, Jennifer Potter, and Hilary Goldhammer, includes the following paragraph:

"Clinicians as Agents of Community Change

"The clinician's role should not be restricted to the examining room or hospital ward. Clinicians are respected in the community; their opinions are sought out and given great credence, and their influence as role models and community leaders is clear. Thus, it is crucial that clinicians use their positions of leadership and respect in joining in community coalitions, advocating for improved services, laws, and practices; and modeling respectful, nonviolent behavior. In short, clinicians can very effectively 'teach peace' in the course of their professional and personal activities. The 'public health' role of the clinician as leader, advocate, and change agent is perhaps as important as the 'private health' job of providing expert care for individual patients." [54]

Educating providers, in addition to the public, is a unique contribution Fenway Health has been able to make over the years, one that was made possible by its early leadership in the treatment of patients with HIV—a disease that few other medical professionals understood as well as Fenway did. Dale Orlando recalls it as "our self preservation strategy. Our vision was to continue to serve the entire LGBT community beyond the epidemic, and not to become Boston's AIDS clinic. Teaching others to care for 'their own' rather than sending everyone with HIV to

Fenway was the only way to accomplish this as the epidemic grew." These other providers came to depend on Fenway not as much for referrals; after all, as late as 1990, there was a two- to three-week wait for first-time appointments at Fenway's tiny offices for patients with HIV. Instead, they asked Fenway's health professionals for information: what treatments worked in slowing the disease, what were the most common side effects of these drugs, what questions do AIDS patients ask and how can they be best answered, how did Fenway's staff deal with the stress of seeing so many young people die? In the time of AIDS, Fenway learned much about how to manage the care of its patients. Under the guidance of Ken Mayer, who frequently presented the health center's research finding to the larger health community, Fenway also realized that sharing this knowledge with other providers was unique and important. Identifying its best skills and using them as the basis for education of other professionals started with Fenway's intense experience treating AIDS patients in the 1980s, and has been a key focal point of its strategy ever since.

Fenway's advocacy for government programs and policies aimed at improving the health and health care of its constituencies also reached a national level in the late 1980s and early 1990s. For a long time, President Ronald Reagan was notorious for not even mentioning the term "AIDS" until September 17, 1985, at a press conference; this was over four years since the June, 1981, reports in *Morbidity and Mortality Weekly Reports*. Congress had begun authorizing funds for AIDS research and treatment as early as 1982, but those funds were never allocated until 1986 under HRSA. The Reagan Administration issued its first AIDS committee report in 1986.[55] Fenway staff participated through early consultation and later review of Senator Edward Kennedy's draft of the Senate's CARE (Comprehensive AIDS Research Emergency) Act which, when hammered out in conference with the House became the Ryan White CARE Act, the largest federal program funding AIDS treatment, services, and research. Formulated in 1988 and enacted in 1990, it still provides grants to cities and states with high incidences of AIDS, to organizations engaged in the provision of direct AIDS services, to medical institutions offering such secondary services as dental care or emergency services to people with HIV, and to researchers to encourage the development of innovative treatment and prevention programs. The Ryan White CARE Act has been renewed several times, most recently in 2009 for four additional years, at a level of $2.1 billion.[56]

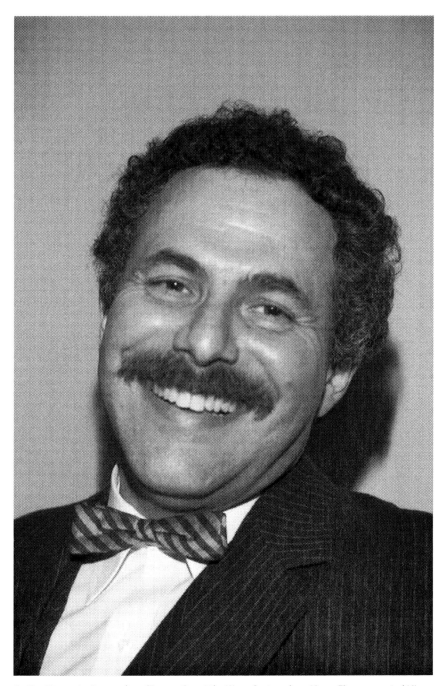

Dr. Ken Mayer at a Fenway benefit reception at the Wang Center where Mayor Flynn presented Lily Tomlin with a Revere Bowl March 31, 1989 (*Ellen Shub*)

In addition to the achievements Fenway made in the provision of health care, the creation of a world-renown research program, and its advances in professional education and policy advocacy, the time from 1980 through 1996 also saw the center's greatest advances in management and leadership. Ken Mayer believes there are four great Executive Directors in the history of Fenway Health: Sally Deane, Dale Orlando, Michael Savage, and Stephen Boswell. Between 1980 and 1996, all of them had worked at the health center (Stephen Boswell became Medical Director in 1994, and was named Executive Director in 1997). Sally Deane's tenure, from 1980 through 1984, saw the initial professionalization and strategic planning and the development of a health care system that could bill for and receive third party payments, organizational development, and program growth, as discussed earlier in this chapter. She positioned Fenway for leadership by insisting on standards and laying an organizational foundation for success before, and during the earliest stages of an epidemic. Dale Orlando, who served as Executive Director from 1986 through 1990, oversaw exponential organizational development and program growth, added managerial development and career ladders, dramatically increased the center's funding levels, and added new programs and experimental therapies. She also led the effort to plan, build, and open the organization's first new building, 7 Haviland Street, in 1990. Michael Savage, Executive Director from 1991 through 1994, would bring Fenway to a statewide and national position of leadership in advocating for increasing levels of government support for gay and lesbian health organizations; he was perhaps Fenway's greatest coalition-builder. Stephen Boswell, CEO from 1997 through the present, would preside over the health center's transition from an organization that had become a leader in the midst of a great crisis to one that is internationally-known, strategically focused, and uniquely able to articulate its vision of LGBT care in both word and deed.

Dale Orlando secured Fenway's first new health center building with a $2 million dollar agreement from a real estate developer and the Boston Redevelopment Authority. With assistance from Director of Development, Steve Huber, Harry Collings, Fenway's Capital Campaign Director, led Fenway's successful effort to raise an additional $2 million and build the center's new facility at 7 Haviland Street, across the street from Fenway's basement space. To the

best of our knowledge, this building was the first LGBT community owned health facility in the United States.

"The best example of the spunk that characterized FCHC then was our ability to talk Harold Brown and the city of Boston into donating a site and building shell for the new health center," says Dale Orlando, speaking about the construction of the 7 Haviland Street facility. "'Ask and thou shall receive' may be a simple lesson for people who think they deserve good things. It's more difficult for people who are taught to fear that every power greater than themselves dislikes them. We learned to put fears aside and ask for help in our time of need, when sixty employees and over nine thousand patients were jammed into 3,600 square feet of basement fighting a deadly virus. We learned the value of making friends in the larger community. For people who know the Fenway Health Center building story, it will always symbolize everyone's right to ask for the help they need and receive it."[57]

In addition to construction of the new building, Dale Orlando oversaw the development of Fenway's substance abuse counseling programs beginning in 1988, and its innovative expansion of these services to include acupuncture therapy. "It's one thing for a single man to go to the Pride Center for 90 days of detox and counseling services, but what was available for a woman with children who needed help with substance abuse? Acupuncture had been shown to be an effective treatment, it was low-cost, and could be provided on an outpatient basis so a woman could stay at home with her family," Dale Orlando remembers today. During her tenure, Fenway launched its "Living Well" educational programs that focused on staying healthy with HIV.

Fenway's development of these new programs was the result of Dale Orlando's aggressive marketing efforts on behalf of the organization as it searched for resources needed to respond to the rapid growth of the AIDS epidemic. By this time, Fenway Community Health Center had established a fast-growing national profile in HIV care and research. On a local level, its broadening primary care services were attracting increasing numbers of patients. This growth led to additional programs, including substance abuse counseling, which began at the health center in 1988. By that year, the early efforts of Dale Orlando, Stewart Landers, David Scondras, and other Fenway leaders to obtain a new building for the health

center were beginning to gain momentum, and 7 Haviland Street became not just a dream, but a plan. With that accomplishment, another critical moment of choice came to 16 Haviland Street.

Fenway's rapid growth in the late 1980s was in stark contrast to the retrenchment and loss of other gay and lesbian organizations in Boston. *Gay Community News* ceased publication in 1992. As noted earlier, the Cambridge Women's Community Health Center closed its doors in 1981. Homophile Health Services went out of business in 1989. However, along with Fenway, GLAD, Our Bodies, Ourselves, and BAGLY (now the Boston Association of Gay, Lesbian, Bisexual, and Transgender Youth) survive today. One reason for Fenway's survival has always been its focus on medical care and research above all else. But another was the commitment of its leaders to "do whatever it takes" to make sure the financial and professional resources would be available to fulfill its mission, even when the organization was ahead of its time in recognizing these resources before funding sources did.

Until 1987 there was no "treatment" money available for AIDS. Medical reimbursements were for routine doctor visits predicated on 15-minute intervals. A complete physical, lab work, and a diagnostic AIDS exam, if it resulted in a positive diagnosis, would predict a patient's death within 9 weeks, or, at most, 18 months. As if this weren't bad enough, it also took at least 45-60 minutes of a physician's time, if not much more, before even beginning to deliver this news to the patient. Medical Director Scott Harris and his team struggled under the time pressures of an exploding volume of sick patients who required longer visits for diagnosis, treatment, comforting, and information. In addition to all of these patients, there were countless other demands on the medical staff: referrals, provider inquiries, press inquiries with their periodic office intrusions, sick relatives and partners, sick staff, briefings on the epidemic and new attempts to stop it, budget constraints, a laboratory overwhelmed with tests, and a chronically full waiting room. Until 1990, every patient was seen in one of only three exam rooms, and a hallway with provider "stations," which were nothing more than counter tops for writing notes. The waiting room would fill to overflowing with each new press release about the epidemic, news of Rock Hudson's death, or Magic Johnson's life. Understanding that Fenway's tiny facility could not carry the

burden alone, Orlando went after the first money (federal, state or local) available to underwrite the doctors and nurses, lab technicians and physician assistants fighting the epidemic, The AIDS Service Demonstration Grant. She brought in one of a dozen awards in the country by forming alliances with other service providers. The Metropolitan Area HIV Services Alliance (MAHS), was a program administered by Fenway with the Dimock Community Health Center in Roxbury, The Red Cross Blood Bank, the AIDS Action Committee, and the Visiting Nurses Association, that coordinated a full range of health services for people with AIDS throughout Boston, and eventually New England, under the fiscal umbrella of the city of Boston, Department of Health and Hospitals. She also created a second multi-agency program for substance abusers at risk for AIDS, the Drug Abuse Health Care Services (DAHCS) with NIMH funding, with Cambridge Hospital, the Dimock Health Center, and Martha Eliot Community Health Center in Jamaica Plain, a health center of Children's Hospital. "If getting support for the staff meant that I had to find support for my staff and every other provider in Boston, to compete with New York and San Francisco and LA, I didn't care. We were going to find a way to keep them going." Dale says today.

Her track record as a successful grant developer and her graduate degree in Community Psychology brought experience building grass roots coalitions, forging new programs, and starting successful organizations. She was also skilled in using the media to build and change an organization's profile. Prior to each proposal submission were conversations with Congressional staff people, state legislative aides, or local political assistants. Requests for letters of support were prewritten for them to send to agency heads, and pledges were made and kept that entire press conferences would be arranged for every award, with the most senior politician invited to make the announcement. After several federal awards were managed in this way and the work of the health center was gaining national recognition, requests came from Senator Kennedy's office for assistance with writing the CARE Act.

Under Research Director Ken Mayer, Fenway established a national profile with UCLA Medical Center in California to test the toxicity of Peptide T, a drug that was believed to be effective in treating multiple symptoms of HIV infections. In response to gay bashings on the street, the organization added the

Victim Recovery Project, forming a task force including Fenway's Mental Health Department and Andrea Cabral, who is today Suffolk County Sheriff. The task force renamed this program the Violence Recovery Program, as a new Fenway service aimed at reducing assisting LGBT victims of hate crimes, while expanding its scope to include efforts to reduce domestic violence in the gay and lesbian community.[58] Sheriff Cabral remembers, "In the late 80's, the criminal justice system was intimidating and, in some cases, downright hostile to LGBT victims of violence, especially domestic violence. Prosecutors and victim advocates had no reliable resources to help victims manage their fears, build trust and stay involved long enough to hold the perpetrators accountable. The Victim Recovery Project was a godsend. It was the only—and I do mean only—program of its kind in the state. Robb Johnson, Emily Poe and Curt Rogers were the groundbreakers. I know that program saved people's lives. I'm still so proud of that work, especially when I see how it's grown and what a crucial part of Fenway it's become."

Fenway's service statistics also changed dramatically in the late 1980s. In July of 1986, fewer than 5% of Fenway's client visits were HIV related; in 1989, more than 60% were. This increase was in part because of the increasing prevalence of gay and lesbian people among its patient population, and also due to a rapid overall increase in the number of patients using Fenway's widely expanding HIV services. "It was a bigger slice of a much bigger pie" remembers Dale Orlando, "Once the Board was clear on the Fenway mission of providing comprehensive health services to the gay and lesbian community and community residents, new programs began to be developed quickly." As this transition was occurring, and with the launch of so many new programs aimed at gay men and lesbians, Fenway's Board voted in 1987 to change the organization's mission statement to one that more clearly reflected its primary concern with these two communities and a secondary commitment to neighborhood residents.

In January of 1991, just two months before the opening of Fenway's new 7 Haviland Street offices, the center completed a six-month national search for a new Executive Director, hiring Michael Savage, a gay and lesbian community leader from Chicago. Michael Savage's emphasis was on forming statewide and national coalitions to secure additional funding for AIDS-related services. Building on Fenway's track record with forging coalitions, that

Fenway's Director of Behavioral Health, Phyllis Dixon (right foreground) shakes hands with actress and Fenway supporter Lily Tomlin (left foreground) during a 1991 visit to Fenway's 7 Haviland Street location. 7 Haviland Street's garden was named Goosebump Park in reference to Tomlin's one-woman show, "The Search for Signs of Intelligent Life in the Universe," to recognize continued support from Tomlin and her partner, Jane Wagner. (*Photo courtesy of Phyllis Dixon*)

summer Fenway organized a coalition of over 150 agencies from throughout Massachusetts to advocate for additional state appropriations for AIDS services. By the middle of 1992, under Michael Savage's leadership, Project ABLE (AIDS Budget Legislative Effort), which Fenway founded, secured $25.2 million for AIDS-related spending from the Commonwealth, a 35% increase and the first after three years of level funding.[59] Michael Savage wasn't shy about advocating for the needs of Fenway's constituents in public, either. The same month he announced the results of Project ABLE's success, he wrote about the needs of lesbians for increased breast cancer education and screening:

"As you may know, breast cancer is a major concern facing the lesbian community. There is significant research documenting that women who do not bear children are at 50% increased risk for breast cancer as compared to

childbearing women. A larger percentage of lesbians do not have biological children as compared to their heterosexual counterparts.

"Additional research documents that women who have children after age 35 are also at increased risk. Many lesbians with biological children conceive these children at older ages. In fact, many lesbians choosing alternative insemination (AI) do so in their mid- to late-30s.

"These two factors combine to place the lesbian community at disproportionate risk of breast cancer. That's why FCHC is working with the Department of Public Health to ensure that the $3 million appropriated for breast cancer education and screening in the Commonwealth's FY93 budget addresses the lesbian community.

"It took years and an enormous amount of energy and money to have gay men included in AIDS research during the 1980s. It is our intent to do our best to ensure that the lesbian community avoids a similar situation and process in the 1990s."

He would have lots of help. Board Chair Deborah Heller launched The Women's Dinner Party in 1992, an annual event to bring in funds for increased women's health services at Fenway. She enlisted the support of renowned breast cancer specialist and author, Susan Love, MD, and her partner, Helen Cooksey, MD, who lent their impeccable credentials and credibility to the effort. Twenty years later, The Women's Dinner party has become one of Fenway's greatest annual events, along with The Men's Event, which the organization initiated two years later, in 1994. Each has raised millions of dollars to support the health center's service programs, in addition to being two of the best parties of in Boston every spring. The Dr. Susan M. Love Award, given at the Women's Dinner Party, and the Congressman Gerry E. Studds Award, presented at the Men's Event, have also become two of the most prestigious local awards for service to the LGBT community.

Boston Homeless Advocate Kip Tiernan, receiving the Susan Love Award at the 1997 Fenway Women's Dinner Party (*Northeastern University Archives*)

Lily Tomlin, who would herself win the Dr. Susan M. Love Award at the 2009 Women's Dinner Party, kicked off the groundbreaking ceremonies for 7 Haviland Street with Dale Orlando in 1989. Two years later, Michael Savage presided over the formal opening of the new Fenway Health Center building, organizing a weekend program at which Mayor Raymond Flynn, Urvashi Vaid of the National Gay and Lesbian Task Force spoke, before a large assembly of Fenway Community Health Center clients and supporters cut a 75-foot ceremonial ribbon on Friday, March 1. The next day featured an all day street fair on Haviland Street, which was covered by a tent for the occasion, followed by a community dance in celebration of the center's opening and its 20th anniversary at Boston City Hall that evening. Years of hard work by many individuals were celebrated that weekend, as Fenway looked back on twenty years of service to its community, and to a bright future in a new building that would enable it to serve more people than ever before. Fenway had earned the right to be proud, but it had also become skilled in communicating the center's mission and programs in a way that cemented its place in Boston's health care system, solidified its role as a leading organization in its neighborhood, and put Fenway at the center of a number of multi-agency coalitions advocating for the rights of AIDS patients, gay men, and lesbians in Boston, Massachusetts, and the United States.

Still, with all these accomplishments, Fenway's AIDS patients were dying in greater numbers than ever before—twenty or thirty per month. Nationally, the year in which deaths from AIDS peaked was 1995, when 50,877 died.[60] The treatment "bridges" such as AZT, which slowed the virus's replication, or antibiotics that were used to treat some patients' deadly infections, could only go so far. But, in 1996, two events brought about a dramatic decline in the death toll. First, the effects of improved preventive education programs in previous years "caught up" with the epidemic. For several years, the number of new cases of AIDS had declined, beginning in the early 1990s, although the incidence of death lagged behind this figure by one to two years.[61] More important, new treatment options, in which multiple drugs were used to attack the virus, dramatically improved patients' survival rates. Stephen Boswell remembers the time well. "I saw patients come back after two weeks of taking the new drugs, and they had gained ten or twenty pounds. I knew then that we found something that worked."

Like other health care institutions treating patients with AIDS, Fenway could celebrate the transformation of the disease from an almost universal death sentence taking only weeks or months, to a chronic condition in which patients could survive for years, or now, decades. The battle is far from over, as anyone at Fenway today will tell you. Jon Vincent, Program Director for Prevention, Education and Screening at The Fenway Institute, notes that, "nobody 25 years old should die of AIDS today," but people still do. Still, the battle has changed. Before 1996, people came to Fenway with early symptoms of the disease, they got worse, and they died. Staff balanced the need to "help people die," as Jerry Feuer put it, with the search for new treatment options, or a vaccine. Others looked to prevent the spread of the virus by understanding its path from one individual to another, and encouraging people change their behavior in order to slow or stop it. Still others worked to educate health professionals in the large hospitals, where many AIDS patients would spend their final days, about how to manage their care in the best and most sensitive way possible. And there was always the challenge of convincing government officials at all levels that AIDS was a problem for all of society, not just gay men, and resources needed to be committed to solve it.

The stresses were enormous. Fenway's organizational coping skills included regular counseling groups for its staff, and discreet reporting systems through which the deaths of patients were recorded in notebooks, or on blackboards, in a room at the clinic where staff could go in private to review the list without the need for them to discuss each death in front of other patients who were still alive. Some staff left Fenway, having given all they could. Others stayed, many reporting that they couldn't imagine being anywhere else, or doing anything else, other than working there. A number of them are still here today, some ten, twenty, or even thirty years later.

Nothing can compare with the daily life-and-death nature of direct patient care in the time of AIDS. The words of Vincent Perrelli, Fenway's first Medical Director, ring true, when he commented on the center's earliest days, stating that "once you close that door, the relationship between a doctor and a patient is always the same." Other Fenway staff remember seeing patients and, at the end of their appointments, wondering whether they'd ever see them again. But the toll of these struggles also affected Fenway as an organization, particularly the

people who served as its Executive Directors. For all their accomplishments—and they were many—neither Sally Deane, or Dale Orlando, or Michael Savage—lasted more than five years on the job. Each of them left, as Dale Orlando put it, "with a broken heart." They had to manage the unimaginable stresses of an organization dealing with "this monster from space," as Jon Vincent calls AIDS. And they also had to shepherd an organization that had its roots in free care for all, maintaining its financial health while meeting ever-changing compliance with government regulations; and building a reputation for excellence in a larger community that was not always friendly, to say the least, toward its core constituencies. They had to balance the interests of Fenway's growing services to multiple populations, including gay and bisexual men, lesbians and other women, local residents, college students, transgender people and members of Boston's health workforce, which could not be ignored even as the monster from space was consuming everything and everyone Fenway could muster to fight it. And most of all they had to be the adults, guiding the way for an ever-growing, idealistic young staff following them—some of them sick, too many of them dying, and all of them willing to trudge until they dropped in a hopelessly dark tunnel, with the relentless monster in hot pursuit.

1996 brought a gift to Fenway on its 25th anniversary with the introduction of new, effective drug therapies against HIV; just as 1991 brought a new building to Fenway on its 20th anniversary. It was clear that Fenway was here to stay, although new challenges would require more from the center's medical, research, education, and policy leaders. But, in a way that would define its growth since that year, Fenway had a new resource, a gift that had been given to the health center just as much as it had been given to each of its HIV patients who had survived long enough to receive it. It was a gift that the health center staff would use to manage impressive, if at times uneven, progress, from that year forward. Fenway now had time.

We already are global if you consider The Fenway Institute. You can have the greatest health care in the world but if you're on a mountaintop and people have no access to it, what good are you doing?

It's important for us to have an important business model that is more of a model that helps the organization to support itself above and beyond grants and donations. It's always about the special people at the core of Fenway Health. We can have a great model, but we need the right people to implement it, to lead it.

—Allison Salke, Chair, Fenway Health Board of Directors, 2009

1980–1996 CARE

"It was the first time that it really hit us that we weren't going to save everyone from this disease. I think somewhere we believed that if we could just get people's stress down, if we could just give enough hugs, people didn't have to die."[62]

—Larry Kessler, Executive Director, AIDS Action Committee, commenting on the 1983 deaths of Paul Diangelo and Bill Beneville, two prominent spokespeople for people with AIDS in Massachusetts, and founding members of AIDS Action.

The innocence of a young community organization remained a part of Fenway for a long time. Its leaders had literally built the clinic by hand, discovering new skills within themselves from carpentry and plumbing to community education and fundraising. They faced roadblocks and opportunities together as a collective—a dysfunctional form of management over the long haul, but one that kept people close together and committed to the cause. By 1980, that cause had become health care as Fenway moved collectively toward obtaining a clinic license and the hiring of professional medical staff. The Board hired a new Executive Director who would lead the organization to a new level of professionalization, including strategic planning, financial discipline, and the creation of an organizational structure that could support the development of new programs within the center's emerging focus on medical care.

Core programs like STD screening and treatment, women's health education, and wellness care for the elderly continued to grow, and were supported by a marketing program to increase patient visits, now that billing procedures, cost control, and pricing systems were in place. Good programs from an earlier time—rat control education and referrals, after-school activities for local children and adolescents—were discontinued as Fenway became more of a medical organization. Sally Deane remembers the process as one in which the center moved away from a reliance on leaders with strong ideas and big personalities to managers who knew how to "put boots on the ground."

She embraced the city of Boston's plans for Fenway's growth as a neighborhood health center, and followed the guidance of Mayor White's Commissioner of Health and Hospitals, Andrew Sackett, to establish a partnership with the New England Deaconess Hospital through which Fenway would provide primary outpatient care, and could refer patients who needed more to a major teaching hospital with links to Harvard Medical School. This partnership also came with a $25,000 grant from the city to Fenway in support of these services, a sum that would help Sally Deane solve the financial crisis she discovered on her arrival at Fenway. She also remembers how different the world was then, and her encounter with unexpected prejudice from administrators at the New England Deaconess. Fenway's medical director at the time, Mike Lambert, was a family practitioner committed to services for all three of the center's core groups of patients. He was also Jewish, and at the time, this earned him and Fenway a chilly reception at the New England Deaconess in the early days of the two organizations' relationship. Lambert found it easier to work with doctors at Beth Israel Hospital, where the medical staff in the late 1980s would not only treat AIDS patients referred to the hospital from Fenway, but assist Fenway physicians to get hospital admitting privileges and release patients back to the health center after treatment. The two hospitals would merge in 1996 to form Beth Israel Deaconess Medical Center, an institution with which Fenway has enjoyed an enduring and supportive relationship.

In the early 1980s, Sally Deane and her staff, including nurses Lena Sorenseon and Joyce Pulcini, built supportive relationships with other organizations as well, some of them formal, others more ad hoc and practical. For about two years, Sally Deane remembers driving to Boston City Hospital (now Boston Medical Center) to load up on medical supplies that were unofficially donated by Barbara Huntress, a member of Fenway's Board who worked there. Fenway's new Board Chairman Dan Cirelli, a successful businessman in the food industry, helped develop the Board as a resource for Sally Deane's managerial improvements and brought additional connections to corporate funding sources. She remembers a growing sense of self-confidence throughout the organization as challenge after challenge was met. Dan Cirelli began planning a celebration for the center's 10th anniversary, which eventually did happen, but not until 1983, two years late. With

a strategic plan that structured Fenway's clinical and organizational priorities on "those who needed us most," Sally Deane believed the center was on its way to be a "center of excellence for care and to do more than just be 'gay sensitive.'" Fenway was exploring a broad range of gay health care programs, while not abandoning its base of local elderly patients. The center recruited a new Medical Director, Natalie Mariano, who was equally committed to earning a reputation for Fenway as a "serious" medical facility.

Then Ken Mayer, an infectious disease specialist, who was still treating patients as he became the part-time head of Fenway's new research program, brought up the subject of a strange new disease among young gay men in New York and California. He believed that it would soon come to Boston, and within a few months and he was correct. A growing sense of uncertainty and urgency would begin to compete with the innocence and self-confidence of a young health center planning for its orderly growth as a "center of excellence for care." New medical programs and improvements to existing ones were still moving forward, including mental health services and an alternative insemination program designed to meet the needs of lesbians who wanted to have children. In 1981, when the Cambridge Women's Health Collective (CWCHC) went out of business, Fenway agreed to house its medical records, and opened its doors to CWCHC patients. It would not be the last time Fenway would accept the remnants of another health care organization in Boston to fulfill its mission.

Mental health services at Fenway had begun in the 1970s, as one of the programs offered by the Women's Health Collective using unlicensed volunteers, or as Fenway's 1991 history document, *Opening New Doors*, called them, "un-credentialed activists." In 1981, Sally Deane and Natalie Mariano hired Rhonda Linde, a PhD Psychologist, to develop a more formal mental health practice. With Jim Fishman, she created the program "in an office the size of a small closet." As she built a small staff dedicated to traditional therapy, Dr. Linde would tell prospective employees that Fenway was dedicated to "providing formal and professional services in an informal atmosphere." By 1987, with assistance from Dale Orlando, under the direction of Lee Ellenberg, the Mental Health staff expanded the department to include group sessions, substance abuse counseling, and the Victim Recovery Program (now called the "Violence

Recovery Program", or VRP). In the early 1980s mental health services were added to the center's managed care-like contract with the New England Conservatory of Music (NECM), that Sally Deane negotiated in 1983. Tony Knopp, who succeeded Sally as Executive Director, recalls the Conservatory paying "a large amount at the time, something like $15,000 per semester," to cover medical services for the Conservatory's students. Rhonda Linde and Tony Knopp both remember the vast majority of patients from NECM coming to Fenway for its mental health services. By 1991, the Center's mental health services had grown exponentially, with 28 staff people working in the newly named Mental Health and Addiction Services Department. Rhonda Linde and Jim Fishman started two "AIDS (GRID) Forums" in 1982 to discuss medical and psycho-social issues surrounding the disease, drawing 40 people who agreed to meet regularly to talk about "doing something" about GRID. Fenway Board members Larry Kessler and Jon Stein attended these meetings, and formed what would eventually become the AIDS Action Committee (AAC) as a special committee of the Board of Directors that same year. They created the Buddy Program and started a telephone hotline for people with questions about AIDS, two of AAC's longest-standing programs.

Also in 1983, Fenway launched its Alternative Insemination (AI) Program for lesbians interested in becoming parents, one of the Center's most successful and innovative medical practices. The story of its development demonstrates the unique mix of activism, innovation, and medical conservatism that have defined Fenway for most of its 40 years. The program began because lesbians who wanted children couldn't find medical professionals who would help them inseminate. "Artificial Insemination," as the service was called outside of Fenway, was designed for women with fertility problems, as part of the medical specialty known as endocrinology. There was no precedent for healthy women wishing to become pregnant outside of a relationship with a man. Sperm banks wouldn't do business with unmarried women. Medical insurance companies wouldn't pay for insemination services if a woman were able to conceive a baby with a man, but chose not to. As far as they were concerned, there was no medical issue to justify treatment, or payment for that treatment if a woman wanted it. This is still true today as all of Fenway's AI clients self-pay for these services. To serve the interests of the lesbian couples and single women seeking to become parents on their own,

Female Dr. and Patient August 22, 1991 (*Ellen Shub*)

Former Fenway board Chair, Dan Cirelli (*Photographer unknown*)

Fenway would have to break new ground, creating an entirely new type of "choice" beyond what the rest of the world understood the word to mean in the context of women and pregnancy.

Consistent with the self-help philosophy that had been part of the women's health movement since 1970, Fenway's AI program began with education. Women (and men) were invited to come to the Center to learn about their options, legal responsibilities, financial requirements, plus practical steps in obtaining sperm and inseminating themselves at home. Fenway did not provide office insemination services until 1993. These informal education services became regularly- scheduled "Considering Parenting" short-term counseling groups that Fenway's Behavioral Health Department now hosts six times per year. Jane Schwartz, PA, became the first Director of the AI program; she was so inspired by the experience that she went on to become a psychologist at Beth Israel Deaconess Medical Center. The programs cover a full range of educational topics, including ovulation, the menstrual cycle, common emotional experiences women might anticipate, and the commitment required to raise children. Any infertility issues require referral to an infertility clinic or endocrinologist; Fenway does not provide these services. Men who want to become parents can receive counseling at Fenway about adoption or surrogacy, but Fenway does not provide any direct adoption support or surrogate parenting programs. Instead, these men are referred to different agencies if they wish to adopt or enter a surrogate parenting program after counseling. Men and women who want to have a baby together in a "known donor" arrangement can also receive counseling at Fenway, but Fenway will not provide any medical support in these cases because of the risks involved in working with live sperm. Again, they would be referred to another agency for direct services if they want to move forward after counseling.

Sally Deane's commitment to doing things by the book can be seen in the program's early design, particularly the decision to only work with sperm from licensed sperm banks which screen for diseases and ship frozen product to Fenway's AI clients. Few organizations in the United States understood the mechanism through which HIV was spread, or the health risks associated with infection, as well or as early as Fenway. Further, as a gay and lesbian health center, few organizations had as much to lose if anyone contracted AIDS from one of its medical programs. Medical protocols for the AI program continuously evolved

during the 1980s and 1990s to afford maximum protection regarding the risk of HIV and other diseases.

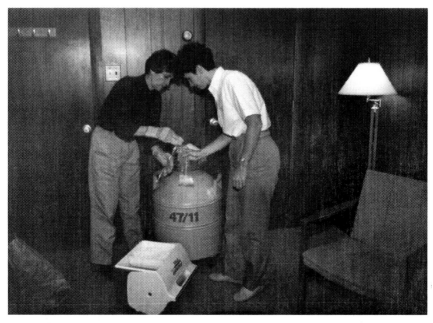

A tank of sperm, essential equipment for Fenway's Alternative Insemination Program (*Northeastern University Archives*)

Fenway's interest in providing services to women has always been at the fore-front of its program development, and starting the first AI program for lesbians and single women in the United States is an example of that commitment. Liz Coolidge believes that AI was designed not only to meet the needs of women considering becoming parents, but also to let women know that Fenway is a place where innovative and quality health care for women can always be found. "We know that Fenway wants to bring more women into the Center," as she puts it. By coincidence, the AI program grew at the same time AIDS care, research, and education did. She remembers discussions about whether the need to respond to the epidemic was taking resources away from the AI program. "We understood the reason why AIDS was so important and why our services were, and are, heavily weighted toward men. For a time, I was the only staff person at Fenway dedicated

exclusively to women, so sometimes women had the feeling that 'Fenway is great for men, but not for us.'" Looking back on this subject from the present day, Sally Deane remembers those discussions well. "Fenway was probably the only place in the world where a debate about providing alternative insemination services vs. HIV care could even happen."

Another interesting aspect of the AI program is the fact that it engages more than one of Fenway's departments in order to provide services. In the 1970s, Fenway's three collectives organized the center's programs around their unique target populations. Women coming on Tuesday nights received different care than the gay men who came on Wednesdays, because the center responded to what its patients were demanding, and did so through the efforts of a discreet group of volunteers dedicated to those services. Women came for self-help health education and counseling; men came for STD screenings and treatment. There was some cross-over, when either a woman might need an STD test, or the Gay Health Collective adopted the Women's Collective's health education model of selling books by other organizations at a discount. If the same doctors or nurses worked on both nights, there would be similar care, but the center's programs weren't designed to meet the same medical needs, or provide the same standards of care. In the early days of the 1970s, when it came to the "politics vs. professionalism" debate and other mission-related discussions, each collective would face these issues separately, even if their debates looked a lot like each other. As Fenway grew in the early 1980s, it began to organize itself by service delivery—medical vs. mental health, for example—and its professional staff worked to establish standards of care and case management that worked for all patients. Mental health staff would follow the same procedures for patients as individuals, and then build a treatment plan around each patient, instead of a treating each class of its patients with programs designed specifically for them by a collective organized to serve that population. Overall quality of care was easier to manage through specialization by medical service, but there was always the possibility that a patient might need both mental health and medical services, and communication between the two departments would be the only way to assure a coordination or "continuum" of care. Or, when it came to research, the Medical Department was always a good source of patients who might be recruited as study participants, and

the results of ongoing research could be used to design new treatment methods. But this worked only if there was strong communication between departments— something that wasn't needed under the old collective system. This changed when Sally Deane began strategic planning for Fenway in 1981. In 1986, Dale Orlando introduced the regular process of planning through a central management team, a change in organizational structure that enhanced teamwork among the staff.

As it turned out, the need for cross-departmental communication was a good problem for Fenway to have. The need to coordinate care across departments encouraged organization-wide discussions about improvement of overall care, and a focus on patients as individuals. So, when the Mental Health Department saw lesbians and single women who wanted to be parents, they could explore their patients' needs and bring them to the Medical Department for a broader discussion. Women seeking alternative insemination services needed counseling and education, to be sure, but they also needed sperm. Only the Medical Department could be responsible for meeting government standards in this area.

The Alternative Insemination Program also served to focus another long-standing debate about Fenway's mission: to what extent is the organization engaged in health care and health care only, or can it provide health care in the context of other, non-medical community programs? Alternative insemination is delivered at Fenway in a way that meets the organization's medical protocols— licensed social workers offer counseling, doctors ensure compliance with CDC and other regulatory requirements in the handling of sperm, and only frozen, tested sperm from accredited sources are used by AI clients. But other elements of America's medical system don't consider Fenway's AI to be medical practice. It's not delivered in the context of infertility services or by endocrinologists, and health insurance companies won't pay for it. So there is at least a philosophical argument (and when has Fenway ever failed to enjoy a good philosophical argument?) that AI is not medicine. Until 1993, actual insemination procedures happened in participating women's homes, after they received education at Fenway about how to do it. But that's not where the philosophical issue of medicine vs. non-medical services lives when it comes to Fenway; instead, that issue relates more to the free workshops on "Considering Parenting," or the community

outreach and education programs introducing lesbians and single women to the choice Fenway provides them in becoming parents.

As Fenway grew in the later 1980s and 1990s, other services developed that were designed around patient needs and involved multiple departments. The Violence Recovery Program started in the Mental Health Department, but involved the Medical Department as well. Fenway's Transgender Health Program also involves these same two departments. Later in its development, Fenway created a new Health Promotions Department, to manage education and outreach programs about public health care needs, and to make people aware of services they might want to receive at Fenway. Research, Health Promotions, and the Medical Department would all be involved in launching Fenway's "Living Well" Program for people with HIV in 1986. Liz Coolidge and her colleagues in the AI program eventually moved into the Health Promotions department, where they were joined by many other programs that crossed Fenway's departmental lines to serve its patients. Today, the Health Navigators in Fenway's HIV Prevention and Education Program work for The Fenway Institute, but have unprecedented freedom to seek support from any other component of Fenway Health in order to meet the needs of their clients. The inclusion of AI in Fenway's Health Promotions Department didn't end the debate by any means. In fact, other programs run by that department—Essence of a Woman, and SASSIE (Sisters Acquiring Safer Sex Information and Education), two programs providing informal sex education for lesbian women of color—faced similar objections from some at Fenway.

The question of whether Fenway ought to be in the business of reaching out to support women's rights to have children is an issue that relates to other, similar choices Fenway would make time and time again in defining its core mission. It was at the heart of the decision to end medical and mental health services by "un-credentialed activists" in the late 1970s; it would soon be raised in the decision to make the AIDS Action Committee an independent nonprofit organization because its "Buddy" program, public education, and other services were not health care. An organization that had significant financial challenges in the 1970s and

again in the 1980s had to make choices. Liz Coolidge describes them as "condensing to provide services that make money," or, with a less financial emphasis, "if we can only do one thing, what is it that we can do?" She notes that these philosophical discussions happened among staff, and never affected the quality of patient care or health education programs Fenway provides. But they are real, and recurring debates. Fenway has a long history of responding to community needs, and starting cutting-edge programs before there is money to pay for them with careful planning, resource sharing and "finding money" through special appeals.

In 1988, Homophile Health Services, an early local community health organization that was at least as old as Fenway, had fallen on hard times. It changed its name to Gay and Lesbian Counseling Services (GLCS) in 1983, attempting to survive by specializing in counseling and giving up its original broad medical care mission. Still, resources were scarce, and for over a year in the late 1980s, GLCS tried to merge with Fenway, seeking board seats, staff positions, and a place to continue services within the soon-to-be-built new health center. However, Fenway's board voted not to merge with GLCS. Shortly thereafter, in 1989, GLCS closed its doors, and Fenway Health accepted its contracts for services from the Massachusetts Department of Public Health and Department of Mental Health, along with its clients. The Gay and Lesbian Helpline had already moved to Fenway in 1988, when GLCS could no longer afford its operation. At that time, Fenway's leaders determined that the Helpline's services were similar to the phone counseling interventions provided by Fenway's large and growing HIV Counseling and Testing Center, as well as the call-in services for victims of gay crimes, which were part of Fenway's new Violence Recovery Program. These new synergies were also the result of continued "professionalization" of the health center. Under Dale Orlando's leadership at the time, Fenway required that trained and licensed professionals run all therapies and counseling modalities, while those grass roots advocates on the health center's staff who wanted to continue delivering services were given the opportunity to be schooled as paraprofessionals.

Even in 2011, there is no gay community center in Boston as there are in other American cities, where these organizations serve as social or political centers that identify and support gay people and their struggle for broadly defined human rights. Liz Coolidge is one of several Fenway staff who note the absence of such

a center, and who wonder whether Fenway ought to fill that void. She might not go so far as creating an all-encompassing social and political organization for Boston's entire LGBT community, but she might start with a group for gay and lesbian parents. Ruben Hopwood, who runs Fenway's Transgender Health Program, notes that Fenway, through its Living Well and health Navigation Programs, operates an annual dinner for transgender people in the hope that this effort will spark someone to start a community group for them down the road. Ultimately, Fenway's AI program has been in place for nearly 20 years not only because it became "popular" with single women and lesbians who want to become parents. It also exists because there were no alternatives, or at least there weren't until recently. (Liz Coolidge reports that today, in 2011, there are three other Boston programs where single women can receive alternative insemination services—two midwife groups and a third run by Harvard Vanguard). Fenway started and maintained its AI program as an answer for women who were being denied a right that requires enough medical care for the health center to justify as one of its programs, and was started at a time when no one else would help them at all. And they did it at a far lower cost than women would incur if they paid for these services at an endocrinologist's office. In that sense, AI has much in common with Fenway's decision to provide aerosolized pentamidine therapy for AIDS patients with PCP (pneumonia) later in the 1980s, and its vigorous efforts to obtain reimbursement for this program from the Massachusetts Department of Public Health. It might not fit as easily in Fenway's first mission statement, "health care is a right, not a privilege," but it surely can be included in the second one, "health care for people, not for profit."

One last mission-related debate sparked by Fenway's AI program is the center's relationship with the community and how its medical services affect both its supporters and those who would oppose it. The decision to start AI was made after much debate about whether it would incite violence. People were firebombing abortion clinics in the 1980s. Might they do the same to Fenway, or might they harm one of the organization's clients or staff? Fortunately, none of these ever came to pass, although there were many threats over the years. A more surprising community reaction came from gay people. As Liz Coolidge puts it, "The LGBT community has very high expectations for Fenway." Women who came to the

AI program with a male friend who had agreed to donate live sperm were disappointed to learn that Fenway wouldn't help them; they could only enroll in the program if they accepted Fenway's compliance with CDC guidelines on the use of frozen, tested sperm—the medical standard of care in Boston.

Even more controversial, the CDC guidelines on who can become a sperm donor exclude anyone who answers "yes" to the question, "have you ever had sex with a man?" Liz Coolidge remembers being contacted by the Rainbow Flag Sperm Bank, a California organization working to allow gay men to become sperm donors, asking for Fenway's help with its mission. Fenway ultimately said no, and the Rainbow Flag Sperm Bank was outraged. Turning away an organization dedicated to the inclusion of gay men in a program Fenway had pioneered for gay women is what Liz Coolidge calls "a weird consequence of our medical conservatism." Fenway made the right decision to protect lesbians and their unborn children, not from gay men themselves, but from a disease that was rampant in the 1980s and most often spread by male-to-male sexual contact. Less publicly known was that Fenway's AI protocols actually helped shape those CDC guidelines, as the notion of single women having children grew more popular in the 1990s. The center was by that time a partner with the Center for Disease Control, the NIH and NIMH, and the Health Resources Services Administration, in shaping many AIDS-related policies.

Even with the rapid expansion of its mental health practices and AI program, Fenway's Medical Department, like its new research department, was mounting an even more rapid response to AIDS. Medical staff interviewed for this history—Jerry Feuer, Harvey Makadon, Ken Mayer, Stephen Boswell, and Charlene Metrano—all remember a feeling of helplessness in the face of the growing number of very sick young men who just got sicker, no matter what Fenway's doctors and nurses tried to do for them. They remember throwing everything they had into finding something that might work to treat the disease, or one of the many secondary infections AIDS patients contracted as their immune systems collapsed. The time between infection and first appearance of symptoms turned out to be so long that

successful efforts to prevent the spread of the disease didn't result in any reduction of its annual death rate for an agonizing fifteen years. But the time a patient might be expected to live after being first diagnosed with those symptoms was measured in only weeks or months from 1981 through 1995. The first drug that slowed AIDS in any way was AZT, in 1987. There were other small victories from time to time, including Fenway's aerosolized pentamidine therapy in 1988, but patients died in greater numbers every year. No community health center in Massachusetts saw more AIDS patients, and, by 1991, only Boston City Hospital, known for care for the city's indigent poor, minorities, and drug abusers, saw more patients with HIV than Fenway. Fenway's experience with AIDS patients established its leadership in the field of HIV care in Boston's medical community. Gay people had already learned to trust Fenway from its early anonymous STD screening and treatment services. In the early 1980s, when fear of dying from the disease overwhelmed gay men and fear of catching the disease from them caused others to hate gay people, the first small victories were found in convincing hospitals to respect the dignity of their patients, even when Dale Orlando, Fenway's Executive Director from 1986–1990, recalls Fenway's own health providers asking for reassurance. "They'd come to me in the hallways and say, 'Just tell me I'm not going to get sick. I have my hands in these guys.' I'd look at them and say, 'You're not going to get this. We can't afford to lose you. I know it's scary. Breathe deep and go back to work.' They would breathe deeply, give me a cheery smile, say 'okay,' and go back to work. We were all afraid at some level at one time or another that we were going to get sick and die." It was the horror stories of doctors considering quarantine as a public health response to AIDS, or hospitals leaving AIDS patients' meals outside their hospital room doors because they were afraid to go inside, that motivated Fenway to advocate for more humane care everywhere, even in the face of their own doubts and fears.

Sally Deane and Ken Mayer remember getting together after work with other Fenway staff at each others' houses in the early 1980s for pot luck suppers where they would brainstorm what they knew, and what that knowledge could justify them doing, about the disease. Their commitment to professional medical care and research kept them grounded in a way that allowed Ken Mayer and his fellow researchers at Fenway, at the New England Deaconess Hospital, and elsewhere, to look methodically at their early patients and determine the most likely way the

disease spread from one person to another. The information they gathered—that it was most likely spread by anal sex, and the receiving partner was more likely to get AIDS—was promising for future treatment and research. But it still did nothing for the patients they interviewed to learn about the epidemic, who kept getting sicker as they discussed their sexual histories and the progression of their disease, hoping first for a cure for themselves, and then, later, hoping that their deaths would not be in vain as they signed on to be studied. Time became the enemy. Ken Mayer would talk with Sally Deane, then Tony Knopp, and eventually Dale Orlando and Mike Savage, about the need to raise money for medical care for Fenway's growing numbers of people with AIDS.

Until the late 1980s, there were dollars for AIDS research, but not for care. This had a direct impact on Fenway's budget, staff morale, and its ability to keep the doors open to serve the dual populations of the very sick and dying patients with AIDS, as well as other members of the community. Dale Orlando remembers her first Senior Management team meeting in 1986 with the "new" group of senior managers selected from the ranks of the still flat organizational chart. "I thought the first thing was to give them some hope that we would be able to keep the doors open and have more new patients coming in than the number who were dying." How could a small health center with a patient base of only 3,000 individuals, averaging 9,000 annual patient visits, grow exponentially when so many of the patients were dying? "It takes more than one leader. It takes a team that for the first time could not go to their respective collective's corner of care for men, or care for women, or care for the neighborhood elderly. These young managers had to learn quickly not only to manage their fiscal and personnel matters, they had to begin thinking strategically about the business of health care and how to apply that strategy to our medical practice. I remember that we started with a Force Field Analysis of what we wanted and what forces of change might constrain our efforts, or advance them. The real eye-opener was how much our own poor self image and lack of support for each other's efforts stood in the way of building a viable health care practice."

Force Field Analysis for Strategic Plan

Pro Fenway Strategy	Negative Social Forces
Increase Income-Grants	Anti Gay/AIDS stereotypes
	No treatment money-only education
Increase Med/MH Income-Word of Mouth	Traditional Low Profile- no ads
	Perception no real doctors
	Low Staff Moral-infights, self-esteem
Increase Medical/MH referrals	Few medical/MH allies except LGBT
	Hospital "Black Hole"
	No Intra-department referrals"
Increase Research Income	No research outside hospitals
Improve Image in Community	Iinternal Homophobia/Closet gays
	Basement image is poor-no wealthy
Get better working space	Unsufficient income
	Insufficient support/donor base
	Society hates Gays and AIDS-no help

(1986)

"We had to build our stature and create a positive profile quickly in order to survive. We decided that the rest of the Senior Management Team would work with their staff to come up with ways to change our internal systems to maximize inter-departmental referrals, deal with a general lack of self esteem, and create positive word-of-mouth information about Fenway, especially within the gay and lesbian population. I would tackle the externals: the health center's low profile, its sort of defensively closeted services, our lack of allies in the city's medical system, and the larger social hatred of gays, particularly those sick with HIV. I always though I got the easier job of the two." According to Dale Orlando, the main accomplishments in the Medical Department from 1986-1990 were a dramatic increase in revenue for the entire health center, a similar increase in the number of people served and type of services rendered by the health center, and improvements in the quality of patient care. We became a true primary care practice with doctors who followed our patients by rounding at hospitals as well as bringing them back to the health center after hospitalizations. These tasks might be straightforward for hospital-owned clinics. But they were overwhelming for Boston's smallest and least-known health center, one with only a single arm's-length hospital affiliation and front-line responsibility for treating a disease that caused many health

professionals to abandon their medical careers in fear. Accomplishing these tasks required the impeccable medical skills, self-effacing sense of humor, and dogged determination of Dr. Scott Harris, Fenway's Medical Director, and his small but dedicated staff.

Gay men who thought they might have AIDS could come to Fenway, and by 1984 they could be tested for antibodies to HIV that served as a marker for the disease, but this knowledge still didn't mean they could receive treatment for the disease beyond compassionate conversations about improving their diet, or reducing their use of drugs and alcohol, or practicing safe sex to protect others and reduce their chance of re-infection. Ken Mayer and his researchers had found evidence to suggest that re-infection seemed to accelerate the disease process. Not until 1987 could staff reliably talk with those already infected about how to not spread the disease, or with the "worried well" about how to not catch it. By the late 1980s, as the reliability of HIV testing evolved and improved, it was also possible to discuss HIV test results with a degree of certainty. Before that time, Fenway's medical staff faced the irony of delivering test results that were uncertain at best, along with information about treatment options that would be the same for some- one with either a positive or negative test result—practice safe sex, reduce use of drugs and alcohol to ensure the use of good judgment when meeting new sex part- ners, and generally watch one's diet to keep healthy.

Still, the health center's research and medical staff were always looking for new information that could prove useful in keeping people alive, and healthy, longer. Rhonda Linde wrote in the Fall, 1988, *Fenway Research* newsletter, that "we are setting out to test the hypothesis that there is a relation between certain personality variables and factors already being studied, namely sexual behavior, health and antibody status...for example...it is not known if one's emotional state and personality play a role in affecting a person's immune system functioning and ability to resist progression to AIDS...certain psychological variables may be correlated with such self-destructive behavior as alcohol, drug abuse and high risk sexual activity, thereby also increasing one's risk for illness." Patients could also take comfort that they were someplace where others like them were getting care. And they could count on honest information from Fenway, even when this infor- mation included blunt discussions about the gap between improved information

and the difficulty in using that information to treat people with AIDS. Ken Mayer wrote in that same 1988 newsletter:

"Continued careful monitoring of individuals with HIV infection and continued epidemiological surveillance of the type done in the ongoing Fenway Community Health Center studies will help answer some of the questions that these newer diagnostic capabilities raise. Since ten HIV genes have been described thus far with many gene products, other antigens and antibodies may be developed as diagnostic tests in the next few years. One important part of the Fenway studies will be the use of these newer diagnostic tests in an effort to see which ones can tell us the most about how people are doing and therefore form the basis for deciding when to begin appropriate therapies." [63]

By 1989, Fenway was treating patients with HIV in a number of ways, including experimental Peptide T therapy, Aerosolized Pentamidine, AZT, and a new Holistic Health Program launched that year. The fall, 1989, edition of *Fenway Research* provided updates on Peptide T and AZT:

"Peptide T, developed at the National Institutes of Mental health by Candace Pert and Michael Ruff, has demonstrated the ability to inhibit gp-120 (a molecule of HIV) from binding to the brain tissue and also to inhibit HIV replication of *in vitro* cell culture. A July 22, 1989 letter to *The Lancet*, published by the British Medical Association, reported no observed toxicity in another phase I study of Peptide T conducted in Los Angeles.

"The FCHC study is designed to monitor for toxicities to three randomly assigned dose ranges. Though the study is still quite young, no apparent toxicities have been noted. No definite conclusions can be drawn about toxicity until the study is complete. Other functions of the six-month FCHC protocol are to 1) assess the drug action of intranasal Peptide T, and 2) to obtain *preliminary* data on the ability of intranasal Peptide T to prevent, halt, and/or reverse the immunological and/or central nervous system manifestations of HIV infection." [64]

Note the optimism surrounding Peptide T's hoped-for effects on two of the most serious symptoms of AIDS; Fenway was then the only clinic offering it, and, as Dale Orlando observed, early patients who enrolled in Fenway's experimental program "loved it." (After the study concluded in 1990, Fenway arranged for them to continue to receive Peptide T until it was eventually demonstrated that the drug was not an effective treatment for HIV). With AZT, the health center's staff was more measured in discussing its pros and cons. After reviewing the results of treatment at various doses and in patients at different stages of HIV infection, Martha Moon, the nurse practitioner who oversaw administration of Fenway's Research Department, noted:

"Current data do not prove whether or not overall length of survival will be affected by AZT treatment. However, this study does show that AZT can delay the disease progression in HIV-infected persons with <500 T4 cells.

"What are the implications of these results? The CDC is encouraging earlier testing so that people can take advantage of earlier treatments, such as AZT. There is no data yet, however, which show that AZT remains effective over a long period of time with continued use. If it does not remain effective, this could have serious implications for the optimal prescribing regimen.

"...The Research staff is always available to provide you with resources and information about AZT or newer treatments, but you and your primary care provider must ultimately make the decisions about your treatment plans."[65]

By 1990, it was clear that Fenway was a national leader in understanding HIV and the options that were being explored to slow its progress or even "cure" it. But, well into the 1990s, it was also clear that the people with AIDS who came to Fenway were contributing toward the development of treatments that would help patients in the future, but might not help themselves.

"I began using the Fenway Community Health Center when I was a college student living in the Fenway. My lover, Roger Portal and I continued to receive our medical care at FCHC because when we went elsewhere we had to explain our sexual choices. Fenway staff was always sensitive and knowledgeable.

The same caring nature describes the staff of the Research Department. In 1985, my lover and I chose to give something back to FCHC by joining the newly started Partner's Study. Through the study we learned of his AIDS diagnosis and my positive HIV status. We never felt like mere subjects in a study. We were always treated like people. The researchers even came to our home when my lover could not comfortably come to the Center. Martha, Daniel, Bev, Clay, Patrick, and the other members of the Research Department became part of our support network. When Roger died in 1987, the staff grieved along with me. As I continue to help them find some of the answers to the many questions AIDS poses, they continue to help me and my new lover David maintain our health."–Steve Shuman, research study participant, writing in 1991.[66]

The respect Fenway's staff have for these individuals, their courage, and their generosity, is one of the great legacies of a time when the health center was working as hard and as fast as it could, but simply couldn't save them. Harvey Makadon's listening, Larry Kessler's hugs, Charlene Metrano's laughs, Gail Beverly's comforting words, and Ken Mayer's ideas were great. But for a long time, they simply weren't enough.

Fenway's experimental use of Aerosolized Pentamidine in 1988 is an example of how the health center sought new treatments, and offered them with its unique blend of quality care, respect for patients as people, and commitment to learning. The chapter about research at this time tells the story of how quickly Fenway moved to add this treatment to its services for patients after learning about its use in California, and how Fenway's staff and board people convinced the Massachusetts Department of Public Health to allow them to continue using the FDA approved drug outside of a formal hospital setting. Treatments began in Fenway's "treatment center," an upstairs room at 16 Haviland Street that was one of the health center's first new spaces converted from the billing office and Executive's office that moved to a temporary space. Tiny–barely big enough for three patients and a nurse's station–it was the first outpatient HIV treatment center in New England. In order to keep patients as comfortable and socially engaged as possible–AIDS was the reason for a lot of isolation in those days–their treatment was delivered to them as they sat in chairs in one area of the room, reading or talking with each other as they breathed in the antibiotic mist. "That

worked great until one of our nurses came down with tuberculosis," remembers Dale Orlando. Fenway quickly adapted by constructing phone-booth-like treatment stations that reduced the spread of diseases to others in its treatment center by containing the air inside and filtering it after each use. Aerosolized Pentamidine used as a prophylaxis was eventually replaced by bactrim, the same antibiotic in pill form that was previously administered as treatment after hospitalization, and other drugs also taken orally, which proved to be just as effective in preventing the onset of pneumocystis carinii pneumonia (PCP).

In addition to the Treatment Center, Fenway also founded the first full-time HIV Counseling and Testing Center in New England in 1987. At the start of 1986, when Dale arrived at the small basement health center, two plywood "cubicles" had been constructed over a bench in the laboratory to house the new, part-time HIV testing program run by Jennifer Walters, who was soon assisted by Gail Beverly. Originally run by the Medical Department, the HIV Counseling and Testing program actually supported the growth of Fenway's Medical, Research and Mental Health Departments through the widespread media exposure it received. In addition to media attention and outreach efforts targeted at gay men, this free, anonymous testing services attracted a broad spectrum of people from throughout New England we've already called the "worried well." What wasn't well known about the "worried well" was that many of the repeat users of Fenway's HIV Counseling and Testing Center were not concerned about their sexual relations as much as they worried about their working conditions. Because the tests at Fenway were free and anonymous, they were a much safer prospect for health care professionals who wanted to avoid HIV testing at their own facilities and risk being the subject of gossip among their colleagues. In addition to gay men and others who were sexually active, Fenway's HIV counselors gave reassurance to delivery room personnel who were exposed to their patients' blood on a daily basis, to members of surgical teams, dental professionals, and others with potential exposure by blood contact or an accidental needle stick. To a lesser extent, this pattern repeated with public safety and emergency personnel, many of whom had previously been quite vocal regarding their intolerance of gays. In one of the more surprising chapters of its history, the once obscure "grubby little health center" founded by radical activists, and known primarily by gay men and lesbian women,

began to receive referrals from all over New England. Many medical professionals who first came to Fenway for HIV Counseling and Testing quickly learned how much the organization knew about the epidemic, and this growing understanding of Fenway's expertise led to larger requests for medical, research and mental health assistance among people treating people with AIDS, individuals at high risk, and other consumers with secrets.

Fenway continued to make efforts to draw in women patients, who still represented only 15% of its total visits in the mid-1980s. In 1986, Fenway hosted New England's first Women and AIDS Conference, a second conference two years later, and a third in 1991. As cases of AIDS increased from 5% of Fenway's caseload in 1986 to 60% in 1989, the preponderance of gay men coming to Fenway for care would make it difficult to increase the percentage of women among its patients, even as the actual number of women seen in care rose steadily.

The formal incorporation of the AIDS Action Committee as a separate nonprofit in 1986 is an example of Fenway's commitment to support the development of other organizations to deliver important services that were not central to Fenway's mission. In 1989, this process was repeated with the establishment of CRI New England and its regional expansion of the community-based research model that Fenway started. Fenway would continue to help launch new organizations at this time, including the Sidney Borum, Jr. Health Center, which grew out of the health center's "kids street project," an early effort to reach out to homeless gay adolescents with information on how to protect themselves from HIV. It began its development from the work of a few staff and volunteers, like Stephen Busbee, who at the time wanted to create a new program for gay adolescents at Fenway. "With the political climate being what it was in the late 1980s, I thought were asking for trouble from people who could accuse us of 'recruiting' young people to be gay," remembers Dale Orlando. She convinced the group that the program would be better housed at Children's Hospital and their affiliated health center, The Martha Elliott in Jamaica Plain. These health organizations had already partnered with Fenway through the federal DAHCS program, and were better positioned to support a new program to deliver health education and care to LGBT street youth. Eventually the program found its way to the Justice Resource Institute (JRI) under Michael Cronin, where by that time it had grown to include school and employment

assistance, but the dream remained for these youth to get health care developed specifically for their needs. Today, things have come full circle; this organization, now known as the Sidney Borum, Jr. Health Center, became part of Fenway on July 1, 2010.

In 1988, Dale Orlando also helped Cynthia Harris, a Fenway employee, and others found the Multicultural AIDS Coalition (MAC), in an effort to reach out to people of color who needed information, education, and care about HIV. In another self-preservation effort, Fenway reached out to serve minority LGBT people needing health care, but chose to support the MAC in building self-help education programs for the broader minority communities, rather than trying to encourage this population to seek services at its still-overcrowded 16 Haviland Street headquarters. Fenway had expanded its geographical reach beyond its neighborhood early in its history, but was still having difficulties reaching minority people, who were acquiring AIDS at higher rates every year. Part of the problem was that people with HIV/AIDS encountered the stigma that being seen at Fenway meant being seen to be gay, even if they were not. In the late 1980s, Boston's minority communities saw their religious leaders speaking out against gays, alternating between condemnation and outright denial that gay people of color existed in their neighborhoods. To protect the growing number of people with AIDS, as well as to preserve itself as an existing resource for the patients it was already serving, Fenway assisted in setting up the MAC to offer education, counseling, and advocacy programs similar to those provided by the AIDS Action Committee. *The Boston Globe*, in an editorial dated April 8, 1990, advocated for the need to increase preventive education programs about HIV, noting:

"Black and Hispanic adults now have a 10 times higher case rate for AIDS than lung cancer. Among these minorities, the AIDS case rate of 300 to 500 cases per 100,000 population, now exceeds what it was in 1988 among the first group to be widely infected, homosexual men. Techniques of AIDS prevention are well known, but it has been difficult to convey them to minority groups, largely out of fear that by targeting minorities they would be unfairly stigmatized."[67]

"Starting an organization dedicated solely to reaching people of color, and locating it in Jamaica Plain, made more sense than anything else. We needed to get the epidemic under control in every neighborhood, not just our own," says Dale Orlando.

In the late 1980s, Fenway also continued to absorb other organizations in order to expand its mission or continue services to its core patient populations. As was the case with the Cambridge Women's Health Center in 1981, when Boston's Gay and Lesbian Health Services (formerly Homophile Health Services) closed its doors in 1989, Fenway took in its patients and some of its programs. Through that contract, Fenway expanded substance abuse services in its Mental Health Department. It had incorporated the Gay and Lesbian (now LGBT) Helpline months earlier– both former services of Gay and Lesbian Health. Fenway would later expand its helpline model by adding a Peer Listening Line for LGBT teens and young adults. Volunteers staff both lines; those at the Peer Listening Line are 25 or younger; volunteers at the Helpline can be of any age.

Phil Finch, Fenway's Vice President of Development and Communications, remembers an evening when he was a volunteer for the Helpline many years ago. "I remember a call from a kid's mom, who called to say thank you, and I had never even spoken with her son. She had found our helpline number in her son's room, and realized that he had called us many times over the course of seven years,

Acupuncture was the first of Fenway's holistic therapies in 1988. (*Northeastern University Archives*)

dealing with his own sexual coming-out issues. And she just called to say thank you; she had a hard time dealing with her son when he first started coming out, but through a lot of work with each other and with professional counselors, they were able to have a relationship. She called us that night to say that without our resources, her son might not have ever gotten started as early as he did on coming out and being the person he truly wanted to be. She was just so thankful."

The addition of substance abuse treatment to Fenway's Mental Health Department was important to Fenway for two reasons: first, it was a recognition that substance abuse is an important risk factor in acquiring HIV. People whose judgment is impaired by drugs or alcohol are more likely to engage in risky sexual behavior; helping them gain control of their use of legal and illegal drugs has the added benefit of preventing the spread of HIV. Second, Fenway would soon adapt its substance abuse treatment options to include acupuncture detoxification. This led to introduction of other holistic therapies—models based on the health center's understanding of its target population and their practical concerns about treatment options available to them. Market research among lesbians had shown that, given a range of therapeutic health care options, most preferred Eastern to Western practices for their own care. Women, whose commitments to children and family life made it less practical for them to enter residential detox treatment centers, needed something that would work while they remained at home. Acupuncture had been shown to be effective in lowering substance abuse, and was a service that Fenway could provide on an outpatient basis at 16 Haviland Street (much like aerosolized pentamidine in 1988). While its staff was initially concerned about what the rest of the medical community would think, acupuncture was soon used by Fenway's Medical Department "for conditions of immune system dysfunction, including Chronic Fatigue Syndrome, Epstein-Barr virus, and HIV-related concerns." Massage, chiropractic, and polarity therapy were also added to Fenway's initial Holistic Therapies Department that same year, to treat a variety of medical conditions, including "stress-related symptoms...particularly for HIV infected patients." Fenway's Holistic Therapies Program was located at 332 Newbury Street, one of the two spaces Fenway had leased as its medical programs expanded beyond the capacities of 16 Haviland Street. 332 Newbury Street also housed Fenway's Gay and Lesbian Substance

Abuse Treatment Program. Fenway's administrative offices had moved to 93 Massachusetts Avenue a short time before.[68]

As noted earlier, Fenway added the Victim Recovery Program (now Violence Recovery Program, or VRP) to its Mental Health Department in 1986, with a focus on anti-gay violence, expanding from gay bashing to domestic partner abuse. Another service that crossed departmental lines in order to treat the unique needs of its patients, Fenway's Victim Recovery Program combined mental health, medical, and research department staff to collect data on gay bashing in Massachusetts to support the passing of the statewide Gay Rights Law and Hate Crimes Statistics Act.

"Being assaulted by a fag-basher can be a very confusing experience. In addition to the injuries one might suffer from any attack, the victim of anti-gay violence may also have to contend with hostile police officers, a homophobic employer, and family and friends who really don't understand the problem. The victim who wishes to pursue criminal charges against his or her attackers may soon find himself trying to negotiate an often unsympathetic and labyrinth legal system without benefit of a map.

"...In addition to providing referrals for medical help and emotional support, the advocates at the VRP will explain the options available to victims of anti-gay crime and how the criminal justice system operates.

"...For those who do seek justice, the VRP can act as a liaison between the victim and the police. From filing the initial complaint to accompanying the victim to criminal court, the VRP is there to help. And with that help, gay-bashing cases are coming to trial and bashers are being convicted and sentenced by the courts. This sends a powerful message that anti-gay violence will not be tolerated."—Alan Jobe, VRP Client, 1991[69]

In 1989, nearing the end of its second decade, Fenway Community Health Center reported over 26,000 formal patient visits in its Medical Department, Research Department, and HIV Testing Center, with another 2,500 mental health visits. 60% of its medical visits were HIV-related, as were 20% of its mental health visits. Many more visits for HIV testing, phone counseling and educational services were performed. The center's income statement showed $2,997,628

in revenue vs. $2,789,186 in expenses, for a surplus of $208,442. Its revenues increased by more than $1 million over the previous year. Complete service and financial statistics for 1989 follow in the Leadership section of this chapter, and illustrate how much Fenway had grown in the ten years since it was Boston's smallest neighborhood health center at the end of the 1970s. Patient visits increased by a factor of four, while the center's operating budget was 12 times larger than it was in 1979. The distribution of services, and the fact that about half of its medical services were paid by private insurance, Medicaid, or Medicare also demonstrate the degree to which Fenway had developed as an established part of Boston's medical care system.

From 1987 through 1990, Fenway Community Health Center led a five-organization coalition to form Boston's Metropolitan Area HIV Services Project (MAHS). This coalition, which included Fenway, the AIDS Action Committee, Boston City Hospital, Dimock Community Health Center, and the Visiting Nurses Association, was created to deliver community-based health care for people with HIV at Dimock, Fenway, and via the Visiting Nurses Association, with back-up treatment at Boston City Hospital, and a city-wide education and support network through the AIDS Action Committee. The initial coalition had also included the Boston chapter of the American Red Cross Blood Bank. Funds were passed through the Department of Health and Hospitals of the city of Boston, who were designated as the fiscal conduit to give Fenway access to funds from the Health Resources and Services Administration (HRSA) to administer the program. In return, Fenway paid a small fee to the city for processing and distributing funds to the participating organizations. In addition to primary care for people with HIV, this program also provided education for health care providers on the delivery of medical care to AIDS patients along with efforts to make these providers "more comfortable with HIV-related care." Providers could come to Fenway, or Fenway would send its nurses and physicians to them, for consultation, direct teaching, or case conferences on HIV care, and hands-on experience in the practice of community-based, outpatient medical treatments. MAHS was one of Fenway's first multi-agency medical care programs,

and it provided further evidence of the health center's growing reputation as a leader in HIV care and education. By the early 1990s, Fenway would lead Project ABLE, a statewide coalition of medical care, health education, and other human service organizations to successfully lobby for increased funding of programs for people with HIV.

In coordination with the health center's new research programs centered on lesbians and breast cancer, Fenway once again re-launched its Lesbian Health Programs in 1992, offering education on the importance of breast examinations, along with diagnostic and treatment services at Fenway's original 16 Haviland Street headquarters. Consistent with its history of delivering health care to women with an emphasis on self-help, Fenway's Lesbian Health Program offered workshops and printed materials on how to perform breast self-examinations.

Fenway's Research Department was the first to break the news to the health center of promising new treatments for HIV in 1995, when the Federal Drug Administration fast-tracked a new class of drugs called protease inhibitors. Like AZT and other previous therapies, these new medications were designed to prevent HIV from replicating by blocking the virus's protein-cutting enzyme, or protease, from "programming" human cells to replicate HIV. [70] These new protease inhibitors were more effective than past treatment options, and researchers further discovered that, by combining them with older antiretroviral drugs, they could dramatically reduce patients' viral loads. Changes in patients with HIV were sudden and dramatic. *The Los Angeles Times* took few words to report the big news "that reduction in viral replication has been accompanied, in many cases, by reversal of AIDS symptoms, an emptying of hospital AIDS wards and a sharp reduction in the AIDS death rate."[71] At first, doctors believed these combinations, known as HAART, or highly active antiretroviral therapy, would eliminate HIV from the body, effectively "curing" AIDS. However, they found that, even after 30 months of treatment, "patients still have reservoirs of the virus that can reignite the disease if treatment is halted."

Since 1996, HAART has become the standard of care for HIV, and has evolved from multiple doses of different medications to a single daily pill combining all three. At the 2011 Conference on Retroviruses and Opportunistic Infections

(CROI) in Boston, where some workshops and meetings were hosted by Fenway, researchers discussed the fact that HAART might be an effective form of prevention. Research that Fenway helped conduct had demonstrated that, among a large sample of people taking this same daily pill, very few became HIV positive, and those who did may not have taken the pill as prescribed. The questions now include whether the cost of daily preventive therapy is justifiable; who should receive it—everyone, or only those in high-risk groups; and whether giving this drug to healthy people prevents others with the disease from getting life-extending care. "The bad news is we can't get rid of the virus entirely," said Dr. Robert F. Siciliano of the Johns Hopkins Medical Institutions. "But the good news is that, as long as people infected with HIV keep taking the triple-drug cocktail, they have an excellent chance of surviving the infection for a long time."[72] HAART is not the cure people thought it might be in 1996, but it is at least the longest bridge in a series of bridges to keep people alive until something better is discovered.

At Fenway Health, the arrival of HAART was cause for great relief if not celebration. Stephen Boswell remembers the difference over a short couple of weeks, when he went from not knowing if he would see some of his patients again for their next visits to seeing them come back gaining weight and becoming healthier. Jerry Feuer was happy that he and his colleagues could actually offer something that helped people coming to Fenway with HIV, instead of counseling them or providing a relatively ineffective treatment that extended patients' lives for a short time. He also remembers the transformation it brought to the Boston Living Center, an AIDS organization where he used to visit patients in their final months of life that has become a drop-in center where people living with AIDS come for nutritious meals, health services, counseling, and social programs. At Fenway, the dramatic reduction in death rates from AIDS, and the equally dramatic improvements in the health of many of its patients, gave the health center the opportunity to expand its medical programs to add wellness care, and to develop new programs for people without HIV—women, the elderly, and transgender individuals.

For some people, however, there was a surprising dark side to this wonderful news. Harvey Makadon remembers how difficult it was for some people who, believing they were dying, had taken viatical settlements on their life insurance policies, left their jobs, and even accumulated large credit-card debt. Not dying as planned

left these people unemployed and in debt, and it took years for some of them to put their finances back in order. He remembers that, sometimes, the question, "You mean I'm not going to die?" wasn't the expression of hope and relief we might expect. Fred Cowan, a long-time Fenway patient and friend of so many people lost to AIDS, remembers his mixed feelings at the time. "I stopped counting the number of funerals I attended at forty. I literally lost almost all my friends. I didn't want to be left behind." What he meant was that he wanted to join everyone he knew by dying from AIDS, and had become comfortable with the fate he anticipated for himself, even though he was HIV-negative. "For a long time, I was angry at the fact that so many were lost to a disease we couldn't cure. And, then, when we did find a treatment that kept people alive, I was still angry, but now because I was going to have to live for a long time without so many people I loved."

..

We've always been able to see the next big problem coming down the pike in time to be able to react to it. We were one of the first places where people with HIV could get service. They could come and they wouldn't be shunned. They would find doctors that would touch them and treat them and make them feel valued, make them feel like they were understood and accepted. There weren't a lot of places that did this. Fenway didn't start out to be a gay health center. It responded to the needs of the gay community who were among its first patients. When marriage was made legal in Massachusetts, Fenway was the place where people could go to get the blood work that was then necessary to get a marriage license. It was still awkward in some places for two men or two women to show up and ask for this blood test, because not everybody was on board with same-sex marriage right away. So Fenway offered marriage clinics when it was first legalized.

We were also one of the first places where unmarried women could get alternative insemination. This was done specifically because it was difficult for lesbians or single women to find these services. The peer listening line was the first nationwide program for kids to call in and deal with issues around sexual identity. Fenway started programs for people to deal with physical or sexual abuse from their partners, or because of hate crimes or gay bashing. We were one of the few places that would accept gay people with these issues when the Violence Recovery Project started. We trained police forces in

Boston and around Massachusetts in how to be sensitive to the specific needs of lesbi-ans and gay men who experience this sort of violence. These are examples of the types of programs that started through the vision of the people at Fenway. We've always been at the forefront of whatever the community's needs are, and we've been able to respond to these needs quickly with our programs.

–Phil Finch, Fenway Health Vice President of Development and Communications

FIGURE. *MMWR* report on *Pneumocystis* pneumonia in five previously healthy young men in Los Angeles — June 5, 1981

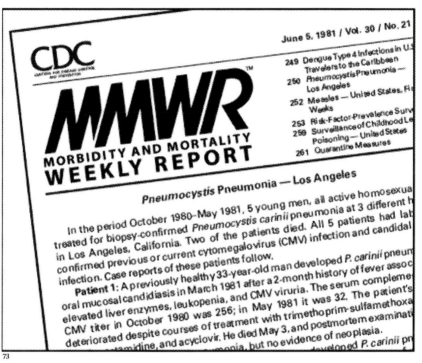

73

The news began on June 5, 1981. Ken Mayer was a regular reader of *Morbidity and Mortality Weekly Report*, a free publication from the Centers for Disease Control and Prevention (CDC) in Atlanta, which he describes as "the Women's Wear Daily of Epidemiology." During the first week of June, he brought his Fenway Health Center colleagues an article about five young gay men in Los Angeles contracting Pneumocystis pneumonia (PCP) during the 8 months since October, 1980. Two of these patients had died. July brought a second article about 26 young gay men in New York and California presenting with Kaposi's sarcoma (KS) over the previous 30 months. Eight of these patients died. This second article also updated the June 5 report to add ten more gay men with PCP in Los Angeles and also San Francisco,

for a total of 15, now dating back to September of 1979. The July article goes on to note that, "The occurrence of this number of KS cases during a 30-month period among young, homosexual men is considered highly unusual...It is not clear if or how the clustering of KS, pneumocystis, and other serious diseases in homosexual men is related...Physicians should be alert for Kaposi's sarcoma, PC pneumonia, and other opportunistic infections associated with immune-suppression in homosexual men."[74]

Ken Mayer remembers thinking that, "if this thing shows up in Boston, it'll probably show up here at Fenway." One month later, in August, 1981, Fenway saw the first confirmed New England case of what we now call AIDS—a young gay man with persistent wasting disease, who died later that year. With barely sixty days' warning and within months of completing its formal licensing procedures as a medical clinic, Fenway Community Health Center was thrust into the beginnings of its role as a national leader in the treatment of patients with a new and mysterious disease, and in the search for its cause. During the remainder of 1981 and throughout the 1980s, new patients kept coming, and more of them died. Those who could be seen as outpatients came to Fenway because of the organization's history of competent care for gay people, and as a result, the center's patient population grew dramatically. Those who were sick enough to require advanced care would go to one of Boston's major hospitals, and an increasing number of them had been Fenway's patients. As Fenway's reputation grew, doctors at these hospitals would contact the health center to discuss these and other patients' histories and treatment plans. In other cases, patients' need for additional care while away from home led them or their loved ones to contact Fenway for help. The center quickly became aware that many patients willing to participate in medical research needed a variety of services to manage their lives, particularly if they lived alone. Paying rent, feeding pets, looking for important mail, or stocking the refrigerator with food after a hospital stay might all be needed, and are important elements in the care of any patient. The organization responded by providing "Buddies" to advocate for hospitalized patients' needs in the community, and to keep them connected to friends and colleagues. Larry Kessler, then a member of Fenway's Board of Directors and a key figure in the Paulist Center's development of the Walk for Hunger in the 1970s, volunteered to lead this program.

The beginning of Fenway's research program pre-dates the announcement of what would become AIDS in *Morbidity and Mortality Weekly*'s June 5, 1981, edition by only six months. Dr. Ken Mayer's five-page "Proposal for Venereal Disease Research—Fenway Community Health Center," to Executive Director Sally Deane, dated December 14, 1980, began with these words:

"The following thoughts represent some of the issues that are still not optimally clear in the management of sexually transmitted illnesses, and are areas in which I feel the Fenway Community Health Center can make an important, and in some cases, unique, contribution to better comprehension and patient care."

Dr. Ken Mayer first approached Sandy Reder, Fenway's Medical Director, in 1977, when he was in Intern and Resident at Beth Israel Hospital. His interest in research on hard-to-treat infectious diseases in gay men began when he was a medical student at Northwestern Medical School and spent time at the Howard Brown Clinic in Chicago, one of the country's earliest medical facilities providing care and counseling to gay men. His discussions with Fenway staff about research continued for three years before his proposal to launch Fenway's research program. Ken Mayer and Sally Deane both recall their first meeting, in the summer of 1980, when they discussed his interest in conducting a research study among Fenway's patients at the center's gay evening clinic. He had just been appointed to a three-year fellowship at Harvard Medical School, studying infectious diseases at Brigham Hospital. As part of his fellowship, he was seeing patients at Fenway one or two nights per week. "You're going to be very busy," she told him, concerned that he might not have the time to conduct a proper study, or that he might find it difficult to balance Fenway's research interests with the other demands of his fellowship.

They agreed to begin a research program under three conditions: 1) Dr. Mayer would stay with Fenway long enough to complete the study; 2) all research would be conducted at Fenway (i.e. any specimens would be stored there and not taken elsewhere); and 3) the research would adhere to the highest standards, so it would not be subject to attack from people who didn't appreciate the work of a community health center specializing in the delivery of medical care to gay men and women. Ken Mayer calls the first two conditions as "prudent." Sally

Deane describes the third point as "internalized homophobia," her belief that gay people's best defense against anti-gay bias is the maintenance of impeccable standards. In the case of Fenway Community Health Center, they were, and still are, standards of care, research, education, and advocacy. As discussed previously, her commitment to these high standards would help lay the foundation for Fenway's future success. Her insistence on these standards would also cause controversy among others in the organization who believed gay people were being unduly denied opportunities for advancement at Fenway when they were the only ones who cared enough to do something about a strange new disease that was killing them.

Ken Mayer's December, 1980, proposal included a wide range of diseases to study—gonorrhea, syphilis, nonspecific urethritis, trichomoniasis, condyloma accuminatum (venereal warts), herpes, enteric diseases, scabies, and hepatitis. Some of these investigations involved gay men: for example, the study of gonorrhea and its incidence among gay men visiting bathhouses, and the effectiveness of traditional and relatively new vaccines in treatment; or relative rates of infection with nonspecific urethritis among gay men vs. heterosexuals. As previously noted, Fenway's bath house screenings were identifying 50% of all new cases of syphilis in Massachusetts in 1980. Other investigations involved women: the incidence and patterns of transmission of trichomoniasis among lesbians. Some included both men and women: herpes, syphilis, and the evaluation of how patient education aimed at gay people can "cause a demonstrable decrease in VD."

Fenway's Board approved the idea of Mayer's research, and, along with the health center's staff, he began setting up the infrastructure necessary to meet its requirements. Within a few months, events far beyond anyone's imagination would influence the direction of Fenway's early research program. And the impeccable standards with which this program was begun earned a credibility that would sustain Fenway's leadership in Boston's medical community, and in international efforts to find the cause and treatment options of AIDS. Thirty years later, Rodney VanDerwarker, current Administrative Director of The Fenway Institute, still keeps a copy of this initial research proposal in his office at 1340 Boylston Street. "When we moved here in 2009, we became paperless. But I have documents I really want to keep in a box by my desk. Ken Mayer's proposal is remarkable when you think about the barriers to Fenway starting research at

the time. The health center was so young, so grass roots. The idea of a community health center engaging in medical research was unheard of. And people were resistant to being part of a research study. They wanted care; they didn't want to be guinea pigs. But Ken Mayer said that if we didn't develop this capacity, someone else would set the LGBT agenda. This proposal is an amazing document. Many of his original ideas are things we are doing now. We did some of them right away. Others took thirty years. But it all started with this typed proposal, with all those corrections handwritten in ink."

If there is a precise moment that can serve as a marker of the transition from Fenway's early days as a politically active, anti-establishment gay and feminist clinic in the 1970s to its professional leadership in the field of LGBT health, perhaps it is Ken Mayer's decision to preserve specimens from Fenway's first research study, which he conducted with Dr. David Ayotte, to explore the abnormal balance of T helper and cytotoxic/suppressor cells in people infected with symptoms of this new disease. "We chose this abnormal balance of T helper and cytotoxic/suppressor cells, since that was one early harbinger of developing AIDS, known well before the virus was identified." Recalls Mayer, "I believed that if we were drawing blood to do the T helper tests, we should save anything left over, since I was convinced that eventually there would be a more specific blood test, once the cause of AIDS was known." Keeping with the initial agreement he made with Sally Deane, these frozen specimens were stored at Fenway's 16 Haviland Street headquarters. Two years later, what Sally Deane called "our little treasure trove" would prove its value in a larger study with Dr. Jerome Groopman of the Deaconess Hospital, after the antibody for HIV (then called HTLV-III) was discovered and could be identified in blood samples.

In the meantime, from 1981 through 1983, there was a combination of "the urgency of the moment and a lack of clarity about what was causing all these people to get sick," as Ken Mayer recalls. "Systematic research was needed to evaluate which of many possible theories might be correct. Was this a new bug? Was it an old bug that had become more weird? Were these men victims of immune system burnout, from years of sex and drug use? Was a particular chemical behind the epidemic? Early surveys of people with KS, PCP, and other

infections showed a high correlation with use of poppers, or amyl/butyl nitrates. Was this the cause?"

Ken Mayer and Fenway's early research program looked more like a medical Sherlock Holmes novel than the classic double-blind, confidential, statistically significant research program we see today in the search for answers about AIDS. He conducted many interviews with patients and their partners, and noticed that some people who got sick were not engaged in obvious risky behavior, such as drug abuse or sex with multiple partners. He saw that, in the case of couples, one partner would get sick, and then so would the other. He also found that women who were infected reported unprotected sexual intercourse, as did men having sex with men. So, early on, the idea that GRID (Gay-Related Immune Deficiency) was spread through sex seemed worth pursuing. Then came the next round of questions: what sort of sexual activity was causing this disease? What should people do, or avoid? Can we still kiss, hold hands?

Ken Mayer's early insight into the strange ratios of T-helper and T-suppressor cells in people with GRID helped researchers "see" the immune system and distinguish between people with normal and compromised immune systems. But what did a compromised immune system mean for people who were otherwise healthy? Were they going to get GRID and die? Until and even after the 1984 announcement speculating that the virus causing AIDS had been discovered (an argument that continued for a number of years), this painfully slow series of partial answers followed by alarming questions based on those answers continued, and contributed both to the expanding knowledge about the disease, and to the fear and misinformation included in Mayer's "second epidemic." For example, the May 21, 1982, issue of Morbidity and Mortality Weekly Reports preserves this combination of discovery and fear in language that is both clinically precise and chillingly incomplete:

"Since October 1981, cases of persistent, generalized lymphadenopathy—not attributable to previously identified causes—among homosexual males have been reported to CDC by physicians in several major metropolitan areas in the United States. These reports were prompted by an awareness generated by ongoing CDC and state investigations of other emerging health problems among homosexual

males...This unexplained syndrome is of concern because of current reports of Kaposi's sarcoma (KS) and opportunistic infections (OI) that primarily involve homosexual males... Although these cases have been identified and defined on the basis of the presence of lymphadenopathy, this finding may be merely a manifestation of an underlying immunologic or other disorder that needs to be characterized further...Homosexual male patients with unexplained, persistent, generalized lymphadenopathy should be followed for periodic review."[75]

What else does this mean? How long would it be before "periodic review" might help? Are people with swollen glands going to get sick and die?

In 1983, Fenway's research program made its first nationally significant contribution to solving the mystery of AIDS, using the frozen blood samples left over from Mayer and Ayotte's earlier study on T-helper and cytotoxic/suppressor cells. Ken Mayer describes these events in his typically thorough prose: "We referred sick patients to Jerome Groopman, an oncologist at the Deaconess, who was particularly interested in Kaposi's sarcoma and the immune manifestations of AIDS. He told me in late 1983 that Robert Gallo, head of the National Cancer Institute's AIDS research program in Bethesda, MD, might have isolated the AIDS virus, and thought that the panel of specimens we saved from men who were at risk for HIV, but not yet sick, would be of great interest, since we might be able to see if some of the men were infected with HTLV-III without being sick." Ken Mayer and Jerome Groopman sent Fenway's frozen blood samples to Bethesda, and Gallo found that all of the samples from men who had since become ill tested positive–an important validation of his theory, and a key milestone on the way to his April 23, 1984 announcement that he had found the virus causing AIDS.[76] But 21% of those without symptoms did as well, raising the disturbing question Ken Mayer envisioned two years earlier. What did the 21% positive rate among asymptomatic men mean? Would they all get sick and die?

There was fear of the unknown in the early 1980s to be sure, but the true toll of the epidemic would dwarf those early fears. In July of 1982, the CDC had reports of just 452 cases of AIDS from 23 states. By the end of 1983, there were 3,064 cases, of which 1,292 had died. Two years later, in December, 1985, there were 15,948 reported cases of AIDS in the U.S. From 1981 through 1987, the average life

expectancy of someone diagnosed with AIDS was 18 months.[77] And the disease was spreading rapidly, if silently, all the time. In 2008, the CDC used new technology to look back at the rates of new AIDS infection to find that the peak years for the annual number of new infections were in from 1983 through 1985, at over 130,000 per year.[78] By June of 2006, when the CDC published "Twenty-Five Years of HIV/AIDS—United States, 1981-2006," there would be 1,000,000 confirmed cases of AIDS in America, and 500,000 deaths.[79] For hundreds of thousands of people in the 1980s, who asked whether their swollen glands, Kaposi's Sarcoma, strange ratios of T-helper and suppressor cells, or partner's diagnosis of AIDS meant they, too, would get sick and die—and for several of Fenway's staff treating patients with the disease—the answer turned out to be "yes."

If the mid-1980s were the time of greatest tragedy and fear, they also marked the beginning of progress in understanding and treatment of AIDS, both nationally and in Massachusetts. Under the Reagan Administration, the Federal Government was slow to acknowledge the crisis, allocating $5 million to AIDS research in 1982, $29 million in 1983, $61 million in 1984, and $110 million in 1985. It took the House of Representatives to increase the 1985 allocation by an additional $70 million, and set the total amount for 1986 at $225 million.[80] In the meantime, three states—California, New York, and Massachusetts –put their own money into AIDS research. The Massachusetts Department of Public Health awarded funds to 8 organizations in the Commonwealth in 1983 to interview patients, collect histories, and analyze data as way to shape future studies and treatment. Fenway Community Health Center was one of these 8 groups, marking the first time any non-teaching hospital received such a grant from the state. A year later, the CDC funded the Multicenter AIDS Cohort Studies (MACS) in the United States, with one group based in San Francisco to concentrate on heterosexual transmission of the virus, and a second, based at Johns Hopkins University in Baltimore, studying men having sex with men. Fenway was included in this second group. Also in 1983, Ken Mayer co-authored one of the first books in the United States about AIDS, The AIDS Fact Book. (He and his co-author, H.F. Pizer, have collaborated on several other books about AIDS, including *The AIDS Pandemic: Impact on Science and Society*, published in 2004, and *HIV Prevention*, published in 2008.)

As a community health center, Fenway had opportunities and limits that helped define its role in the early days of AIDS research and treatment. Ken Mayer noted that, like other community clinics serving gay men in New York, Chicago, and California, Fenway saw patients earlier than hospitals did. With its growing mental health programs, Fenway also saw partners and friends of AIDS patients seeking support, most of whom were outwardly healthy. As mentioned earlier, when patients became too ill for Fenway's outpatient services, the health center referred them the New England Deaconess Hospital, based on the city-wide health care network Boston had established a decade earlier. Other AIDS patients who went directly to Boston's hospitals saw physicians who knew that Fenway had experience with similar cases, and many of these doctors contacted the health center for the most current information. Other specialists at different local hospitals saw Fenway as a source for participants in their own research studies. By the mid 1980s, different and competing demands brought questions about priorities that were central to the health center's mission, in an urgent way that wasn't always in harmony with the organization's history of lengthy internal debates.

Fenway's research team began research on the markers of what would be called AIDS in 1981. They participated in national studies that identified the responsible virus in 1983 and 1984. There was still no cure, but it became clear that education aimed at gay people might decrease the incidence of future infections. Patients in various hospitals throughout Boston were receiving different levels of medical care, and they were also subject to wide variations in support or even tolerance as gay men from hospital staff. Some physicians in town recognized Fenway as a resource in learning more about the disease, others saw the opportunity to recruit patients for their own research, and still others were openly hostile. Ken Mayer remembers that one hospital wanted to quarantine AIDS patients, and he had to work with other health professionals to argue against this strategy. Was it a time to concentrate on medical care, or research, or education, or advocacy? Was it possible to separate any of these from the others in a time when so little was known about HIV? Would Fenway, barely ten years removed from its roots as a free clinic with volunteer providers, be stretched too thin if it tried to meet all of these demands at once? What would be done for the continuing and real demands

of Fenway's other constituencies—women, the elderly, students, and poor residents of the neighborhood—when endless resources could be dedicated to trying to find a way to treat people with AIDS?

Two decisions Fenway Health Center made in the mid-1980s provide insight into how these questions were answered. The first fostered the development of its AIDS patients "Buddy" system through a working committee of its Board of Directors and staff, and then participating in the evolution of this committee which became the allied but independent nonprofit AIDS Action Committee. This was a deliberate choice not to provide advocacy services or any other services to people who weren't directly related to their medical care or their research participation at Fenway. Because people with HIV/AIDS were often so sick that they couldn't keep up with daily life, the demand for these services was becoming as overwhelming as the demand for patients' medical care and advocacy. Research, medical care, sharing information with doctors at hospitals, helping patients pick up their mail or stay in touch with family and friends, were happening and developing and demanding more attention, all at once. Ultimately, when it came to the "Buddy" program, the Board decided these services were not Fenway's to provide, because they were not medical care. The AIDS Action Committee moved to different space nearby, and began to act as a quasi-separate organization, still using Fenway's nonprofit corporate shell for fundraising and administration, until it became a totally new and independent organization in 1986. While some early harsh feelings lingered between the two organizations, the decision to "spin-off" the AIDS Action Committee was the first of many examples of Fenway serving as an organizational incubator in the multi-level fight against AIDS.

In the tradition of Fenway's governance history, this mission-critical decision was accompanied by much debate, with passionate and valid arguments on both sides of the question: should Fenway add community services to its mission, or remain focused on health care? Was Fenway a gay service organization providing health care as one of its services, or was it a health care organization whose patient population was primarily gay? Ultimately, another in a familiar series of decisions was made that Fenway would focus on health, and would continue to advocate for patients among its core constituencies of doctors, nurses, hospital administrators, and other health professionals. It chose not to become a larger organization

taking on social services for AIDS patients, or the launching of city-wide media campaigns to educate the public about how to reduce their risks of getting sick, even as its research department was helping to identify the importance of health education about sexual practices in reducing the spread of this mysterious disease. These services would be left to other trusted nonprofit agencies that could call on Fenway for its best thinking on patient care and the message to include in public education programs. Fenway would concentrate, for the time being, on medical care and research, along with those education and advocacy programs aimed at patient care, health professionals and government officials, which were closer to its core mission. Today, the AIDS Action Committee has served at least half of all people in Massachusetts with AIDS for the past thirty years.[81]

The second decision to spin off the AIDS Action Committee enabled Fenway to focus on its role as a community health center in a world of AIDS research dominated by teaching hospitals, and demonstrated the health center's commitment to foster innovative treatment options that other community-based organizations might initiate before larger teaching hospitals might. In 1988, Fenway was present at the founding meeting of the Community Research Initiative of New England (CRINE, or CRI New England), at Boston's Club Café. AmFAR, the American Foundation for AIDS Research, issued a national RFP for 8 community-based programs to study drugs that could combat AIDS-related opportunistic infections. In keeping with the coalition building model that Fenway leaders had initiated as Boston's primary method of combating AIDS, Fenway Health, the Cambridge Health Alliance, AIDS Action Committee, and other organizations came together to apply for one of these grants. AmFAR required that all applicants have experience with institutional review boards, community-based trials, and administration of previous Federal grants. Of all the organizations in Boston's group, only Fenway had these credentials and was selected as the lead agency once again, as it had been in medical care under federally funded AIDS treatment (MAHS) and in mental health under federally funded AIDS Substance Abuse Intervention (DAHCS), only this time in research.

This RFP was ground-breaking, because, as Mayer remembers, in the mid-1980s, community health centers were receiving the bulk of their grant money for preventive AIDS treatment and care from state agencies, while hospitals were awarded the most funding for research into medical treatment options primarily through federal funding. This trend made sense, but he saw two problems with it. First, as AIDS spread, patients from other parts of Massachusetts needed care, and would probably contact a community health center for care before going to a hospital. Second there were few other community health centers in the state ready to participate in preventive research. Fenway had prior experience in how to form a community review board, employ a staff coordinator, enlist bioethics people, hire statisticians, retain lawyers, and build other elements of the infrastructure required to obtain research grants. Other community health centers represented at the meeting didn't want everything to be based at Fenway, even though Fenway was the only such organization that understood the immense administrative burden of having to reinvent this wheel for each and every new research initiative. Mayer saw the need to collaborate with these other groups to develop a statewide,

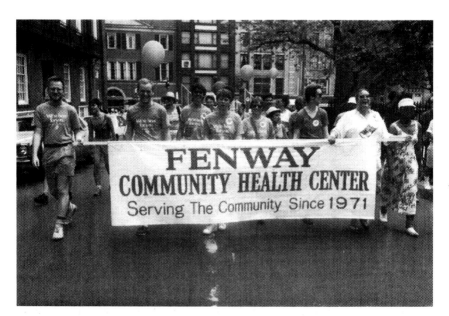

Fenway's Research Department carries the banner at the Pride march on Park Street, June 13, 1987 (*Ellen Shub*)

community health based research and treatment response to AIDS. Confident that Fenway could help set up a research infrastructure for a consortium of Boston organizations that would be as good as the one it had built for its own programs, Mayer and Dale Orlando wrote the bulk of a grant application in response to the AMFAR request for proposals. Later that year, they were successful in winning one of AmFAR's grants, beginning the CRI of New England, nurturing its infrastructure, and launching Fenway's next two decades of community-based leadership in clinical research. Fred Mandell, Boston's first Human Rights Commissioner and a member of Fenway's research cohort at the time, became the first Executive Director of CRI New England, serving until his own death from AIDS in 1991.

Today, CRINE operates two independent centers, one in Boston, and a second in Springfield, MA, coordinating clinical trials, treatment education, and financial assistance for approved drug treatments. Its notable achievements include the founding organizations' commitment to study drugs for HIV/AIDS at the community level with the 1989 Community Based Clinical Trials Network, which allowed for the exploration of alternative therapies. Others include a study of acupuncture as an effective treatment for peripheral neuropathy (a burning, tingling, or numbness in the toes and feet, or fingers and hands, that is a side effect of AIDS medication, including AZT). In 1995, CRI New England was the world's largest enroller of participants in the first protease inhibitor clinical trial, and had the largest number of female participants of any site worldwide. Fenway Health has been involved in each of these important studies. Of the more than twenty drugs available today for people with HIV/AIDS, CRINE has contributed to the approval of over half of them.[82]

The second problem Ken Mayer and his colleagues at Fenway saw in the HIV research system was its concentration of medical treatment research at major hospitals. For example, AZT, the first drug used to treat AIDS, caused profound side effects in patients. When it was introduced in 1987, it was based on other cancer treatments at the time, which Mayer describes as "knocking the socks off (the disease)" with what were essentially large doses of poison. Patients were also required to take AZT every four hours, around the clock, seven days a week. This treatment regimen, and side effects such as anemia, muscle pain, nausea,

sleep disruption, heart disease, and strange redistribution of body fat, stretched the idea of AZT as an outpatient therapy. It slowed the progress of the disease, in effect buying a limited amount of time until other drugs could be made available. Still, it was the only treatment available, and most people took it willingly. They brought their concerns about side effects and difficulties in keeping up with the treatment regimen to Fenway and other community health centers, not necessarily to the hospital where they received their initial prescriptions; the last thing they wanted was to be re-admitted. Treating AZT's toxic effects in the community required innovation and experimentation, creating a need for these clinics to share information about which of these secondary therapies worked best.

Another example involved what Mayer calls "edgy" research into experimental treatments that traditional hospital-based researchers might not be willing to undertake, or, as it turned out in the some cases, actively oppose if someone else did. Aerosolized pentamidine therapy at Fenway, one of these edgy treatments, turned out to be a major milestone on the way to the 1988 meeting where CRI New England was founded. By way of background, pentamidine was FDA approved to treat Pneumocystis (PCP) in 1969, a rare form of pneumonia. It was one of the drugs that could only be distributed by the CDC and state health departments, so that they would have an effective surveillance system for the diseases or exposures that these materials treat. In fact, the system worked as intended—increased requests for pentamidine in 1981 were one of the clues that led to the initial reports of AIDS cases in California. Later on, when some of the same patients contracted PCP a second time and required repeat treatments, the CDC began paying even closer attention.[83] Until that year, no one had ever requested a refill. Previous PCP patients were either cured in one 10-day treatment, or they died.[84]

Prior to the AIDS epidemic, pentamidine was administered through a standard 10-day injection regimen, and its side effects—severe and possibly life-threatening lowering of blood pressure, cardiac arrhythmia, and others—warranted manufacturers' warnings requiring that these treatments be limited to hospital settings.[85] Without rapid intervention, however, PCP could be fatal, and limited access to pentamidine could cause otherwise preventable deaths in patients with AIDS. By the late 1980s, doctors at Fenway had heard that outpatient clinics in New York and San Francisco were having success treating patients with an aerosolized

version of the drug. Essentially, these individuals would breathe vapor for a period of time, and then go home. Ken Mayer thought this didn't sound too complicated, and believed it was something that Fenway could do. With Executive Director Dale Orlando's agreement, Fenway began this experimental treatment in 1988 using rigid protocols painstakingly developed by Martha Moon, based on Ken Mayer's extensive research about the drug and its administration. The treatments seemed to work, and patients stopped developing PCP. Confident that this would be welcome news, Orlando contacted the Massachusetts Office of Medicaid to set up a payment structure for these treatments—a call that had an unexpected effect. An alarming return call came from officials at the Massachusetts Department of Public Health, and Fenway directors were summoned to the Massachusetts State Laboratory for a meeting. Along with Ken Mayer, Dale Orlando took the Chair of Fenway's Board of Directors, Stewart Landers, a public health researcher and attorney, past Chair of Fenway's Board, Holly Ladd, a lawyer for the Boston Fair Housing Commission and Scott Harris, MD, Fenway's Medical Director. They argued successfully that the health center's protocols for administering the drug, along with Fenway's established clinical research standards, warranted the continuation of their aerosolized pentamidine therapy on an outpatient basis at Fenway. Armed with Massachusetts DPH approval, it took several months, but Medicaid approved payment for pentamidine, which triggered the domino effect of similar reimbursements from third party insurers. At that point, calls came in from many outpatient providers in Boston and the United States to obtain copies of Fenway's protocols.

When one of the research nurses contracted tuberculosis, probably from proximity to the patient inhalers while they were in use, physicians at MGH, who were impressed by Fenway's determination to save lives, devised and delivered three airtight, phone-booth like seat boxes, each with a self-contained inhalation apparatus and filtered air exchanges. These would be used until bactrim, the pill form of pentamidine formerly used as a survivor home treatment following hospitalization, was released for use as a prophylaxis against PCP. Orlando muses, "We didn't even know who to thank. The booths just showed up with a note that they were from the doctors at MGH. Things like that had started to happen for us. Their kindness still makes me tear up..."

Ken Mayer recalls this event as a milestone: Fenway Community Health Center had responded to both the challenge of treating AIDS, and a challenge from the medical establishment questioning its new treatment methods. It was one of the early moments when he and others at Fenway realized they had proven the center could be an effective leader in alternative treatments for AIDS. It also taught him that "we're in a fishbowl," and, without the rigorous procedures and formal structures Fenway had in place for its research, if something bad were to happen, it could hurt the credibility of community-based care and research. Fenway and other organizations like it would have to be very careful indeed.

Fenway's research study on Peptide T, a short string of amino acids that was believed to block HIV infection of T-helper cells and improve brain function, was important evidence of Fenway's growing national reputation for AIDS research. In 1988, Candace Pert, a researcher at the National Institute of Mental Health, introduced this drug as a promising treatment for the epidemic. NIMH funded a research program to test it; Fenway and UCLA were the only two places in the country where patients could receive Peptide T. "Whatever it did, our guys loved it," says Dale Orlando. "They felt great, and we began thinking, what if this really is the cure for AIDS?" While the results of the Fenway–UCLA study confirmed that Peptide T was non-toxic, the drug ultimately did not become an important therapy against HIV infection. However, it is still an important chapter in the story of Fenway's Research Department, and its growing national reputation. Fenway patients were able to continue taking Peptide T after the clinical trials ended in 1990, while further tests of its ability to prevent infection continued. This "compassionate use" of an experimental drug was not uncommon during the AIDS epidemic, since many researchers and medical providers believed the possible benefit of these drugs outweighed the risks of any side effects while tests were continuing. Mayer also remembers the formality with which Fenway approached this particular study. "We had all the infrastructure in place—a community review board, staff coordinator, statisticians, bioethics people, and lawyers. We followed rigorous procedures. We knew from our experience with aerosolized pentamidine and the DPH that we had to do things right."

Dale Orlando also remembers the NIMH study and its relationship to a promise she made to her staff when she began working at Fenway. "I told them that if they

followed my lead, we would come out of the epidemic as New England's gay and lesbian health center, and not just as Boston's AIDS clinic. That involved making tough choices, and staying focused. We kept opening and operating services for what we now call the LGBT Community in all our departments—medical care, mental health, education, and research. But we also made choices about what not to do, and in this case, Ken Mayer and I saw risks in running experimental treatments like Peptide T. If it really was the cure for AIDS, people would have come to Fenway from everywhere, and we would become not just Boston's AIDS clinic, but one of the country's leading AIDS clinics. It would have changed our identity in a way that would have prevented me from keeping my promise. It was a relief when we incubated and spun off the CRI to do these things."

Candace Pert was also a controversial figure at the time, and Fenway saw the risk in becoming too closely affiliated with her researchers, who wanted to try AIDS drugs in lower-cost settings through the national research institutes, in this case NIMH. Orlando claims, "It wasn't just Candace, the competition between the research goliaths of NIH and NIMH could have easily made waves large enough to capsize our little boat, and our cargo was too precious for that. All of our research subjects were our own patients, not some number in a study, and they had to come first." In addition to being a magnanimous decision to share its resources with other organizations to promote a broader community-based research response to AIDS—which it was—the decision to launch CRI New England was also made to keep Fenway in control of its own mission. If Peptide T had turned out to be the cure, other organizations could also claim success and all the attention wouldn't come to Fenway alone. But if Candace Pert and her colleagues at NIMH eventually drew too much competitive heat, Fenway wouldn't be seen as part of that problem. "Sometimes it's not just what you do, it's what you don't do that keeps you going with a successful strategy," notes Dale Orlando. All of Fenway's other great leaders have made similar strategic choices.

Fenway's research programs were always closely tied to its medical care for people with HIV and AIDS, and, beginning in 1988, the center's Research Department began publishing *Fenway Research*, a newsletter separate from the health center's regular newsletter, then entitled *Frontlines*. The research newsletter contained information on treatment options, contact information for

other agencies providing services to people with AIDS, and a "People are Asking" section which published questions from the community such as, "What about oral sex?" or "If a person is seropositive, is it for sure that he/she will develop AIDS?" Fenway had become a credible source of information about the disease, for medical professionals and the public at large, and willingly took on the challenge of keeping everyone current with its best thinking and latest research findings on HIV. Fenway also used its credibility with patients and the public to recruit individuals into its expanding research programs.

In the Autumn, 1988, edition of *Fenway Research*, Research Department Clinical Coordinator Martha Moon, in her "Notes from Martha" column, asked for participants in a new study of HIV-antibody discordant couples (in which "one is HIV-antibody positive, and one is HIV-antibody negative). She wrote, "We are interested in studying HIV transmission between these partners, by analyzing data concerning behavior, physical findings, and laboratory findings. If you or someone you know is interested in finding out more about this study, please give us a call...An important research question which we are hoping to answer with this study is, 'Why do some men transmit HIV more efficiently than others?' The answer to this question may have implications for treatment as well as vaccine development."[86]

Fenway was honest with its patients and research clients in a way that reminds us how little was known about the disease at the time. Martha Moon's request for participants in the couples study also includes this paragraph:

"Speaking of treatment, in the past two years many new HIV-related treatments have hit the scene. It is as difficult for health care providers as for consumers to keep up with the latest new therapies on drugs and the most recent findings concerning them. We have enclosed a list of resources for HIV-related treatment. Information about treatments is ever-changing. We are not in a position to recommend one over another, although we will be happy to discuss any of them with you. We encourage you as consumers to do as much research as possible on your own prior to embarking on a new therapy."

In another article, "HIV Antigens and Antibodies," Research Director Ken Mayer explains what these terms mean, and their importance in studies that might predict how HIV infection might progress in different individuals.

"Thus, it may be possible to have diagnostic tests that can assist in predicting that an individual may develop opportunistic infections over the next five years. One problem with this information is that we do not yet know which drugs might be useful for asymptomatic people for five years; the therapeutics are lagging behind the diagnostics...it is still not totally clear how clinicians can best use these test."[87]

Fenway Research was published at least through 1991, when Martha Moon left Fenway after six years for the University of California, San Francisco, to pursue a doctoral degree in nursing. Her farewell note in the spring, 1991, edition explains the close bond Fenway had established with its research study participants, who, in many cases, were also coming to Fenway for their medical care:

"I have seen many changes at the Fenway during my tenure here...What hasn't changed is the loyalty and dedication of the Research clients who have faithfully come in for visits every six months where they are poked and prodded, stuck with a needle, and requested to complete an interview or questionnaire detailing their most intimate sexual behaviors since the previous visit. These men and women are the real heroes of this epidemic. Without their willingness to participate, we would not know what we do about the natural history of HIV or about the transmission of HIV between sexual partners. There are still many questions which are unanswered but through these participants' unflagging dedication, we are able to make strides toward some of the answers."[88]

Fenway expanded its research on HIV to include women beginning in 1988, and it also conducted New England's first regional study on lesbian health around the same time. By 1992, Fenway's Research Department formed the Lesbian Health Research Subcommittee, which worked closely with new Executive Director Michael Savage and Fenway's Board to advocate for inclusion of lesbians in the FY 1993 Massachusetts Department of Public Health's breast cancer education and screening programs. On its own initiative, Fenway launched its Lesbian Health Series, providing outreach and education to lesbians at high risk of developing breast cancer, that same year. Expansion of Fenway's research programs also included an assessment of the health needs of lesbians and elder gay people,

and a study of STD transmission between lesbians. Both of these studies were also launched in 1993.

At the same time, Fenway became one of two community health centers in the United States (and one of 8 total research sites in the program) to participate in the first NIH-funded HIV vaccine trials, beginning over ten years of active research into the search for an effective preventive therapy in a series of clinical trials. The search for an HIV vaccine received much attention in the media at the time, with reports alternating between optimism that a cure was within reach, and pessimism that HIV had so many different forms that no single vaccine could ever be developed. In September, 1993, Fenway participated in a vaccine study sponsored by the State of Massachusetts, the first state-funded HIV research program in the United States. *The Boston Globe* reported:

"State to Sponsor Trial of Vaccine for People with HIV

"(September 3, 1993) Massachusetts health officials yesterday announced the first state-sponsored trial of a vaccine to treat HIV infection. The announcement was made at Roxbury Comprehensive Community Health Center, one of 12 sites where the therapeutic AIDS vaccine will be administered...

"Even before yesterday's press conference, more than 200 people had asked to enter the study, which will enroll only 140 patients statewide. An estimated 30,000 Massachusetts residents are infected with HIV, the virus that causes AIDS. Researchers hope the vaccine, called GP160, will boost patients' immune systems, allowing them to fight off the virus more effectively and remain healthy longer...

"The vaccine, intended only to help those already infected with the virus, has been given to thousands of people worldwide and seems safe, said Dr. Alfred DeMaria, assistant public health commissioner and a principal investigator of the study.

"The Massachusetts study is unique in several respects, DeMaria said: It is the first to be run by a state, the first to use gamma interferon and first to enroll only patients with advanced signs of HIV infections, with a CD4 cell count under 400. CD4 cells are white blood cells that serve as a marker of disease progression...

"In addition to the Roxbury center, the study will be conducted at Fenway Community Health Center, Cambridge Hospital, Community Medical Alliance in Boston, the Massachusetts State Laboratory in Jamaica Plain, Outer Cape Cod Community Health Center, New Bedford Community Health Center, North Shore AIDS Health Project, Lowell Community Health Center, Metro West Medical Center in Framingham, Visiting Nurse Association of Central Massachusetts in Worcester and Brightwood Riverview Health Center in Springfield."[89]

Fenway devoted significant resources to a number of vaccine research trials, from 1993 through at least 2005. Today, there is still no vaccine to prevent HIV infection, although some argue that regular doses of anti-retroviral drugs can keep HIV-negative individuals from becoming infected. By the mid-1990s, Fenway, along with other national leaders in the fight against AIDS, became increasingly focused on viral loads as the key to diagnosing people at risk for development of AIDS symptoms, and as a measure of the effectiveness of treatments for individuals with AIDS. The lower these patients' viral loads, the less likely they would be to contract pneumonia, Kaposi's Sarcoma, or other serious AIDS symptoms. Then, in 1995, the FDA allowed the fast-tracking of protease inhibitors, a new class of drugs designed to prevent HIV from replicating in human cells. They worked in reducing viral loads, and by 1996 became part of the "triple drug cocktail" that would change the nature of the AIDS epidemic.

Also called HAART, or "highly active anti-retroviral therapy," this form of treatment includes protease inhibitors and two other drugs that keep HIV from replicating in different ways. Taken together, they substantially reduce the chance that the virus can develop a resistance to any single drug and continue replicating. According to NYU Medical Center's AIDS Clinical Trials Unit, "Suppressing viral replication with HAART allows the body time to rebuild its immune system and replenish the destroyed CD4 or T cells. HAART has been clearly shown to delay progression to AIDS and prolong life. Note that a curative treatment of HIV/AIDS is not possible at the present time, or in the near future, and when HAART is stopped, HIV becomes detectable in the blood once again."[90]

Even though it is another bridge that keeps patients alive until something better is discovered, HAART has been the best bridge so far, so much so that

many people who were at Fenway at the time remember the difference as a turning point. For clinicians, it meant patients were no longer dying in great numbers, and there was actually something to offer people with AIDS other than treatment for symptoms, or counseling, or "helping them die." For researchers, it meant at least two things: first, there was a promising path of new research to improve HAART from its initial reliance on a demanding daily regimen of multiple pills on a strict schedule to a more practical delivery model that would increase medication adherence, and second, a search for new drugs that could provide the same anti-viral benefits without the toxic side-effects of early HAART therapy, and would work even longer than the first generation of these treatments.

For Fenway as an organization, HAART also meant that its leadership could finally imagine a world in which AIDS was not the overwhelming health crisis that it had been since its discovery in 1981. The "monster from space" wasn't gone, but at least it could be held at bay. New challenges in education and advocacy could be addressed, including a fight against complacency among gay men who no longer feared a still-deadly disease, and a similar fight for resources needed to continue progress on better HAART and, eventually, a vaccine. Another consequence of this new and effective treatment was the opportunity Fenway now had to explore and address the health care needs of its entire population. By 1995, 40% of its 54,000 patient visits were HIV-related. But 1996 marks the end of what Ken Mayer calls "the AIDS wilderness." It was now time to revisit the organization's priorities with regard to lesbians, women, the elderly, students and young people, people of color, transgender individuals, and others in need of Fenway's unique model of health care. Within a few years, progress in all areas would be underway, and Fenway would be the leading health care institution serving gays and lesbians in New England, as Dale Orlando had first promised her staff it would be when she began working at Fenway in 1986. Within a year, that promise had resulted in the expansion of Fenway's mission statement to include bisexuals and transgender people. A few years after that, it would be clear that Fenway's reputation was not only regional, but national and even international in nature. But the time immediately after Fenway's AIDS patients began to live longer lives brought new challenges—for them, for community research, and for the health center.

I believe Fenway would not have succeeded without the contributions of four of its Executive Directors: Sally Deane, Dale Orlando, Michael Savage, and Stephen Boswell. All four of them were intensely political in a good way, and intensely aware of the contradictions they had to deal with on a daily basis. By political I mean that they were very good in realizing that there are a lot of great people out there and if you have a strong work ethic and you care about the community, then you'll have a lot of natural allies. They also realized the need to be articulate and strategic, because if you're good at what you do there are people who will seek your support or your patronage for what these other people see as the proper priorities.

Every one of these four Executive Directors wanted to do something for the LGBT community, but they knew it was not right for Fenway to only focus on those communities. An LGBT person is also a citizen, and is someone who deserves good services because of that. All citizens deserve good services, including those who are not LGBT. All four directors kept a holistic approach and expanded programs with an eye to all of Fenway's target populations. For example, being the go-to place in the community response to AIDS would allow us to provide other ambulatory services at the same time. They made sure that we provided great services to people who needed them, but they also made efforts to keep good relations with the elderly people at Morville House and the students at Berklee and the Conservatory. All four of them have been really good at keeping us from becoming polarized. There were problems from time to time, but they kept the organization intact internally and maintained strong ties with all the people outside of Fenway. That's not easy to do, and I really respect them all for their leadership.

–Ken Mayer, Co-Chair, Fenway Institute

1980–1996 EDUCATION

"INFORMATION ABOUT AIDS

"Service and support groups are addressing the anxieties of gay residents who fear they may have been exposed to AIDS, or who want to discuss modifying their lifestyles to decrease the risk of contracting the illness:

"The AIDS Action Committee (424–5916) will be forming groups to discuss AIDS anxiety and offer support to those with lifestyle questions in the coming weeks. For information, write The Fenway Community Health Center, 16 Haviland St., Boston, Mass. 02115 or call 267-7573.

"Tickets at $25-$35 for the June 15 performance of the Broadway-bound musical 'La Cage Aux Folles,' at the Colonial Theater, will benefit the work of the AIDS Action Committee and the Fenway Community Health Center, if purchased through the health center."

—Boston Globe, June 8, 1983[91]

Through the early 1980s, Fenway's education programs were focused on STD awareness and prevention for gay men, and on self-help diagnostics and wellness education for women. To a degree, these programs reflected disappointment in the ability of Boston's traditional medical system to provide the care Fenway's populations needed. Fenway's gay and bisexual men didn't believe they could trust "regular" doctors to keep their sexual practices and identity confidential, let alone anonymous. Its women believed that male doctors were so unaware of their basic health needs that they had more confidence in each other, armed with copies of *Our Bodies, Ourselves* and some basic training in how to use a speculum, to deliver the quality of care they wanted. When it began, Fenway's Alternative Insemination Program was promoted carefully, through word of mouth, rather than with brochures or advertising, for fear of being discovered by administrators at a large hospital or the Massachusetts Department of Public Health.

In 1983, the health center began a citywide health education and patient services program, and spun it off in 1986 as a separate organization—AIDS Action Committee. Fenway's women's health education programs included Alternative Insemination, no longer a secret, along with programs for women with HIV, and breast cancer awareness and prevention services for lesbians. More notable is the fact that, by 1996, Fenway's most innovative education programs were delivering information and skill development to doctors, nurses, and other medical providers—not only to people at risk for AIDS or the public at large. This shift was a conscious choice by Fenway's leaders, and was based on the health center's growing research programs and early efforts to reach out to other health providers. Fenway's unique ability to conduct research among people in the community was noted and appreciated by providers in Boston's hospitals, and also by medical professionals throughout the United States, since the mid-1980s. But it wasn't easy. Fenway's early education and advocacy efforts were designed to push back against discrimination against (and outright fear of) people with AIDS, throughout Boston's medical care system. With Fenway's growing credibility, these initial efforts at combating fear and prejudice were gradually replaced with consultations and ongoing conversations with these same professionals about how to treat people with AIDS. Fenway's research programs didn't take long to be recognized as the basis for sound education about HIV. AIDS Action took the results of this research to the public, while Fenway itself became increasingly concerned with educating medical professionals. The Metropolitan Area HIV Services Project (MAHS), which Fenway led from 1987 through 1990, created a network of five health care organizations to help people with AIDS. In addition to administering the program, Fenway Health was given the responsibility of educating health professionals from the other four organizations in best care practices and in how to relate to their patients.

During these 16 years, Fenway's early desire to provide an alternative to Boston's existing medical care system grew into an approach aimed at changing that system—making it more effective and responsive in its dealings with gays and lesbians, and, eventually, bisexual and transgender people. The decision to create the AIDS Action Committee and allow it to become an independent organization was only half of the story of how Fenway's commitment to medical care over community education was expressed. Had Fenway simply let AIDS Action carry on with its education

and advocacy work in the community, while the health center's doctors, nurses, and researchers cared for people within its walls, the story would make sense, and the degree to which this care and research became recognized for excellence would be a success in itself. But the way in which Fenway managed its education programs as it grew tells us more about the vision its leaders have always had for its future and the vision they shared for their community. Fenway recognized its unique opportunity to educate health providers and filled this important need. Had Sally Deane not insisted on developing high standards of care and research in the early 1980s, Fenway might not have earned the credibility that served as the foundation for future leadership among medical professionals. This credibility also led the Cambridge Women's Health Collective to select Fenway as the place where its medical records and patients could go when it closed in 1981. On her arrival in 1986, Dale Orlando met with medical leaders from large hospital systems concerned about the safety of their staff, and arranged free anonymous HIV testing that put providers from throughout Massachusetts in the hands of competent HIV Testing Counselors at Fenway—breaking down very old barriers and establishing enduring new ties. Michael Savage took Fenway's established leadership to create statewide coalitions of health care and other organizations to effectively lobby for the government support needed to continue the fight against AIDS in the early 1990s. And, as we will see in the next chapter, Stephen Boswell would further develop the organization as the "academic community health center" he calls it today—one that not only leads in the provision of care to the LGBT community, but one whose pioneering research programs contribute to the provision of better care to these same people at other health care facilities throughout the world.

Looking back from the present day, it's important to remember that these achievements were still only potential successes at a time when as many as 20 of Fenway's patients were dying from AIDS every month. Organizational focus and strategic planning are important in their own right, but it took a long time for their results to begin saving lives. Still, three stories about Fenway's education programs in the 1980s and early 1990s can be appreciated for the insights they give us into the choices Fenway has faced—and made—in its forty years. They are: 1) a look at Fenway's education programs as they were organized in 1989; 2) the development of Fenway's Lesbian Health Series in 1992; and 3) a philosophical

debate about whether expansion of quality health care for the LGBT community outside of Fenway might make the organization "obsolete."

A look at Fenway Health's organizational chart in 1989, which is included on page 183 in the *Leadership* chapter, shows six main departments—Medical, Research, Mental Health, Administration, Development/Public Relations, and Community Services. This last department is where Fenway's education programs lived at the time, and included its Alternative Insemination Program, Women AIDS Information Project, Training Programs (for Boston medical professionals), and HIV Counseling and Testing. Thinking about the education programs at Fenway after AIDS Action Committee became independent shows the other half of the story of the health center's core focus on medical care. Alternative Insemination was a medical program that wasn't recognized as such anywhere else. Insurance companies might argue narrowly that healthy women choosing to have children without men do not have a need for medical care, and sperm banks might refuse to sell to single women, but these positions didn't keep women from coming to Fenway and asking for these services. And if lesbian and single women wanted to have children, they still needed the help of medical and mental health professionals to make decisions that were personally wise and medically sound.

It may have taken ten years for the program to evolve to the point at which in-office inseminations began in 1993, but the fact remains that Fenway launched and kept its Alternative Insemination Program because it responded to a real need among its community, and because, in order to respond effectively, medical services had to be included. Women's AIDS information stayed at Fenway because, in its early days, AIDS Action was focused more directly on gay men—those living with HIV or AIDS, or those who needed education on how to avoid becoming infected. Women would become a priority as the organization grew, but Fenway believed it was better positioned to provide targeted HIV education and information services to women than anyone else in Boston. It must also be noted here that at least part of the reason for these services remaining at Fenway was the organization's ongoing interest in bringing more women into the health center, to increase the number of women receiving care. From its beginning in the 1970s, Fenway was gender-integrated, but that didn't mean the rest of Boston's LGBT community was, so special efforts to be inclusive persisted.

Establishing its HIV Counseling and Testing Center at 16 Haviland Street is an example of how Fenway's commitment to medical care was expressed in a positive manner, as opposed to simply allowing other organizations to move forward with programs that no longer fit Fenway's strategic focus on medical care. The AIDS Action Committee engaged in a number of highly-visible, even "edgy" communications programs aimed at changing gay men's sexual behavior to reduce the risk of HIV infection. This 1990 flyer is an example of their educational approach.

92

Fenway's leaders supported programs like this, and in fact Fenway had itself been engaged in similarly "edgy" education programs in the past. Ron Vachon's 1979 column in Gay Community News, "Anal Pleasure and Health," may be the best example. But the decision to focus on medical care, and the need to maintain standards of practice that helped create Fenway's reputation as a leader in clinical AIDS treatment and research, left less room for some of the programs described in AIDS Action Committee's "Safe Company" campaign, even though it worked well in raising awareness of how to reduce one's risk of becoming infected. Fenway's

HIV Counseling and Testing Center was created at a time when a positive test result for HIV brought enormous fear and anxiety. Because of this, Fenway felt strongly that it had to develop a testing program that bridged both education and care. Testing had to be accurate, it had to be anonymous, and it had to be backed up by professionals who could deal with the consequences of telling someone he or she had HIV. The results of Fenway's program design speak for themselves—by 1991, its HIV Counseling and Testing Center became the largest program of its kind, performing 40% of all anonymous HIV tests in Massachusetts. Fenway's HIV Counseling and Testing Center drew great attention from the press, and this coverage reached well beyond the gay community to the "worried well." It is important to remember that these individuals were not just gay men worried that they might catch AIDS; they also included many of Boston's health providers who were in constant contact with blood and therefore concerned about their risk of becoming infected. The level of care, the time taken to interact with patients on an individual basis, and the quality of information that resulted from Fenway's cross-departmental experience with HIV impressed these professionals. The resulting confidence in Fenway's services from Boston's medical community became an important element in Fenway's success, even if it was an unexpected consequence of the health center's care in protecting the identity of its patients with secrets. Coming full circle, the HIV Counseling and Testing Program also gave great "cover" for gays and lesbians working in health care and other places who did not admit using Fenway for primary care, but who might be there for an HIV test.

Fenway's Lesbian Health Series was launched in 1993 as an early and direct response to findings from its growing Research Department. A year earlier, Fenway's Board of Directors formed the Lesbian Research Subcommittee to develop a foundation for future programs aimed at Boston's lesbian community, evidence that, by 1992, the idea that Fenway's Research Department could provide the leadership for program development was established. A possible correlation between breastfeeding and the likelihood of developing breast cancer had been proposed as early as 1926, in London, England. "The breast which has never been called upon for normal function is certainly more liable to become cancerous."[93] By the 1980s, a number of studies were reporting similar findings. Fenway's Lesbian Research Subcommittee applied the health center's long-held

strategy of being the best source of information on LGBT health. First, there are research findings that are likely to explain the origins of breast cancer. Second, if these findings are true, we can apply a combination of imagination and deductive reasoning to conclude that, if women who don't breastfeed are more likely to get breast cancer, lesbians are among them. And third, if all this is true and lesbians are indeed at a higher risk for breast cancer, what are we waiting for? With the same speed Fenway demonstrated in looking for the cause of AIDS in the early 1980s, and its experimentation with aerosolized pentamidine and Peptide T later that decade, the health center launched its Lesbian Health Series in 1993. Programs included breast cancer education and screening programs, while Fenway's Research Department launched studies of the incidence of breast cancer among lesbians. The timing of these developments coincided with the largest march on Washington ever assembled by the LGBT community that year, and the international declaration of 1993 as "The Year of the Lesbian."[94]

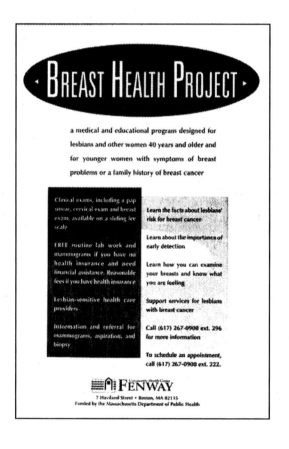

In the early 1990s, Fenway hired Denise Bentley as Associate Director of Health Promotions. Like a few other staff at the time, she came from the Massachusetts Department of Public Health, and saw Fenway's model of community health care and education as an attractive alternative to the large state agency where she worked. Her job was to develop programs to engage women, particularly women of color, at Fenway. Her first impression was that the organization had a lot of programs, but not much for women. "You could go to the doctor, or a chiropractor, or get acupuncture. These programs were for everyone. You could participate in Living Well and other programs that were for men. But what was there just for women?" She began to propose new programs, including what she called "roots and stems," or herbal remedies, that might complement Fenway's holistic medicine programs. She proposed a second program, "Essence of a Woman," that would open doors to women of color who wanted to come in and talk about sex. "The whole thing: who, what, when, and why. People talked about carving, choking, S&M, all sorts of things. I brought in people who were experts on these subjects, and others, like where to buy toys." The program eventually became SASSIE (Sisters acquiring Safer Sex Information and Education), and ultimately focused less on information about sex in general and more on how to have sex and stay healthy. Denise Bentley remembers running into problems trying to get condoms to distribute for her program. She believed that sometimes lesbians might have sex with a man, and that, if they did, they ought to have condoms to protect themselves. But the CDC defined lesbians more strictly. If a woman had sex with a man, then she wasn't a lesbian, and using condoms to protect against HIV wasn't acceptable for programs aimed at lesbians.

Denise Bentley was also frustrated within Fenway when it came to her role in education and reaching out to women—a goal she shared with others in the organization. Whether it was her herbal remedies program or SASSIE, the health center's chiropractors opposed her, even though everyone shared the same goals. The difference was that the chiropractors wanted her to bring people in to see them. After all, they were already here. Why start new programs? The philosophical difference between a medically based health center and an organization centered on community health education and promotion couldn't be clearer. From Denise Bentley's perspective, she was being asked to increase patient visits

for existing medical services—to add demand to the health center's already-established supply. Her idea was to bring people into the center by finding out what they wanted to learn about their health—through surveys, offsite workshops, and informal drop-in programs—and build supply around demands you find are there. "Medical care is measurable. You have an infection, you get a shot; you're cured. Behavioral change isn't as measurable as direct medical treatment. Health promotion changes behavior but you have to wait a while." Denise Bentley's original office was at Fenway's rented 100 Massachusetts Avenue space. "It was better than the new space we moved into. At the old offices, people knocked on the door, and came in. Everyone was there. 7 Haviland Street is a doctor's office. People dropped by 100 Massachusetts Avenue; they didn't drop by 7 Haviland Street."

She has similar feelings about Fenway's new headquarters at 1340 Boylston Street. "They have great staff, a big, beautiful building, and the best doctors. Adding Judy Bradford to co-direct The Fenway Institute is great. And they have a women's floor. But it's not just about the women's floor; it's about getting people there." As far as reaching out to women, Denise Bentley also has strong opinions. "Women are nurturing, sure. But you can be nurturing with an MD after your name. The biggest sign of Fenway's commitment to women was the addition of more than one woman doctor. That was important. Some women don't want male doctors, or even a male nurse. I don't care how woman- or lesbian-friendly you are. I'm not putting my legs in stirrups for any man."

Still, Denise Bentley beams when talking about the Audre Lorde Cancer Awareness Brunch, her "baby," an annual event she founded in memory of her partner, who died from breast cancer. The two of them toured the country, looking for medical care programs for women, and found none for gay women with cancer. When they returned, she worked with Liz Coolidge to start two groups: one for women with cancer, and a second for the partners of women with cancer. Denise Bentley's conditions were that the groups had to be free. "Cancer is expensive enough as it is." The brunch, held for years at Simmons College, attracted support from multiple agencies, all donated. There was food, spirituality ("respect for women who had moved on"), an uplifting speaker, and music and dance. "There always has to be music and dance." Beginning in 2009, the Audre Lorde Cancer Awareness Brunch moved to Fenway's new facility, where it is still held every October. And it is still free.

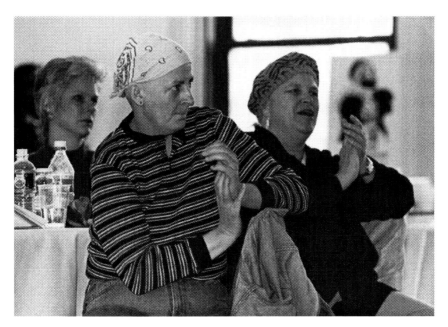

Women attend the Audre Lorde Cancer Awareness Brunch (*Northeastern University Archives*)

We have already discussed how Fenway's medical training programs represent the organization taking advantage of its experience in responding to people with HIV, and sharing this knowledge with other medical providers—first in Boston, and then on a larger national and international scale. Fenway's decisions in the 1980s and 1990s to shift away from education programs that were more community-based than based in medical practice, and to develop new education programs that had this medical foundation, can be seen as early expressions of its current strategic thinking. Fenway was always engaged in the provision of medical and health education services to populations no one else was serving. As new needs for services grew—the AIDS epidemic, or alternative insemination for lesbians— Fenway was there to provide them. As new organizations developed to provide non-medical services to Fenway's core populations—AIDS Action Committee for gay men with HIV and at risk for infection, or the Sidney Borum, Jr. Center for gay

and lesbian adolescents and young adults—Fenway helped these organizations grow to realize their missions. And, as Fenway became more knowledgeable about particular aspects of medical care—treatment options for people with AIDS, or gay and lesbian individuals with substance abuse issues—it freely shared that knowledge with other medical providers to expand the options for care among the LGBT community Fenway serves.

But what if this sharing of information and experience succeeds so well that the LGBT community no longer needs Fenway as a primary source of care? What if other community health centers, or hospitals become so skilled at caring for Fenway's target population that this competition endangers Fenway's future survival? In the larger scheme of things, would such an outcome be a bad thing? Some argue that all nonprofits ought to have a goal of putting themselves out of business. Nancy Lubin, of *Fast Company*, writes, "Charities should wear termination notices as 'badges of honor.'" She cites the September 11th Fund as a charity "that did it right; it raised $534 million for families and businesses affected by 9/11, distributed that money, and shut its doors by 2004."[95] The National Foundation for Infantile Paralysis (also known as the March of Dimes) was founded by President Franklin Roosevelt in 1938 to find a cure for polio. After Dr. Jonas Salk developed a successful vaccine in 1952, followed by an oral vaccine developed by Dr. Albert Sabin in 1962, this mission was largely fulfilled. By 2001, there were only 480 cases of polio worldwide, down from a peak of 50,000 new cases per year before the vaccines were developed. Today, the March of Dimes is committed to "cutting edge research and innovative programs to save babies from birth defects, premature birth and low birth weight."[96]

Daniel Henderson, a social worker at the Anna Bissonnette House at Hearth, Inc., a Boston agency serving homeless elderly people, works with several LGBT individuals. He believes the challenge of helping older LGBT people is just beginning. "Current medical and social agencies for older Americans are designed to meet the needs of heterosexual individuals and their families. Many older LGBT Americans are uncomfortable disclosing their sexual orientation in predominately-heterosexual communities. In some parts of the country, older LGBT Americans still experience discrimination and insensitivity from the medical and human service staff who work in elder care facilities. LGBT couples do not share the financial or legal benefits that are offered to heterosexual couples, even as their needs for these benefits increase

with age. These barriers can separate couples, interrupt their living arrangements, or exclude them from making important medical decisions for each other. The consequences of discrimination and insensitivity toward older LGBT people can make a treatable medical condition debilitating, turn manageable financial difficulties into total crises, cause the loss of friends of family at a time when their support is most needed, and lead to solitude, or even homelessness. One other 'first' for the current generation of older LGBT people involves alcohol and substance abuse. This entire generation, including straight people, is well-acquainted with drug use, including both prescription and recreational drugs. Studies also show that LGBT people have a higher incidence of alcohol and substance abuse, including tobacco smoking. Addressing alcohol and substance abuse issues among the elderly may prove to be an enormous challenge, particularly in providing culturally competent care for the LGBT people among them."

Fenway's focus on medical care for the LGBT community has helped ensure that it would not fall victim to internal struggles resulting from trying to do too much at once. Had Fenway followed Ron Vachon's lead in 1980 and become a more overtly gay organization, or had Fenway kept AIDS Action Committee within its corporate structure a few years later, it might have become less of a health center than a community organization trying to provide health care as one of its many programs. As such, it might not have been able to focus its energies so squarely on the medical research and care programs that enabled it to become the leader in these fields it is today. However, the two organizations just cited—the September 11 Fund, and the March of Dimes—had a similarly tight focus, and each of them faced the need to disband or refocus after achieving success. How will Fenway deal with a world in which the LGBT community can go anywhere for quality, culturally-competent care?

There may be two answers for this question. First, by establishing a strong research component that continually searches for a better understanding of the health care needs of LGBT people, Fenway has established a leadership position that will remain even if it becomes one of many options for LGBT health care. The Fenway Institute, the "home" of Fenway's research programs since 2000, is designed to work with other health care institutions by participating in joint research programs and educating their medical staff on how to treat LGBT

patients. It also provides information that health educators can use in reaching out to the public with disease prevention and wellness programs, and in convincing government agencies of the need to develop policies or allocate resources in order to create a world in which LGBT people can receive the health care services they need. These justifications for Fenway's continued existence will not go away even if every hospital and community health center everywhere becomes as competent in serving LGBT people as Fenway does.

The second reason may be a bit more...primal. Fenway doesn't exist to "solve" the cause of LGBT access to quality health care. It exists, as Dale Orlando put it in 1986, "to be the leading LGBT health care organization in New England." This competitive streak, not a bad characteristic for an organization like Fenway to have, will always remain viable, as long as Fenway is successful in achieving it. No matter how good any or all the other health care institutions in New England get at providing quality care to LGBT people, if Fenway stays true to this part of its mission, it will always be here.

Fenway has been lucky enough to benefit from inspired leadership and tremendous support from the community, and I think both of these have contributed enormously to our growth and success over the years. Fenway's leadership was often called upon to make difficult decisions at critical junctures when a focus on the long view and not just the immediate challenges at hand was required. We would never have been able to expand our services to better serve the community if that same community hadn't supported us through the ups and downs of our early years, the heartbreak and devastation of the HIV/AIDS epidemic, and our need to grow as an organization. Their unwavering support helped us to build first our 7 Haviland Street home and then the Ansin Building at 1340 Boylston Street.

Fenway's real strength, though—what truly sets us apart and drives us to continue to lead the charge for LGBT health equity and access to quality, culturally appropriate healthcare for everyone—is our staff. Throughout our history, Fenway has attracted the sort of people who are not only great at their jobs, but able to connect with patients, clients, and research study participants in a profound way; one that continues to allow us to learn

how best to care for our community and to build programs and conduct research that helps other organizations across the country and around the world to do the same.

The nurse willing to make a phone call to make sure a patient is responding well to new medication; the research associate who thinks to ask one more question that offers real insight into someone's risky behavior and how to change it; that outreach worker who goes the extra mile in making sure a homeless young person gets connected to services that might literally save his life—these are the things that set Fenway apart from other organizations. The knowledge, competence and dedication of our staff at all levels of the organization are what I think make us special and will bring us continued growth and success no matter what challenges we face down the road.

—Chris Viveiros, Associate Director of Communications, Fenway Health

1980–1996 ADVOCACY

"FCHC has a strong commitment to advocacy on behalf of the lesbian and gay community's health care needs. We've had a significant impact on increasing AIDS and breast cancer funding in Massachusetts. Now we are expanding that commitment to the national level.

"The National Alliance of Lesbian and Gay Health Clinics was initiated by FCHC in June of 1992 and now has members in Boston, Hartford, New York, Baltimore, Washington, D.C., Chicago, Dallas, Houston, San Francisco, Los Angeles, and San Juan.

"As an alliance, we will elevate the health care needs of our community to a national level. Stay tuned."

—Michael Savage, Fenway Health Executive Director, Winter, 1993 *Frontlines*[97]

Advocacy for the gay and lesbian people Fenway served in the 1980s began with small, maybe even heart-breaking objectives. "We had to convince hospital administrators and doctors at some of Boston's leading institutions that they didn't have to isolate people with AIDS from other patients, or from the care providers they so desperately needed," remembers Lenny Alberts, one of Fenway's MDs at the time. The fear was understandable; even five years later, Fenway's providers were sometimes afraid they would get sick and die. But avoiding contact with people who came to a hospital or community health center for care was unacceptable in a city with several of the best teaching hospitals in the world. Stephen Boswell remembers a line from Albert Camus's *The Plague* that describes the situation most clearly for him. "I remember reading that in a plague, there are two kinds of people: those that run from it, and those that run to it." Dr. Boswell and many others are proud that Fenway took it upon itself to run to the AIDS epidemic, and to encourage others to follow. Another line from Camus might sum up the early days of AIDS, when little was known and nothing could be done. "You're right, Rambert, quite right, and for nothing in the world would I try to dissuade you from what you're going to do; it seems to be absolutely right and

proper. However, there's one thing I must tell you: there's no question of heroism in all this. It's a matter of common decency. That's an idea which may make some people smile, but the only means of fighting a plague is—common decency."[98]

Advocating for common decency in Boston's medical community was one of Fenway's earliest responses to AIDS, before the disease even had a name.

During its first decade, Fenway's provision of medical care to its lesbian and gay patients *was* advocacy, just as Ken Mayer remembers a similar slogan from the 1980s: "One of the activist slogans today is 'Research equals treatment.'" Fenway's time from collective to crisis was short. Everything—care, research, education, and advocacy—was happening at once. The need for action was immediate, as the lack of information was overwhelming. But the health center's early leadership in caring for people with AIDS came with the responsibility of advocating for their needs in other parts of society. Staying true to its commitment to providing care to its community while tending to so many sick individuals was all it could do. Candace Pert, co-discoverer of Peptide T at the National Institute of Mental Health which sponsored Fenway's clinical trials of the drug in the late 1980s wrote, "I do not buy into the idea that the best medicine goes on in hospitals. Things are happening too fast for some of the big institutions to keep up. For too long, medicine has divided people into body and mind. I believe medicine involves the whole human being. Emotional support is important for getting well and for getting good results in a clinical trial. I'm proud Peptide T is being tested in a place run with heart." [99]

Having a heart and fighting a plague with common decency would be all there was until government health agencies began to fund research, and then care, for people with HIV. Fenway's credibility allowed it to compete for these funds, and win its share of early grants. The professionalization of its care and research programs in the early 1980s would pay dividends, as would the leadership skills taught to its staff, and the trust Fenway had earned with its patients. They would come to Fenway for care, and would willingly enroll as subjects in its growing research studies on HIV, how it spread, and how it might be treated. Government-funded research studies would begin at Fenway in 1984, and would expand every

year after. The first grants to support medical care for people with HIV would not be available until 1987 (Metropolitan Area HIV Services Project), and 1988 (AmFAR).

Beginning in 1986, Fenway's advocacy services would be targeted at insurance companies and the Massachusetts Medicaid program, where Dale Orlando and her staff would argue successfully for reimbursement rates for its treatment programs for people with HIV. "We would get Medicaid to pay for a service, and then go to Blue Cross/Blue Shield, or John Hancock, which held the state employee benefit contract, and let them know that they probably didn't want to be in a position where people on Medicaid were getting better treatment than people with health insurance through their employers. It was a never-ending battle, but it worked," she remembers. Understanding the degree to which so many of Fenway's organizational developments were interconnected is important: Fenway wouldn't be eligible for third-party reimbursements from Medicaid or private medical insurance programs had it not undergone its professionalization a few years earlier. Fenway's Research Department served as the basis for its education programs aimed at Boston's medical providers due to these same efforts. People with AIDS would come to Fenway because they were referred by friends in the gay community, or by other "worried well" health providers being tested for HIV in the Testing and Counseling Center, or from listening to Ken Mayer's research lectures. They would stay because the Medical Department had earned their trust, and then because its research programs promised the best treatment options then available. Money would eventually flow to Fenway in the form of grants and third-party payments because of its professional care, innovative research, and connection to its patients. In a sense, this mirrors Fenway's origins in the early 1970s, when it was the only one of Boston's 24 neighborhood health centers to get its start from "volunteers" instead of an initial seed grant from a hospital or government agency. A decade and more later, Fenway would earn its place as a leader in advocating for the needs of its community because of the human energy contributed by its staff and the willing participation of its patients in trials that might contribute toward effective prevention and treatment of AIDS.

Fenway's ability to advocate for its community grew, doctor by doctor, and hospital by hospital, particularly among infectious disease specialists. This was a lengthy process because initially AIDS patients became ill rapidly, sometimes died

suddenly and without warning, and there were very few of them when compared to Boston's extensive medical resources. Initially, the complaints from Fenway, like the complaints from other independent health centers about patients with many other afflictions, were based on the phenomenon that sending a patient to the hospital was like losing them into a black hole. This was because the infectious disease specialists would keep those who survived each hospitalization in their own practice, for as long as they could, so they could study them. Eventually, as the numbers of people with AIDS grew and the treatments began to have efficacy outside of the hospitals, the tables would turn. By that time it was well known throughout Boston's medical community that the health center had experience dealing with people who had HIV, and could be trusted to monitor these patients for the specialists as soon as they were healthy enough to return home and receive care on an outpatient basis at Fenway. In this stage of the epidemic, Fenway didn't have the problem of seeing patients disappear into a nearby hospital's black hole; it had precisely the opposite one. Nearby hospitals would send their AIDS patients to Fenway as soon as they left the hospital, so that they could continue to receive care through the health center's respected outpatient services.

Mild side effects of treatments would show up when these patients came to Fenway, and doctors wanted to know about them as well as how well patients were adhering to their medication schedules, a fact which was not always accurately reported by patients. Fenway's staff knew how to deal with its patients' intense need for information about treatment options, or the emotional issues surrounding their declining health; doctors from Boston's large hospitals wanted to know about these as well. For a time, Fenway was the only community health center in the United States engaged in HIV research, and this also got the attention of Boston's major teaching hospitals. Individual consultations between Fenway providers and the medical staff of these hospitals grew organically. More formally, Dale Orlando had arranged anonymous HIV Counseling and Testing for medical staff at many of the large teaching hospitals in Boston at Fenway. The MAHS Project formalized Fenway's relationship with Dimock Community Health Center, the American Red Cross Blood Bank, the AIDS Action Committee, and the Visiting Nurses Association; with the city of Boston's Department of Health and Hospitals providing fiscal conduit services in 1987.

Dale Orlando needed a grant manager for the MAHS Project, and didn't have to look far. Henia Handler, then a graduate student at Brandeis University, had been assigned as a staff person for the newly-formed Statewide Advisory Group to the Governor on Primary Care for People with AIDS, a program of the Massachusetts Department of Public Health's AIDS Office funded as a pilot project by the Robert Woods Johnson Foundation. Her job was to explore alternatives to hospitalization, and community health centers were a logical choice. She knew there was no community health center that was working more extensively with this population than Fenway, and chose it as the first health center for her study. While she was there, Fenway and its team of health organizations won the MAHS grant, which Fenway would administer. Dale Orlando hired Henia Handler for the job of project manager, and the rest, as they say, is history.

"I remember our team looking for answers in every way, trying to change the course of illness. People were dying, and there were no answers. All we could do was provide support. Life expectancy was so short. It was extraordinary. But it was equally extraordinary to learn from the first federal grants coming to Massachusetts to support HIV care that there was this new source of funding, the Department of Health and Human Services (DHHS), that had an incredibly broad mission related to public health. In my experience before this grant, there were private foundations that funded medical research programs—the R. W. Johnson Foundation, Rockefeller, Ford, even the Hyams Foundation in Boston. You always got the feeling that you were chosen by them, that you were selected as a small organization, or one of several small organizations, to do good work. But working with the DHHS and going to Washington to represent Fenway introduced me to so many people with a vision that was so congruent with our model of community health. There was a convergence of HIV care and so many other factors that set me on the trail of advocacy and politics. From the whole experience, I was engaged, quickly and emotionally, with patients, with government agencies, with the gay community, and with an ever-expanding network of other groups. Soon we would work with the Portuguese community, then Haitians, Latinos, African-Americans, and so many others. Even before we moved into the new building at 7 Haviland Street, we were running conferences for women with HIV. I have trouble

putting into words the spirit, sense of direction, and focus we had," remembers Henia Handler.

"When we ventured outside of Fenway to Washington, our job was to strip away the shame and communicate our focus on the disease. At the beginning, we had to address the fear people had of infection when it spread through the most intimate way people relate—through sex. No one talked directly about it. They talked around it. They talked about how people got AIDS from IV drug use, or through blood transfusions, or because they were Haitian, or because they were women having sex with infected men. We were the ones who had to bring up the subject of gay men and sex, to legitimize this part of the disease as a public health issue. We had to be bold. There were periods when some of us realized we were subject to what the press called 'the disease of the year,' and that there was a glitz, or gay chic, that came along with it. But we could use that to gain legitimacy, because from that glitz there was a natural progression to learn more about the gay community. People in congressional offices would begin talking about gay people in their families. 'My cousin's gay,' for example.

"Another moment in our advocacy work was the realization that we could use data by Congressional District to make our point. We could tell staff people how many people in their district had AIDS, how many had died, and their gender and age. We made AIDS real, and taught them that it was not just in Boston but was in Worcester, Springfield, Brockton, and other places. And while AIDS was always the issue when we talked about Fenway, we had other tipping points to expand the conversation to the whole context of LGBT health. We used data—Fenway's data— to show that people were coming to our health center from everywhere in the Commonwealth because we were fulfilling our mission to care for our community, and that our community lived where they did."

At that time, gay and lesbian leaders from across the nation were participating in national conferences on gay and lesbian health care and particularly on HIV/AIDS sponsored by the National Lesbian and Gay Health Foundation. Dale Orlando was invited to join the board of that organization and encouraged members of the Senior Management team at Fenway to prepare papers for presentations for each of the conferences held in Los Angeles, San Francisco,

New Orleans, New York and Washington over several years. Participation in these conferences gave a much higher leadership profile for Fenway staff on the epidemic than could be achieved by the Research Department alone with Ken Mayer speaking largely to medical colleagues and less frequently to broader consumer groups. Orlando had arranged national media coverage of Fenway's research and health care on WGBH's highly successful, *The AIDS Quarterly with Peter Jennings*, so LGBT people from across the country became familiar with Fenway. The conferences gave national recognition of leadership within the LGBT community to Fenway's unique and innovative programs in AI, Holistic therapies, research on pentamidine and Peptide-T and the collaborations built with other health centers throughout Boston and the Commonwealth with the MAHS and DAHCS programs. While not unique in having relationships with organizations outside of the LGBT community, Fenway was a shining example of building bridges to the larger community. Used also to reward staff for hard work, these conferences along with the forums and conferences sponsored by Fenway set the stage for Fenway's national leadership in the fight against AIDS and to promote health awareness for the LGBT community. One additional benefit for Fenway Health was that the talent pool for human resources at the health center expanded dramatically as the organization's profile was raised and every job opening brought a flood of applications from across the nation. Fenway was growing in size and in reach, now it began to grow in depth of experience and sphere of influence.

With the MAHS grant funded for 3 years as an AIDS Service Demonstration Grant under the 1988 Health Omnibus Programs Extension (HOPE) Act, followed soon by the DAHCS grant and then research awards from NIMH and NIH, Fenway's work attracted the attention of Massachusetts's Senior US Senator, Edward Kennedy. Well-attended press conferences were called for him to announce each federal award for HIV/AIDS care, and for his nephew Joseph Kennedy, Jr. to be shown bringing that award back to his district, which included Fenway. Moved by the need for health care among people with AIDS, both men worked for the passage of a more comprehensive program of health care, research, and education to combat the disease with assistance from Fenway staff over the next several years. On a national level, the plight of people with AIDS was

Dale Orlando, Executive Director Fenway Health, at a Press Conference with Senator Edward Kennedy, Lt Governor Evelyn Murphy, and Representative Joe Kennedy to announce the AIDS Service Demonstration Grant, September 14, 1987. Fenway was 1 of 21 national demonstration sites. (*Ellen Shub*)

represented by a boy in Indiana who had hemophilia, and contracted the disease from a blood transfusion in 1985 when he was 13 years old. His hometown forced him out of school, requiring him to take classes over the phone because they feared he would spread AIDS to his classmates. Even when his family won his right to go back to school in the courts, many parents kept their children home rather than attend school with him. Ryan White died in April of 1990.[100] Senator Kennedy and Senator Orrin Hatch (Republican, Utah) co-sponsored the CARE (Comprehensive AIDS Resources Emergency) bill, which became law in August of that same year after four years of effort to build public support for it. The Ryan White CARE Act was a sweeping piece of legislation that addressed the need for education, early intervention, and medical care among people with HIV and AIDS. Multiple titles within the law addressed the needs for services in urban areas with a high incidence of the disease in a way modeled after the federal

government's disaster relief, along with funding for demonstration grants to support innovative research and care programs. The Ryan White CARE Act also funded efforts to prevent mother-to-child transmission of HIV, and programs to address the needs of people in prison at risk for contracting HIV. The Act also made the federal government the "payer of last resort," ensuring that people without resources who had exhausted all other options for payment of their medical bills could receive care for HIV-related medical conditions.[101] The Ryan White CARE Act requires periodic Congressional reauthorization, and was last renewed in 2009, in honor of Senator Kennedy, who had died a month before, authorizing $2.1 billion in spending for the next four years. Fenway staff worked closely with Senator Kennedy's office on mounting public support for the bill nationally, reviewing the initial drafting of the bill in 1990, and on every renewal since. Through this collaboration, Senator Kennedy became a strong and much-appreciated supporter of the health center, and made frequent visits to its 16 Haviland and 7 Haviland headquarters. Fenway honored Kennedy with the Congressman Gerry E. Studds Award in 2008 in recognition of that support.

Fenway's participation in the successful enactment of federal legislation supporting medical services for people with HIV in 1990 was followed two years later by its success in leading a coalition of Massachusetts health centers and community agencies to secure additional funding for AIDS-related services. Project ABLE (AIDS Budget Legislative Efforts) was founded by Fenway Executive Director Michael Savage, ultimately including over 150 allied organizations in the effort to increase the state's budget for these services by $6.6 million to $25.2 million, a 35% increase. Project ABLE's co-chair, Leslie Tarr Laurie, director of the Family Planning Council of Western Massachusetts, remarked that "The epidemic's rapid spread throughout the Commonwealth has left AIDS service providers struggling with a demand they cannot possibly meet. The new funding will help us combat the spread of AIDS and provide dignified care to those who are sick."[102] Organizations in Project ABLE included traditional AIDS service agencies, community health centers, family planning clinics, home care agencies, substance abuse programs,

and broad social service agencies. Building on the groundwork of health program development built by coalitions of health care organizations in Boston in the 1980s, and with the support of national gay and lesbian organizations, Fenway led Massachusetts' Project ABLE, and participated in the National Alliance of Lesbian and Gay Health Clinics. Over time Fenway moved its advocacy for gay health services from word of mouth among local doctors and nurses concerned about AIDS to formal national coalitions with allied organizations, government agencies, and political leaders.

Henia Handler has seen the ebb and flow of Fenway's history and mission over the years. It started as a community clinic serving gay men, women, and the elderly. Then the predominance of HIV created an environment in which the center became mostly men—as much as 80% men, she remembers. Later, the health center could broaden out to serve women and the elderly with the resources it had earned through the excellent job it did in caring for people with HIV. Fenway was made larger by its response to HIV, and this larger Fenway was eventually able to provide services that were not only HIV-related, but were important to many LGBT people. She also remembers that the staff was always over 50% women, and these women were predominantly lesbian. They totally stepped up to the challenge of helping their gay brothers, as conversations about lesbian health continued, even in the few quiet moments anyone had to talk about anything else. "AIDS dominated, but didn't negate or erode women's role as part of the practice, both as providers and patients." She remembers the larger dynamic clearly. "From 1981 until 1996—over fifteen years—we struggled with a disease that was not curable. Yet we are an organization whose primary mission is the sustaining of life. I'm not sure I have the words to describe how difficult that struggle was, or how hard it was to work toward our mission in the face of a disease that was so relentless. But it didn't eliminate the desire of the women and lesbians on Fenway's staff to reach out to other women.

"The introduction of antiretroviral drugs changed things gradually. People didn't die after eighteen months. Some lived for two years, some five. Many did not survive, because the early medications were so toxic. It was tough. Each success was a marker, no matter how small. Each was a benchmark—a hope that there would be something better. And there was. 1996 was better than 1995. 1997

was better still. By 1998 and 1999, we had the emotional energy to talk with each other about the health center growing in general. Women were coming in for care, and we wanted more women doctors. After all, if 80% of our patients were men, how would women feel when they came to us for care? We always had an eye for bringing in women. There were grants from the Boston Foundation for women coming into our substance abuse program. There were small grants to reach out to people of color. It wasn't as simple as it sounds, but we understood that the epidemic was a little more under control. Our focus gradually shifted from being about dying and dealing with death, to a focus on working with medications to keep people willing and able to keep going, to stay alive, to get healthy."

..

Being a health center and that clarity about what we are and what we are not is part of our being successful. It's really been an important to sort out that we are primarily a health center and not an LGBT community center. I think Steve is a brilliant business-man and combined with being a medical provider that makes him uniquely able to see the future and get us there. It's not just Steve. We've been so lucky in the staff we've been able to attract here.

This is a place that the administration has never felt stuck or bogged down like in big hospitals or the VA system. It's always been a place that we can do what we want if we have good program ideas and can figure out how to get the support for them and figure out how to do them. If they are successful, they grow. So that has been what seems unique to me. We don't have a lot of "no, we can't do it"—new and exciting things are always encouraged so it's not stagnant.

—Phyllis Dixon, Director of Behavioral Health, Fenway Health

1980–1996 LEADERSHIP

"Harry Collings had this amazing fundraising strategy. He would find out who was coming to Boston to give a concert, buy a bunch of tickets, and take all of his donors to the shows. We paid for our tickets, of course, but we all went together and saw some great shows. We had a terrific time. I remember one time he took us to see Madonna when she came to town. I loved her. Now look at me. Can you believe Harry Collings made me a big Madonna fan?"

—Ron Ansin, Donor, Opening New Doors Capital Campaign, which partially funded Fenway's 7 Haviland Street facility, and future Lead Donor, Ten Stories Capital Campaign, which funded Fenway's 1340 Boylston Street headquarters.

The sixteen years from 1980 through 1996 were the most intense period in Fenway Health's history. A research program grew from a four-page typed proposal into a world leader in understanding HIV, the mechanics of its spread from person to person, the progression of HIV infection within an individual, and possible treatment approaches. Patient visits grew from 9,000 per year in 1979 to over 54,000 in 1996, when 40% of these visits were HIV-related. Education programs grew from free lectures for consumers hosted by the health center's three collectives, to formal education and training programs for health care providers delivered by Fenway's medical and research staff. Advocacy services that began with a simple commitment to offer care to underserved communities expanded to the creation of multi-agency coalitions to deliver coordinated care and lobby for increased government support, and participation in the drafting of national legislation. In order to provide all these increased services and programs, Fenway's budget increased from $250,000 in 1979 to over $8,000,000, and its staff grew from a team of twelve, mostly part-time employees in 1980 to 186 full- and part-time employees in 1996. Perhaps most significant of all, Fenway raised the money, garnered the political support, and managed the construction of its first permanent home, what Ron Ansin remembers as "our enormous three-story building" at 7 Haviland Street, which opened in 1991 at a cost of $4 million.

The management challenges that came with this growth were as significant on a conceptual and structural level as they were in terms of the daily operational demands and work load necessary to reach these new heights. Fenway's old collective organization structure gave way to a more hierarchical one, complete with organizational charts, personnel policies, regulatory compliance, professional licenses, pricing structures and billing rates, and new mission statements. Two significant financial crises threatened the organization's survival, first in 1980 and again in 1985. Some staff who remained at the health center from its origins in the 1970s would try to bring back the collective model of management several times until Fenway's modern corporate structure took root in 1986. Fenway would provide Senator Edward Kennedy's staff with key national advocacy to enact the original Ryan White CARE Act, which passed in 1990. And then, every few years, the need for Congressional reauthorization of the Ryan White CARE Act would create uncertainty and the need for intense advocacy work. This cycle was mirrored in state funding, research contracts, and changes in insurance coverage, as well as the condition of the national, state and local economy. The future of at least portions of Fenway's operating budget were at stake each time. Politically, Fenway was clearly for people, not for profit. As a business it was incorporated as a not-for-profit organization, but was dedicated to generating a surplus, to assure that growth could continue to match the expanding needs of the community. Having outgrown 16 Haviland Street in the late 1980s and expanding into rented space along Massachusetts Avenue across the Massachusetts Turnpike, Fenway would open its new building in 1991, and, within three years, outgrow 7 Haviland as well, expanding back in larger numbers to the same rented spaces it had left behind.

The health center would spin off new organizations, absorb others, and see two of its original founders—David Scondras and Rosaria Salerno—go on to successful careers as Boston City Councilors. Andrea Cabral, one of the founders of Fenway's Victim Recovery Project, would later be elected Suffolk County Sheriff. All four of the health center's "great executive directors," as Ken Mayer calls them, served during these sixteen years: Sally Deane from 1980 through 1984, Dale Orlando from 1986 through 1990, Michael Savage from 1991 through 1994, and Stephen Boswell, who served as Medical Director in 1994, and then as Acting Executive

Director before becoming Fenway's CEO in 1997. Many other Fenway leaders made historic impact on Boston and the Commonwealth as the epidemic grew and the stature of the LGBT community rose in its response to the epidemic. Larry Kessler, David Aaronstein, Harry Collings, Liz Page, and Richard Giglio taught the larger community to take care of each other, first through the AIDS Action Committee programs, and later by establishing fund raising events that continued to share resources with Fenway and other health organizations. Following the successful example of Fenway's MAHS and DAHCS federal grant awards, and in response to state and city calls for collaborative efforts to deliver new services to diverse high-risk HIV populations, Harvey Makadon and Holly Ladd initiated the Boston AIDS Consortium (BAC) in 1987. At the time, Dr. Makadon was on the Board of Directors at Fenway; he was also the Director of Outpatient Services with the Beth Israel Hospital. Holly Ladd was past president of the Fenway Board, having served from 1984 through 1986. She also served as Executive Director of the BAC until 1992, when Denise MacWilliams became Director. The BAC grew to be a coalition of over 70 organizations, service providers, political entities, funding sources, and individual philanthropists during their tenure. It was not only the model for other communities in the Commonwealth, but the primary organizational model for Fenway's Project ABLE, a similar statewide coalition that garnered additional state funding for the epidemic in the early 1990s and still exists as a freestanding organization today.

1996 would see the arrival of HAART and a dramatic improvement in the survival rate of people with HIV, and Fenway Health's 25th anniversary. It would also mark the beginning of a new era as the health center solidified its dream of becoming New England's leading LGBT health care organization. Throughout the HIV "wilderness," Fenway took care not to become Boston's AIDS clinic by maintaining a commitment to health care for women and the elderly, even if there wasn't enough time or money to grow these programs as fully as some might have hoped. But in 1996, there would be time, and, thanks to the work of Fenway's development staff and its Director of Government Relations, Henia Handler, there would also be money. The Board of Directors and a talented senior staff would provide the strategic focus. Still, for sixteen years, the journey to get there was anything but smooth.

It has been noted earlier in this book that Fenway's "professionalization" began with Sally Deane's tenure in the early 1980s. We know the results—a clinic license from the Commonwealth of Massachusetts in 1981, a nationally-known research program, an end to Fenway's collective organizational structure, and a strategic plan that, for the first time, acknowledged the health center's emphasis on serving New England's gay and lesbian community. By 1984, Fenway even accepted Visa and MasterCard. But what was the process? How did this progress happen? Sally Deane remembers beginning her time as Executive Director with two commitments: to make Fenway a safe environment where people could receive high-quality care, and to never lose the spark of genius that made Fenway able to serve the population that depended on it. She also remembers being young. "I was only 32 years old. I saw the need to keep perspective on Fenway's larger mission during the early AIDS crisis, and I felt lonely trying to advocate for women and the elderly at the time. But I didn't make the connection of asking for help in that lonely struggle. Had I brought more of these people onto the board, or people who believed that elders vote, or women are half of our population, that might have helped."

What she did, though, was add people to the board so it wasn't "loaded with health care professionals." Dan Cirelli, Chairman of Fenway's board, was a businessman, and helped with strategic planning. He was also in the food business, which helped with the health center's tenth anniversary party—in 1983. "He arranged the whole thing. We had it at the old Buddies on Boylston Street, and he brought in all the food. It was a great celebration," Sally Deane recalls. Janet Berkenfield, another member of the board, set up the center's first formal medical system as a volunteer. The board authorized the creation of a billing office and professional accounting staff to make sure Fenway received the money it earned from providing health care. The board supported the hiring of staff with relevant education and experience. "We hired doctors and nurses with appropriate backgrounds in adult medicine, and these professionals replaced those with less relevant degrees, such as pediatric nurses, to treat our patients at Fenway," Sally Deane explains. She also cultivated support from Boston's hospitals. Friendly staff at Boston City Hospital would fill her Volkswagen Rabbit with donated medical supplies on a regular basis. Charlie Spaulding, Director

of Facilities at The New England Deaconess, told contractors who worked at his hospital that they had to come to Fenway to fix its facilities as part of their work for him. "He didn't have to care, but he did." And Mayor Kevin White "had the vision to dedicate great resources to the gay community. He recognized and supported the talented people we had on our board and staff. The resources the city provided to us were absolutely key to our survival and growth." The progress Fenway was making was noticed outside the neighborhood, and led to some "out of the blue" events. Sally Deane didn't know the Cambridge Women's Health Collective was closing until she received a call from Jeanne Hubbard, a family practice physician who had done good work at the CWCHC, in 1981. "She said she knew that Fenway did good women's health care, and was putting together a good medical records system. She wanted their records to be kept somewhere, and she thought we would be the best place. So we took them, and mailed letters to all the CWCHC patients to let them know their records were with us, and that they could come to us for care if they wanted."

All of this progress—research, professional care, sound management, record keeping, support and recognition from outside organizations—pointed toward continued development of Fenway Health as part of Boston's health care system. It would be a unique part, the only one to draw on a citywide, if not regional population of gay and lesbian people seeking competent and respectful care. But, before 1981, even this unique target population didn't make Fenway that much different from the other neighborhood health centers in Boston's network of community care. As Sally Deane puts it, "all the business stuff in the minutes of our board meetings would have continued for years, if it weren't for AIDS." After Ken Mayer introduced the fact that this mysterious disease was spreading among gay people in New York and California, and concluded that it would eventually come to Boston as well, Fenway had to be ready. Soon enough, patients would begin to sicken and die in front of the health center's horrified staff, while a national atmosphere of helplessness and fear of the "gay plague" grew. Battles that had been resolved—Fenway would become a professional health care facility, with all the credentials, qualifications, and best practices required for medical care and research—would be revisited as gay people realized no one anywhere else was willing to respond to people with AIDS. Some among Fenway's board and

staff thought the only proper response was for Fenway to become more political, and advocate for the needs of people who were dying just because society at large was ignoring them. Others, like physicians Ken Mayer and Lenny Alberts, viewed the epidemic as something that could be understood by studying the behavior of people who were affected, and worked to develop early and successful theories on how it was, and was not, spread.

But in 1981 and 1982, there was no money available to support their research. Competing pressures—making Fenway a well-managed, self-sufficient part of Boston's health care system, vs. creating a foundation of knowledge for responding to a health crisis affecting a population that Fenway was committed to serve—would overwhelm a young health center and its equally young management. Despite the enormity of the challenge, Fenway would move forward, succeeding on both fronts, but this success wasn't initially well understood by people inside the organization. Gay people didn't think the center's professionalization was an adequate response to the growing AIDS crisis. People representing Fenway's other populations didn't understand how important it was to dedicate resources to a disease that affected only one of its three key constituencies. Perhaps it is understandable that, in the midst of a crisis, patience is one of the first things to go. Building a professional medical staff required raising their pay scale beyond the original collective model, in which everyone was paid the same. Fenway would have to compete with other health care institutions, and it did, offering physicians and nurses the equivalent of what they could be paid at other community health care organizations. But the center's finances couldn't support raising the salaries of its administrative staff at the same pace. These perceived inequities created tensions that added to the stress of managing the health center. Some of the better support staff left for higher-paying jobs. A few of those who remained did so out of loyalty to the health center's historic purpose, and saw themselves as peers of the volunteers on the Board of Directors, who also served because of their dedication to Fenway's mission. Management would become even more difficult in the face of these growing disparities.

Sally Deane describes her dilemma, "If one of our medical providers said to me, 'oh, no, care has to happen this way,' I felt like I was hearing the same message in stereo. I'd hear it during the day from the staff, and then, in a board meeting, I'd hear it again, only louder." By 1984, these competing internal demands

became too much, and, after many accomplishments, she left Fenway to work for Lew Pollack, Commissioner of the Boston Department of Health and Hospitals. Shortly thereafter, she went on to a master's program in public health, where she turned much of her experience into understanding and brought it back to the health care community. Fenway would wander for a while, seeking its mission in a world that had changed in unpredictable and irrevocable ways. The collectives within Fenway struggled with nostalgia for consensus and ideological clarity, but were bracing for the demands of an epidemic that left no time for such thinking. Both Fenway and Sally Deane would move forward to many more successes, but not without consequences. She would leave for bigger and better things, but she left with, as she admits, "a broken heart."

Fenway's next Executive Director, Tony Knopp, came to the organization from New York City, where he had worked as an Administrator for Bellevue Hospital. He remembers being recruited by the health center's board because "I wasn't gay, and I wasn't from Boston." He thought it was strange at the time, since he knew Fenway served more gay people than any other health center in the city. "Looking back, I probably should have known that there might be trouble. But I wanted to move to Boston, and the job looked great." The trouble started relatively early, with what he described as a "commune" among the staff. "The board was supportive of his efforts to continue the professionalization Sally Deane had started four years earlier, but he encountered resistance from a staff that remembered the old days of Fenway's collective structure and sought to bring themselves back into the decision-making process with him and the Board of Directors. "But everything changes when you have to make payroll," Tony Knopp remembers. "I would ask the staff whether it was okay to follow their lead and not bill for our services, and then not to give them their paychecks as a result. They didn't seem to get that they couldn't have it both ways."

Despite the management turmoil he found on his arrival, Tony Knopp was able to establish a few firsts during his time at Fenway. The Women's Health Series launched shortly after his arrival in late 1984. In January of 1985, Fenway began its first funded research study, a tracking of the natural history of HIV infection funded by the Massachusetts Department of Public Health. And he created the health center's first newsletter, with the strangely ahead-of-its-time

177

name *Fenway Health.* By 1985, "Pulse," a regular feature in the newsletter, offered health information and education for Fenway's patients and constituents. The Winter, 1985, edition focused on Hepatitis B, its symptoms, the danger to people who contract it, and the fact that gay men are ten times more likely to contract the disease than their counterparts.[103] The article also provided information on Fenway's screening and vaccination program, which at the time took seven and one-half months for each patient to complete. Tony Knopp also helped AIDS Action Committee develop in its first office around the corner, and remembers meeting with Larry Kessler almost every day to talk about the management and fundraising challenges both organizations faced at the time. Eventually, the friction between a director brought in to solve internal struggles because he had no history with these issues and staff became unsustainable—precisely because his staff didn't appreciate his lack of history with the organization. Tony Knopp left Fenway in 1985. Impatience ruled.

Fenway's next Executive Director, Dale Orlando, learned about Fenway from her friend, Research Director Ken Mayer. He knew she was a good manager and a skilled fundraiser. He had asked her to help raise money for the health center as early as 1984, but she knew then that there was no money available for AIDS research or health care at the time. Working as Associate Director of the Lowell YWCA and running a women's training program for Bay State Skills Corporation, she was called in for an interview and hired in early 1986. Dale Orlando found the same organizational culture that had proven so difficult to manage for its previous two directors. Consistent with each of her predecessors' experiences on arrival, she made a surprise discovery about how difficult her job was going to be when she began her job.

"There were 26 staff at the time: 12 full-time, 14 part-time. Every Friday, they met to make decisions as a collective. But it looked to me like the real decisions were being made by the bookkeeper, who was doling them out by the nickel," Dale Orlando recalls. No one realized the health center was $500,000 in debt, and billings to insurance companies were months or sometimes years late. There were no computerized records at the time, and it was difficult to get a clear picture of the health center's finances. "I remember looking at an empty exam room at 16 Haviland Street and asking one of my new staff why that was. The answer I got

was, 'Gee, Dale, we don't know whether we make money or lose money every time we hire a doctor.'" But the worst surprise came when she asked to meet with Larry Kessler, head of the AIDS Action Committee, to discuss a fundraising strategy she could implement to close some of the financial gap. "'Oh, he's on Boylston Street,' they told me. At first I thought Fenway had an office there I didn't know about, but that's how I found out AIDS Action Committee and all its fundraising operations had become a separate organization. Now we were not only in debt; we were also without the way I had originally planned to get out of it."

Dale Orlando got to work on a broad managerial strategy. She changed the collective structure to a hierarchical one—again—because, as she put it, "AIDS is going to need for us to make decisions, and so will Alternative Insemination." She interviewed her entire staff, with a commitment not to fire anyone, but to build a Senior Management team from within, and teach them everything she knew about management. She used overhead projectors and hand-drawn transparencies to illustrate how money flowed through a nonprofit organization, and led her staff in workshops to explain the process in detail. Total transparency became the rule. "While the staff still didn't like the salary discrepancies, they could understand that our competition for physicians was no longer other health centers, but large teaching hospitals." Then, she and her accounting staff created an actual working spreadsheet to project a budget, complete with detail about the three or four existing contracts with the city and state for services—an actual paper spreadsheet, not a computerized one. She committed to a pay system in which doctors were going to make more money than the person at the front desk, but set a limit so that the highest-paid staff person would never make more than five times the person at the bottom of the pay scale. "For the first time at the health center we put in career ladders, promised that each position would be funded as well as other health centers, and soon developed ways to assist people to further their education. Departments were created as cost/revenue centers with the goal that each would become self-sufficient, contribute to central administration, and if necessary would be able to stand alone as its own successful organization within three years, not that we wanted to lose any department. It was a formula we used for each and every new program we added. There was something that transfixed everyone to have goals in care that they could literally see translated

into budget numbers, and then understand how pulling together as a team would benefit them personally, and not just the abstract concept of 'our health center,' or 'our patients.' I think they were stunned to understand that a budget could be based on what we valued—each other's well being along with our own—and that there were not going to be any secrets. My commitment to the Senior Managers was that if they would lead their portion of the organization, master the human resource and budget tasks, contribute to the strategies, that each of them would develop the skills to run the entire organization. We made and kept promises that if the staff would help us to meet our revenue goals by reaching and caring well for patients, the surplus we would generate would go to salary increases, and those increases would always start with the lowest-paid staff. They were also probably shocked to see on the wall that my salary was closer to theirs than the doctors. It made us a team with the payroll of a corporation and the heart of a collective."

Looking for revenue to close the deficit, Dale Orlando thought Fenway could raise its prices, but ran into opposition from her medical staff, who thought higher prices for care would scare their patients away. When she had asked her friends why they didn't go to Fenway for their care, they answered, "I'd like to get care at Fenway, but I won't because you don't have real doctors." When she asked why they thought that, they replied, "Well, you couldn't possibly have real doctors and charge those prices." Fenway raised its prices to market value, and, surprising many, its patient visits increased. Cash flow followed. Dale Orlando and her staff worked to expand and increase third-party payments for Fenway's services from Medicaid, and used these pay rates to justify similar increases in coverage from Blue Cross and other private insurers for innovative treatments of HIV.

Later, when reimbursements began to fall short of paying for the time it took to deliver needed medical care, Fenway's staff was experienced enough to convince the state and private insurers to raise their rates again, this time for office visits which were lengthy and complex at Fenway. Gradually, the sense that the health center was going to gain control of its finances grew among the staff and board. By 1987, grants became available for HIV care, and Fenway was able to leverage its leadership in the field to lead the multi-agency Metropolitan Area HIV Services Project (MAHS). Patient visits from people with AIDS began to increase dramatically, growing from 5% of its caseload in July of 1986 to 30% in 1987, and

then two-thirds of all visits in 1990. The entire patient load was growing at the same time, fueled by the advertising, press coverage, word-of-mouth endorsements generated by improved staff morale, and the compassionate care provided through the HIV Counseling and Testing site to a much broader population.

FENWAY AT A GLANCE: 1989

Fenway Health Center Annual Budget$2,789,186

Annual Patient Visits . 26,000

Number of Professional Staff 98

"We were shameless in our use of the media at a time when advertising medical services was frowned upon," Dale Orlando remembers, "We were very lucky that WGBH, the PBS flagship, was producing a nationally televised show, *The AIDS Quarterly with Peter Jennings*. They found our struggle in the dumpy little basement to be a novel setting amid the major teaching hospitals and national research centers. The staff almost had a heart attack when Peter Jennings and the entourage showed up for a tour one day. Once we had quarterly coverage of our efforts on national television, our position as part of Boston's medical care system, our place in the national LGBT community, and our standing with Boston's local foundations and philanthropists changed forever. Later, we introduced massive fund raising events with celebrities to attract the gay and lesbian community to support the health center. We used mass media to highlight the health center's every achievement in the battle against AIDS, which increased our local visibility and popularity with donors. This didn't make some of our more closeted patients, or even a few of those wealthy patrons who wanted the health center to remain their own little project very happy, but we were attracting the attention and donations of many large and wealthy supporters and decided to cultivate every source, new and old. In reality, we didn't have a choice. The downside of the media attention was a continuous flood of new patients, and we needed the resources to help them, too. Many people in the larger community still detested gays and blamed them for the disease that changed their own sex lives, but the once-smallest health center had

been successfully positioned in the media as David vs. a Goliath epidemic and as the Robin Hood of the medical community, bringing resources from established institutions of care to a community in desperate need. The fund raising got easier, and by the time Harold Brown gave us the shell of the new health center building, we had several full time development staff. Then we kicked it up a notch and brought on Harry Collings and Cindy Rizzo for the capital campaign."

Innovative partnerships continued throughout the time Dale Orlando was at Fenway; in December, 1990, the health center's Acupuncture Detoxification Program—then called ADAM (Acupuncture Detoxification and Alternative Maintenance) opened a satellite center at Boston's Pine Street Inn, the largest homeless shelter in New England. "The incidence of alcoholism and drug addiction among the homeless is overwhelming," stated Phyllis Dixon, then Director of Fenway's Mental Health and Addiction Services. "For some, one of the direct results of their addiction has been their homelessness. Unfortunately, most shelters do not have the means to address this issue."[104]

Working at Fenway in the face of these pressures brought demands for management that went beyond the "boots on the ground" labor of improving billing systems, reconciling pay scales, or drawing a new organizational chart. It called for adaptations that took into account the personal toll of the disease on staff who watched patients die, staff whose lovers were dying, and, in too many cases, staff who were dying themselves. Dale Orlando adapted a "situational leadership" management system that came into play in these situations. "If Sam's partner had died, we needed to give him work to do; we couldn't ask him for his ideas on how to solve a complex organizational problem. We had to meet his level of functioning while he was going through it, and bring him back to more advanced work later on." By 1989, Fenway Community Health had a new staff organizational chart, one that described the growing, $3 million per year operation it had become. The days of financial uncertainty that had visited the health center from time to time since 1971 were at last a thing of the past.

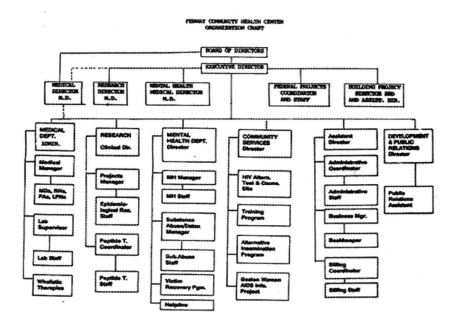

By 1987, Fenway's Board of Directors approved a new mission statement, based upon the work Dale Orlando and her staff did to articulate the health center's community, its commitment to care, and its vision of itself as a leader on a scale larger than the Fenway neighborhood itself. Note the appearance of "Fenway Community Health," an early appearance of its abbreviated corporate identity, without the word "Center" at the end.

"The mission of Fenway Community Health is to enhance the physical and mental health of our community, which includes those who are lesbian, gay, bisexual and transgender, and the people who live and work in our neighborhood. We provide high quality, comprehensive health care in a welcoming environment. We seek to improve the overall health of the larger community, locally and nationally, through education, advocacy and research."

In recognition of her work at Fenway over her first three years, Dale Orlando won the Massachusetts League of Community Health Center's Executive Director of the Year Award for 1989. This seemed a special honor since Fenway had joined the League of 70 other health centers only three years earlier, in 1986. Her acceptance speech to a crowd of over a thousand health workers and dignitaries was a highlight in a long career of public speaking, and also a great milestone for Fenway Health:

"Thank you, Mass League, for this honor tonight. It is an award that belongs to all of the dedicated staff and volunteers at Fenway Health Center because an Executive Director is only as good as the board members who help to articulate a vision of comprehensive health care and only as good as the staff who follow through with compassionate, quality services. So on behalf of the people at Fenway Health Center, I accept this honor and on behalf of the patients and clients at our health center, I thank you for the opportunity to address you tonight as an equal partner in the provision of medical care to a community that some of you know very little about.

"First, I doubt that I'm here receiving this award for our 20 lesbians who have made babies or who are pregnant from our Alternative Insemination Program—although it is quite an accomplishment if you really think about it! So I want to talk for two minutes to each of you as another human being about the AIDS epidemic.

"Three years ago I sat at a table at a Mass League meeting, just as you are tonight, and listened to people articulate the public health agenda that they believed would dominate our health centers over the next decade. No one mentioned AIDS. I was surprised, since at Fenway we were already up to our knees in HIV. Now we are statistically above our waist, and this is my only opportunity to talk with you as a health activist about the second undeclared war of my lifetime.

"The gay and bisexual community is besieged and dying by the thousands from AIDS, so are IV drug users, and so are the sexual partners of these people. This is a war without guns with an endlessly rising death toll. My community, the gay and lesbian community, and all of the men, women, young, old, white, black, Latino, and Asian people in it need your help to stay alive. Three years ago I answered a call from them and declared war against a dragon called HIV. As a

health professional you have two choices with an enemy of this magnitude—go out and fight it, or get busy protecting our elderly, women, and children from being ravished by it.

"In today's economy lots of folks talk about tightening our belts and economizing. Now I'm a pragmatic optimist so I assume that means that Prudential is not going to build another skyscraper with your premium dollars, and the governor is not going to hire ten more baby bureaucrats to delay payments from our tax dollars as health care checks stop at five more desks. Why? Well, because some of us are at war and need to have that money put into the war effort. We need to each make certain that money gets sent to the front lines of our health care system to the people fighting the dragon or tending to the elderly, the women, and the children, right? That's the way it should be.

"So this month I want you to make a personal decision. Are you going to sign up and declare war or are you going to sit back and hope that whoever "they" are will give you enough pennies to run your health center, feed your own kids, and say the hell with the rest of us? People who control our money rely on their perception that you are going to be complacent.

"Well, I know most of you in this room now and I don't believe it. This is the year that each person in this room is going to declare war against the dragon that has been terrorizing and killing all of our people. This is the time to demand the resources to fight back. This is the month that we are going to march together in "From All Walks of Life" to raise money for five of the health centers in this room to form our beachhead in this fight. This is the night that you are going home and making a decision that you are not sitting back any more. You're going to tell your leader, your Executive Director, or your funding source that you want to be involved in this war and demand the resources that you need to fight it until the killing stops and the dragon is dead.

"We do not need to buy anyone's argument that we have to fight each other for limited resources. We need to demand every premium dollar and every tax dollar to slay this dragon and to take care of everyone's health while we do it. Look around yourself at the people next to you. There is no greater force on earth than the love we have for each other. We will use that as our greatest weapon in this

fight. And we will win this fight and we will slay this dragon, and Fenway will no longer do it alone. We will do it together.

"Thank you and may goodness guide your decision."

At the same time Dale Orlando received this award, one of the most amazing accomplishments in Fenway's history was already under way. By 1988, the strains of a growing patient population, research program, and new treatment programs had stretched 16 Haviland Street beyond reason. Rented spaces on Massachusetts Avenue and Newbury Street were a temporary answer, but none of Fenway's spaces were adequate for the medical care its patients needed. Henia Handler remembers one of the funnier consequences of Fenway's first diaspora in the late 1980s. "We had space at 100 Massachusetts Avenue, on the fourth or fifth floor, with the Fred Astaire Dance Studio above us and publishers of Zen literature below. You'd always meet the most interesting people in the elevator on the way up. The Zen publishers were very quiet, but the dancers upstairs weren't always doing Ginger Rogers moves; sometimes they were doing the cha-cha or more active programs. During our meetings, we'd often hear loud music and the ceiling would vibrate. One day they were particularly active, I think they were learning the Flamenco, and suddenly there was a loud thud and a foot, then a whole leg, came down through the ceiling."

Dale Orlando doesn't remember the leg story, but shortly before they had relocated to four rental sites near Massachusetts Avenue and Newbury Street, she had cold-called Harold Brown of Hamilton Realty. Brown was a well-known Boston landlord who owned the property across Haviland Street, then a parking lot, to discuss the possibility of constructing a health center there.

"I told him, I have 25,000 patients in 3,600 square feet, and I need 6,000 square feet to take care of them. I heard him working on his calculator. 'I'll charge you $90,000 a year ' he said. We were paying $12,000 a year for the basement. I told him that we couldn't afford that much and that we needed the ground floor of the building because our little old ladies needed to stay in the neighborhood for their care. Harold Brown responded, 'I don't care about that.' I went on that we might be able to get height restrictions lifted on the building if he could build more stories for other renters and give us the ground floor and finally told him that we had

lots of young people who are very sick and dying. 'I don't care about that, either,' he said. I told him, 'Well, I do care, so I don't think you and I will be doing business together,' and hung up the phone. He called back 20 minutes later, apologized for his gruffness, and asked for a meeting with me, my board chair and the city Councilors we knew. That began the process through which he eventually made the lead gift of $2 million for the outer shell of the $4 million dollar 18,000 sq foot building that became our 7 Haviland Street health center. That was in 1988. I met for over 9 months with Harold Brown and Steven Coyle, Director of the Boston Redevelopment Authority until the deal was settled. We would get all 18,000 square feet for the health center and Mr. Brown would get the tax deduction for his donation and tax assistance as the developer. In reality, the city of Boston was our biggest supporter.

"We formed a Capital Campaign Advisory Group and interviewed some companies that specialized in raising capital funds. Unfortunately, their approach was that they would charge us 10% of the remaining money we needed, which was a little under $2 million dollars, after Harold Brown's donation of the building, and the Federal Health Resources and Services Administration's (HRSA) pledge of an additional $350,000. For $200,000, this company wanted the Advisory Group to give them names of potential donors so that they could conduct a Feasibility Study (a way of seeing who might give during the upcoming campaign). Two of the strongest members of that group, the well-loved President and CEO of Beth Israel Hospital, Mitch Rabkin, MD, and our close friend John Larkin Thompson, the CEO of Blue Cross/ Blue Shield of Massachusetts, convinced me that we should hire from within the LGBT community instead of hiring some outside group that didn't even know our organization.

"Shortly after that, Gail Beverly, Fenway's legendary HIV Counselor, came into my office and said, 'How about Harry?' I said, "Who is Harry?" She told me about Harry Collings and his great fund raising ability as a volunteer for AIDS Action Committee. So I asked her to invite him to come and see me, but not to tell him any financial details about our goal, or how much we might pay for his services. He came in and convinced me that he was the man for the job. He wanted $25,000 to get it done, but proposed a second person, Cindy Rizzo, to write the grants, handle correspondence, and keep track of prospects and pledges. I told him

I would work up a budget and then ask them both if they could accept my terms. When I thought about it, I believed it was important to pay Harry and Cindy the going rate for capital campaign consultants. I believed they were the right people for the job, and also believed that the fact that they were from the LGBT community was no good reason to pay them any less than the consultants we had met earlier in the process. So I made the offer, they took it, and the rest as they say, is history. I also knew that if I only offered Harry the $25,000 he requested, Larry Kessler would be able to hire him back in a month, which was another reason to offer Harry Collings and Cindy Rizzo the money they deserved. Boy, was Larry angry with me. But two years later, we had our new building, debt-free, and with an endowment to maintain it for twenty years."

But getting off to a good start with the initial donation of the building, support from the city of Boston, and the hiring of a great Capital Campaign Team was only part of the battle. With AIDS, nothing was ever easy.

"Next there was the staff. I called a Senior Management team meeting right after David Scondras and I went to see Harold Brown one day, and told them that with enough work, we might get the first floor of a new building in the parking lot courtesy of Mr. Brown. Several of them objected, saying that he had been convicted of a bribe and that they thought some of his staff had been convicted of arson, but in the end my argument regarding our space needs prevailed. They all agreed we should take the gift." Dale's eyes fill, "when they left, I closed the office door and cried for the first time in three years of coping with all the deaths, because I had promised that I would bring new management systems, new computer systems, new revenue sources, programs for AIDS care and programs for LGBT care, and that I would get Fenway a new building; now that final goal was finally in sight. I wasn't sure if I was crying because they convinced me this deal might darken our good name but they would support my decision either way, or from the sheer relief of knowing we would have the space we needed so desperately.

Cindy Rizzo introduces plans for 7 Haviland Street to Fenway's neighbors. (*Northeastern University Archives*)

"Next in line were the neighbors. Building in Boston is never easy either, but that meeting with the staff helped me to prepare for the neighborhood hearing we needed to hold to eventually get the deal through the BRA. By that time, Harry was smoothing our every move downtown at the BRA, and Matt Thall, the Director of the Fenway Development Corporation and a former Fenway Health Center Board member, was gathering support in the neighborhood. The night of the hearing I discovered I could hold my breath for an hour and thirteen minutes. Introductions were made; the architects did their presentation with slides and a building model. Everyone was so polite in this room filled with some of Boston's most vocal activists, some in suits, the rest in Berkenstocks and sweaters. There was a question about shadows from the height of the building, a congratulatory blessing from City Councilors Rosaria Sarlerno, who lived next door, and David Scondras, who lived three doors away. After another polite inquiry regarding noise mitigation during construction that was met with the right response, the meeting adjourned.

"Outside were the cameras from all four broadcast stations and a host of reporters with questions regarding Fenway doing business with Mr. Brown. Never at a loss for an ad lib 30 second sound bite, I stared at the cameras and said, 'The South had it's Rhett Butler. If Mr. Brown wants to redeem his reputation by donating this building to Fenway when we have thousands of young people dying, then I will simply accept his gift on behalf of Fenway and say thank you to Mr. Brown.' And we all left. Harold called me the next morning to congratulate us on passing the next hurdle and told me he always liked Rhett Butler and thought he was a lot like him. I just chuckled and when we hung up I channeled my best Scarlett O'Hara, thinking to myself, "As God is my witness, as God is my witness they're not going to lick me. I'm going to live through this and when it's all over, (we'll) never be hungry again. No, not me nor any of my folk... As God is my witness, (we'll) never be hungry again."

Fenway's Capital Campaign was an unprecedented adventure for Fenway, and in fact it also resulted in the first LGBT-owned health care facility anywhere in the world. Harry Collings remembers the difficulty he had in convincing people it could be done. "That first building was far more difficult than you can imagine, more difficult than the job of raising money for the 1340 Boylston Street building twenty years later. In 1990, we had no donor base. And in the late 1980s, the sum of $2 million was a daunting task. No LGBT organization had ever raised that kind of money in the United States. When people said we couldn't reach that goal, I'd just move on and go back to trying to do it. And then at the end I'd say to them, 'see? We did it!'" Collings remembers the support he got from Ron Ansin, whose lead gift made so many other contributions possible. "I'd heard of Ron, and was aware of his businesses and his support for gay people. I met him, and right away got the sense that it would take a long time to build a relationship with him. He wasn't the kind of person to say yes or no right away. It actually took nine months, and he appreciated the time we gave him to come to his own decision. Later on, I joked with him, that, hey, nine months, we could have had a baby. And we did have a baby. It was our building at 7 Haviland Street."

Harry Collings also remembers the details of the "amazing fundraising strategy" that worked wonders for Ron Ansin and so many other donors. "I knew people in the city of Boston from my past career working there, and in my other

dealings with some of the officials. So I was able to get an advance look at the upcoming shows for the 'Concerts on the Common' that were held every summer at that time. I'd go down the list, pick the performers I thought our donors might like, and get great seats. We'd even try to schedule a reception with the singer after the show, although we could never promise anything; it was always up to the performer. We also took people to larger concerts, like the Madonna show at the old Boston Garden. And, eventually, we hosted an annual street carnival on Blagden Street during Gay Pride, near the old Chaps, complete with a ferris wheel and a stage for a big name act. With all these venues, we saw some amazing shows— Whitney Houston, Madonna of course, Harry Connick, Jr., Patti LaBelle, Gloria Gaynor, Donna Summer, Peter Allen, and the Pointer Sisters. We used this strategy to bring new donors into the fold. The idea was to communicate that we were mainstream. Our message was that you didn't have to be gay or lesbian to support Fenway Community Health Center. And we also wanted to get people's minds off the epidemic, at least for a short time. This is a dreadful disease and we've lost so many people, but we're still a community and we can still have a good time."

A photo from the groundbreaking for Fenway's new building at 7 Haviland Street
(*Photo courtesy of Dale Orlando*)

That first new building—the one Ron Ansin describes as "our enormous three-story health center"—was the result of Harold Brown's generosity, and the unprecedented fundraising campaign led by Harry Collings and Cindy Rizzo. It was also made possible by the political support of City Councilors David Scondras and Rosaria Salerno, two of Fenway's founders who had gone on to citywide success, and the Boston Redevelopment Authority, Beth Israel Hospital, Blue Cross/Blue Shield and other corporations, hospitals, and government organizations. Harold Brown's donation of a $2 million building allowed Fenway's capital campaign to focus on fitting out its interior. Harry Collings and Cindy Rizzo used their "amazing fundraising strategy" to build a donor base that became friends—not just of Fenway, but with each other for years into the future. Dozens of design companies, contractors, and artists joined with HRSA and the Kresge Foundation and hundreds of donors to create the interior spaces that defined Fenway's new home for the next 18 years of its history. Its 18,000 square feet of space was five times the size of Fenway's 16 Haviland Street facilities. Concurrent with the opening of its new space, Fenway's logo changed from its original artwork to a new corporate image including a stylized rendering of the 7 Haviland Street front door. Dale Orlando remembers, "The new logo and a massive number of fund raising events for our health programs ran at the same time as the capital campaign under Director of Development, Steve Huber and very young volunteers like Bryan Rafanelli, engulfing the health center in a cascading swirl of high glitz and celebrity. That led to massive media attention, and the achievement of our goals to not only pay for the new building, but to build an endowment to care for it for twenty years. That gift was from Northeastern University, and, ironically, was one more year than Fenway needed before moving to 1340 Boylston Street in 2009. We also received well-deserved recognition for a staff who worked tirelessly caring for very sick people while we shook the money tree."

Fenway Community Health Center logo, 1991

Fenway's historic main telephone number, in place before local residents needed to dial the "617" area code, changed from 267-7573 to the number it still has today: (617) 267-0900 (the old number still connects to the main switchboard). Fittingly, the new building rose on the site of the old parking lot Fenway's founders used to show movies to neighborhood children on weekend nights, projected onto a sheet hung from the windows of an adjacent building. In the spring, 1991, edition of *Fenway Research*, other changes brought about by the opening of the new building were announced:

"As perhaps many of you know, the Fenway Community Health Center is now located at 7 Haviland Street in a brand new building. The Health Center is no longer in four locations in the Fenway area. There is, however, one exception: the Research Department is still at 93 Massachusetts Avenue, 4th Floor. Our big moment comes probably some time in the late summer, when we move (return) to Haviland Street.

"However, we will not move into the new building, nor will we return to our subterranean offices at #22—fondly called The Submarine—which some of you may remember. Sixteen Haviland, which used to be the Medical Department, will be our new home. We have been promised handsomely refurbished quarters with ample space; we also get part of what used to be the lab on the second floor; new furniture, new carpet, etc. In truth, the Research Department staff requested this space which seemed to be larger than what we would have had in the new building. It will be a nice place—for us and for our loyal research cohort. Until moving day we remain in lonely grandeur at #93 Massachusetts Avenue, 4th Floor."[105]

The opening ceremonies for 7 Haviland Street took two days: Friday, March 1, and Saturday, March 2, 1991. Letters of congratulations were written by Boston Mayor Ray Flynn, Massachusetts Governor William Weld, US Senators Edward Kennedy and John Kerry, and Boston City Councilors David Scondras and Rosaria Salerno.[106]

But perhaps the most memorable part of the new building was *Our Names*, a sculpted wall of marble, granite, and limestone inscribed with 1,500 names to acknowledge Boston's LGBT community's commitment to Fenway's "mission of quality, affordable health care and the fight against AIDS." The wall, unveiled in June of 1991 during Gay Pride Week, was the centerpiece of 7 Haviland Street, and

has since moved in its entirety to Fenway's current headquarters at 1340 Boylston Street, where it can be seen today. Harry Collings remembers it fondly. "It only cost $100 to put your name on it. This allowed so many people, so many parents of kids who had been lost to participate. When it was unveiled, it was so moving. To me, it was so much more moving than the actual dedication of the building. The names wall will always be very special, no matter where it is."

Fenway's new Executive Director, Michael Savage, presided over the opening ceremonies for the new building in 1991. Dale Orlando, her mission accomplished in bringing solid management systems, financial stability, new programs, leadership position in Boston's health care system, and a new building, had left Fenway just months before. Proud of her accomplishments and confident that the health center was on its way to becoming New England's leading LGBT health center, she recalls her time here fondly, and remembers lots of laughs and many lifelong friends. But she also left with many heartbreaking memories. "Too many young people died."

Cindy Rizzo, Capital Campaign Associate; David Scondras, one of Fenway's original founders; Fenway Board Chair Arlene Fortunato; Benefactor Harold Brown; Capital Campaign Director Harry Collings; Fenway Executive Director Michael Savage; and other at the ribbon cutting ceremony for 7 Haviland Street, March 1, 1991. (*Ellen Shub*)

Michael Savage, Fenway's new Executive Director and the third in Ken Mayer's list of the health center's four great directors, started work on January 2, 1991. He came to Fenway from Chicago, having served there as Managing Director of Program Operations for Travelers and Immigrants Aid, "an organization that provides a range of human services, including AIDS education and services, health care, substance abuse treatment, and mental health services to immigrants and the homeless in the Chicago area." Michael Savage also served on the founding board of the Chicago AIDS Walkathon, and on the fundraising committee of the Names Project/Chicago, and was President of the Board of Dignity/Chicago.[107] He was a formidable fundraiser and coalition-builder, and during his tenure Fenway built bridges to many allied organizations in Boston, Massachusetts, and nationwide. He secured a leadership role for the health center in a number of these groups, most notably Project ABLE (AIDS Budget Legislative Effort) in 1992, and The National Alliance of Lesbian and Gay Health Clinics later that same year. Newly appointed Director of Development Harry Collings worked his magic among Fenway's community in Boston, while Michael Savage and Director of Government Relations Henia Handler continued their countless journeys to Boston's City Hall, the Massachusetts State House, and dozens of legislative and federal agency offices in Washington, DC. They renewed and established ties that continue to this day in support of Fenway's programs of medical care, research, and education. By helping draft some of the subsequent language in the Ryan White CARE Act since 1990, Henia Handler has led Fenway's successful efforts to renew and expand the scope of this important piece of legislation at least six times since.

Even with its new building, Fenway in the early 1990s was still a place where AIDS patients came for answers, and there still weren't many. People were still dying, in increasing numbers. The new building was more spacious and comfortable, it was clear that education and prevention programs could reduce the spread of HIV among people in all risk groups, and there was a growing sense of optimism among Fenway's researchers that a cure, if not better treatment, was near. But, because of the lag time between HIV infection and the onset of AIDS, more people

were getting sick every year. There was no relief from the impatience, or even desperation, among a staff who kept track of patients' deaths on blackboards and in notebooks so they could get this news in private, when they were ready for it and out of the sight of the next patients depending on them for hope and support.

The same emotions Dale Orlando communicated in her speech to the Massachusetts League of Community Health Centers were at the core of new director Michael Savage's public comments in speeches and in *Frontlines*, Fenway's quarterly newsletter. Even the name—*Frontlines*—which Dale Orlando started and he continued, tells us how Fenway's leaders felt at the time. It was a battle, and the health center was in the lead. The battle was against the disease itself with Fenway's care, research, and education programs leading the charge in Boston. The targets for Fenway's advocacy efforts were fellow health care professionals, government agencies, and elected officials. The tone Michael Savage took in his comments is unmistakable:

"It took years and an enormous amount of energy and money to have gay men included in AIDS research during the 1980s. It is our intent to do our best to ensure that the lesbian community avoids a similar situation and process in the 1990s.—"From the Executive Director," *Frontlines*, Fall, 1992, discussing the need for state funding to support breast cancer research among lesbians.

"After twelve years of non-existent leadership from the Reagan/Bush administrations, the AIDS community is looking for strong and visible leadership on AIDS. Whether or not White House AIDS Coordinator Kristine Gebbie will be that leader is unclear. Our meeting with Gebbie left me concerned.

"We need the Clinton Administration to make AIDS the public health issue it actually is, rather than the political football it became during the first twelve years of the epidemic. We need decisive action based on health considerations. We understand that there are political considerations in establishing and enacting public health policy. However, we're frustrated with waiting, and a national AIDS Czar isn't part of the solution unless she works with us—the providers, the activists, the educators—to secure adequate funding for treatment, education/prevention, and research.

Ann Sanders (l) and Deborah Heller (r) at the opening of the Ann M. Sanders waiting room in the New Building February 1991 (*Ellen Shub*)

"...Specifically, the Ryan White CARE Act must be fully funded. While the proposed $200 million increase is a good first step, nothing short of full funding is ultimately adequate...Finally, the President's pledge to create a 'Manhattan like' Project to coordinate the best and brightest scientists involved in AIDS research is absolutely critical. We expect Gebbie to bring our demands to the Clinton administration. We're watching to see if Clinton will fulfill his campaign promises concerning HIV and AIDS."[108]

The need to make people aware of the extent of AIDS, and to talk about it openly in terms of its importance to the LGBT community, wasn't just a Boston, or an American concern. Writing about the Tenth International AIDS Conference in Yokohama, Research Director Ken Mayer discussed the scientific findings in the Fall, 1994, issue of *Frontlines*. "If you go to one of these conferences expecting a major breakthrough, you'll always be disappointed. These kinds of meetings are primarily a summation of the current state of research, especially for the media. Positive developments in research are happening in little increments all the time.

It is these little incremental improvements that may ultimately lead to the cure. There were new insights related to the pathogenesis of HIV disease, and modest hopeful improvements in the area of therapeutics. There will continue to be scientific meetings of significant importance in between the biannual events."[109]

The article continued with a caution that "we have to be prepared for the long haul. More than 17 million humans across the globe have been infected with HIV, with more than three million in the past year." But "exciting new findings were presented at the conference regarding studies of individuals who have been HIV-positive for more than ten years without developing full-blown AIDS. "If we can figure out how to mobilize these highly protected cell-mediated and humeral immune responses early after individuals initially become HIV-positive, then we might be able to develop the ability to keep the majority of people living with HIV asymptomatic for many years."

But, after all the reports on research studies and progress being made on understanding HIV, the article closed with a story about how far some countries were from dealing openly with AIDS and its impact on the LGBT community:

Cindy Rizzo, her son Joshua, and the Hat Sisters at 7 Haviland Street, circa 1991 (*Ellen Shub*)

"One of the most interesting byproducts of the conference had little to do with science. Before the conference, neither the AIDS epidemic nor homosexuality were often discussed in Japan. Preparations for the conference as well as the event itself helped to raise consciousness. An HIV-positive, openly gay man appeared on stage at the opening ceremony of the conference alongside the Crown Prince and Princess, an unprecedented event. The conference also prompted Japan to pledge more economic support for AIDS care and prevention in surrounding Asian countries."[110]

Michael Savage left Fenway in early 1994, after four years of successful efforts to expand the health center's leadership in HIV and AIDS care, education, and research on a national scale. By all accounts, he was an accomplished leader, able to describe Fenway's mission and programs in ways that encouraged all who listened to lend their support. He was respected and well-liked by his staff, and brought new people from Boston's business and medical community to the organization's Board. And yet he left the city, and an organization he helped so much, not for more professional challenges, but for love. His partner, who accompanied him to Boston from Chicago in early 1991, was never happy here. After four years of trying, they agreed that staying together was more important than any job, even the job of leading Fenway Community Health, and returned to Chicago in 1994. Ten years later, Michael Savage died in a boating accident in the Grand Canyon. This time, broken hearts were everywhere. Henia Handler remembers him fondly as a leader, a dedicated worker, and a friend. She also remembers him for one more of his many accomplishments. "He was the one who hired Stephen Boswell as Fenway's Medical Director."

In 1994, Stephen Boswell, then the health center's Medical Director, assumed the role of Acting Executive Director while the organization searched for a permanent replacement. The new director, Deborah Ruhe—a native of Norwood, Massachusetts, was the daughter of an early feminist who named Deborah after a Massachusetts woman who fought in the Revolutionary War dressed as a man—began work on October 31, 1994. Her first "From the Executive Director" column, in the Spring, 1995, edition of *Frontlines*, reported Fenway's continuing leadership in HIV research and care, echoed several familiar management challenges, and outlined the center's advocacy priorities for the coming

months—themes that could have been described by any of Fenway's previous—or future—Executive Directors.

"With a rich, twenty-four year history, Fenway has truly developed into a cornerstone institution of the gay and lesbian community, capable of securing groundbreaking grants like the HIV Vaccine Preparedness Study. Our Medical Department has been growing rapidly. Since July, 1994, we've seen a 29% increase in medical visits. Our staff and programs have outgrown our 7 Haviland Street facility. This spring, we relocated several departments—finance, contracting, public relations, and development—to 100 Massachusetts Avenue in Boston. Our outreach and education staff will follow them there shortly. These moves will allow us to undertake renovations to create eight additional examination/treatment rooms. Medical expansion will not only enable us to serve more people—it will assist our ability to negotiate effectively in the increasingly competitive health care environment.

"...Given the current threats to public funding, Medicaid and Medicare, Fenway must maintain a three-pronged approach to insure our continued success. First, we must increasingly look to privately raised funds to support our work. Second, we must maintain our vigilance over the federal and state funding for primary care and HIV/AIDS services. We're working with Project ABLE to advocate for state funding of AIDS services and with other partners to assure reauthorization of the Ryan White CARE Act. Third, we must maintain the quality of care for which we've been known and continue the expansion of our Medical Department."[111]

As Fenway neared the time when anti-retroviral drug therapy would change the face of its HIV research and care programs, many of the issues it had faced since 1981 were still front and center. Its research program was "securing groundbreaking grants." It was known for "quality care." Just three years after opening its new 7 Haviland Street facility, Fenway outgrew it and once again returned to rented space on Massachusetts Avenue, where it had maintained offices for years after outgrowing 16 Haviland Street ten years before. And the health center was still working on its own and in collaboration with other agencies and elected officials to secure future funding for the continued provision of care and the expansions needed to meet rapidly increasing demands from the community it served.

Fenway's operating budget was rapidly approaching $6 million in 1995, nearly 25 times its size at the beginning of the AIDS epidemic. Soon Fenway would be twenty-five years old, a mature organization reaching an even more important milestone as it could both study and use new drug therapies to extend the lives of its patients as it never had before.

On its twenty-fifth anniversary, twenty-five times its size in 1981, Fenway was finally emerging from Ken Mayer's "AIDS wilderness" to a time Henia Handler more optimistically describes as "a time to keep people willing and able to keep going." For the next fifteen years and beyond, the challenges would be many. Keep going in the face of a persistent epidemic, for which there still is no cure, which has spread suffering and death all over the world. Keep going with a constituency of lesbians, gay men, bisexuals, and transgender people who often defy the notion that Boston's unique attempt to bring them all together as a community was a really a good idea. Keep going with the development of a health care institution that conducts world-class research outside the walls of traditional teaching hospitals and medical schools. Keep going with innovative medical programs at a time when the nation's entire health care system is in need of drastic improvements. Keep going with a generation of leaders who were twenty-something when the organization was founded, and who are sixty-something today. Keep going in what may be, as comedienne Kate Clinton describes it, "the largest gay building in the world, with the possible exception of the Vatican." But, most of all keep going...

..

Fenway will continue to expand in programming by adapting to the changing needs of the LGBT community. I expect to see a continuation of program and membership directions that have been successful and experimentation with new innovations in care. Traditionally, women are far greater health care consumers and I anticipate that the lessons of the eighties and nineties when lesbian and straight women stood up for the men who were sick and dying from AIDS will continue to shape the growth in care for women and children at Fenway. Ironically, LGBT people, and the health center in turn, will continue to forge enduring bonds between men and women based upon real friendship that others find hard to obtain. The values of Friends As Family have taken hold at

Fenway and are woven into the foundation of its social fabric. All things rest on and rise up from their foundation, and Fenway Health is no exception.

That said, our social "programming" is very engrained and Fenway health will have to focus on the future while periodically revisiting the past because that is where mistakes between men and women concerning the needs of each of the sexes have been made. Those are the mistakes most likely to repeat, and a few of them almost tore the place in half. So, while it is very important for the health center to maintain a highly successful profile, particularly when lifting up a population that has been relegated as the lowest of the low in every culture on earth for centuries, we shouldn't fool ourselves by canonizing anyone. Everyone at the health center has made mistakes. We are all capable of learning from our own mistakes and the blunders of others if we know what they are.

Fenway Health will be successful if everyone there goes to the glass wall to bask in some light every day; to meditate on what they did to help another human being that day, to feel grateful for their friends at Fenway, and to consider one part of the past that books like this bring into the light. If every person there focuses on one story of the trials that tested those before them and the passionate pursuits that made Fenway a great national organization for our community, then the past mistakes may not repeat, but instead will bring clarity and a brighter future.

I know they can do this because, once upon a time not so long ago, we were crowded into a tiny basement on Haviland Street with an empty parking lot across from the health center. I asked every person at the health center to envision a new health center for us every time they walked past that parking lot on the way to the T stop or the Dunkin Donuts. They did. The nation's first LGBT community-owned health facility manifested itself there. So I would never bet against the people at Fenway finding their way to glory or seeing and securing a bright and prosperous future, because for centuries our people have kindled hope from despair. With the health center, we learned how to turn our dreams of a better future into reality.

—Dale Orlando, Executive Director, Fenway Community Health Center, 1986-1990

Chapter Three
1996–2011

1996–2011 OVERVIEW

"After fifteen years, the promise of the multi-drug cocktail in treating HIV gave us the sense that it might finally be our turn. We had spent so long taking care of people with AIDS, most of whom were gay men. It was the right thing to do. The cruel fact of the matter was that, even with its early promise, anti-retroviral therapy still had a long way to go in 1996. It turned out that it wasn't quite time for Fenway to dedicate freed-up resources to lesbian and women health care. AIDS never behaved the way we all hoped."

—Dale Orlando, Executive Director, Fenway Community Health Center, 1986–1990

Victory over the "monster from space" didn't happen overnight. Many would argue that it hasn't happened even now. And the optimism of 1996 wasn't without precedent. AIDS researchers had high hopes for AZT, for Peptide T, and for any number of vaccines that seemed "just around the corner" beginning in the late 1980s. The difference in 1996 was that, for the first time, death rates slowed significantly. People gained weight. They stayed healthy for long periods of time. Progress was being made. But there were still too many deaths, and the side effects from early multi-drug therapy were debilitating. While there was hope and relief, much work remained to be done.

What happened at Fenway in the late 1990s was a curious combination of rededication to broader issues of LGBT health and an almost wishful belief that the health center would finally have the time to venture beyond the AIDS wilderness. Many staff members, exhausted from the relentless struggle to find some way to help its patients, were eager for the opportunity to declare victory and move on. Pent-up dreams of becoming New England's leading LGBT health care institution at a time after AIDS seemed within reach. The promise that Fenway would create new health care, research, and education/advocacy programs for lesbians and women had been made and postponed for too long. For them, as Dale Orlando put it, it seemed like it was finally "our turn."

The Fenway Women's Softball Team, also known as "The Fens Fatales" (*Photographer unknown*)

And in many ways, it was. Things just didn't happen overnight. The monster from space was retreating, but it was a slow retreat, and finding the best combination of anti-retroviral drugs took longer than expected. In addition, if Fenway was going to bring about new programs aimed at women and lesbians or transgender people, it was going to do so using its successful research-based "academic health center" model, as Stephen Boswell describes it. Doing the strategic planning, and creating the organizational infrastructure of a more formalized research program including all of the health center's communities—what would ultimately become The Fenway Institute—would be deliberate, and would take time. Fenway's constituents were coming together in a way they had never had the opportunity to attempt before. But Fenway wasn't simply going to reinvent the wheel; it was going to become New England's leading LGBT health center by assembling its unique combination of care, research, education, and policy advocacy, and moving forward across all these fronts. Success would come, but it would

take years. Not all of Fenway's AIDS patients had those years, and, as it turns out, not all of its staff and constituencies wanted to wait during those years, either.

Fenway still made remarkable progress during its most recent years. By 1996, it had already outgrown 7 Haviland Street, and was once again renting space in the same buildings it had rented before 1991. A new building was needed, and the organizational groundwork that led to Fenway's 1340 Boylston Street location began many years prior to its opening in 2009. The Fenway Institute was formally created in 2000, and the hiring of Judy Bradford as Co-Director opened the door for Fenway's delivery on its promise to be New England's leading LGBT health center. Fenway's extensive array of health care, behavioral health services, dental care, eye care, holistic therapies, and services for young gay people are part of the remarkable success story of the years since 1996.

The last fifteen years have also witnessed the development of the health center's transgender health services, completing the four communities that now comprise Fenway's "LGBT" identity. Surprisingly, this story includes early resistance among Fenway's other three communities to welcome transgender people, for reasons that seem hard to understand for transgender health care consumers. After all, each of these groups shared a common, if strange bond as outcasts and, as it would turn out, were each different from their peers in the larger society for biological reasons beyond their individual control.

Each group shared the disdain, the beatings, and the humiliation doled out by the larger society and a resulting internalized low self-esteem. But behind the unlikely assembly of these groups, whose destinies were cast together as outcasts by others, lay a common bond of struggle for freedom that relies heavily on acceptance by other outcasts.

The hard-to-lose internalized fears and prejudices of gay, lesbian and transgender people toward each other mirrors our larger society, and like the larger society is still a work in progress. Perceptions of transgender people are still often confused with cross dressing transvestites and drag queens, who might be gay or straight in their sexual attractions or behaviors. Each of these groups has felt discriminated against by gay, lesbian and bisexual people, and yet even transgender people could not fully escape their own early gender conditioning

in stereotyping men and women. It's truly a testament to humanity that these groups managed to not only band together to face the larger society by "coming out" into their own group and individual identities, but that they worked side by side through an epidemic that killed so many in one quarter of their community. Then each group managed the patience to wait their turn for the laws of the greater society, and the services of Fenway and other organizations, to pay attention to their needs.

By no means was this wait a silent process as group after group pushed their own leaders to the forefront in order to gain access to resources. Clearly this was not the type of coalition where resources once acquired were simply going to be handed out to each other because it was the "right thing to do", although if any organization came close to achieving this type of sharing it was Fenway. Smaller in number, less visible in society, transgender people were finding their own leaders who would join the ranks of Ron Vachon and Ken Mayer, Michael Savage and Stephen Boswell, Sally Deane, Dale Orlando, Susan Love and Judy Bradford in making contributions to the entire community on behalf of Fenway and in particular for their own within the health center.

Ribbon cutting cermony for the Ansin Building at 1340 Boylston Street, May 7, 2009
(*Marilyn Humphries*)

Joanne Herman, Fenway's first known transgender board member observes, "Women who are treated at Fenway have been treated in peaks and valleys. We have really made a huge difference in having a staff of women providers. We are committed now to maintaining a consistent level of women providers to keep our female population... I think it's good to keep in mind that Fenway was started by nursing students from Northeastern and in those days that meant women were the providers who wanted to care for people in the community.

"For transgender people the competence in house began with Lee Ellenberg in the Behavioral Health department and then The Fenway Institute and finally the medical providers...The transgender community is small relative to the lesbian and gay community. The most recent statistics say we are about 1% of the population and the lesbian and gay community is about 4%, so while I understand there are many things that we can do best for ourselves, it is impossible for us to do it alone. The lesbian and gay community has made great strides they developed great connections, they have great facilities like this one and there are a lot of synergies because so many of societies expectations are based upon gender. So I see it makes sense that if we can work together with gay and lesbian people that it makes sense we will be better off for that. I want to work within the system to change the difficulties in working together and to forgive what has been some of our past...What is often forgotten is that it was transgender women who lead the riots at Stonewall and earlier in San Francisco and it wasn't until much later that transgender people who could transition left to take a place in the broader community."

Fenway's national, even international leadership in the fields of LGBT health care, research, and education grew from 1996 through 2011 as never before. In 2007, The Fenway Institute, through Judy Bradford's efforts, was funded by the Eunice Kennedy Shriver National Institute for Child Health and Human Development (NICHD) within the National Institutes of Health (NIH) to develop the "Center for Population Research in Lesbian, Gay, Bisexual and Transgender Health". Population centers are funded by the federal government to study fertility, mortality, and morbidity of the US population; fewer than 20 such centers existed, and all were located in major universities. This 5-year grant to The Fenway Institute was the first awarded to a non-university based organization and

the first federal funding for a research center focused on the study of sexual and gender minority health. A signature accomplishment for TFI, this award represented "acknowledgement by the federal government of LGBT people as a unique population with specific health risks and disparities."[112] Harvey Makadon, Ken Mayer, Jennifer Potter, and Hilary Goldhammer co-authored *The Fenway Guide to Lesbian, Gay, Bisexual, and Transgender Health*, published by the American College of Physicians in 2008 after nearly a decade of development.

The time between Fenway's 25th anniversary in 1996 and its 40th birthday in 2011 can be seen as a time of organizational development, a time of unprecedented achievements, and a time of expansion in the delivery of health care services to its community, broadly defined. With the time and resources to think strategically, Fenway has done just that, by articulating its mission as a "cradle to grave" health center and creating the programs to deliver it; by using its research-based approach to medical care and education to demonstrate what an "academic health center" can be; and by using its standing as an international leader in LGBT health care to confidently add services that might not have been added twenty, or even ten years before. In the late 1980s, Dale Orlando resisted those in the organization who wanted to add services aimed at gay and lesbian youth, concerned that reactionaries in the United States might accuse Fenway of "recruiting" young people to be gay, as they did in those days. A testament to how times have changed, and how Fenway's reputation has benefited from the hard work of so many people, is the fact that the organization's acquisition of the Sidney Borum, Jr. Health Center in 2009 was not only accepted by Boston's health care establishment; it was celebrated. Fenway finally had its first pediatricians on its medical staff to serve LGBT youth sheltered by other health providers for twenty years and at long last to serve the children that Fenway helps women to conceive through Alternative Insemination.

Bisexual, transgender and youth services were improving, but what about Fenway's origins and the promise to women that their day would come at Fenway— for comprehensive care, and not for a special AI program or occasional conference on breast cancer? Phyllis Dixon, Fenway's chief of Behavioral services responded, "There has been a huge issue over the years about bringing in more women to the health center. I've been here 21 years, and for a long time, similar to the transgender community, there were many angry lesbians who saw the health center to be

excluding their care, and it was very hard and demoralizing. There are lesbian staff who have left and are still mad at Fenway.

"That has been changing more recently. Our department has always had 50% or more women staff, but the Medical Department has been more male-dominated, with one woman physician now and again, which has not been sufficient to change people's perceptions. Now we have made a commitment to having a number of women physicians at Fenway in a way that is dedicated to the provision of women's health care. My first contact with Fenway in the 1980s was to go to a Fenway workshop run by a lawyer with a huge group of lesbians to talk about having children, so Fenway has always done that sort of thing well for women. It is HIV that changed everything. Perhaps if there had been no HIV, there might have been an earlier equality in the programs, but HIV brought in so much money, and as a result people were hired to take care of people with HIV and reach out to them. I think that is what changed the balance and it's been so hard to make it right. There's been a real effort to find a balance, but at least we now have female providers. They see men too, of course, but for so many years we had only one female provider who would burn out, and then another would be hired. The women's health team now includes about 25 women in the medical, mental health, and research departments, coming together, and thinking together about workshop ideas to bring more women in for services. It's not just about physician care, it's about having more than one woman provider, especially when there used to be ten to twelve male providers and a single woman doctor all the time."

Many challenges remain. Will medical care providers worldwide commit to the use of anti-retroviral as preventive therapy vs. HIV? Will the arguments against its use prevail? Critics say it's too expensive, and use of these drugs for prevention in the United States and Europe takes them away from people with AIDS in Africa, who need them to stay alive. Since 2006, Ken Mayer has collaborated with Humsafar Trust in Mumbai and YRG Care and the TB Research Center in Chennai, India, on the study of HIV and AIDS in India. And, in February of 2011, Fenway Health hosted meetings during the international Conference on Retroviruses and

Opportunistic Infections (CROI) in Boston, where the health center featured its research findings on the potential for anti-retroviral drugs as viable preventive therapies against HIV infection.

As gay men and lesbians age, will Fenway realize its mission of caring for its original three target populations—gay men, women, and the elderly—through sheer demographics? Will Fenway's collaboration with the Multicultural AIDS Coalition in Jamaica Plain help it reach LGBT people of color with its health care, education, and advocacy services? Will services specifically designed for women and lesbians become a permanent part of Fenway's health care programs going forward, along with those aimed at gay men, bisexuals, and transgender people, or will some members of Fenway's community always be jockeying for "our turn"?

One hint comes from Jon Vincent at The Fenway Institute, describing how a recent finding from the organization's research programs is informing future programs of care and education. He mentioned the concept of "syndemics," or the synergistic combination of two or more diseases or health issues, and how these combinations can lead to complications much larger than the consequences of any single disease or issue. For example, if someone with AIDS contracts Hepatitis B, the results can be life-threatening, even if we are now able to manage either disease, at least in relative terms, on its own. One can also imagine other combinations of health risks for any number of people in the LGBT community, and understand that Fenway is one of a handful of organizations in the world that is even thinking about these possibilities, and what they mean for the life expectancy or quality of life of people who rely on the health center for care.

That is where Fenway Health is today, in 2011, at forty years of age. Issues of fairness, of the proper allocation of resources, of priorities in the face of so many worthy, even necessary things to be done are there for debate. But, after four decades of debates, struggles, innovation, and achievement, Fenway still relies on the search for new, more comprehensive challenges as guides for its future. What will the study of LGBT people as a part of American society in general teach us about how to provide the best care for them in the future? What can we learn from concepts like "syndemics" to give consumers and health care providers the

information they need to address such negative synergies before they become the next monster from space?

In the last fifteen years, Fenway Health has established an organizational personality, for lack of a better word, that defines its unique way of identifying and addressing the challenges of the future—by looking beyond the obvious choices to learn more, and to use this knowledge to guide Fenway's future, and the future of other health care institutions around the world. Dale Orlando often said that organizations tend to take on the attributes of their major client groups. For example, we can see Fenway in its early days as a young gay adolescent, focused on its internal struggles while keeping a low profile in the larger community. Then we find the health center coming out, standing up, and assuming a responsible maturity in the 1980s, when its various constituencies united to fight a life-and-death battle against a formidable foe. Finally, in Fenway's most recent history, we see a self-confident adult, fully engaging all of its internal groups in becoming a provider, a leader, an educator, and an advocate for itself and all of its constituent groups—and expanding its concept of "community" beyond Boston or even New England to one that is global in scale.

Rodney VanDerwarker, Administrative Director of The Fenway Institute, agrees with Dale Orlando's idea of the health center taking on the personality of its people, and sees this similarity in terms of the organization's staff. "Sometimes I think of my fifteen years at Fenway as a time we grew from adolescence to adulthood. It coincides with my own growing up, in a sense, along with some of my contemporaries here. I was twenty-five when I arrived as a research assistant—the twelfth research department staff ever hired. The organization had a very informal structure then, and it allowed us to mature along with it, learning by doing before we were given the responsibility to work on our own. As the department grew, we became more professional and developed more protocols and training programs for new staff as they arrived. Today, I'm forty years old, oddly enough, and Fenway at forty has procedures that are very different—more adult, you might say—for welcoming new staff to our team than we had when we first arrived."

212

..

"With Fenway, it's hard to know what made it successful back then but I'm sure the seeds were sown. Today there's a really engaged talented group of people who work on the staff and who volunteer to it that are very proud of it so they continue to make it successful. Fenway as an organization holds social events that people look forward to. It's one of the things that makes the LGBT community in Boston hang together because we have such a great health center. As long as the health center supports our care, we will continue to support Fenway."

—Joanne Herman, Member, Board of Directors, Fenway Health

1996–2011 CARE

"One of the really exciting times in my work with Fenway was the most recent local transgender health conference in Peabody, Massachusetts, in January of 2010. It was the first time in my five years as Coordinator of our Transgender Health Program that I wasn't the lightning rod for everything Fenway did wrong.

That was the first conference where no one complained. There I was at our table for three whole days, and no one complained. That's the barometer I use. It's exciting because listening to complaints isn't the nicest thing, but the fact that no one was yelling at me is also evidence that what Jenny Potter and Alex Gonzalez are doing is making a difference."

—Ruben Hopwood, Coordinator, Transgender Health Program, Fenway Health

Fenway's patient visits had been growing dramatically throughout the late 1980s and early 1990s, even if most of this growth was among gay men and other people at high risk for HIV infection. Consistent with the health center's mission, from its earliest days, no one was turned away—not when the health center served gay men who appreciated its low profile in the 1970s, and not even when Fenway's leaders understood that they did not want to become Boston's AIDS clinic, but would never deny anyone care. By the mid-1990s, Fenway was caring for about 500 individuals with HIV, by far the largest group of these patients at any health care institution in Boston. Fifteen to twenty of these patients were dying every month. Lesbians, women in general, bisexuals, and a few transgender individuals were coming to Fenway for medical services, but by and large they were seeing individual doctors and nurses who were willing to treat them. Strategic planning had been happening at the health center since Sally Deane's tenure in the early 1980s, but responding to an ever-growing population of people with HIV, and gay men concerned about managing their risks of becoming infected, was always a more immediate and pressing priority. Fenway's Alternative Insemination Program was a key exception, and the growth in demand for the health center's other actual and potential populations became the source of debates about what Fenway

could do for its patients vs. what society might tolerate. For example, Fenway's mental health/behavioral health programs were notable for their growth, and for the diversity of consumers who came for them, while the Board of Directors made a conscious decision not to develop programs for young gay and lesbian people, fearing that society at large might be unduly influenced by anti-gay politicians and other leaders, who were always at the ready to accuse gay organizations of "recruiting" youth to become gay. Still, with all these mission-centered discussions and debates, for fifteen years, there was no bigger challenge than trying to keep people with HIV alive.

And then in 1996, that challenge was met—not entirely, but in a way that all of Fenway's providers saw clearly. It was time to "take a breath and step back from crisis management," as Steve Boswell put it. It was time to plan for a future that had taken far too long to appear on the horizon. Strategic planning began in earnest in 1997, with a look at what services Fenway was providing, how these services were funded, what populations needed Fenway's unique blend of medical care and cultural competence, and what the future of medical care in the United States held in store for community health centers like Fenway. Resources—primarily funding—were available for AIDS treatment and research, but the health center's leaders didn't want to simply chase dollars because they were available. There were several conclusions that were relatively easy to draw in the early stages of this plan.

Fenway had a research program unlike any other community health center, including broad support from federal agencies like the National Institutes of Health (NIH), and a solid infrastructure capable of qualifying research findings for consideration nationwide and around the world. At the time, Fenway also had over 25 years of experience caring for the LGBT community, enabling it to earn the trust of its patients and from leaders of other, allied organizations. Its tireless work in treating people with HIV had also built large reservoirs of knowledge, trust, and respect for its commitment to medical care, and allowed Fenway to teach other providers about how to care for people with HIV, and how to care for LGBT people in general.

Fenway Health's staff grew dramatically from 1988 (above) to the mid-1990s (below) (*Northeastern University Archives*)

In addition to gay men, Fenway had made a longstanding commitment to serving the entire LGBT community. It was time to renew this commitment, and to design health care programs that would bring more lesbians to Fenway for primary health care, not only special program initiatives, on a permanent basis. Breast cancer screening and treatment for lesbians; women's health care, more broadly defined; and an expressed openness to make bisexual men and women feel comfortable at Fenway were all part of the early plan. Oddly, it would take another ten years for transgender people to be welcomed to the health center in large numbers, even though there were fifty such patients at Fenway in 1998.[113] With time to plan more strategically, Fenway could again look to the elderly, and residents of the Fenway, who were one of the three original target populations when the health center was founded. After 25 years, many of its women and gay male clients were aging, perhaps making it easier to reach out to now-elderly people who had first come to Fenway for adult medicine. It was also time to look at how the health center could welcome people under the age of 18 to its community of care.

Fenway still held its traditional positions that health care is a right, not a privilege, and that medicine should be provided for people, not for profit. Its core services—primary care, wellness care/preventive health education; mental health and addiction services; HIV testing and treatment; violence recovery program; and complementary/holistic therapies—were strong and could form the basis for expanded use by the populations Fenway sought to serve. New services could strengthen certain areas—family and parenting services would complement the Alternative Insemination Program; and more comprehensive case management for patients with complex health problems could help patients with HIV and other conditions—but these could be seen as extensions of existing care programs rather than entirely new medical programs. New Medical Departments would include the addition of a pharmacy, and the extension of Fenway's transgender health program into national leadership in the field beginning in 2006. The Transgender Health Program would also reinforce the concept of multi-department collaboration at Fenway around the needs of each individual patient, a concept that had long been part of Fenway's model of care but which finally had a nationally-recognized name: "patient-centered care."

Since the 1980s, patient-centered care had been available for many of Fenway's clients, from HIV patients who needed counseling from the health center's mental health department in the 1980s through substance abusers who sought both counseling from Fenway's behavioral health professionals and acupuncture therapists in its Medical Department. In the last fifteen years of Fenway's growth these services were extended to transgender people, and new programs developed that combined the resources of Fenway's Medical Department with the resources of The Fenway Institute. The Fenway Institute's health navigators—people who work with patients to secure their eligibility for government-funded health services and help to manage the daily affairs of their lives—are a critical element in Fenway's client-centered approach.

 Fenway's budget had grown to approximately $8 million annually by the late 1990s. Thanks to none other than Harry Collings and his efforts to help launch it, the Boston to New York AIDS Ride, an annual bike-a-thon fundraiser, was generating almost $3 million of revenue for the health center. But, by 1997, the independently operated Ride had begun to raise concerns due to its relatively high fundraising costs. It was time for Fenway to separate from this agreement, which it did in typically deliberate fashion, crafting a three-year exit strategy in order to give the organization time to replace this formidable source of unencumbered operating income.

The late 1990s also saw Fenway growing its ability to provide care to the community by acquiring an LGBT focused private medical practice then known as Russell-Harris Associates located in Boston's Back Bay/South End. The "Harris" in the name was none other than Fenway's former Medical Director Scott Harris and in 1998, Russell-Harris merged with Fenway Community Health, bringing Harris back into Fenway's fold. Located at 142 Berkeley Street, the practice is now known as Fenway: South End and offers medical and behavioral health care as well as a full-service pharmacy in a 10,000 square foot space.

Fenway had earned broad respect for its unique combination of care and research. The model of leading new programs based on research findings has long been a sound way to begin the expansion of its services to the LGBT community. This would mean creating a more formal organizational structure that would

support this research-driven growth strategy, a move that would lead to the transformation of Fenway's existing Research Department into the new Fenway Institute in 2000. It also meant bringing in researchers and other staff who would be able to expand Fenway's services into the new communities it wanted to serve. Recruitment of more women providers was a critical first priority in this mission. Education would also remain focused on health providers and actual Fenway patients rather than on the general public. This commitment built on the health center's strengths to teach Boston's medical providers how to care for people with HIV, and is also based on the strong relationships the health center had built with its patients during the long ordeal of the AIDS epidemic. Additional internal synergies would be developed as Fenway added a pharmacy, transgender health care services, and then a dental clinic and eye care facility, to its services. Patients who come to Fenway for any number of reasons are encouraged to look to the organization as a culturally competent provider of "95% of their medical care needs." This concept, a now-national model known as the medical home, is a growing organizational model for community health centers throughout the United States.

With the broad array of health care services Fenway now provides, it is well-positioned to be a national leader in this new medical home model of "cradle to grave" community health care—regardless of whether that community is defined as a traditionally-underserved group of people (i.e. LGBT individuals), or an urban neighborhood, or a geographic, multi-state region. What makes Fenway unique in the development of its medical home model is the fact that its care is expressly based on medical research conducted by Fenway itself, or by other organizations with like-minded missions. The results of this research are communicated to patients as part of this care. "Come in and talk with us" is a way of encouraging patients to become better informed about their health and how to manage it; this invitation is also a way of reminding people that Fenway is thinking about them—not just keeping track of their upcoming schedule for appointments, or inquiring about their health. Realizing Stephen Boswell's concept of Fenway as the country's first "academic community health center," the organization is *really* thinking about them in ways that apply the most up-to-date medical knowledge to help them avoid illness and injury in the future. It harkens back to the earliest

days of Fenway's Women's Health Collective, whose medical services were based on information written in *Our Bodies, Ourselves.* And it also reminds us of the unique relationship Fenway had with so many of its HIV patients during the fifteen-year-long AIDS wilderness battle, when all the health center could offer was information and its best thinking as it raced to build a bridge—any kind of a bridge—to keep people alive long enough for new and improved therapies that might extend their lives further.

"Come talk with us," and Fenway's current messaging that "medical committees charged with recommendations for patient care in the specialty area affecting you," are subtle but effective ways to communicate something truly different about the relationship Fenway is trying to build with its patients. While many doctors' offices will call patients to say, "it's time for your colonoscopy," and then move on to whatever date and time works best, Fenway's message is more engaging. Telling a patient it's time for his or her appointment is simply a way of asserting the doctor's position as someone in charge of someone's health care. The answer to the question, "why is it time for my appointment?" is, more or less, "because I'm the doctor, that's why." At Fenway, however, the message is, "we keep up on these matters; there's a committee of experts who recommend your appointment every year (or two, or five) as the best way to maintain your individual health circumstances and prevent injury or illness." That's a different message, one that communicates a respect for the patient by providing a reason for the request to come in. And, in addition to the better answer to a patient's possible question of "why?" is the final piece of Fenway's message, "come in and let's talk about it." Fenway is not simply inviting the individual to come in and submit to its medical team; it is encouraging a dialogue about what care is needed, when it is needed, and who recommends the treatment. The intended message is, "you (the patient) are in charge, and we're here to explain your options and help you make the best decision for you."

Another innovation that would come from Fenway's strategic planning efforts was its early adoption of an electronic medical records system in 1997, well before most other health care institutions in Boston. Beyond the obvious efficiencies in billing, financial management, and statistical reporting, Fenway's electronic records have two other benefits that directly enhance its ability to provide care:

first, these records make it easier for the health center's multiple departments to communicate with each other about each patient as a unique individual, and to tailor comprehensive service programs to that individual's specific needs. And second, these electronic records can be used to review each patient's history of care, so that routine screenings and vaccinations can be scheduled by health center staff even if the patient forgets to make an appointment.

The results of Fenway's strategic planning efforts would lead to two profound shifts in the health center's development. First, it would take deliberate steps to increase services for the entire LGBT community, by adding service programs, hiring more female providers to take care of women, and requiring all of its staff to take part in training programs where they could learn about "culturally competent care" for lesbians, transgender people, and other groups of individuals. Second, Fenway's planning would bring a new focus on improving the health center's programs across the organization, regardless of who a patient is, or whether that individual is lesbian, gay, bisexual, transgender, or none of the above. Sally Deane, who brought "professionalization" to Fenway thirty years ago, sees the similarities between her efforts and the growth of a more "modern" Fenway, but also sees a clear difference.

"Advocacy today isn't about gay rights, it's about taking care of a population. Until now, there was always an external threat—sanctioned hate against gay people, or a disease that might wipe out half of all gay men. Gay people—all LGBT people—are more accepted now, and Fenway is widely respected as well. The last group to join was the transgender people, and it took a longer time than you'd expect for lesbians, gay men, and bisexual people to welcome them. But we're all here now, and because of that, and because Fenway has secured for itself a place of respect in Boston's larger community, our modern story is very different than the stories of our past.

Dale Orlando sees the development of Fenway as a medical home, or as the First of the academic community health centers, as more than a continued commitment to excellence. She sees Fenway's modern story as one that could only happen with sound clinical leadership at the top. "Only a clinician could lead the medically-focused strategy driving Fenway today. Directors like myself

and others in Fenway's past could create solid managerial systems, raise a lot of money, or lead planning efforts with the staff and board of directors. But none of us had the clear understanding of medical issues, or the ability to articulate the clinical reasons for choosing a focus on medical care over community service, and then map out the deliberate steps on the way to Fenway's future in the way that Stephen Boswell can. Caring for transgender people is a great example of this, since the wider medical community actually led the advances in surgeries and care procedures and protocols for these folks, not politicians. Fenway is actually catching up with their care recommendations from years of medical experimentation around the globe through leadership by our able clinicians."

In other words, there are a lot of things others could do, even with the choices facing a "modern" Fenway Health. Executive Directors with great administrative skills could set up systems for managing multiple departments, or develop strategic plans designed to help the health center make critical choices about medical care vs. community service. They could set up electronic medical records systems and create organizational structures designed to facilitate Fenway's reliance on medical research—academics—in the development of new programs. They could advocate for LGBT health, and they could reach out to their communities to better understand the needs for health care. But they couldn't directly provide leadership in three areas critical to Fenway's future mission in the way a physician can. They cannot personally endorse the reliance on the best medical science to guide Fenway's future programs for care, education, and advocacy. They might not as easily understand the marketing value of making reference to the opinions of committees of medical professionals when recommending care to patients who have missed appointments for routine or preventive care. Finally, they would find it more difficult to break through the "healthy skepticism" many doctors in other institutions have about new medical findings and procedures, since they were not practicing clinicians, even if their information was correct. A physician, and one with both hospital experience and many years in direct patient care for LGBT people, can understand his colleagues' need for proof in convincing them to follow Fenway's leadership in caring for its community, even as that community becomes more broadly defined. It's the same credibility Ken Mayer won during his more than thirty years developing the health center's research programs.

But how does it work? What exactly is an "academic community health center?" Why was there a need to create a separate "Fenway Institute" to manage the organization's research programs? Why did health education wander from a department with that name to one called "Health Promotions" and then to the publication of the nation's first textbook for providers about how to care for the LGBT community? Finally, how does the modern Fenway create and manage new programs that can take advantage of all this clear thinking, deliberate action, talented personnel, and evidence-based medicine?

Stephen Boswell's concept of Fenway as the first of the "academic community health centers" is nothing like the academics of graduate school in Austrian literature, or advanced astrophysics for that matter. It's not cold, detached, or aloof. It's academic as the term is defined by those who practice medicine, and it's real, visceral, even blood-and-guts. Other health centers can adopt electronic medical records systems and use them to identify the need for a patient to come in for a colonoscopy, or to have their teeth cleaned, or to follow up on any number of recommended procedures for wellness care. Like these other organizations, Fenway uses its electronic medical records to invite patients to come in for similar visits. But it invites them by saying, "the medical committee responsible for setting standards of care in this field of medicine has determined that the best way to manage your health is to come in for routine screenings every two years, and it's been three years since you've been here. We would like you to come in and talk with us about what this screening can do for your well being." Fenway won respect for its pioneering medical research during the HIV crisis, and it continues to use the information learned from its research, and from other researchers throughout the world, to guide the development of its medical programs. Ken Mayer, another well-known MD at Fenway, has pioneered the health center's research efforts since 1980. Because words matter, note that the invitation is to "come in and talk with us," not to simply schedule a check-up or a vaccination. Fenway's care always comes with a healthy dose of education and insight.

This conversation is central to the concept of the "academic community health center" Stephen Boswell advocates for Fenway's future. This model begins with many characteristics of any well-run community health care institution in the United States in 2011. Care is provided by highly qualified professionals. This

care is further supported by a well-run organization that can earn revenue for patient care, augmented with grants from foundations and government sources, and designed with innovative new programs to deliver health care to a single community, or many of them. Care can also be delivered in partnership with other medical institutions or even community organizations who can deliver their own specialty services as they are required by individuals across a broad spectrum of ages, backgrounds, and other demographics. Other elements that can be incorporated into the definition of a well-managed and mission-driven community health center include robust quality control, sound relationships with government and regulatory agencies, strong ties to the community, and a talented medical staff equipped with the best technology.

Fenway has all of these in 2011. What makes the concept of an "academic community health center" different is that the organization's leadership, including the person in the most senior position, is made up of clinicians. That is Fenway's greatest strength going forward, and is also in a very real sense the culmination of the organization's forty year of struggle with what it wanted to be "when it grew up." In 1980, Fenway needed to be professional, for the first time, in all its programs—medical care, counseling, education, and research. Later that decade, Fenway needed to stay professional in the face of challenges no organization would choose—challenges that could easily have doomed the organization in any number of ways. It would have to construct a professional response to an unprecedented epidemic and help identify the cause for this mysterious disease, while simultaneously working toward a cure, or at least a treatment "bridge" that would prolong lives while searching for better therapies in the future. Then, after the epidemic had reached a stage when it became more manageable, Fenway needed to find a way to manage the pent-up demands from other groups within its broader LGBT health care community, after dealing with life-and-death issues it didn't invite but could never refuse.

But in a way almost as daring as the decision Sally Deane and Ken Mayer made back in 1980 to start a proper research program, Fenway never strayed from its commitment to focus on medical care first, and community services second. This set the stage for a 1997 strategic plan that could build on Fenway's medical care and medical research credentials to provide its future services.

Fenway would serve the LGBT community with medical care because it knows this population better than any other similar organization. It can recommend the best care for these individuals because it has a leadership founded in both clinical and managerial excellence—within each member of its senior staff, but certainly among the team as a whole. Having a clinician—a licensed MD who still sees patients at the health center—as CEO helps underscore the importance of medical care as the primary mission of the organization. Fenway could have become many things, but it is ultimately nothing other than an organization that consistently chose to grow into a great community health center. Stephen Boswell's own words tell the story well:

"A well-run organization is as much about what it doesn't do as it is about what it does do. I've always been a firm believer that an organization should make deliberate decisions about what it doesn't do, and should understand why it makes those decisions. If Fenway was going to become a health care institution, it needed to be a medically-focused organization and not a community center, which would have been worthy of support, but wasn't a direction in which I felt I could take the health center. The board made a deliberate decision to be a medically focused health center. This decision about being a community center, but being a health center has helped focus the staff and board on the agenda at hand, the one that that's been spelled out in detail by the board. A lot of organizations—LGBT organizations in particular—struggled with these issues and suffered from not making deliberate strategic choices. Whitman Walker in DC, for example, stayed with the community center approach. Medical care became a small part of the overall organization. There were lots of new programs, even housing at one point. But when funding dried up, many of these programs ended. Whitman Walker has since recovered, but it's still about one-half the size it once was."

Fenway, on the other hand, was growing significantly. Its FY 1999 operating budget was $10.5 million, and an operating loss of $1.3 million was offset by net fundraising proceeds of $1.6 million, yielding a surplus of $300,000 at year-end.

FENWAY AT A GLANCE: 1999

Fenway Health Center Annual Budget$9,187,057

Annual Patient Visits . 45,000

Number of Professional Staff169 [114]

Strategy at Fenway wasn't always about deliberate choices about what not to do. The development of two new programs from 2006 to the present highlight the way the organization's planning methodology works. The first is Fenway's Transgender Health Program; the second is its HIV Prevention and Education Program. The latter is based in The Fenway Institute; the Transgender Health Program is based in the Behavioral Health and Medical Departments. Employing health navigators as advocates for individual patients (HIV Prevention/Education) and licensed clinicians to support patients coping with life transitions (Transgender Health), these programs bring Fenway's model of care outside the walls of 1340 Boylston Street into the community. And both are led by a new generation of Fenway leaders.

Ruben Hopwood first heard about Fenway at a Passover Seder in 2006, where he sat next to Randi Kaufman, who was then head of the health center's Transgender Health Program. Then a graduate student in counseling psychology, he was interested enough to start working there as an intern. Soon enough, the Blue Cross/Blue Shield Foundation funded a training program in transgender competence in clinical care for all the providers on Fenway's behavioral health staff. Before the grant, Randi Kaufman and Ellen Rottersmann, each worked four hours per week as the Transgender Health Coordinator: a one one-hour group session with the staff, with the other three hours for administrative work and coordination with staff to set up future sessions. When Ruben Hopwood was hired, his hours went from 15 to 20, then to 24 hours per week, training every one of Fenway's providers, including all Medical Department staff. After this was completed, the Health Center hired Ruben Hopwood as the new Coordinator of Transgender Health. The 30-hour position was not full-time because Ruben still had to complete his dissertation.

"There were acrimonious relationships with the community at the time that were destructive," he recalls. "Until 2006, there wasn't a transgender health program at Fenway; services for transgender people were grass-roots, hit and miss care. There was no evidence of a plan. There was a single provider, who saw 75% of transgender patients, and the other 25% were not assigned to anyone. Our goal was to distribute the caseload, create an integrated team of providers among the behavioral health and medical staff, and teach them how to interact with gender-variant folks—to understand who they are, and how to help them with medical services and behavioral health services." Fenway's current Medical Director, Alex Gonzalez, co-led these agency-wide training programs, and made the decision that every Fenway provider would participate in the transgender health program. "Now, every one of them sees transgender patients. We went from that single provider to over twenty of them," notes Ruben Hopwood. "Our regular transgender team is an integrated group of six to eight providers from the behavioral health and medical staff. It's a credit to Alex Gonzalez that we've shifted from a collection of individual practitioners, loosely connected with each other, to a real clinic practice where care is coordinated across the whole team."

In addition to making sure every Fenway provider was trained by the health center's transgender program, Hopwood and Gonzalez also went about changing the way care was delivered. Fenway did not, and still does not, provide any surgical services on site in the program. While hormone treatments are administered at Fenway, surgery is arranged by referral to outside providers across the U.S. and abroad. When Ruben Hopwood began as coordinator, Fenway held to the "old way" of requiring every transgender client to go through three months of counseling before being qualified for hormone therapy. It put members of his team in the role of gatekeepers, creating an "ugly relationship" with his clients. "They saw us as being in the way. I wanted us to be helpers. Fenway sent Ruben Hopwood to other transgender programs throughout the country to look for a better model. At the Mazzoni Center in Philadelphia, he found one. This organization, much smaller than Fenway Health, was seeing 800 transgender clients, while Fenway was still seeing only 200. Their model was to eliminate the requirement for three months of counseling, limiting pre-hormone treatment sessions to a single meeting in some cases. "They didn't spend 12 sessions getting people to convince them

who they were. They really took the position of helping people get the treatments they wanted."

Ruben Hopwood brought back this information, and Fenway created a hybrid model. The three-month mandatory counseling requirement was no more, but there would still be enough evaluation to make sure no one was being set up for failure—maybe two or three visits. From 2007, when the program was adjusted in this manner, Fenway's transgender clients grew from 200 to more than 500 today. "We now have a client-centered harm reduction model. There's a lot of trust, a tremendous change from the way things used to be." At the time, Ruben Hopwood was the only full-time coordinator for a transgender health program in the country. Now that other health centers are sending their staff to Fenway to learn about its Transgender Health Program, others have used his job description and interdepartmental structure to set up similar programs in other cities.

"Harm reduction" isn't limited to efforts to address a lack of sensitivity among Fenway's staff. It also leads Ruben Hopwood's team to reach out beyond the walls of 1340 Boylston Street to help transgender people. "We understand that people get so frustrated with the health care system that they take hormones on the streets. We try to take over these treatments, since people really can kill themselves with these drugs if they're not careful," he says. And Ruben Hopwood's team understand the "old days" of resistance to treating transgender patients— mostly because those old days are really not so long ago. "Individual providers at other institutions had a healthy skepticism about care practices without any data to justify them. And there wasn't any data." There was information that the hormones transgender people were taking might cause high blood pressure or raise cholesterol, increasing the risk of heart disease, a valid argument against prescribing these therapies. So Fenway looked for an evidence-based way to prove to providers in other institutions that its program really is harm reduction. "We settled on statistics about suicide attempts. Among transgender adults, the rate is extremely high—41%. The average for all adults in Massachusetts in 2010 was 0.6%, and nationally, it was 10.6%. And studies further showed that the rates for transgender people drop by 50% with medical treatment. Even if these drugs raise cholesterol or blood pressure, the trade-off is worth it." Fenway's search for data and its use of it to advocate for LGBT people in Boston's (and the nation's) health

care system has one interesting potential drawback, as Ruben Hopwood sees it. "We've helped create an explosion of awareness, which is very recent, only four or five years old. We have new data about violent attacks against transgender people. Are these reports evidence that attacks are increasing, or are they just being separated out from general violence against gays and lesbians for the first time?" If in fact reporting new data is a problem, it is a short-term problem, one Fenway has had for thirty years or more as new information discovered by the health center's research staff and medical providers stands alone for a while, before others join in these programs and add data to build the critical mass necessary to qualify as data to be used in the design of new programs. Based on current plans for The Fenway Institute, this uniquely short-term problem of reporting new information early is also a continuing long-term opportunity to develop new solutions, an opportunity that will be with Fenway for a long time.

Fenway's Transgender Health Program uses the organization's Health Navigators to support its patients outside of the health center's offices. These individuals are community advocates, case managers, and HIV prevention and education specialists who provide prevention, outreach, advocacy, and overall case management. Transgender people are often unemployed and under-employed, and therefore at high risk of being denied the care they need. Navigators work with Fenway's clients and help get them stabilized. They go to court dates with them, help them arrange for housing, make appointments with a broad range of other agencies, and go with their clients for support. Another marker Ruben Hopwood uses to measure the success of his program is the acceptance he sees by other human service agencies in Boston, particularly large hospitals. "Our health navigators and community advocates can get people into care anywhere in the city today—not just at Fenway."

Hopwood also sees the boundaries of his program, and he can articulate some of the deliberate choices about what not to do. For example, he knows that Fenway can't specialize in the provision of care to the homeless, so when his program encounters a homeless gender-variant person, they work to assess whether the individual needs homeless services or medical care. If homeless services are a priority, Fenway knows organizations that can help, and can make a referral. "Maybe, when they're more stable, they can come back" to Fenway's Transgender Health Program. Hopwood

has also seen Fenway face the medical institution/community center issue. "We are clearly a community *health* center, not a community center. But we do hold an annual tea for our clients at Club Café to help them feel that they are part of a community. We celebrate with food and fun awards. We don't see anyone else doing it yet, so in this case we go a little beyond, at least for now. We hope someone eventually picks up on this need but in the meantime, we do it.

This balanced approach helps Hopwood talk about the dangers of becoming too specialized. "Look at the survival of animals. Maybe one species evolves so it can only eat one berry of one plant on one island. Then there's a hurricane and they all starve to death. If Fenway served only the LGBT community, we wouldn't survive. We still serve the neighborhood, and the students from Berklee Music School and Boston Conservatory. We keep our perspective on who's out there and what the need is. In this way, we've grown beyond queer health to women's health— *all* women's health.

"There's a recent internal staff survey on our sexual/gender identification. We weren't sure it was even okay to ask the question, but we did. It turned out that we are 50/50 LGBT/straight. This was a big surprise; we all assumed Fenway's staff would be 75% to 80% LGBT. When you think about it, this same assumption applies to HIV. It's not just a gay thing. Our organization isn't just a gay thing, and neither are the people who work here. The culture within Fenway Health, and the one we project out is that we have certain populations because we can't serve everyone. But we don't turn people away. I see people from northern Maine, India, and Asia. We have a wonderful ability to make everyone feel welcome. Anyone can come here. We have the critical mass, size, and the ability to be national, even world leaders in care. Training providers at other hospitals and medical schools is now a whole new program. We have all kinds of providers coming here, even for two weeks, to learn about care for LGBT people. Next, we need to do the same thing for behavioral health care. We can take the same approach we use with doctors and apply it to training psychologists, and if we do, we can be a national leader in training psychologists about how to work with LGBT people. There's no program for that now. Also, expanding into the lower age range of 12 to 18-year olds instead of people 18 and up is something we can do now that the Sidney Borum is part of

Fenway. We can even build on our alternative insemination program. We help people get pregnant but we don't provide obstetric care. We need to do that.

"In four years, we've come from one physician who treated people when nobody else would to now, when Joanne Herman is on our board. Large organizations don't change as fast as Fenway Health has. To see how fast Fenway Health has changed is incredible—it's not the way organizations typically change. But we have. And it's visible to transgender people outside while it's been seamless inside. That's a marker. Joanne is a vital part of the board. She's making a difference. From four hours a week in 2005 to a full-time coordinator and a team of six to eight providers, and having a transgender person on our board—it's incredible.

"One of the most exciting things that has happened recently is the acquisition of the Sydney Borum, Jr. Health Center, because it is a center for adolescents, particularly for transgender adolescents. It's not only a chance for us to serve much younger people, but also demonstrates that we still care for those who have many fewer resources and need culturally competent care. That is still part of our mission." says Joanne Herman, "As a transgender person I transitioned at age 40, which used to be a fairly 'normal age' for people who transitioned. As awareness has increased, the age at which people transition is getting younger and younger, and so you actually have adolescents and teenagers doing it, and you have a developing area of medical practice around the corner at Children's Hospital, focusing on puberty and the changes we all go through at that time.

"Children's Hospital gives children who have a persistent feeling of being another gender enough time so that when they do qualify for any gender change procedures, they haven't had as many secondary sex changes occur yet. So for a young transgender boy, one who began life as a female, he would not go through puberty and would not develop breasts, for example. For someone born male who feels internally female, like me, the two big things that happen in male puberty that can be avoided are the dropping of one's voice and the fact that we tend to be taller than most women our age. There are now lots of younger women who are taller than me, but for many transgender friends my age, we are much taller than most women. I would love to see Fenway play a role in that, maybe as it gets involved in efforts to make transgender medicine part of the routine care

available for youth here, like the care available for them at Children's. It's something that we can do."

Jon Vincent, Director of The Fenway Institute's HIV Prevention and Education Program, had heard about Fenway even when he was a young man living in Los Angeles. He got a job doing "volunteer wrangling" at AIDS Action Committee when he moved to Boston in the 1990s, where he met Larry Kessler, someone he also admired from across the country before heading east. "He's like my dad, he has a perspective of giving, nothing but pure altruism," Jon Vincent remembers. Through AIDS Action, he was introduced to Gail Beverly, Fenway's legendary counselor, whom he adopted as his second mother, to complete the family. He began working with Fenway in 1996, and, like Ruben Hopwood, has loved working here ever since. "The smartest researchers in the world on HIV are just down the hall," as he puts it. His work—testing for, and preventing HIV—is defined as "translational research," and moved from Fenway's Research Department to The Fenway Institute when it opened in 2000. As happy as he is at the health center, he has no illusions about the challenges that remain in combating HIV. "There are still problems ahead. People have HIV and they don't know it. Recently, there's been a 27% increase in syphilis, and statistics from 2007 show that 12% to 14% of men having sex with men are HIV positive. Here at Fenway, 2.5% of those coming in for a test find out they're HIV positive for the first time. We have to change behavior, not just by encouraging safer sex practices, but by convincing people to get tested. If 50% of the people in Boston who are HIV positive don't know it, that cuts our national statistics on reducing new AIDS infections in half.

"But it's not just HIV, it's syphilis, too. If 1/3 of the people who have syphilis don't know they're infected, within ten years, their brains fall apart, and they get holes in their hearts. The outcome isn't all that much different from what happens with HIV." Jon Vincent also talks about the concept of "syndemics," a concept embraced by The Fenway Institute's researchers that certain diseases accelerate the infection rate and progression of other diseases. "Hepatitis C 'jumps' quickly among HIV-positive people. Hepatitis C may be sexually transmitted, but it isn't

always transmitted that way. It can be spread through dirty needles. But if you're HIV positive and have Hepatitis C, and you then get Hepatitis B, you'll probably die. People need to know this." Fenway's HIV Prevention and Education Program is built on an understanding of how syndemics can destroy a person's health, and includes information about this danger along with community outreach to overcome resistance to testing and education for multiple health issues. "The same stigmas that stand in the way of getting an HIV test also keep people from getting tested for any STD. Similar social stigmas keep people with drug issues from seeking help. People who abuse crystal meth are at increased risk for HIV, Hepatitis C, and syphilis. We've always served people who can't get care and we need to keep finding them, looking for them. We need to keep at it." Jon Vincent remembers his days at AIDS Action Committee, and the differences in how Fenway structures its education programs as compared to other organizations. "Fenway Health is conservative in its outreach. We don't use profanity or pornography in reaching out. We're not in your face but we're effective. It reminds me of what Teddy Roosevelt is quoted as saying, 'speak softly but carry a big stick.' Our experience is our big stick. People respect Fenway Health."

Fenway's HIV Prevention and Education Program is also structured around current demographics of the HIV epidemic and "syndemics," and how the health center's patient population matches up against those demographics. Jon Vincent knows that "black gay men are unbelievably disproportionately affected by HIV, and not for the reasons people think." On the other hand, he also knows that black gay men make up a small percentage of Fenway's current clients. To reach out to those most at risk for infection, the program made two important moves. First, it developed a multi-level partnership with the Multicultural AIDS Coalition (MAC) in Jamaica Plain, training their staff in how to work with people with, or at risk for, HIV, while learning from MAC about how to work with people of color. Second, after listening to the staff at MAC and people surveyed directly by the Institute, Fenway decided that a more grass-roots, neighborhood location would encourage at-risk individuals to seek testing and education services, and made a remarkable decision. They would return to the health center's 16 Haviland Street location, still leased by Fenway after all these years. With an interior well refurbished for its new role, the health center's historic headquarters is the new

home of "Fenway: Sixteen," the official name of the new partnership with the Multicultural AIDS Coalition.

"The key elements of Fenway: Sixteen are a level of integrity and under-standing, so we get buy-in from our partners and the larger community to competently address the current issues surrounding HIV. We want black men to go to their offices for the program, but we expect that white people in Jamaica Plain will go there as well. And we also want black people to come to 16 Haviland Street. Our goal is to achieve cultural healing and integration, which in many ways is just as important as our HIV work," Jon Vincent says. "We want to serve the broader community but stay focused. We want to increase our capacity with people of color and transgender people. People have been critical of the way Fenway worked with these communities in the past. We're dealing honestly and with integrity to overcome these issues. We've always pushed for LBG stuff. In our state today, there's same-sex marriage. But we weren't competent or caring about the transgender community. And by 'we' I mean all gay people—not just Fenway. But today, Fenway has built pragmatic health services for transgender people. We need to remember that in the larger society anyone different is subject to attack and Fenway has."

Bringing HIV testing and education services back to 16 Haviland Street can be an emotional subject. For many, it's coming full circle, going home to where so much began so long ago. For others, it's a step back. One longtime Fenway patient wondered aloud, "why would I want to go back to that rickety old building when the health center has such a big, modern, clean building? Why would I want to be a second-class citizen again?" The important thing to remember about how today's Fenway Health operates is that this move is based on research and fact-finding in its program design work—there is evidence that many gay men from a variety of racial backgrounds prefer the confidentiality of an unassuming neighbor-hood storefront—and also that the program incorporates individual choice. "We expect that 80% of our counseling and testing operations will go there," says Jon Vincent. The other 20%, or whatever the ratio turns out to be, can still walk into 1340 Boylston Street or Fenway: South End and receive the same level of care and welcoming consideration.

Cameron Kirkpatrick is a black man who first came to Fenway in 2003 to volunteer for its HIV Vaccine Trial Network study. He remembers the first day he want to 16 Haviland Street to begin his four years of participation. "You went down a little alley way and then down a ramp. It was an alley. It didn't look like a health center at all. It was just this plain gray door and you had to ring a buzzer because there were no windows. It was a little creepy now that I think about it. There was this interesting kind of discreet anonymity, which was kind of cool; I guess...a little cloak and dagger. Thinking about Fenway going back to that building to reach out to gay black men brings up an interesting topic. Is it much cooler to be gay and white than to be gay and black? Is it much more socially acceptable in our communities? Is being on the down low a particularly important thing? Do we continue to just stay in the shadows or do we just deal with it? I've been out since I was fifteen. It's been a really long time. Being gay isn't an issue to me.

"But if I had to choose between going to 16 Haviland Street, or 1340 Boylston Street, I don't know. I like shiny new things as well as really cool old things. The new building is really bright, there's actually good parking, and it's probably easier to get into and out of than 16 Haviland. 1340 Boylston Street is a really beautiful building. It's brighter and it looks cleaner. I'm sure both facilities are sterile but this one has the appearance of being shiny, metallic, sterilized. There, it's an alleyway. There are cats, mice. But there's discretion there. To be honest, if that clinic was located next door to where I went to school and if my colleagues only saw people who went in there who were HIV positive, then it might stigmatize anyone who they saw going in there to be HIV positive. Therefore that stigma might be transferred to people going in there for health care. So I could see why people would want the discretion.

"But this is 2011, and I think that it's much easier to be a gay man and it's much easier to be anyone living with HIV now, because the world knows so much more about it. There's less stigma about it than there used to be. If it's 2011, I'd rather come to this building. However, if it were 1984 and people didn't know what HIV was, and they thought it was this gay immunodeficiency thing that everyone was deathly afraid of, and no one wanted to be associated with, no one wanted to be labeled as having it, then, yeah, the discretion of that gray door probably had its place."

Jon Vincent's program's Health Navigators operate outside of both 16 Haviland Street and 1340 Boylston Street much of the time. Many of them are also young, some just out of college. He describes them in words similar to those Ruben Hopwood uses to describe Fenway's Health Navigators. "They do what it takes to help HIV patients. They advocate for them at human service agencies, even help improve their credit scores. Each of them sees about fifty people per year. One navigator went to a guy's house and found him, then took him to the hospital and stayed with him until he died. It's both happy and sad. You can't always win the battle but you can make the outcome easier to manage. Our navigators see 20% mortality per year. That means 10 of their 50 people die. It's tough, but disease, destitution, and pain strike from nowhere. We send out our ethically centered young navigators to help. "

"Above all, Fenway is careful and conservative. We strike a delicate balance. Isn't that what care is—moving gently through the world and doing things to achieve the best possible outcomes? If that's what Fenway is about—being metered and not reactionary, then that's fine with me. We can build programs that are based on a public health model, or we can build them on a grass-roots reactionary model. We choose the medical model because we don't want people to be sick. We want to stop pain and suffering at its source. It's a cultural balance between our organization and others with which we work."

Within Fenway's overall clinical mission, Jon Vincent has found a way to describe the unique aspect of the HIV Prevention and Education Program and its team of Health Navigators. "We're not researchers, we're not therapists, we're not doctors, we don't generate any revenue. But we hold the line. We float in this cool, weird space that is called translational research. We get to do stuff that we think will work. It's an echo of what Fenway started out to be."

..

I've seen organizations suffer greatly for ego. I think there's a place for ego, because someone with vision and passion is going to come across as having one. There's been a long and interesting cast of characters at Fenway who were passionate, driven people who doubtless believed they knew exactly what the right thing to do was, but there have

always been enough people and systems in place to check folks and to check their power of conviction as opposed to letting it take over.

I want to be careful not to sound like Fenway is a weapon against the people who would hurt us, but I'm not afraid to put the concept out there that Fenway is a response to a threat to our culture. It's a very thoughtful, careful response that has always been metered and perpetually challenged from within. I've never seen this organization not be self-aware. I've never seen our senior management team and not seen them question each other and what we're doing in an honest and ethically centered way. It comes down to being centered. We are not so stupid to let our own agenda damage a larger picture, which is the power-based symbol of how our culture—LGBT culture—cannot let space monsters like HIV or hate, discrimination, or injustice, get any further along than they already are.

Fenway draws a line beyond complete and utter abandonment and chaos of the community and the things that could go wrong and wound us further. I wasn't here in 1971, but I imagine that the spirit was the same among the nursing students who fired up Fenway at the beginning. It was our unspoken mission statement that we would always do the right thing. Why would we not? This entire organization is based on the mission of mitigating pain and suffering.

—Jon Vincent, Program Director fo Prevention, Education, and Screening

1996—2011 RESEARCH

"Knowledge is useless if it is not put to work to create change."
—The Fenway Institute, 2009

The late 1990s were a time of tremendous growth for what was then still called the Fenway Research and Evaluation Department. In the autumn of 1998, what was then "the largest and most advanced anti-HIV vaccine study in the country" began at Fenway's 7 Haviland Street headquarters. Volunteers were inoculated with an experimental drug called AIDSVAX, designed to stimulate the production of anti-HIV antibodies to prevent infection. Fenway recruited over 150 of a total of 5,000 men participating in the study worldwide. This initial study, supported by a biotechnology firm called VaxGen, was quickly followed by a second, larger network of HIV prevention studies, known first as HIVNET, and then as the HIV Vaccine Trials Network, or HVTN, supported by a multi-year grant from the National Institutes of Health. These networks included nearly 20 sites worldwide; in Boston, Fenway collaborated with Harvard Medical School, the Brigham and Women's Hospital, and Brown University. HIVNET and HVTN tested a number of different approaches, including the combination of two anti-HIV vaccines.[115]

A second international study, this one focused on prevention, was also funded by NIH, linking twenty-five research sites around the world. The international HIV Prevention Trials Network (HPTN) included Fenway as the leader in a consortium with Brown University and a community-based organization in Chennai, India. For the first time, Fenway was engaged in an international HIV research study, a position it would continue and expand to Mumbai (Bombay). Fenway is working to develop research, education, and preventive intervention programs for men having sex with men in India, because its "severe legal and social sanctions" against gay people create an environment in which the HIV epidemic is rapidly expanding. Fenway's international leadership has also grown to include training programs in HIV care for providers in India, Asia, Europe, and Africa, and projects in Eastern Europe and Russia to study "the link between public policy and HIV risk among injection drug users in those countries."[116]

A third research priority was aimed at the identification of people who were very recently infected with HIV, and possible treatments that could prevent early infection from causing a generalized infection. Fenway, along with Massachusetts General Hospital, Brigham and Women's Hospital, and Lemuel Shattuck Hospital, was designated a Center for AIDS Research (CFAR), which focused on early detection of HIV in the blood, before an individual makes antibodies against HIV. Ken Mayer explained, "The thinking is to try new treatments to see if the virus can be removed from the body. And even if it can't be removed from the body, what if you could help the immune system become so strong—because you treated for HIV early on—that you could stop the anti-HIV medications and the virus would stay suppressed?" Non-occupational Post-Exposure Prophylaxis (nPEP) was a similar effort to prevent early exposure to HIV from progressing to a general infection, and Fenway was one of two study sites in the United States to receive funding from the Centers for Disease Control and Prevention (CDC) to study it. This precursor to the Post-Exposure Prophylaxis (PEP) and Pre-Exposure Prophylaxis (PrEP) regimens that have been proven so successful from 2008 through 2011 was also called the "morning after" HIV treatment at the time. Animal studies had demonstrated that, during the first 48 hours or so after exposure, HIV would remain "local" to cells in the exposed area. nPEP was based on the theory that, if anti-retroviral drugs were administered early, they could prevent these localized cells from replicating and spreading the virus throughout the body. The immune system could then attack and destroy these small numbers of localized cells.[117] It was clear that, even as HAART (highly active anti-retroviral treatment) had lengthened the lifespan of people with HIV/AIDS, Fenway's researchers weren't about to slow down their efforts to treat, and possibly prevent, the epidemic.

But the late 1990s were also a time when Fenway was realizing its promise to be New England's leading LGBT health organization. With the time—and the resources—to dedicate to the rest of its community, Fenway, through its Research and Evaluation Department, embarked on important new programs aimed at improving women's, and lesbian health. In addition to the organization's early Women's Health Collective, or its first-in-the-nation Alternative Insemination Program, its new wave of lesbian health research is sometimes traced to Fenway's Lesbian Health Needs Assessment, a study funded by the Massachusetts Department of Public

Health, and done in conjunction with Family Planning of Western Massachusetts. While this project "made important contributions to the growing body of knowledge about lesbian health issues," a true watershed was Fenway's hosting of the first annual Lesbian and Bisexual Women's Health Research Forum in New England, in 1998. This event drew over 100 researchers from across the United States to Boston, and was truly the first annual such forum, having been held ever since.[118]

Of particular note at the 1998 conference was the keynote speaker, a national pioneer in lesbian studies from Virginia Commonwealth University, Judy Bradford. She had done her doctoral dissertation on AIDS in 1983, when there were only two known cases of the disease in Virginia, and was able to get a "snowball" study funded by the CDC through the Virginia Department of Health. "It was a sample of asking people about what do you know about AIDS, and how does this relate to your life? These questions allowed me to ask about feelings about being gay, about being out. Getting the study funded taught me a lot about how to make creative use of resources available," she says. At the same time, she was doing her dissertation, Judy learned about the plan to conduct a national survey of lesbian health. Gloria Steinem provided funding to support the National Lesbian and Gay Health Foundation in its plan to conduct the first such study—the National Lesbian Health Care Survey (NLHCS), still recognized as the benchmark study of lesbian health. Judy Bradford was the NLHCS Research Director, having met the study's instigator Caitlin Ryan at an international AIDS conference in New York City. The NLHCS remains noteworthy for its sampling strategies, including survey distribution by a broad network of lesbians throughout the US.

Judy Bradford remembers being impressed with Fenway's research program and the closer connection to underserved populations that could be afforded by community-based programs, compared to similar work conducted by university-based researchers. "To do public health research, for example, state governments have to be convinced to support studies. Politicians need data to convince them that there's a need. With gay men and lesbians twenty years ago, or transgender people today, there's a problem, which is that people don't trust researchers or government, so it's hard to get them to even begin to want to be studied, so you can get baseline data to show politicians. Community-based organizations like Fenway had that trust, and they could get the baseline data. They could tell the

Jenny Potter, Director of Women's Health at Fenway and Beth Israel Deaconess Medical Center, receives the Susan Love Award at the 2008 Women's Dinner Party. (*Marilyn Humphries*)

state health department the information that was needed to take to the politicians: these people live in your counties, in your jurisdictions. At that time, and still too often today, marginalized people would not come into a university or a pure research facility to do that. There was virtually no trust in research. But the community-based approach worked. Increased money could be allocated to study gays, lesbians, and transgender people because they would actually go to a community-based program. Fenway did all of these things—they had health care, they had a research department, and they had the people. That's what was so impressive to me."

At the same time, Fenway was looking to expand its research programs beyond HIV/AIDS and gay men to include lesbians, bisexuals, and transgender people. Judy Bradford impressed everyone at the 1998 conference, and she was impressed by Fenway's research accomplishments and the relationship with its patients it had established after twenty-five years of community health care. Even before

the Massachusetts Supreme Court decision of 2004, it was a marriage made in heaven. Judy Bradford remembers her courtship well. "Between that conference and the founding of the Institute in 2001, I was connected to Fenway at forums and in the growing national LGBT health movement. After an historic meeting of several LGBT scientists and national organizations in the Office of the Surgeon General, Fenway organized and hosted the first gathering of LGBT health leaders to develop a plan for national action on LGBT health and to create what became the National Coalition for LGBT Health. Steve Boswell, Ken Mayer, and Henia Handler were key leaders in this emerging movement. I met and got to know them personally and to learn more about Fenway during this amazing series of events at the turn of the century."

In fact, Fenway facilitated development of the Coalition and organized national organizing meetings for LGBT health during the 2000 Millennium March in Washington. The first document reporting county and state-level prevalence of same-sex households in the 2000 US Census was produced by The Fenway Institute, in conjunction with the Policy Institute at the National Gay and Lesbian Task Force and research support from the Survey and Evaluation Research Lab at Virginia Commonwealth University.[119] This report was used effectively by the Coalition to awaken Senators and Congressmen of the presence of sexual minorities throughout all but a handful of counties across the country. Also in 2000, Fenway and Judy Bradford co-produced the Women's Health Information Study, which also included the Hutchinson Cancer Research Center in Seattle, and Wheaton College. "Lesbian and heterosexual adult women were compared on a variety of health-related measures." The basis was being formed for larger-scale investigations of lesbian health. But it was clear that this was just the beginning. Louise Rice, then Director of Research and Evaluation at Fenway, understood the problem as well as anyone. "In research with any minority population, one difficulty researchers face is invisibility—finding the member group you want to investigate. There are a number of issues we want to pursue, but we are still learning about the community and this is why survey research is so important. So much of the success of this kind of research depends on becoming savvy about our community, working with a strong professional staff, and being in the right place at the right time."

242

For Judy Bradford and Fenway Health, the right place and the right time might have been a conference in Santa Monica, California, in 2000. Ken Mayer and Stephen Boswell were there. She remembers getting on an elevator, and there were the two Fenway leaders. "They said, 'how about if we go to dinner,' and I agreed. They wined and dined me, and asked me to come to Fenway and co-chair the Institute. They were very convincing. 'You know what, we can do this. We have the infrastructure; we're known at the federal level, our medical center is outstanding about HIV/AIDS. We need to create a broader-based LGBT research structure than we have had. We want to build it out and create an institute.'" Judy Bradford was impressed. "I knew Ken Mayer was a great scientist, but that night I learned he is a caring physician, like my father was. It felt right that the person in charge should be a doctor. I knew Fenway by then, and I knew LGBT health. I had conducted my dissertation study on AIDS when we had two known cases in that geographic area, I received the first research dollars to Virginia from the CDC, and by then had conducted over 2 dozen population-based surveys to track response of the state health systems to AIDS. The NLHCS had been accepted and promoted by the US government. Although I had no direct experience with clinical trials research, I had become immersed in the LGBT research movement and wanted to find a place that would focus on doing this work. Fenway's level of research was something to build on, and they had what no university could have—the ability to get people to come. And, in addition to the LGBT people who were already coming to Fenway, they also had the researchers. There weren't that many good people interested in doing LGBT research at the time, but those people were already here at Fenway."

Judy Bradford agreed to co-chair The Fenway Institute, and began her new position in 2001, with Ken Mayer as the other co-chair. In addition to her experience in lesbian health research and assessing Virginia's response to AIDS, she brought a range of skills in probability studies of the general population and methods used to conduct research with hard-to-reach populations and, for lack of a better word, "street smarts". The Health System Navigators that Jon Vincent uses in his programs are based on her translational research experience and techniques, using researchers with skills similar to case managers in medical care/ social work and applying similar techniques to support individuals and keep research cohorts together over long periods. She also provided a highly effective model for reaching out to and maintaining contact with

high-risk individuals—people with HIV/AIDS, or transgender individuals—and was able to help Fenway secure the first federal funding to "adapt and evaluate patient navigation as an effective HIV prevention intervention for disadvantaged persons infected with HIV, from the HIV/AIDS Bureau in the Federal health Resources and Services Administration."[120]

Judy Bradford's academic street smarts are also a significant, if unexpected contribution to Fenway. "I learned long ago that the key to funding research is to find a way to match resources given to you by the government for their intentions to support what you want to do with those resources. It goes back to my experiences in Virginia in the 1980s. We got AIDS money and channeled it into broader research on LGBT issues. We got grant money by responding to a proposal and, in the execution of the study; we expanded the purpose, and the cohort around the edges. Sometimes, the data discovered in the study itself leads to new areas of investigation. In other cases, you can use unrestricted funding or contingency budgets to explore topics that suddenly seem promising. It's about being a pioneer, creating something new from a number of different sources. You use these funds to build a critical mass of scientists and infrastructure. You get a cadre of people to manage your data with the highest of standards. You hire scientists and students early in their careers and put them to work. You get senior scientists to provide leadership and train others. At the core, you have to know how to do this and balance resources so growth doesn't get too far ahead of your infrastructure and you don't fail. What makes this possible is having a good eye for opportunity. It's like tennis. You have to have a good eye about where to hit the shot. You have to be smart enough and nimble enough to get to where you need to be, and you have to have an organization that can move quickly while others might take a long time. You have to get your infrastructure together and take some risks. Hit a top-spin backhand when everyone else thinks you'll circle around and drive a forehand down the line." Fenway's past experience in developing its research programs, combined with Judy Bradford's experience and talent for creating her own, became nothing short of Ken Mayer's wish fulfilled.

The Fenway Institute began its work in earnest, even as Judy Bradford spent the first few years of her tenure as co-chair commuting between Boston and Virginia. In addition to its research, the Institute developed its own combination of education

and training programs aimed at both consumers and medical professionals; mental health interventions as well as medical innovations; and advocacy work. The Institute defines its three major areas of focus as HIV/AIDS, the study of trends in LGBT health through Fenway's Center for Population Research, and a growing body of international work.[121] It created its own distinct mission statement:

"To ensure access to high-quality, culturally-competent medical and mental health care and to reduce health disparities for traditionally underserved communities, including lesbian, gay, bisexual, and transgender (LGBT) people, and those affected by HIV/AIDS."

The search for a preventive AIDS vaccine has been a dream for researchers almost since the beginning of the epidemic. From the mid-1990s on, clinical trials of various therapies have been conducted worldwide, and Fenway has participated, even led these studies since October 15, 1998, when the first volunteers were injected with the VaxGen drug ADSVAX. Since that time, over 500 people have participated in Fenway's HIV/AIDS vaccine research. Cameron Kirkpatrick, whom we previously met discussing the differences between the health center's 16 Haviland Street and 1340 Boylston Street offices, encountered Fenway's street team at Club Café in 2003, where they were handing out condoms, providing safe sex education, and recruiting volunteers for an AIDS vaccine research study. He thought it would be a great way to help out the community, and since he was already getting tested regularly for HIV, decided to enroll. His first day at Fenway's 16 Haviland Street offices, he met Janet Dargon. "She was great, probably the most bubbly person you can imagine. After a hearty, 'hey, how are you doing?' she sat me down over a cup of coffee, and explained what the study was trying to do. They had grafted a possible vaccine onto the adenovirus, a virus that causes the common cold. They assured me that I wouldn't be injected with any live virus, and answered my questions as best she could. Some were easy—if I went somewhere else for an HIV test while enrolled in the study, I might get a false positive result because the vaccine was designed to make my body produce HIV antibodies. Some of my other questions—what were the side effects, and how long would the vaccine stay in my body—weren't able to be answered." He remembers Fenway being "community based, a bit of a little family, gay-centric, and very relaxed. They were focused on their work of HIV testing and counseling. I felt very little

stigma about anything." After his initial interview, Cameron Kirkpatrick agreed to participate, and was invited back a short time later.

The day he began testing the vaccine, he went back to 16 Haviland Street, and, over another cup of coffee, was asked questions about his sexual history, any allergies, and emergency contacts if anything went wrong. Then he received his first injection, and left. He came back one month later for the researchers to draw blood. There were a total of three injections, and in-between they tested his blood to see if he was producing antibodies. "I went once a month for a year, and then every six months thereafter for a total of four years. They were good about continuing to offer counseling at every visit. They would talk with me about how I might react if I got a positive test result for HIV. What would I do? How would I tell my family, or my partner?" Cameron Kirkpatrick knew from the beginning that he was in a double-blind study, and he was given a participant number that didn't tell the staff whether he was in the live vaccine group or the placebo group. Like all the other volunteers, he didn't know until the research team "unblinded" all the results at the end of the study. They did this in a social gathering at—where else?—Club Café. "We had a couple of drinks together and talked about our experiences, and then we found out whether we were in the placebo group or the active group. I was in the active group, and they also told us that they found the vaccine was non-efficacious. Actually, the people in the active group were slightly more likely to sero-convert. Whether it was behavior, because people felt they were protected with the vaccine and were less careful, or perhaps because the vaccine slightly weakened the immune system, they weren't sure."

Cameron Kirkpatrick remembers a couple of things when he looks back on his four years in the study. "We all made the same choice to do something for the greater good. I was motivated for the greater good myself, but I don't believe I did anything to be part of a community of people participating in the study. And also, for me, it wasn't just for the greater good. It was a paid study. Every time I walked in the door I got $50, which, as a student, I really appreciated." He also has one more enduring memory. "One day, Ken Mayer came in and talked with me. And I thought, 'what an attractive man Ken Mayer is. Wow.'"

Three other prevention strategies have proven more promising than Fenway's AIDS vaccine research. One is the use of antiviral medications to prevent infection after likely exposure to HIV, or post-exposure prophylaxis (PEP). This treatment option had been recommended for healthcare workers for years, but Fenway was among the first to evaluate the use of this treatment among people exposed to HIV through unprotected sex. PEP builds on Fenway's nPEP work before the founding of the Institute, and is based on research findings that there is a brief period early in the course of HIV infection before the virus spreads throughout the body. A second treatment option is pre-exposure prophylaxis, or PrEP, through which antiviral medications are given to HIV-uninfected people to prevent them from acquiring the infection at all. PrEP is "anti-retroviral therapy (ART) given until it's present at levels which prevent HIV from replicating." The Fenway Institute was part of the first global study of the effectiveness of PrEP, and its work continues to this day. In fact, PrEP was the subject of much discussion at the 2011 Conference on Retroviruses and Opportunistic Infections (CROI), which was held in Boston. International studies have demonstrated that PrEP is effective in preventing HIV infection; in fact, research results indicated that it is almost universally effective. The only instances of HIV infection in people taking PrEP were likely explained by a failure to take the drugs as prescribed, or by the inadvertent taking of PrEP by people already infected with HIV. With effectiveness largely demonstrated, much of the conversation at the CROI session held at Fenway Health on February 26, 2011, centered on practical and ethical issues that derive from PrEP's proven ability to block HIV infection and be an actual game-changer. "A pill a day to keep HIV away" was the title of one of the presentations.

There are practical and ethical questions about PrEP and its place in the development of future anti-HIV programs. To date, PrEP does not build up in the body; in order to be protected, an individual must take the drug on a regular basis. Given that fact, does the cost of PrEP mean that we should only give it to people at risk of becoming infected? And, if that's the case, how do we get people to volunteer the information that they are at risk? In much of the world, it is still unlikely that a patient will volunteer that he is a man having sex with men; in fact, most providers don't even feel comfortable asking the question. In some countries, parental consent is still required for the antiviral drugs used in PrEP. Are teenagers likely

to tell their parents they're having unsafe sex? Given these barriers, does it make more sense to give PrEP to everyone, regardless of reported high-risk behavior? What would the cost of universal PrEP be? Does it make sense to give antiviral drugs to uninfected people in the United States and Europe when HIV-infected people in Africa still need these drugs to stay alive? What about side effects? Is it better to have everyone protected from HIV, even if a large increase in side effects were the result? Will medical insurance or Medicaid cover PrEP?

A third treatment option being explored is the use of microbicides—vaginal and rectal gels or suppositories that might prevent the spread of HIV through sex. "An effective microbicide could dramatically expand prevention efforts, especially for women in the third world who often cannot advocate for their own sexual health."[122] With promising preventive therapies now being tested, and their effectiveness appearing to be well documented, we may have reached a true milestone in the fight against HIV. While practical and ethical issues remain related to the ability to deliver PrEP to everyone who can benefit from it, these concerns are a far cry from the practical and ethical issues facing providers in the 1980s, when there was little they could do except "monitor their patients closely," or, as Harvey Makadon remembers, listen with compassion to their concerns and fears in the face of a disease that would likely cause their deaths within weeks or months. For the first time since that day in June, 1981, when Ken Mayer brought *Morbidity and Mortality Weekly Reports* to his colleagues at Fenway, there are both treatment and prevention bridges that can keep people alive until more effective treatments or cures are developed. And also for the first time, "effectiveness" of treatment is not measured in additional weeks or months of life, but in the ability of patients to get and take the medication as prescribed, or in terms of its side effects, or by looking at the economic impact of universal prevention efforts. One participant at Fenway's CROI sessions said, "We don't want PrEP to be like methadone." For many people fifteen to thirty years beforehand, this would have been a nice problem to have.

If the face of HIV/AIDS research has changed dramatically, The Fenway Institute's larger focus on LGBT health, and on lesbian health research, has made an equally dramatic impact by just getting started. Judy Bradford came to Fenway not just because it was a promising place to conduct LGBT research, but because she knew that "LGBT people have unique, largely unstudied health needs," and she wanted to "develop the science that leads to more comprehensive and sensitive care for sexual minorities." Under her leadership, The Fenway Institute joined with other organizations such as the Gay and Lesbian Medical Association (GLMA) and Columbia Medical School to advocate for the inclusion of LGBT people in the US Department of Health and Human Services' *Healthy People 2010* and *Healthy People 2020*, recommendations on the health of America's citizens designed to:

- Identify nationwide health improvement priorities.

- Increase public awareness and understanding of the determinants of health, disease, and disability and the opportunities for progress.

- Provide measurable objectives and goals that are applicable at the national, State, and local levels.

- Engage multiple sectors to take actions to strengthen policies and improve practices that are driven by the best available evidence and knowledge.

- Identify critical research, evaluation, and data collection needs.[123]

At a meeting in New York in 2000, Fenway, the LGMA, and Columbia Medical School began to lobby for the inclusion of LGBT people in HHS' *Healthy People 2010* study. They were unsuccessful in this effort, because, as Judy Bradford remembers it, there wasn't enough data to qualify for more inclusion of LGBT people in the document. There was official mention of "persons defined by sexual orientation" as one of six groups of people with disparities in access to health care, along with racial minorities and women—"the usual suspects," as she puts it. Without getting into the real book, this coalition did "the next best thing," and published a companion document. With funding from the LGMA and the Federal Government, they assembled 120 writers from across the country, including Ken Mayer from Fenway, to publish a book that summarized what was known about LGBT health, how the CDC works, and a guide to the resources that could

be used to make sure LGBT people would be included in the next edition of the HHS study, *Healthy People 2020*. The coalition's companion document, which was published privately after the election of George Bush ended their hopes of having it produced by HHS, formed the basis for nationwide training on the need to develop standardized descriptors for groups within the LGBT community who deserve to be included in *Healthy People 2020*. In December, 2010, HHS in fact did just that, announcing that its blueprint for the next decade of public health prevention and policy goals would include LGBT populations.

A more significant milestone was reached just three months later, when, on March 31, 2011, the Institutes of Medicine issued an historic report entitled, *The Health of Lesbian, Gay, Bisexual, and Transgender People: Building a Foundation for Better Understanding*. This report will be used by the National Institutes of Health (NIH), other federal agencies, and the U.S. Congress to address the health care needs of LGBT people. Fenway's Judy Bradford and Harvey Makadon served on the 17-member committee that assembled the report. Writing in the April 7, 2011, edition of *The Huffington Post*, Bradford notes the importance of this unprecedented study:

Dr. Judith B. Bradford, Co-chair of The Fenway Institute and Director of The Center for Population Research in LGBT Health. (*Marilyn Humphries*)

"LGB youth are at increased risk for suicidal thoughts, attempted suicide, and depression, and early indications are that the same is true for transgender youths. Compared to heterosexuals, LGB elders may have higher rates of tobacco and alcohol use; research on tobacco and alcohol use among transgender elders is largely lacking. And compared to heterosexual women, lesbians and bisexual women have reported higher rates of breast cancer and obesity, a factor associated with cardiovascular disease...Among the report's (other) findings: LGBT individuals face financial barriers, limitations on access to health insurance, and widespread ignorance and insensitivity on the part of medical providers. Lesbian and bisexual women are less likely to have regular checkups than heterosexual counterparts, reporting negative experiences of their own and what they have heard from others. Although very little research has been conducted on the quality of care experienced by sexual and gender minorities, limited data suggest that when transgender-specific services are accessible from knowledgeable providers, transgender patients report high satisfaction rates. A recent data fact sheet from the CDC reports that black gay men and other men who have sex with men (MSM) are at greater risk of HIV infection than Caucasian counterparts; among young MSM, young black MSM bear the greatest HIV/AIDS burden—twice that of white or Hispanic counterparts.

"...LGBT people who are also members of other minorities already tend to face multiple forms of discrimination—including structural income and employment inequities, which impede or prevent their access to insurance and proper health care...That is why it is so crucial that the HHS has recognized both the size of the gaps in research, and the need to fill them. As its document notes, "LGBT people have been denied the compassionate services they deserve," and that in treating LGBT people, we must "recogniz[e] that diverse populations have distinctive needs." And they have outlined some smart steps toward achieving this goal: an overall increase in the number of federally funded health surveys that track sexual orientation and gender identity; a new effort from the CDC to ensure that questions about sexual orientation and gender identity are asked; and crucially, a goal of addressing LGBT health care disparities through the Healthy People 2020 initiative, driven by both existing data and the input of the LGBT community.

"The significance of the HHS calling for these steps is enormous, as it has never before called for LGBT inclusion or conducted disparity research on anything resembling this scale—or for the funding that such an effort requires. And as for the IOM report, no government-affiliated organization has ever produced a report that documents the state of LGBT health this comprehensively, and its release would have been unimaginable during any prior administration.

"The picture of LGBT health is far from complete, and without it, policy makers still cannot draft health care policies that account for the full range of challenges we face. Yet taken together, these two documents constitute an excellent road map for the future of LGBT health. Our challenge is now to ensure that their recommendations are heeded—so that all LGBT Americans can have a better, healthier future."[124]

Judy Bradford still sees many challenges ahead. "The master database HHS uses is a big federal warehouse of information, like the census. Data needs to be standardized in order to store it for future use. Descriptors for sexual orientation and gender preference need to be standardized so they can be searched. But the problem is that, even with these measures in place, there aren't enough people now in each category. We have to face a tough choice: either we conflate gay, bisexual, lesbian, and transgender people together to get a significant number of people counted in order to justify allocating health care resources, or we use low numbers for each individual group and start with percentages for these smaller groups within the larger, numbers. But within the larger LGBT community, there are people who are well-off, there are poor people, and there are people who are discriminated against for other reasons. It's going to take time to create a standardized system that works."

Working with large systems and organizations like Boston's major teaching hospitals, the Massachusetts Department of Public Health, or the US Department of Health and Human Services has always required patience and perseverance. Strategies like assembling research data by Congressional District to convince legislators to pay attention to the LGBT people who live in their constituencies also take time. So does the reliance on evidence-based approaches to advocacy for new medical treatments or preventive education programs. In many ways, the

forty-year story of Fenway Health is a constant struggle to balance the needs of its patients and its communities for care now vs. the understanding that, when you're advocating for disadvantaged people or trying to bring innovation to traditional systems, you need to do your homework. It's a deeply philosophical argument whether patience is a virtue when people get sick or even die while change happens slowly. But forty years of survival and hard-won respect also brings its own rewards: in some cases, you don't have to wait, and you can do things yourself. You can write a book to reach out to medical providers on an individual basis even as you work to change large organizations inch by inch. In a process that took many years even within its own friendly confines, Fenway and The Fenway Institute did just that, with the publication of its *Fenway Guide to Lesbian, Gay, Bisexual, and Transgender Health* in 2008. Its preface summarizes the challenges of creating new approaches to health care for marginalized people in a way that can only come from direct experience:

"While we talk about the importance of practicing evidence-based medicine, the reality is that medical science is still very much an art. This is particularly true when caring for sexual minorities, since few population-based studies have been done to document health disparities, yet stories of difficulties connecting with a caring clinician are legion. This book is dedicated to clinicians who are committed to practicing the art of medicine—learning how to form caring relationships with a wide range of patients, determine each person's unique health needs, and offer culturally relevant state-of-the-art healthcare.

"Real-life experience is crucial in developing true comfort with lesbian, gay, bisexual, and transgender (LGBT) patients. Herein we describe clinical issues that are pertinent to LGBT communities and provide practical guidelines to help clinicians address these issues using a sensitive and caring approach. We hope that this information will increase clinicians' willingness to venture into new areas with patients, and thereby lead to an experiential exploration of the issues that many LGBT patients have long kept secret. Immense joy and satisfaction can be found in this work. The process of helping LGBT patients come to self-awareness and acceptance, learn how to lead healthy lives, and create strong connections with family embers and friends is incredibly rewarding.

"Each of us has approached this text with a unique viewpoint based on his or her own training and experience; we have worked together to include all of these perspectives in The Fenway Guide. We hope this work will be useful to the broad range of clinicians—nurses and nurse practitioners, physician assistants, mental health practitioners, physicians, and others—who provide primary care to LGBT patients.

Harvey J. Makadon, MD

Kenneth H Mayer, MD

Jennifer Potter, MD

Hilary Goldhammer, MS[125]"

..

We've been absolutely blessed with amazing leadership. Steve Boswell became Executive Director when I started here. I mean leadership in the broader sense; Steve Boswell is one example of that Ken Mayer is another one. The Fenway Institute wouldn't exist without Ken Mayer's leadership. If he had decided to go back to Chicago, or to go to San Francisco, I'm 1000% confident that the Institute wouldn't be here now, at least not in the way it looks today. He's the one who literally worked two full-time jobs to do it, to build what was going on here while also maintaining his career at Brown University. People who have been on our board—bright, caring people, some with access to resources, others with access to people, some with knowledge, are leaders as well. Sometimes I see our finance committee asking questions and I think, "wow, you people are incredible." Henia Handler is another one; my God, where would we be without her? Phil Finch has been here for so many years as leader in a whole new position, and he grew things with a lot of smarts. In recent years, Jeff Lieberman is a savvy finance guy who is just incredibly talented in his area. And so it started way back: that good attracts great. I truly believe that's a big part of our success. And so is being mission-driven. When we look at our employee satisfaction surveys, we know that what keeps people here is the mission. I strongly believe that we're a mission-driven place.

Contextually, being in Boston has also favored Fenway's success. We've had very supportive government officials. For example, the Department of Public health provided money for the earliest HIV studies. Without that, we might not have been able to start our research program. Did the liberal context of Massachusetts draw people who wanted to live here? Steve Boswell came to Boston; he wasn't a native. Neither was Ken Mayer. It's part of the draw; those things play into the reasons for our success as well. So my final answer is talented leadership and commitment to the mission that have made Fenway a success.

I think in the future, I think we should take over the world. Fenway's model of health care is really interesting and really good. We need to think about ways to continue to expand. I would love for us to be a national trademark. Why can't we have LGBT health centers throughout the country that are Fenway? I think that would take a lot of work, but there's something about gay people. We have this type-A personality and we want to be successful, so we'll do anything we can put our mind to and we'll get it done. There are several LGBT health centers around the country, and I think it would be really cool to tie them together in a formal structure. They all need to be community-driven. Our local community is what makes Fenway thrive. So the local communities have to make the other health centers thrive, too. But there could also be a lot of efficiencies we could achieve together. There are already many connections; we talk to each other all the time. There's lots of good collaboration we could match with good efficiencies we could achieve together in a national network.

—Rodney VanDerwarker, Administrative Director, The Fenway Institute

1996–2011 EDUCATION

"The volunteers arrived gradually and around 10 pm we checked in with the nurses around operating procedures (i.e. can a drunk person be referred to the van?) and went on a tour of the venues. I dropped Adam Navidi and Joan Costa off at Club Café and accompanied Aimee Van Wagenen to Fritz, where patrons were totally enraptured by the Sox game on the TVs.

This did not bode well for our outreach and van recruitment efforts. With all the attention on the game, no one wanted to talk about STDs and testing. After an initial run through the bar, quickly and casually mentioning the presence of the testing van, and handing out supplies, we were rescued by the arrival of Michael Fontana (looking fabulous in drag). Within five minutes of his arrival into the aloof crowd at Fritz he had gotten us our first client at the van: a young man in his late twenties who had just emerged from a bad relationship and hadn't been tested in quite some time."

—Steven Belec, Fenway Health Assistant Manager of Outreach and Education Programs, in his South End Van Outreach Report, May 14, 2005

The Fenway Guide to Lesbian, Gay, Bisexual, and Transgender Health costs $64.95. It has four co-authors listed with their degrees, and counts 36 additional people, all with similarly advanced degrees, as contributors. It is 526 pages long, and one chapter is called, "Medical and Surgical Management of the Transgender Patient." It is not a book designed to sell to the general public. And yet it is a cornerstone of Fenway's education programming in the 21st Century. *The Fenway Guide* is "the first truly comprehensive clinical reference to enhancing the health care and wellness of LGBT patients." Fenway Health's pioneering efforts in educating medical providers in how to care for and interact with LGBT people is both a strategic choice and an historical legacy. Since the health center became "popular" with gay men who appreciated its anonymous STD screenings and treatment in the 1970s, and through its first-in-the-nation alternative insemination services for lesbian women in the 1980s, Fenway has offered sensitive, or "culturally competent" medical care to lesbians, gay men, and bisexuals. Transgender people found their way to Fenway as well,

even if it took the health center until the early years of the 21st century to create a truly comprehensive medical program for them.

The health center's years of experience with the LGBT community were a major reason why Boston's hospitals turned to Fenway during the HIV/AIDS epidemic; this experience is also an important element in the growth and success of The Fenway Institute and its precursor, the old Research and Evaluation Department. Codifying its experience, and calling on the many talented clinical staff who have worked at Fenway for years, is both a logical step and a useful contribution to the organization's goal of improving access to quality care for LGBT people everywhere. Concentrating its education efforts on clinicians instead of the general public is also a choice that is consistent with Fenway's longstanding emphasis on being a medical facility, not a community center. The AIDS Action Committee has been providing HIV community health education programs in Boston since it was still a committee of Fenway's board of directors in 1983. Publishing a medical textbook like *The Fenway Guide* is also consistent with Stephen Boswell's efforts to make Fenway the first of the academic community health centers, and it complements The Fenway Institute's efforts to include LGBT people in the Department of Health and Human Services *Healthy People 2010* and *Healthy People 2020* recommendations.

Amid all of this strategic synergy and the traditional leadership Fenway has provided in improving the health of its community by focusing on the education of providers, there may be something else to consider as we look at Fenway's educational programs in their entirety. It isn't true that Fenway only educates providers; since its early sojourns into Boston's gay bathhouses to conduct STD screening programs in the 1970s, the health center has always reached out to its target population with education and information. This chapter opened with a quote from a 2005 report on its South End Van Outreach program at several gay bars and on the street. The Women's Health Collective used *Our Bodies, Ourselves* as the basis for self-help health education almost since the day Fenway Community Health Center opened its doors in 1971. Today's health navigators support people with HIV, and transgender individuals, throughout the Greater Boston area with a wide variety of education and advocacy services. Even the approach used to encourage people to come in for vaccinations, screening tests,

and other preventive care is framed not as a request to schedule an appointment, but to "come in for a talk."

In addition to its provider education programs, Fenway has always operated education programs for consumers that are based on personal interactions between the health center's professional staff and its patients. Some have noted that Fenway's approach is "conservative" and "clinically-based" when compared to the media campaigns that are part of other organizations' efforts to educate the public about HIV, breast cancer, or other LGBT health issues. Again, this is true. But it also needs to be discussed in light of the fact that, in order to be educated by Fenway Health, a person almost always must come into contact with one of the health center's staff. In-person one-to-one, or small group education can also be seen as a key element in Fenway's public education programs. Providers can read *The Fenway Guide*, but even that book is designed to teach them how to interact in person with LGBT people. Working to improve the relationship between clinician and patient is a stated goal behind programs like *The Fenway Guide*. It has also been a longstanding goal of Fenway's medical care; Fenway's doctors and nurses are well-respected for the time they take to build strong relationships with their patients. But that same commitment to create strong relationships—not just to make people feel welcome and respected, but to share "evidence-based" health information with them—seems to be at the core of the health center's education programs for consumers. Whether people meet a Fenway outreach worker at Club Café, or they participate in one of the health center's many workshops and lectures, or they accept the invitation to "come in for a talk" about scheduling a colonoscopy, they're interacting with someone. In a very real way, the health center's clinical focus has a strong influence on the way it delivers education and information to Greater Boston's LGBT community, even when the people delivering education and information are young college graduates hired to be health navigators, or volunteers on the Gay Helpline and Peer Listening Line telephone programs.

In an odd way, Fenway's interpersonal approach to consumer education today is a way of coming full circle. The health center began its education programs by using books like *Our Bodies, Ourselves* and *The Advocate's Guide to Gay Men's Health* in the 1970s, and has now written the book—*The Fenway Guide*—on how to care for LGBT patients. The health center's early education programs were delivered at

a time when its clinical services were not well developed. Volunteer doctors and nurses working in a tiny basement facility with donated equipment were still standard operating procedures back then. There was no mental health department, no alternative insemination program, no pharmacy, no dental clinic, no optical department, no research, and only limited primary care. But there were very dedicated young college graduates and other volunteers eager to help women, gay men, and the elderly learn how to keep themselves healthy. As the health center became "professional" beginning in 1980, it gradually built a team of skilled clinicians, with a commitment to the provision of quality care. Today, over thirty years later, Fenway's well-respected clinical care and medical research professionals can package a combination of the knowledge they have learned from their work, with their skills in providing respectful care to individual patients. Now they have given this package to a new team of young college graduates and volunteers, for their use in providing the health center's enduring and unique brand of consumer education.

Today, Fenway Health's 1340 Boylston Street headquarters hosts dozens of health education programs every month, on many subjects that might be expected—living with HIV for those who are HIV positive and also for their partners, who may not be; "considering parenting" groups for lesbian couples and gay male couples who want to join Fenway's alternative insemination program or adopt a child; and women's health forums on a variety of topics including menopause, bisexuality, and breast cancer. There are also a number of programs and workshops one might not expect—partners of people with Alzheimer's disease; social gatherings for hard-to-reach populations such as Latino and black gay, bisexual, and transgender people, with an emphasis on promoting healthier lifestyles; groups for gay men with compulsive sexual behavior; and smoking cessation projects for lesbians and other members of the LGBT community. And there are community events that strive to educate constituents about health.

In 1996, Fenway hired Nan Dumas, who co-chaired the 1995 Dinner Party, as a member of its Development Department, to expand female philanthropy as a source of support for the health center. Among the many programs she launched, Nan Dumas has always found the time to help keep the Women's Dinner Party thriving. By 2011, twenty years of Women's Dinner Parties had brought in over $3.5 million dollars to keep the promise of women's health care alive at Fenway.

Every year, the Dr. Susan M. Love, MD Award has been a staple at the Women's Dinner Party, given to a woman or organization that has made a significant contribution to women's health.

The Women's Dinner Party Dr. Susan M. Love, MD Awardees since 1992 are listed below:

- **1992** Susan M. Love, MD

- **1993** Boston Women's Health Collective

- **1994** Mercedes Tompkins

- **1995** Ellen Bass

- **1996** Amber Hollibaugh

- **1997** Kip Tiernan

- **1998** Diane Laskin Siegal Beverly Saunders Biddle

- **1999** Irene Rabinowitz

- **2000** Lois G. Pines, State Representative

- **2001** Deborah Heller

- **2002** Byllye Avery Ngina Lythcott

- **2003** Suzanne Haynes, PhD

- **2004** Valerie Fein-Zachary, MD

- **2005** Susan Troyan, MD

- **2006** Hortensia Amaro, PhD

- **2007** Nancy Norman, MD, MPH

- **2008** Jennifer E. Potter, MD

- **2009** Lily Tomlin

- **2010** Tammy Baldwin, US Senator

- **2011** Catherine D'Amato

In 2011, after being recognized at the twentieth annual Women's Dinner Party, Deborah Heller reflected on the history of this event in a thank-you letter to the women who shared the evening with her:

"As many of you know, in the late 70s and early 80s, Fenway lived in the 'beloved basement' of Haviland Street. In 1991, we moved into a wonderful building, consolidated our services, and made a public statement that services for LGBT people would be provided in a dignified and beautiful environment. At the same time, the Fenway Board of Directors began to change to include more women and people of color, and was led by Arlene Fortunato. We hired Mike Savage who significantly began the growth of the Fenway and fostered collaborations among multiple health

centers to change the funding struggles into a win-win rather than a zero-sum game. We wrote many more successful grants and began to position ourselves financially to meet multiple needs and challenges. As Board and Senior Staff, we focused on providing care to all who needed it and also grappled with needs, utilization, return on investment, attractiveness to funders and donors, and identifying our unique and specific niche. We were *the* place for patients with HIV and AIDS. We offered primary care services to healthy gay men and some lesbians, to the Fenway neighborhood, and we were also trying to establish a presence in women's health. There was commitment from the Board and Staff, but as many of us remember, there were many competing needs. While there were concerted efforts, we were unable to establish a consistent presence in women's health.

"We saw the women's dance in part as a 'guerilla' effort to create a constituency of women donors, a population of women who would come for services and as a source for ideas about programs and services that would be financially positive. We thought if we could create a groundswell external to the health center, that we might be able to fuel the Board and Staff commitment to invest and to grow services for women. We believed that if we presented ourselves as having 'comprehensive women's services' by having a big party and talking about what we offer, that we would ultimately offer what we were promising. It worked!

"Second, twenty years ago we understood that lesbians were starting businesses, earning good salaries in the private sector, and were beginning to have some disposable income. Gay men and their families had been enormously generous to the Fenway and we believed that if we could tap into the resources in the women's community sooner rather than later, perhaps we could capture some of those donors. We knew women were becoming philanthropists and we wanted to be part of their donation strategy. We saw the dance as a way of reaching them. It worked!

"Third, we knew that the concept of women's health was in the process of being defined. Medicine was just beginning to understand that men and women were different and perhaps lesbian needs were different from heterosexual women's needs both physically and emotionally. Thinking about how the Fenway could take a leadership role in the new and developing areas of health care delivery and

Boston Mayor Thomas M. Menino speaks at the 2009 Men's Event. (*Marilyn Humphries*)

research for lesbian and bisexual women was exciting and we wanted to be in the forefront. It worked!

"And, of course last, there was no place for women to get dressed up and go out for dinner and dance. For many years in the summer, the Ritz Hotel had a dinner dance on the roof and some of us yearned for an evening like that for us. That's where the idea for dancing right through dinner came from. I have been trying to bring that idea back for years.

"Fenway has been enormously successful. The leadership in services and research is stellar and we can all take great joy in what we have all accomplished. Ultimately it is the Fenway staff that makes all this happen. Ann and I are so proud of the Dance and its 20 years. We are so grateful to Nan who has kept this alive and so appreciate all the co-chairs and committees that each year with the support of the Development Office and the Fenway Staff make it happen. We believe this dance is a 'unique differentiator' for the Fenway and adds a special something to who we are and who we have become. From our end, it was an idea Ann and I had. From your end, it was making the idea live. Saturday night was

so moving for me and for Ann. We felt such joy and our joy was not only for the dance itself, but for all the remarkable accomplishments, for all the care you give, for the lives you have changed, for the enormous impact you have had nationally and internationally on LGBT health.

"Thank you. Thank you."

A few years after the first Women's Dinner Party, Fenway's Men's Event began, providing a similar night of recognition and celebration for providers, consumers, and supporters. A milestone was reached in 2003 when the event sold out for the first time, drawing over 1,500 attendees. Since then, the Men's Event has raised a similar amount of money for the health center as does the Women's Dinner Party, routinely drawing over 1,000 people for every event. The Congressman Gerry E. Studds Award is given at the Men's Event to honor individuals of integrity and selflessness who embody the spirit of service and provide positive leadership for the LGBT community. Congressman Studds represented southeastern Massachusetts in the U.S. Congress from 1973 to 1997 and became the first openly gay Member of Congress in 1983 when he proudly acknowledged his sexual orientation standing on the congressional floor. Studds Award winners have included US Senator Edward M. Kennedy, Olympic Diver Greg Louganis, First Lieutenant Dan Choi, and Dr. Ken Mayer.

The Men's Event, Gerry E. Studds Awardees are listed below (l=local, n=national):

- **1994** Randy Price (l)
 Rod & Bob Jackson-Paris (n)

- **1995** Jonathan Scott (l)
 Greg Louganis (n)

- **1996** Gary Bailey (l)
 Harvey Fierstein (n)

- **1997** Harry Collings (l)
 Dan Butler (n)

- **1998** Gary Daffin (l)
 Steven Wilson (l)
 Tony Kushner (n)

- **1999** GBBC

- **2000** Honorable Jarrett T. Barrios

- **2001** Gary Burton

- **2002** Chris Beckman, MTV

- **2003** Honorable David N. Cicillin
- **2004** Reverend V. Gene Robinson
- **2005** David Collins
 Michael Williams
- **2006** Reverend Peter Gomes

- **2007** Ronald M. Ansin
- **2008** Senator Edward Kennedy
- **2009** Andrew Tobias
- **2010** Lt. Dan Choi
- **2011** Dr. Ken Mayer

...

Connecting to age-appropriate services can be difficult for older LGBT individuals. Medical programs for them should include not only access to services, but opportunities for social contact with other older LGBT people. Outreach to shut-ins and older LGBT Americans living in long-term care can help connect them to services and add a level of safety for them even if they are no longer mobile. Training in LGBT care, like that found in the Fenway Guide to LGBT Health, but more focused on older individuals, can help medical staff, human service staff, and caretakers do their part to reduce the discrimination and isolation older LGBT people encounter even today.

When reaching out to a younger population, the main challenge is to let them know that you are there; more often than not, they will manage to find you. Working with an older population is much more challenging. You need to go to them and knock on their doors a few times before they come out. Fenway Health has earned great respect because it did not forget the gay community in a time of true crisis. The organization found ways to address people's needs and get others involved in helping the LGBT community through their ingenuity and perseverance. I know that they will not ignore the needs of older LGBT people today, who in fact are the same people who were there during that crisis. They remember the health center's commitment to them, their lovers, and their friends, and will be counting on Fenway again to care for them with dignity and pride.

—Daniel Henderson, Program Social Worker, Anna Bissonnette House, Hearth, Inc.

1996–2011 ADVOCACY

"These days, we are seeing the end of an era, or the beginning of a new one, with HIV. Even though for thirty years we have been hoping for a vaccine, we haven't found one. But we have found a pill, and we've developed a public health approach that emphasizes behavioral change.

So, many people think we have 'normalized' HIV. It's become a chronic disease. Except when you go to places like Whitman Walker Clinic in Washington, DC, and see street people there who are HIV positive. For them, HIV is certainly not chronic. They're really sick.

Today, people of means get the pills. People who can absorb our public health information can get themselves into care. The disease now equals poverty. HIV has become another social issue that makes poverty so tough to deal with. When AIDS first started, it was bad to say that Haitians or Portuguese people were at high risk, because it sounded like discrimination or prejudice. Today, we've accepted the concept of 'viral pools,' or reservoirs where the disease can live and spread.

We accept the reality that people from the inner city, from lower socio-economic classes, and from certain racial and ethnic minorities are more at risk. Medication really is the best answer we have for HIV. The challenge now is that we've got to get people into care."

—Henia Handler, Director of Government Relations, Fenway Health

Stephen Boswell's definition of Fenway's advocacy role is "to help people around the world articulate policy as it affects our community." To better understand the evolution of this role, we have used the term "advocacy" in this book, because of the highly personal way terms like policy and community have been defined at Fenway at different times throughout its history. A mature, self-aware, well-respected health care institution can affect policy at the level of city, state, and national governments, both in the United States and throughout the world. Individuals working for that same organization, whether they are one of the 250

staff people in this mature organization today, or one of the earliest volunteers within one of its three collectives forty years ago, have also affected policy, to be sure. But they have done it one patient, or one doctor, or one community activist at a time.

When Fenway was Boston's smallest community health center, seeing patients a few evenings per week, the simple act of providing medical services for people in need was its own policy statement. For a long time, this message might not have been heard much beyond the borders of its neighborhood, but, over time, the city of Boston and Massachusetts Department of Public Health heard it, and so did doctors and administrators at the New England Deaconess Hospital, then Beth Israel Hospital, and eventually Boston City Hospital and many others. With Ken Mayer's research department came the opportunity to spread the message even further; at the same time, so did the Alternative Insemination and Violence Recovery Project. Dale Orlando's Metropolitan Area HIV Services Alliance and Drug Abuse Health Care Services in the late 1980s expanded the message to groups of health care collaborators throughout New England. Michael Savage led Project ABLE and the National Alliance of Lesbian and Gay Health Clinics in the early 1990s to influence statewide and national policy on behalf of Fenway's communities, which then included not only individual patients and consumers, but other LGBT health care organizations.

Today, with Fenway's staff having helped write language for federal and state legislation authorizing funds for HIV and LGBT health care, with a research department that has international standing as a leader in these same two fields, and with a medical staff who have literally written the book on Lesbian, Gay, Bisexual, and Transgender health, its ability to "to help people around the world articulate policy as it affects our community" is well-established. There were choices made along the way to limit, delay, or even refrain from certain activities aimed at influencing policy. Ron Vachon lost his vote in 1980 to bring Fenway directly into the political struggle for gay rights. The AIDS Action Committee became a separate organization in 1986 so Fenway could concentrate on health care and not community education. CRI New England, the Sidney Borum, Jr., Health Center, and other organizations and coalitions are more examples of Fenway helping to start organizations to lead advocacy and policy-making activities instead of taking these

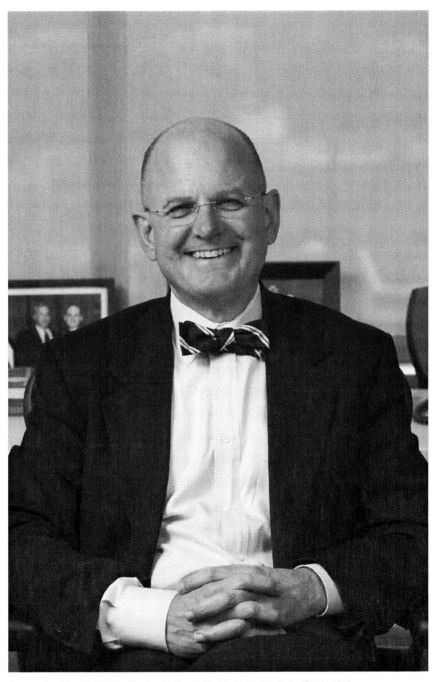

Fenway President & CEO Dr. Stephen L. Boswell in his Ansin Building office in 2010
(*Marilyn Humphries*)

responsibilities upon itself. But these were strategic choices, efforts to make sure Fenway didn't weaken itself or dilute its mission at key moments in its history. And the record largely shows that Fenway didn't simply abandon the causes of gay rights, or community education, or community-based medical research. Instead, it helped support other organizations taking on these causes, and developed strong alliances with them that survive today, even as these allies expand their efforts to articulate policy as it affects our community. Now perhaps the time has come for Fenway Health to re-imagine it's future in the context of a much larger and more open LGBT community and all of the challenges that entails.

For example, many older LGBT Americans have experienced discrimination in the health care system throughout their life span. They are often cautious about being involved in a system that has historically been out of step with their health care needs. Many of them lost close friends to AIDS at a time when the health care system was unresponsive to the LGBT community in their time of need, leaving them suspicious and reluctant to come out to care providers. As they age, this generation of older LGBT Americans will be the first of its kind to live openly in American society. It will also be the first to explore how others will treat them as a result of this new openness, even members of their own community.

It is no surprise that current media, including television, newspaper, and online sources aim their messaging at younger men and women; this emphasis on youth is even more evident in LGBT culture. Young people in all American communities are familiar with social networks, giving them even more access to information, including opportunities for entertainment, socializing with peers, or access to services, including medical care. Older LGBT Americans have a different orientation. Most prefer to meet face-to-face in social situations, and are not as likely to use LGBT social networking sites. So reaching out to older members of the LGBT community with comprehensive care and providing advocacy particularly for frail elders who are alone in the world can be a daunting challenge.

It's important to note that advocacy and policy development at today's Fenway have evolved beyond the simple act of leading by example. Providing care to a previously underserved population, or developing innovative research and medical programs, are now the proper responsibility of the medical and research

departments within a large, mature organization. Similarly, the effort to seek financial support for existing and proposed service programs is internal to the operations of a large, multi-faceted health care institution—more properly the responsibility of fundraising staff, administrative directors, and the board of directors. There may never be bright lines between what is strictly policy advocacy and leadership; any more than there are such lines between research and care, or education and advocacy. But, as an organization grows and it develops larger internal departments, the blurry lines between its core operations become more clear and distinct. The same organization's size and diversity of programmatic departments may allow it to support different initiatives within its structure, instead of spinning off organizations to manage initiatives that seemed to threaten its core focus in the past. Yesterday's Fenway Community Health Center might not have been able to handle the leadership of international partnerships with LGBT health centers in India (although some of yesterday's leaders may have wanted to), just as today's Fenway might not have made the decision to spin off AIDS Action Committee or CRI New England because it now has the resources and an organization structure that is diverse enough, flexible enough, and large enough to handle the challenges that would come with broad consumer education or regional community-based education programs.

The advocacy challenges since 1996 include several that have existed in previous years: funding for HIV research and care on a broad national and international scale; health care that is designed to meet the specific needs of sexual minority women; access to medical services of all kinds, but specifically HIV-related services, to the poor and disenfranchised; and continued support for the expansion of medical services to the LGBT community. Even health care reform can be found as an element of Fenway's advocacy programs at least as far back as twenty years ago. Structurally, many of these initiatives have become part of The Fenway Institute since its founding in 2000. The established international leadership of Fenway's Research Department now resides here, and with it, the efforts to expand HIV research and care throughout the world, along with efforts to increase awareness of the unique needs of LGBT people for health care, and the rights of these individuals to receive quality, competent care no matter where they live.

Renowned Author Rita Mae Brown speaking at the 2007 Women's Dinner Party (*Marilyn Humphries*)

Healthy People 2020 is an example of this larger effort on behalf of LGBT health, and the blurry line between what is properly research vs. policy advocacy. Henia Handler's quote at the beginning of this chapter is another example of the many blurry lines between care, research, and policy. When effective treatments for an epidemic have been developed, and the main obstacle between their potential use and actual deployment is no longer a medical issue, or even an issue of discrimination against LGBT people, but is a consequence of poverty, or access to care, or other problems like substance abuse, what is to be done? Do we define poverty as another element in the "syndemics" of HIV and create a comprehensive health care program to reach people most at risk, using Fenway's established strategy of leading with research to develop such a program? Do we find people who are already working in anti-poverty programs and teach them how to deal with HIV, as Fenway has done so for so long in teaching medical providers these same skills? Do we start and spin off a new program aimed at poor people with HIV, and then support it as it grows independently? Do we advocate for the inclusion of poor people and racial and ethnic minorities with HIV as another population

to be included in the Department of Health and Human Services *Healthy People 2020*, or *Healthy People 2030*?

These are profound strategic choices for an organization to make, and it is a mark of Fenway Health's forty years of progress that it is in a position to be able to wrestle with them. But, on a more basic level, concern with these choices is also a statement of how consistent Fenway has always been in looking at the broader issues of health care, and access to quality health care, for the people in its communities. "Health care is a right, not a privilege," Fenway's first slogan in 1971, encompasses this same struggle to expand access to quality care, even if the organization's founders were less focused on what the definition of quality care was than today's leaders are concerned with expanding access to life-saving HIV treatments that the health center's researchers helped develop. "Health care for people, not for profit," another early statement of Fenway's mission, resonates today in terms of how the Affordable Care Act of 2010 will be implemented on the local level. It may seem remarkable that the challenges of medical care in the 21st century can resonate with the early slogans about health care access forty years before. But Fenway has always been an organization composed of people who saw problems and tried to solve them. After all, its early volunteers built a health center, relying almost exclusively on volunteer efforts and donated equipment. Today, the professionals and volunteers in each of its large, sophisticated programs still share this commitment to find challenges and solve them. And, in that sense, even with the specialization required for an institution with 250 staff people and 80,000 patient visits per year, the same blurry lines between key elements of its mission statement still exist, and they still explain how Fenway remains strong. Advocacy may once have been the unspoken result of the organization "just doing it," just leading by example and showing what can be done. Today, it may be far more formalized and divided among Fenway's different internal departments, each of them working to make sure they are articulating policies that affect our communities. Perhaps Sally Deane says it best, reflecting on these similarities over time. "Research is advocacy. Medical care is advocacy. Everything is advocacy. Get active. Do something. Make a difference"

Fenway will certainly grow as a health center. It will grow as well as a leader in research related to all things that affect primary health care for special populations. That growth will most likely bring expanded services. For example, we need to keep in mind that one of our next goals is to expand into pediatric care and children's care at both the Sidney Borum Center and here at 1340 Boylston Street. We'll have to expand in terms of the geography of Boston itself. We need to look at Steve Boswell's hub-and-spoke model and think about whether it's still viable, and how we approach it. Does opening up a site in Jamaica Plain actually become competitive with this site? How deep is our market? We want to be careful we don't diffuse what we're offering here, or then again maybe we actually want to diffuse what we're doing here. But whatever we do, we have to be fluid and we have to be nimble, but we have to make a continued commitment that service delivery is still the very heart and soul of the health center. Then, over here, we have the institute, which we also need to nourish and have flourish. Remembering that the relation between the health center and the institute will never be antagonistic, we need to be sure that the emphasis on one doesn't diminish our focus or our work to get resources to support our programs of care, prevention, and wellness for our community.

Someday we may need to provide long-term care here. We may have to ask ourselves the question of whether we want to become more like a combined community center and health center. Someday if there's a building next door, should we be offering exercise classes there? Should we open a yoga center, or invest in alternative physical activity programs? Should we look at the services that were offered in the old-fashioned settlement houses of Boston or New York? For years, these places provided a broad range of education services to immigrants. Should we be doing that someday for the gay community? Those are the questions I would ask as we move our vision forward. What would be the substance of our work with LGBT people in the Commonwealth, and what would be the symbolic nature of our work beyond our geographic area?

There's so much to accomplish at both the health center and the institute. And we've accomplished a lot. We just hired seven female physicians, for example. And our tendency is to look at achievements like this and say, 'we did it.' But saying 'we did it' isn't the end, it's only the beginning, because for every 'we did it,' there's another 'we did it,' or 'we should be doing it' around the corner.

—Henia Handler, Director of Government Relations, Fenway Health

1996–2011 LEADERSHIP

"Of course there's room for cost savings in health reform. Our administration and finance people spend 40% of their time trying to find ways to get health insurance companies to pay for our patients' care, and the health insurance companies' finance and administration people spend 40% of their time trying to deny us."

—Stephen Boswell, MD, CEO, Fenway Health

All of the components we associate with solid leadership in any community organization—strategic planning, fundraising, communication, excellence in delivering on its mission, the professional skills of its staff, support from its constituencies, and an ability to evaluate its own performance in order to make adjustments as they are required—have always been part of the forty-year conversation among Fenway's staff, board members, and other leaders. The health center's original founders started with the distribution of a questionnaire, or market survey, to the people living in the neighborhood. Its original three collectives debated the need for free health care and how to deliver it for over a decade, until Sally Deane and Dale Orlando gradually replaced Fenway's collectives with a centralized board of directors and a staff managed by the Executive Director. Strategic planning has been part of the organization since the 1980s as well, as have fundraising, staff training, evaluations, and other activities that mark the existence of effective leadership in a nonprofit organization. Many of the management characteristics of Fenway Health were started by previous leaders and have continued from their inception through today. A few were started, faded away, and came back. Still others came to Fenway through the addition of new service programs, or the hiring of new professional staff with their own unique skills.

For example, we have seen how Judy Bradford brought her academic street smarts to The Fenway Institute, giving the organization the opportunity to become part of a larger national study of LGBT people's health as a defined component of American society. Harvey Makadon brought his commitment to

L to R: Boston Mayor Tom Menino with Fenway Executives Deborah Ruhe, Dale Orlando, Sally Deane, and Stephen Boswell, MD, at the 2009 Women's Dinner Party (*Northeastern University Archives*)

professional training, and his connections with Harvard Medical School, to help the health center publish *The Fenway Guide to Lesbian, Gay, Bisexual, and Transgender Health*. Further back in time, Michael Savage brought his coalition-building skills, Dale Orlando brought her fundraising and team-building expertise, Ken Mayer developed the first research program based in a community health center, and Sally Deane steered a nearly-bankrupt organization to financial stability while laying the organizational groundwork for its future success. As David Scondras said in describing Fenway's founding, there were many contributors, many tributaries, some coming from places you would never expect.

Despite the relative ease with which we can point to precedents for almost all of Fenway's current managerial and strategic initiatives, there is something qualitatively different about the Fenway of 1996 through 2011 when compared with the early days of collective chaos in the 1970s, or the constant crisis of the AIDS wasteland from 1981 through 1996. Earlier, we have argued that, like its HIV patients, the advent of anti-retroviral therapy gave Fenway Health Center

time—another example of the organization taking on the characteristics of the clients it serves. Certainly, this gift of time has been part of what makes the "modern" Fenway different. Leaders now have the time to reflect, and to remember promises made to women, the elderly, adolescents, neighborhood residents, and others who had to wait their turn while the organization threw everything it had into the battle against HIV. With this time to reflect and remember also comes the time to plan, and to develop strategies—to anticipate the future and manage toward it, instead of reacting to the immediacy of a crisis, or recalling a time of innocence and trying to re-create it.

The main accomplishments of what many people call the more recent conservative, corporate era of Fenway include the creation of The Fenway Institute; the successful planning and building of 1340 Boylston Street, the world's largest LGBT-owned health center; the diversification of programs from crystal meth interventions through dental and eye care; and the achievement of international leadership in LGBT health studies, HIV research, health policy development, and education programs for medical professionals. Interviews with Fenway's current staff reveal a commitment to teamwork, a confidence in the organization's ability to achieve its goals, and a shared vision of how the organization will address the challenges of achieving its mission in the future. Maybe the gift of time that came in 1996 is really the gift of believing in the future. Knowing that Fenway will survive has given the organization the ability to reach back on all it has learned to craft a strategy for making the world a better place. Today's Fenway may approach this mission in a more practical, deliberate way than the organization's founders might have envisioned, but the goal—a better world where people receive better health care—is something Fenway's leaders have always shared.

What's new in the modern Fenway is a shared sense of confidence. For many years, there were confident individual leaders, and there were teams dedicated to unbelievably difficult struggles, but there was a sense of uncertainty if not desperation. Will we have enough money to keep going? How many more of our patients will die? Why can't we combine our medical mission with efforts to become Boston's LGBT community center? Why do people like me have to wait our turn to receive quality health care? Holding things together was everyone's full-time job. The people at the top had to hold the organization together in the face of an array of threats, while the rest of the staff had to do their best with

limited resources, or with no answers at all to a "monster from space." Today, there is a palpable feeling of dedication to the organization's work, and a large team of 250 professionals is definitely holding the organization together, but uncertainty and desperation have been replaced by a combination of big thinking and attention to detail that would never have occurred to Fenway's activist founders, and which the health center's many dedicated staff people couldn't see in the 1980s and early 1990s.

For example, Rodney VanDerwarker sees the future of Fenway in grand terms—a growing "hub and spoke" model with 1340 Boylston Street at the center, and a growing number of community-based health centers delivering Fenway-quality care in new neighborhoods where LGBT people live. But he also sees the details that need to be in place in order to achieve the organization's goals in new facilities. When talking about Fenway: Sixteen, the new HIV and STD testing and counseling center for gay men located at the health center's legendary home, he notes, "the spaces there need to reflect who we're targeting specifically. Any clinic space needs to be neutral, and we're fortunate that our neutral here at 1340 Boylston Street is really beautiful. But the space at Fenway: Sixteen needs to be a little more geared to gay men. This includes the artwork on the wall, the information you can find in the lobby, the staff that work there, and the hours we're open. Our new building is a piece of our overall strategy, and Fenway: Sixteen is another. But we're also looking at expanded test sites, at bringing testing programs into the bars and clubs, and maybe going to sex parties. We've got to bring our services to the people we want to reach."

Rodney VanDerwarker is also aware of the criticism of Fenway as being too conservative or corporate. "We're careful now, but that doesn't mean we're not caring. It's part of Fenway's new adulthood. Gone are the old days when you might come to Fenway and see a phlebotomist in shorts and a t-shirt. But the community's grown up as well. The Pride Parade doesn't have gay men on stilts flashing the crowd, or lesbians rolling around on beds. There are church groups and corporate staff teams marching now. And I know we try to avoid the word 'corporate,' but the word can not only mean Lehman Brothers; it can also represent Kenneth Cole and that company's socially responsible advertising, or Kenneth Cole himself being Chairman of the Board of AmFAR for ten years."

Fenway's history is something that inspires VanDerwarker, and not just in terms of Ken Mayer's 1980 research proposal he keeps in his office. "It's so exciting to know that Boston has always been a hub of LGBT activity. I always hear from people at conferences about how much they admire the old *Gay Community News*, or the Harvard Radicals that protested against homophobia and took over buildings to start women's centers forty years ago. Fenway has always had the mission of advancing LGBT causes. But sometimes stating a mission can be easy. Making it work—working out the details and the numbers—is much harder." VanDerwarker also has a way of explaining what The Fenway Institute is, and how it fits into the larger organization. "It's not just a new name for the old Fenway Research Department. We have 75 staff, and an annual budget of over $6 million just on our own. We're engaged in studies of vaccines, microbicides, chemo-prophylaxis, and epidemiological studies of LGBT health. Our focus is also broader than before—we have a full mission of addressing both HIV and LGBT health in general. We are also involved in programs like our health navigators, who are 'translational research' people in public health language, but they're also case managers if you look at them

Fenway President & CEO Dr. Stephen L. Boswell and actress Lily Tomlin, National Honorary Co-Chair of Fenway's 10 Stories Campaign, tour 1340 Boylston Street during construction in October, 2008 (*Marilyn Humphries*)

through the eyes of a clinician. And we're involved in the sorts of health policy issues like expanded HIV and STD screening and testing, along with professional education work like the publication of the *Fenway Guide*. Even thinking about Fenway's future hub-and-spoke model for the future happens here at the Institute."

The mission of The Fenway Institute, distinct but related to the larger mission of Fenway Health, is worth quoting here: "The mission of The Fenway Institute is to ensure access to high-quality, culturally-competent medical and mental health care and to reduce health disparities for traditionally underserved communities including lesbian, gay, bisexual, and transgender (LGBT) people, and those affected by HIV/AIDS."

Harry Collings, in his typical "man of few words" style, shares a few stories about the campaign to raise the $57 million required for Fenway's second new building in 2009. "First, we were able to secure the land at below-market value from developer Steve Samuels. Next, we were able to quality for $35 million in new market tax credits, which would turn into a grant for about one-fourth of that amount in five years. This was the largest amount a community nonprofit had ever received up until that time. The city recommended us to the state, and then stockbrokers sold these approved tax credits to people who need them. New market tax credits always sell, because there are always people who want to buy tax credits. The real challenge, and our real success, was in getting the city's endorsement of Fenway as a priority for these instruments. Once we had that, the other pieces fell into place. We sold the 7 Haviland Street property to Berklee Performance Center, and the rest of the money came from donations and a loan. Along the way, there were many other professionals who played a role with very fairly-priced legal services, and a great team of architects, designers, and contractors who made the building happen."

Was there ever a time when Harry Collings thought Fenway might not make it in raising the funds for its new headquarters? "Yes, there was a crossroads relatively early in the process. Steve Samuels, who owned the land, had a very short window of two weeks to decide whether to go forward with sale of the land to Fenway or not. There were tax credits that had to be made available in that time frame for things to work out for him. He came to me and said, 'Harry, I know you like Fenway, but this

is a huge commitment. I'm going to sell my land not for what it's worth, but for what I paid for it. I'm going to treat them well. But I have to know that they're going to go forward. I have to know that they're going to close on this deal.' So I talked with Steve Boswell and told him we had to assure Steve Samuels, and we did, and he got the tax credit. In the end, Steve Samuels took a huge leap of faith for Fenway."

Phil Finch, Fenway's Vice President of Development and Communications, is proud of the new building, but he believes Fenway needs to be seen more as an organization than as a building. His comments on this subject are included below in the "Futures" chapter. He sees three key challenges in getting the message about Fenway the organization into the community. First, there is the challenge of communicating directly with its patients, and with people who are not yet patients but could benefit from Fenway's services. "Some of the communities that we're charged with supporting, communities of people who we want to make sure have access to health care, may not have some of the resources that others do as far as technology goes. Sometimes it's a challenge to communicate with the more marginalized people in our larger Fenway community about the programs and services we have for them. At the end of the day, the most important people we serve are our patients, and we help anyone who needs our help, regardless of their ability to pay. We've learned along the way that if resources are a challenge; sometimes the ability to get information can be a challenge as well. That's something we can never afford to lose sight of. Some of the people who need to hear our information the most may not be able to hear it through traditional channels. Our goal, to put it in the most basic terms, is to have 'good people talking good things about a good organization.' We want individuals to tell their friends, 'my doctor's really good. So come see him or her at Fenway.' When we can't do this through our website or other communications media, we rely on basic word of mouth. We try to engage our patients in spreading the word, and we have a large Board of Visitors, ambassadors if you will for Fenway who are charged with encouraging others to use our health center for their own care."

The second challenge Phil Finch sees is the dichotomy between Fenway's local, community-based health care programs and its increasingly national and

international profile. "Our current communications strategy relates to how much more we're nationally-known, and yet still so local. We do cutting edge research, which may some day contribute to finding a cure or at least a good vaccine for HIV. But because we're very localized organization in many aspects, it's tough to get attention on a national scale. We have leading scientists who work here. We do work that is comparable to that done at major teaching universities. But because we're a nontraditional sort of academic institution, it's tough to get a lot of attention. One of the goals Chris Viveiros, Associate Director of Communications, and I share is to build a higher profile for Fenway on a national basis. We want to help build the reputation of the organization for the work we do." It's easy for many of us to assume that the work Fenway does earns it all the attention it has received over the past forty years. But the words of Phil Finch, like those of many other Fenway leaders before him, remind us that recognition doesn't always just come to an organization; it is often the result of professionals within it who see the big picture, but who work every day on the challenges contained within the larger mission.

The third challenge is more internal. It relates to Fenway's brand identity, and how it communicates the mission of the organization. Over time, under the leadership of Stephen Boswell, the organization has changed its name from "Fenway Community Health Center" to "Fenway Community Health," to "Fenway Health." This change has not always been well received by individuals who are closely connected to the organization. Former Assistant Director of Health Promotions Denise Bentley didn't like the initial word change. "'Fenway Community Health' seems like an unfinished sentence. 'Fenway Community Health what?' Where's the center? Let's open the gates, pick up all the pieces that are spread out, and bring them back together. Go back to the idea that community health education is the hub, and everything feeds off from that center."

Phil Finch explains the strategy behind the organization's new name. "We've evolved our brand identity over the years. We've gone from being called Fenway Community Health Center, which to me indicates a small, local, modest building, into Fenway Community Health, and now to Fenway Health, to reflect our core mission as more than a place or a number of places. The Fenway Institute is a part of this change, and it plays an important role in how we see ourselves as an organization focused on health—health care, health research, health policy, health education—all the things we

FENWAY ▤ HEALTH

do now and are looking to do in the future. But now, just like thirty of forty years ago, we're still known as 'Fenway,' or 'The Fenway.' Our patients say, 'I get my care at the Fenway, I'm going to a meeting at the Fenway, or I'm going to the Fenway Men's Event. Our legal name is one thing, and our brand identity can change over time. One day we may want to look at The Fenway Institute and evolve that more. The Institute can grow exponentially over time; it already has."

FENWAY AT A GLANCE: 1999

Fenway Health Center Annual Budget$50,000,000

Annual Patient Visits . 90,000

Number of Professional Staff 305

Joanne Herman, a member of Fenway's current Board of Directors, spoke eloquently about the organization at both the 2009 Men's Event and Women's Dinner Party. Her speech to the Men's Event, on Saturday, April 4 of that year, drew a standing ovation:

"Good evening. My name is Joanne Herman, and last fall, I gave the gift that named the waiting area of the new Women's Health floor at 1340 Boylston Street. I had no idea it would turn out to be the largest gift ever given to Fenway by a woman! I gave my gift because it allows me to share my joy of finally living in my true gender after 47 years.

"My story begins almost 30 years ago, when I married a wonderful woman named Barbara Wermeyer. I was still living as a guy back then, and Barbara

and I married right as we both graduated from college. Twenty years ago, we started supporting Fenway. Barbara and I had just become friends with our first gay couple. One member of the couple was Lee Ellenberg, a therapist in Fenway's Behavioral Health Service, and we thought what he and Fenway were doing was very important.

"Six years ago, after finally coming to grips with the gender incongruity that I had felt all my life, I transitioned to live as a female. And Barbara stayed with me! In fact, she'd still be with me today except for one thing. She had a rare form of cancer called carcinoid. Three years ago, Barbara lost her life to carcinoid, and I lost her.

"During her 52 years, including the 30 with me, Barbara had been passionate about all things Egyptian and very active at the Museum of Fine Arts. So, to help people remember her, I endowed the annual Barbara W. Herman Memorial Lecture at the MFA. And now every year, patrons can learn something new about Egypt's history, and friends can remember Barbara and her passion.

"Barbara's passing was a true wake-up call. Life is short. And soon I was wondering—how will people remember me? Will people know that I was so happy in my true gender that I dedicated the rest of my life to giving back in ways that make it easier for those coming behind me? Will people know how proud I was of Fenway's leadership—its groundbreaking research in HIV/AIDS, an important issue for some in the transgender community, and now its growing role in providing compassionate care for all of the trans community? And most important, will people know how proud I was to be a woman—and proud of Fenway's women's health legacy and its new commitment to the health needs of the women's community?

"When I heard of the possibility of naming the Waiting Area of the Women's Health Floor, I just had to do it. An entire floor dedicated to women's health, at Fenway's new building at 1340 Boylston Street, the largest LGBT-focused health care center in the world. It's the perfect intersection of everything I am, and it's how I want people to remember me.

"So...how do you want people to remember you?"

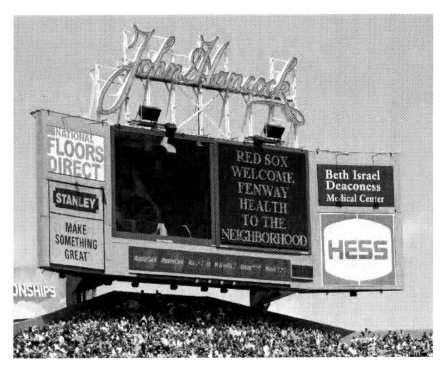

Fenway receives a big welcome from the Boston Red Sox upon opening the Ansin Building at 1340 Boylston Street (*Photo courtesy of the Boston Red Sox*)

Henia Handler, Fenway's Director of Government Relations, offers her own perspective on how achieving Fenway's larger mission requires diligent efforts in new fields of endeavor. Earlier in this book, Dale Orlando described how Fenway always made sure to announce federal grants in collaboration with its Senators and Congressmen, to show them "bringing home the bacon" and getting credit for Fenway's growing success. Henia Handler, who began working at Fenway during Dale Orlando's tenure as Executive Director, has taken the concept of government relations to another level, one that would be hard for Fenway's founders to believe. She remembers the days leading up to the passage of the

Ryan White CARE Act in 1990, and compares them to the current environment in Washington and on Beacon Hill.

"Back then, hospitals weren't responding to people with AIDS," recalls Henia Handler. "We knew we needed resources, and we needed them at the level that only the federal government could provide. A group of gay people in Washington, DC, went to Senator Ted Kennedy and said, 'we need to do something.' These driven social justice people wrote the CARE Act that Kennedy introduced. Then Fenway, along with about 100 other organizations, created the Title III Ryan White Coalition, which I pulled together along with Michael Savage. Each of us contributed $1,000 for the services of a lobbyist to ensure that the money would be authorized and allocated to community organizations. Tom Sheridan was the one we chose; he was also a good friend of Senator Kennedy's. For about six years, he was always there with Senator Kennedy when it came time to lobby for resources for HIV care. When it came time to re-authorize the Ryan White CARE Act in 1995, we decided to recruit a panel to represent people from around the country. We needed people who were in care, and who could speak in front of a group of legislators and agency people to put a human face on the epidemic. The perfect person would be someone who doesn't do drugs, who doesn't have sex, but has HIV. Think about that. But we found a patient, a woman who was married to an HIV positive man. She also had two kids. She was the right face, and the right story, for the job, and it worked. But Senator Kennedy always did his part to help with the Ryan White Act, and through his efforts and ours, we received funding from the CARE Act for almost twenty years.

"We learned from him how to play the game. Whenever there was a fundraiser that cost less than $500, I'd go to represent Fenway. I'd shake hands, meet people, and get to know his staff. We knew we had an ally, and we needed to keep ourselves visible. Between 1998 and 2005, I told Steve Boswell we needed to make a stronger presence in Ted Kennedy's life. When we went for our 330 Community Health Center funding in 2002, we had fundraisers for Kennedy at our houses, and Ted Kennedy would come with his staff and his wife Vicki. As a result, his staff would always call when they needed information about HIV and AIDS. Even more important, in Ted Kennedy's last campaign, we were invited to a fundraising event in Hyannis on the Kennedy Compound lawn. This was the ultimate sign

that 'we've made it.' I look at it as an obligation. If someone will advocate for us, we have to stuff envelopes, or write a check. It's not buying favors, its saying thank you." The staff of the modern, "adult" Fenway learned to do the things that are needed to succeed in mainstream American society. The fact that LGBT people are more accepted in the United States today is true, but it didn't just happen. This mainstream success is just as much the result of people like Henia Handler, Phil Finch, Harry Collings, and Rodney VanDerwarker making the efforts to bring Fenway into the larger community of American health care organizations and their supporters, and not just LGBT health organizations. Self-confidence earned through so much hard work on behalf of its core community led to broader acceptance of Fenway and its constituencies, and this acceptance led to even more confidence. It's progress, Fenway style, and it continues every day.

The person behind this combination of strategic planning and the daily blocking and tackling required to advance toward Fenway's goals is President and CEO Stephen Boswell. In an organization that had previously never had an Executive Director last longer than five years, he has been here for seventeen years, fourteen of them as the organization's leader. The details of his work—his unique combination of clinical and administrative skills and responsibilities, his strategic planning efforts aimed at the development of an organization focused on medical care and research above all, his creative vision of Fenway Health as the first of America's academic community health centers, and even his communication of his vision through simplification of Fenway's brand identity from Fenway Community Health Center to Fenway Health Center to Fenway Health—have been covered elsewhere in this book. But his leadership and ability to inspire his staff can be seen and heard in the things these people have to say in their conversations about the organization. Many of them express a sense of joy and satisfaction in coming to work every day. They use words like, "I never want to work anywhere else," or "I don't know of any other organization where the leadership really listens to its staff and makes sure to develop systems where we have the opportunity to contribute our ideas," or, "there's no other organization I know that is so self-aware." As can be seen throughout this chapter, Fenway's forward momentum has the unmistakable stamp of a leader who listens, engages, and communicates in a way that makes each of us want to contribute more to Fenway Health. Earlier, describing the way the

health center encourages people to come in for regular check-ups, vaccinations, and preventive health procedures, we noted that part of the message is, "come in and we'll talk about it." In many ways, that style is not just Fenway's, it is also the style of its leader.

Perhaps Harry Collings says it best. "He's a guy who is always looking at where we'll be five years, ten years from now. He's always looking at the big picture. I look at him and say that I have to keep helping the organization. Everybody tries to do strategic planning. Steve Boswell is strategic planning."

...

Fenway Health is at the perfect place in the perfect time in the overall environment of health care in the United States. There is general acceptance by policy-makers and providers that our health care system is damaged and is not meeting the needs of our citizens. Big change is really needed, and it will come in a number of different forms. One is the way we organize ourselves around the provision of care. Now, people are treated in episodes of illness. You may see your doctor for an exam once in a while—a physical—or something else that forces you to see a doctor—a pregnancy or a sore throat, for example.

It turns out that this is a very inefficient way of taking care of people. A much more efficient way is the taking care of a population of people. Instead of having doctors think of their role as taking care of the next sore throat that comes through the door, it's caring for a person who may have a sore throat next week, but may not. And then it's looking at all the needs of those people and figuring out how to keep them healthy. And finally it's about taking responsibility for that. This is one of the basic tenets of the "medical home" concept. Community health centers have always been all about those things. We have always been about taking care of the community. The biggest impediment to moving in this direction is reimbursement. The way we pay for medical services is focused so much on procedures and visits that it prevents these other things from ever happening. What health reform is trying to do is change the paradigm to pay clinicians in a different way so they can care for the whole person. Fenway Health is perfectly positioned to be able to do that. It's a big emphasis on the kind of primary care we provide—not just medical care, but dental services and eye services and a whole set of services more frequently used.

Fenway Health is also one of the first community health centers in the country to begin using electronic medical records. We started in 1997. We can use these systems to provide care to a population of people in a way that will be increasingly important in the future. Our systems can tell us when a patient hasn't come in for services we believe he or she needs to stay healthy—a vaccination, or a screening service to routinely decrease the likelihood of becoming ill, for example a colonoscopy at fifty. If our patients don't show up after a year and a half, we call them up, and tell them that all the medical committees recommend they get a colonoscopy. Then we invite them to come in and talk about it. These services save costs.

We're fifteen months away from becoming an NCQA (National Committee for Quality Assurance) Level 3 Patient-Centered Medical Home. We're working on expanding The Fenway Institute. Our Resident Training Program in LGBT Care in collaboration with Beth Israel Hospital and Harvard Medical School is growing, as is our presence in Washington, DC, and Beacon Hill. The health center's demographics are also expanding. We will build pediatrics alongside the Sidney Borum, and we'll have an adult day care center next door to 1340 Boylston Street. Above all, we will continue to identify needs and meet those needs. In doing so, we won't reinvent the wheel, but we'll put our own unique Fenway Health twist on it.

—Stephen Boswell, M.D., President and CEO, Fenway Health

CONCLUSION

Fenway Health's forty-year journey has been a dialogue, often starting as a conversation between strangers who became friends and stayed that way. They would see each other on occasions, in times of trouble or celebration, and become each other's pals, role models, or heroes. Their conversations and connections have changed over time, mellowing from confrontations with "the system" about people vs. profit to a usually civil debate about health for all. They've matured from one-way pronouncements from medical providers to patients to engaging explorations of each individual's options for care. And they've grown from immature attacks against each other's politics to heartfelt advice and equally intent listening by many different groups. It is a journey that could not easily take place in these forty years anywhere other than the Commonwealth of Massachusetts, a place some would say is only a short distance from the state of denial, the former home of too many LGBT people.

With a solid foundation and a little luck, the dialogue that Fenway Health has become moves forward, fulfilling the dreams of the hippies who founded it on naïve notions of peace, love, and free care for all. Today's dialogues are richer in content, as information is shared across the globe and people benefit from deeper conversations with providers about their health care. But sometimes there are entities with which no dialogue is possible, and we must make sense from our own internal dialogue, informed by experience alone. If the "monster from space" told us anything at all, it was the lesson that we need to open our doors to each other. When there is truly no place to hide, then there is no need for closets. In times of crisis it's best to work together to build bridges to safety by talking to, and working with each other—no matter who we are. The story of Fenway is the story of fireside whispers and secrets shared across the decades with yesterday's heroes. For a long time, they huddled in the dark, fearing the monster but determined to defeat it, hoping to come home or at least find a new neighborhood and make it a friendlier place. They inspire us not only because of what they achieved, but also because they always found the time to laugh together, or to dance with each other to disco anthems, believing in better times that, thankfully, finally arrived.

At first the people at Fenway thought they were saving the world, and, if you count progress toward that goal one person at a time, they saved many worlds, even if they failed to reach everyone soon enough. The bridges they built to the future link us with an untold number of unforgettable people—from long-haired physicians volunteering their time, to the early AIDS patients who realized they were going to die, but contributed their blood and lives for information that would help lead to the discovery of a treatment or cure that would work for others. Remember them. The keystones that held these bridges steady were management, medicine, and grueling hours of research, combined with a countless blur of lab tests, trials, and tears. How important will it be in 2020, or 2050, that AIDS happened the way it did from 1981 through 1996? How will society change for LGBT families going forward? Will our children and grandchildren remember the thirty years of a successful AI program, revolutionary in its time, that allowed lesbians and single women to become the mothers they yearned to be? Who will lead in the future? How will these new leaders interpret all that has gone before?

Susan Love, MD (L) and Helen Cooksey, MD (R) flank their daughter Tammy (*Marilyn Humphries*).

The strangest legacy of all might be the unique combination of people and organizations that become friends and helpmates in this awkward but beautiful odyssey. Once upon a time, not so long ago, really, the city of Boston was a haven of hate-spewing City Councilors, who sought to convert, contain, or even quarantine the gay community. And yet this same city, largely through the efforts of different, more sympathetic leaders, actually helped Fenway obtain its first new building at a time when additional space was absolutely necessary. The health center battled for the dignity of its community with minority clerics who preached love, but insisted there were no Black or Latino gay people, only IV drug users and prostitutes with AIDS. Fenway erected bridges of hope anyway, to bring these "nonexistent" people into an open dialogue about a different kind of care. Fenway's heroes have taught us how to rise above fear, ignorance, and prejudice. On a deeply personal level for many of us, the story of Fenway is much like our own. It begins with accusation, moves through retribution, and ends with forgiveness and peace.

While some may fear that Fenway might lose its place in the nation's health care system as the LGBT community is more fully assimilated American society, it may be true that, through The Fenway Institute, Fenway has found a way to keep that from happening. An "academic community health center" will always be able to demonstrate that there are differences between the health of the LBGT community and Americans at large—differences that will preserve the integrity of Fenway regardless of shifts in social acceptance for our community. Fenway has a long lead in learning, and then teaching lessons about health care for LGBT people. When you really think about it, the real question might be asked the other way around: Will other health centers in America lose *their* place to organizations like Fenway? Will Americans in all shapes, sizes, colors, and sexual orientation seek providers who have learned to provide competent and sensitive health care while engaging their patients in insightful dialogues about how to manage their own health?

After 40 years of struggles, Fenway Health celebrates its achievements in a new 10-story building that stands proud and tall, an iconic birthday cake layered with stories of health, tragedy, joy, life-saving science, and human compassion. Remembering a time long past, some of us may choose to return for our health care to Fenway: Sixteen, a different sort of icon. Others remember the thrill of what was, once upon a time, the "new health care building," Ron Ansin's

"enormous new building" at 7 Haviland Street, a place that Woody, the Fenway Receptionist, dubbed "our funky little health center" even when it was new.

Phil Finch reminds us of how our pride in past accomplishments can get in the way of our future mission. He remembers that Fenway's 7 Haviland Street building was the first LGBT-owned health care facility ever, and that, celebrating this achievement, the building was designed as part of the health center's logo for twenty years. "It was a remarkable achievement in a much different political climate with a much different viewpoint toward the LGBT community. And what we have now is the biggest health care facility for LGBT people in the world. But even with that status, we still have to remember that we're an organization first, and a building or a collection of buildings second, even if we have an enormous sense of pride in how these buildings represent what we have done."

Above all, the story of Fenway is the story of an organization that was founded to solve problems that are still waiting to be solved, and about the people who decided to try rather than standing on the sidelines waiting for someone else to make a difference. It's a story about people being totally unrealistic, about thinking more of possibilities and less about the barriers on the way to realizing them, or as the minister said when ground was broken for 7 Haviland Street in 1989, "You have dared to manifest an audacious dream of fairness and equality that is symbolized in this building." It's a story about doing everything we can possibly do in the face of overwhelming odds, and realizing that sometimes all we can do is not enough. It's a story about care, and about caring. It's a story about bringing people together who, on the face of it, have no reason to be together, but who somehow find a way to make it work. It's a story about finding someplace we never want to leave, and realizing how special that is, even as some of us learn that we have no choice but to move on.

It's a story about being heroes together, facing terrible enemies, and also about being our own worst enemies, tearing ourselves apart—thankfully, for only a short time. It's about triumphs shared, losses mourned, and always about laughs, tears, and holding each other close. Taken together, it's a story about forty years of a remarkable organization that set out to right too many wrongs, yet somehow found a way to concentrate on the most important ones, and prevailed. But it's

also a story of life and death—so much more complicated, and at the same time so much simpler. At a time when Fenway Health celebrates forty years of community, collaboration, and care, it's a story about each of us and our relationship with an organization that is both an enduring symbol and a lasting accomplishment. When all is said and done, the story of Fenway Health is the best kind of story of all. It's a story without end that starts within each of us.

It's a love story.

END NOTES

Introduction

1 Kuhr, Fred (2009). "Fenway's Great Big International Success Story." *Boston Spirit*, March/April, 2009. pp. 20-26, 92.

The 1970s: Overview

2 American Friends Service Committee, "Who We Are." www.afsc.org.

3 McLaughlin, Jeff (1979). "Gay Boston is a Reality." Boston *Globe*, February 18, 1979, pp. 87, 92.

4 Our Bodies Ourselves, "Who We Are," www.ourbodiesourselves.org/about.

5 Day, Katharine (1971). "Women's Group Seizes Harvard Building." Harvard *Crimson*, March 8, 1971. Online archives at www.thecrimson.com/article/1971/3/8/womens-group-seizes-harvard-building-brbrbdemand/

6 Women's Community Health Center (Cambridge, MA) Records, 1953-1987. "History," Arthur and Elizabeth Schlesinger Library on the History of Women in America Finding Aid. www.oasis.lib.harvard.edu/oasis/deliver/~sch00351

7 Cambridge Women's Community Health Center (1978) Newsletter: *On Our Way*, April 1978. pp. 5, 6.

8 Our Bodies, Ourselves, "History of Abortion," www.ourbodiesourselves.org/book/excerpt.asp?id=27

9 *Op Cit*, Women's Community Health Center Records, 1953-1987.

10 Newton, Huey (1970). "A Letter from Huey Newton to the Revolutionary Brothers and Sisters about the Women's Liberation and Gay Liberation Movements," LGBT History Month Weblog, October 4, 2007. www.lgbthmuk.blogspot.com/2007/10/black-civil-rights-womens-liberation.html

11 Clendinen, Dudley, and Nagourney, Adam (2001). *Out for Good.* Simon and Schuster, New York, NY, p. 220.

12 Young, Dale (1982), *A Promise Kept: Boston's Neighborhood Health Centers.* The Trustees of Health and Hospitals, City of Boston, MA. P 47.

13 *Ibid*, p. 38.

14 George Washington University, School of Public Health and Health Services, Department of Health Policy, "Dr. Count Gibson," www.gwumc.edu/sphhs/departments/healthpolicy/ggprogram/gibson.cfm

15 *Op Cit*, Young, p 42.

16 *Op Cit*, Young, pp 45.

17 *Op Cit*, Young, p 43.

18 *Op Cit*, Young, p 41.

19 *Op Cit*, Young, p 46.

20 Hareyan, Adam, "The History of Medicare," EmaxHealth, Hickory, NC. www.emaxhealth.com/72/1272.html

21 *Op Cit*, Young, p. 45.

The 1970s: Care

22 Miller, Neil (1995), *Out of the Past*, Vintage Books, a division of Random House, New York, NY. p 400

23 *Op Cit*, Young, p. 94.

24 *Op Cit*, Young, Appendix B 12.

25 *Op Cit*, Young, pp 123, 140.

26 *Op Cit*, Young, p 80.

27 *Op Cit*, Young, p 123.

28 *Op Cit*, Young, pp 122–128.

29 *Op Cit*, Young, p 140.

30 US Department of Health & Human Services, Office of
 Population Affairs, "Public Law 91-572, December 24, 1970."
 www.hhs.gov/opa/about/legislation/pl91-572.html

31 *Op Cit*, Young, p 143.

32 Haseltine, F. P., and Greenberg-Jacobson, B. (1997). *Women's Health Research:
 A Medical and Policy Primer.* Washington, DC.: Health Press International.

The 1970s: Education

33 Our Bodies Ourselves, "The Boston Women's Health Book
 Collective and Our Bodies, Ourselves: A Brief History and
 Reflection," www.ourbodiesourselves.org/about/jamwa.asp

34 *Ibid.*

35 *Op Cit*, US Department of Health & Human
 Services, Office of Population Affairs.

36 Hoffman, Amy (2007). *An Army of Ex-Lovers*, University
 of Massachusetts Press, Amherst, MA.p. 88.

The 1970s Advocacy

37 *Op Cit*, McLaughlin, Jeff (1979) Boston *Globe*.

38 Diamant, Anita (1989). "The Good Fight," *The Boston
 Globe Magazine*, August 27, 1989, p 61.

39 Watergate.info, "Nixon's Address to the Nation on the War in
 Vietnam, the 'Silent Majority' Speech, November 3, 1969. www.
 watergate.info/nixon/silent-majority-speech-1969.shtml

40 Anonymous, "The 1968 Election and the Moral
 Majority," Powerpoint Presentation, slide 18.

41 The Moral Majority Coalition, "Moral Majority Timeline."
 www.faithandvalues.us/mm_timeline.htm

42 *Op Cit*, Miller, p. 381.

43 "Ten More Good Years: LGBT History Files, Lookout Films,
 www.web.me.com/lookoutfilms/Ten_More_Good_Years/
 LGBT_History_files/timeline

44 "Moments in Time: Anita attacks," Gay San Diego,
 www.gay-sd.com/communities/history/moments-in-time-anita-attacks/

45 Mitzel (1980), *The Boston Sex Scandal*, Glad Day Books, Boston, MA. pp 74-77.

46 *Op Cit*, McLaughlin, Jeff (1979) Boston *Globe*.

1980–1996: Overview

47 Fenway Community Health Center (1991), *Opening
 New Doors*, Boston, MA. p 33.

48 *Ibid*, p. 33.

49 *Op Cit*, Miller, p. 418.

50 *Roots of Pride: 30 Years of Community and Controversy*,
 The History Project, Cambridge, MA, 2010.

51 *Op Cit*, Fenway Community Health Center (1991), p. 34.

52 *Op Cit*, Fenway Community Health Center (1991), p. 35.

53 *Op Cit*, Fenway Community Health Center (1991), p. 38.

54 Makadon, Harvey, J., Mayer, Kenneth, H., Potter, Jennifer, and
 Goldhammer, Hilary (2008) *Fenway Guide to Lesbian, Gay, Bisexual, and
 Transgender Health*. American College of Physicians, Philadelphia, PA. p. 268.

55 "Reagan Did Mention AIDS Publicly Before 1987," History
 News Network, www.hnn.us/blogs/entries/5621.html

56 "Ryan White CARE Act," AIDS Alliance for Children, Youth,
 and Families, www.aids-alliance.org/policy/ryanwhite

57 *Op Cit*, Fenway Community Health Center (1991), p. 36.

58 *Op Cit*, Fenway Community Health Center (1991), p. 41.

59 "Fenway-initiated Project Wins Increased AIDS Funding," *Frontlines*, Fenway Community Health Center, v. 4, n. 3, Fall, 1992, p. 1.

60 Osmond, Dennis H. (2003), "Growth of the Epidemic in the United States from 1981-1996, Epidemiology of HIV/AIDS in the United States," *HIV InSite*, University of California, San Francisco. www.hivinsite.ucsf.edu/InSite?page=kb-01-03#S1.4X

61 *Ibid.*

1980-1996: Care

62 *Op Cit*, Fenway Community Health Center (1991), p. 37.

63 Mayer, Kenneth, "HIV Antigens and Antibodies," *Fenway Research*," Fenway Community Health Center, v. 1, n. 2, Autumn, 1988. p. 4.

64 Huyett, Jeff, "Peptide T Update," *Fenway Research*, Fenway Community Health Center, v. 2, n. 2, Fall, 1989, p. 2.

65 Moon, Martha, "Notes From Martha...Expanded Use of AZT," *Fenway Research*, Fenway Community Health Center, v. 2, n. 2, Fall, 1989, p. 3.

66 *Op Cit*, Fenway Community Health Center (1991), p. 43.

67 "Squeamishness, Money, and AIDS," Editorial, Boston *Globe*, Boston, MA. April 8, 1990, p. A.24.

68 "New Program, New Location, New Director: Substance Abuse Treatment Program Launched," *Frontlines*, Fenway Community Health Center, v. 1, n. 3, Summer, 1989. p. 1.

69 *Op Cit*, Fenway Community Health Center (1991), p. 43.

70 "Protease Inhibitors: What Are They?" *AIDSMEDS: Your Ultimate guide to HIV Care*, www.aidsmeds.com/archive/PIs_1068.shtml

71 Maugh, Thomas H. II, "Drug Cocktail Can't Eliminate HIV, Experts Say," Los Angeles *Times*, November 14, 1997. Los Angeles, CA. www.articles.latimes.com/1997/nov/14/news/mn-53636

72 *Ibid.*

1980–1996: Research

73 "Pneumocystis Pneumonia–Los Angeles: Epidemiologic Notes and Reports," *Morbidity and Mortality Weekly Report*, June 5, 1981. v. 30, n. 21. pp 1-3.

74 "Kaposi's Sarcoma and Pneumocystis Pneumonia Among Homosexual Men–New York City and California," *Morbidity and Mortality Weekly Report*, July 4, 1981. v. 30, n. 6. pp. 6-8.

75 "Epidemiologic Notes and Reports Persistent, Generalized Lymphadenopathy among Homosexual Males," *Morbidity and Mortality Weekly Report*, May 21, 1982. v. 31 n. 19, pp. 249-51.

76 "1984 History: History of AIDS Up to 1986, " AVERTing HIV and AIDS, www.avert.org/aids-history-86.htm.

77 "History of HIV AIDS: HIV Channel," Health Communities.com. www.healthcommunities.com/hiv-channel/what-is-hiv-aids.shtml

78 "Estimates of New HIV Infections in the United States: HIV/AIDS Statistics and Surveillance," Centers for Disease Control and Prevention, Department of Health and Human Services. www.cdc.gov/hiv/topics/surveillance/resources/factsheets/incidence.htm

79 "Twenty-Five Years of HIV/AIDS --- United States, 1981-2006," *Morbidity and Mortality Weekly Report*, June 2, 2006. v. 55, n. 21, pp. 585-589.

80 Wainberg, Mark A, and Read, Stanley E, "Public funding for AIDS research in Canada and the USA," *Canadian Medical Association Journal*, January 15, 1986. v. 134, p. 109.

81 "About AIDS Action Committee of Massachusetts," AIDS Action Committee. www.aac.org/site/PageServer?pagename=about_home

82 "A History of CRI," Community Research Initiative
of New England. www.crine.org/history.html

83 *Principles of Epidemiology, Second Edition.* Public Health Service, Center
for Disease Control and Prevention, Department of Health and Human
Services. Public Health Practice Program Office, Atlanta, GA. 1992. p. 301.

84 *Op Cit*, AVERTing HIV and AIDS.

85 "Pentamidine Isethionate," RxMed.com. www.rxmed.com/b.main/
b2.pharmaceutical/b2.1.monographs/CPS-% 20Monographs/CPS-% 20
(General% 20Monographs-% 20P)/PENTACARINAT.html

86 Moon, Martha, "Notes from Martha..." *Fenway Research*, Fenway
Community Health Center, v. 1, n. 2, Autumn, 1988, p. 1.

87 *Op Cit*, Mayer, Ken, *Fenway Research*, Fall, 1988.

88 "Goodbye Note from Martha," *Fenway Research*, Fenway
Community Health Center, Spring, 1991. v. 4, n. 1. p. 3.

89 Lehman, Betsy A., "State to sponsor trial of vaccine for people with HIV,"
Boston *Globe*, September 2, 1993. Boston, MA. Metro Section, p. 25.

90 "HIV Treatment Options," HIVInfoSource, NYU Medical
Center, Bellevue Hospital Center, New York, NY.
www.hivinfosource.org/hivis/hivbasics/treatment/

1980–1996: Education

91 "Information about AIDS," Boston *Globe*, June
8, 1983, Boston, MA. Living Section, p. 1.

92 "AIDS Action Committee's Safe Company flyers (ca. 1990):
Sexual Freedom & Liberation," *Gay & Lesbian Pride & Politics.*
Northeastern University Library Archives and Special Collections.
www.lib.neu.edu/archives/voices/gl_sexual4.htm

93 "History of Breast-Feeding in Relation to Breast Cancer Risk: a
Review of the Epidemiologic Literature: Journal of the National

Cancer Institute," *Oxford Journals*, Oxford University, Oxford, UK.
www.jnci.oxfordjournals.org/content/92/4/302.full

94 Op Cit, Miller, p. 551.

95 "If Nonprofits Aren't Working Themselves Out of Business, They're
Failing," Good Business, www.good.is/post/should-charities-die/

96 "Uniting to Beat Polio: History of Success," *March of Dimes*.
www.marchofdimes.com/aboutus/789_821.asp

1980–1996: Advocacy

97 "From the Executive Director," *Frontlines*, Fenway
Community Health Center, Winter, 1993, v. 5, n. 1. p. 2.

98 "Camus, Albert (1947). *The Plague*. Translated by Gilbert, Stuart.
Alfred A Knopf, a division of Random House, New York, NY. p. 241.

99 Op Cit, Diamant, *Boston Globe Magazine*, August 27, 1989.

100 "Sunset Possible for Ryan White," *On the Ten*.
www.ontheten.blogspot.com/2009/09/sunset-possible-for-ryan-white.html

101 "A Living History: The Ryan White HIV/AIDS Program," Health
Resources and Services Administration, Department of Health
and Human Services. www.hab.hrsa.gov/livinghistory

102 *Op Cit, Frontlines*, Fenway Community Health Center, Fall, 1992, p. 1.

1980–1996: Leadership

103 *Fenway Health*, Fenway Community Health Center, Winter, 1985, p. 3.

104 *Frontlines*, Fenway Community Health Center, Winter, 1991. v. 3, n. 1, p. 5.

105 *Fenway Research*, Fenway Community Health Center, Spring, 1991. v. 4, n. 1, p. 3.

106 *Op Cit, Opening New Doors*, pp. 4–13.

107 *Op Cit, Frontlines*, Winter, 1991. p. 1.

108 *Frontlines,* Fenway Community Health Center, Winter, 1993. v. 5, n. 1. p. 2.

109 *Frontlines,* Fenway Community Health Center, Fall, 1994. v. 5, n. 6. p. 2.

110 *Ibid.*

111 *Frontlines,* Fenway Community Health Center, Spring, 1995. v. 6, n. 1. p. 2.

1996–2011: Overview

112 "Fenway Health," Beth Israel Deaconess Medical Center, www.bidmc.org/CentersandDepartments/Departments/CommunityHealthCenters/FenwayHealth.aspx

1996–2011: Care

113 Mayer, Kenneth; Appelbaum, Jonathan; Rogers, Tracey; Lo, Wilson; Bradford, Judith; and Boswell, Stephen; "The Evolution of the Fenway Community Health Model," *American Journal of Public Health,* June, 2001. v. 91, n. 6. p. 892.

114 Boswell, Stephen, "Kicking Off Our Fourth Decade," *Outlook,* Fenway Community Health, Winter, 2001. p. 2.

1996–2011: Research

115 *Op Cit, Outlook,* Winter, 2001. p. 4.

116 The Fenway Institute, 2008. *Making Life Healthier,* Fenway Health, Boston, MA. p. 4.

117 *Op Cit, Outlook,* Winter, 2001. p. 7.

118 *Ibid,* p. 9.

119 *Op Cit,* The Fenway Institute, 2008. p. 4.

120 *Ibid,* p. 6.

121 *Ibid,* p. 3.

122 *Ibid.*

123 "About Healthy People," Healthy People, Office of Disease Prevention and Health Promotion, Department of Health and Human Services, Washington, DC. www.healthypeople.gov/2020/about/default.aspx

124 Bradford, Judith, "A road map to a new day for LGBT health," *Huffington Post*, April 7, 2011. www.huffingtonpost.com/judith-bradford-phd/a-road-map-to-a-new-day-f_b_846062.html

125 *Op Cit*, Makadon et. al., p. iv.

APPENDIX

Preliminary Proposal for a Fenway Health Centre

June 23, 1971

I Abstract:

The following is a proposal which has taken form after
nearly one year of meetings with residents of the Fenway area
and provider institutions in the same area. Part of the data
which has shaped the proposal is included in the work of five
students from the Boston University School of Community Medicine
entitled A Study in the Problems of obtaining Medical Care for the
Elderly of the Fenway.
The underlying philosophy which has guided those who have worked
toward making the centre a reality is, synoptically:
1. It is the obligation of the society to provide adequate
medical service to everyone in the society as a matter of human right.
2. The form of service can best be assessed by those serviced,
the form of organizational structure necessary to provide that
service is best ascertained by those engaged in providing the service.

These considerations have led us to holding many meetings in
an attempt to maximize community involvement in the project with
an eye to the creation of a consumer council of residents who
will be the directors of the Centre. They have also led us to
meetings with provider institutions to determine to what extent
resources are available to us and in what ways they might be able
to help us. Finally, these considerations have led us to an
emphasis on community organization and education.

II Form of Organization.

Our understanding of the Fenway area (Boston Centre for Older
Americans direct service area, c.f. data from the Centre.) leads
us to emphasize the creation of a centre of even limited service
capabilities. First, we know that the needs are many, immediate
and are not being presently met. [1] Secondly, we feel a good deal
of time and energy will be necessary to catalyse the kind of
cohesion necessary in our area to make the consumer council
a viable, effective organization.

1. See the appropriate sections of the B.U. Fenway Report.

Initial proposal for Fenway Health Centre, page 1, June 23, 1971.

304

In line with this concern, we have applied to the Boston
Brookline Health Resources Organization for funds enabling us
to have a full time community organizer working on the project.

Since we are concerned with an area comprising variagated
sociological groups among them many elderly over 65, we are concerned
with continuing care. At present we have three organizations
which have resonsibilities for part of the cachment area:
the Visiting Nurses Association from which Joan Goldsberry
has shown a direct interest in the Centre, the Home Medical
Service of Boston University, from which Dr. Frederick Brand
has shown interest, and the Boston Centre for Older Americans
from which Mr. Fritz W. Crumb has shown interest. Each of
these groups, besides having obligations which cover part of
our area and thus serving as presently available back-up to us,
has expressed a desire to participate more fully with the
Centre.
 1. Dr. Brand has indicated that, pending a clear understanding
of his available resources in the fall, it might be possible to
assign part of his service to our area.
 2. Joan Goldsberry has indicated that the VNA may be able
to provide an educational service toward the formation of a
'health maintainance sector' depending on available funding.
This coincides with our effort at developing indigenous
'community advocates' for our follow-up service.
 3.The Boston Centre has indicated a willingness to provide us
with social services including meals, home aid, recreation,
etc. and one social worker who would be our FHC-BCOA coordinator.

These three groups constitute our resources in the area of
'continuing care'.

We do not envisage ourselves as a 'screening clinic' soley.
Such a form might be less than helpful, in that it violates our
concept of follow-up. In order to provide the kind of care
we feel necessary, we need back-up services in other areas
from those mentioned above.

Thus far, we have the following services available:

 1. Mental Health. Dr. D. Scherl of the Massachusetts
Mental Health Centre has assured us of available psychiatric services.
A formalization of this back-up, possibly with an on site person,
is pending further meetings. Miss. E. A. Commerford is also
involved in helping us organize psychiatric back-up.

2.

Initial proposal for Fenway Health Centre, page 2, June 23, 1971.

2. Hospitalization. We have requested from the Health Resources Corporation specific back up in this area. The executive board has not yet met on our proposal.

3. Diagnostic Lab. Miss. V. Mendez of Health Incorporated said at a meeting concerning the centre that given a competent lab tec hnician, it might be possible to work out an arrangment for the use of their laboratory. We now have such a technician, a Mr. Marshall. [2] It remains to be seen what HI will do.

4. At present, even in the absence of other back-up, we can utilize Health Incorporated in those instances where it is necessary to have fairly elaborate back-up. We have spoken with the representative, Miss. Mendez , concerning our wish to avoid duplication of effort. It is too early to determine the best way to organize around that problem.

Given the tentative nature of much of the preceding, we propose that commitments be made on the part of those hospitals which service our area, namely the Peter Bent Brigham, Beth Israel, Boston City and Massachusetts General, to provide the necessary back-up.

III Community involvement in services.

We consider it necessary to open every avenue which facilitates community control of institutions. One area in which this is to be accomplished is with respect to community advocates. We intend to train residents to be health advocates, to go with individuals to our back-up services and determine that proper service is in fact made available, in short to ascertain in every case that adequate medical service has been obtained; for this reason part of our funding must include a request for educational purposes. Both the VNA and BCOA have resources and interest in providing them to this end.

Secondly, in light of the difficulty other centres have faced with respect to police ambulance services, we would like a formal arrangement with the police department which clearly defines our role as one which does not require an investigatory team to be sent in place of ambulance service, but which requires an ambulance. To this end we propose working such an arrangement through the community relations board and/or the Health Resources Corporation.

Finally, we propose that the Consumer Board take over the administration of the Centre as soon as this is feasible.

3

2. See Linda Beane, 262-9027

Initial proposal for Fenway Health Centre, page 3, June 23, 1971.

IV Temporary Administrative and Use Structure.

1. Space:
The Boston Centre for Older Americans has donated adequate space for us within the agency. This also serves to provide us with an umbrella respected and used by the elderly in the Fenway area, thus catalysing the use of the centre by the elderly.

2. Financial:
The Administration of the Boston Centre will administer our funds for a period of time, until we have incorporated and feel prepared to undertake that responsibility. An aggreement to pay 15% of funding for administrative overhead has been reached.

3. Equipment:

At present we have an air conditioner, examining table, two refrigerators and waiting room furniture, all donated. We need considerably more equipment, including a microscope and also ongoing supplies. This constitutes much of the line-item budget request.

V Personnel:

Dr. V. Perrelli; Health Incorporated. He will donate time on a weekly basis for the year.
Dr. Irma Gili; Dermantology, Peter Bent Brigham Hospital. Will donate time.
Miss Linda Beane; R.N., Boston City Hospital. Will donate time.
Mrs. Georgia Sharpe; Social Worker, B.C.O.A. . Will coordinate our activity vis a vis the B.C.O.A. .

We need additional personnel . We have approached the Medical Committee for Human Rights. Thus far we have had no response.

4

Initial proposal for Fenway Health Centre, page 4, June 23, 1971.

VI

 In light of the necessity of determining future needs as a function of the staff capabilities of the organization, only a sketchy presentation of a line-budget is possible.
 Tentatively then, our request is as follows:

Personnel: Community Organizer	$7,200.00	
Laboratory Equipment	$5,000.00	
Initial Supply Level	$2000 .00	
Initial Drug Closet	$2,000.00	
Total	$16,200.00	
15% of Total	$2,430.00	
Request Total	$18,630.00	

 The above figures were secured from conversations with personnel from the Black Panther Clinic.

David Scondras, 262-6350

5

Initial proposal for Fenway Health Centre, page 5, June 23, 1971.

FORM NO. CO-100 (Rev. 10 / 71) - 1040 - 10 - 21 - 650373

The Commonwealth of Massachusetts
JOHN P.X. DAVOREN
Secretary of the Commonwealth
STATE HOUSE
BOSTON, MASS.
ARTICLES OF ORGANIZATION
(Under G.L. Ch. 180)
Incorporators

NAME POST OFFICE ADDRESS

Include given name in full in case of natural persons; in case of a corporation, give state of incorporation.

Norma Gaye Martin 70 Fenway, Boston Mass. 02115

William Vincent Perrelli, M.D. 20 Lawn St., Roxbury, Mass. 02120

Michael Alan Vance 109 Gainsborough St., Boston, Mass. , 02115

The above-named incorporator(s) do hereby associate (themselves) with the intention of forming a corporation under the provisions of General Laws, Chapter 180 and hereby state(s):

1. The name by which the corporation shall be known is:

Fenway Community Health Center, Inc.

2. The purposes for which the corporation is formed are as follows:

1. To make plans for, and to take all necessary steps, including applying for a determination of need under General Laws Chapter 111, Section 51, in order to establish a clinic to serve the residents of the Fenway and surrounding areas of the city of Boston.

2. Educate the people in the Fenway and surrounding areas of Boston, and assist these residents in improving the quality of health care in this area.

The activities and purposes of the corporation will be exclusively charitable and education. The corporation will not engage or participate in any activity or practice which is prohibited to any tax exempt organization under Section 501 of the Internal Revenue Code or sucessive provisions thereof.

NOTE. If provisions for which the space provided under Articles 2, 3 and 4 is not sufficient additions should be set out on continuation sheets to be numbered 2A, 2B, etc. Indicate under each Article where the provision is set out. Continuation sheets shall be on 8½" x 11" paper and must have a left-hand margin 1 inch wide for binding. Only one side should be used.

Fenway Community Health Center, Inc. Articles of Oranization, page 1, 1972.

3. If the corporation has more than one class of members, the designation of such classes, the manner of election or appointment, the duration of membership and the qualification and rights, including voting rights, of the members of each class, are as follows:—

 Non-applicable*

* 4. Other lawful provisions, if any, for the conduct and regulation of the business and affairs of the corporation, for its voluntary dissolution, or for limiting, defining, or regulating the powers of the corporation, or of its directors or members, or of any class of members, are as follows:—

 1. To elect or appoint directors, officers, employees, and other agents, to fix compensation and define their duties and obligations, and to indemnify such corporate personnel.

 2. To pruchase, recieve, take by grant,gift, devise, bequest or otherwise, lease,or otherwise aquire, own, hold, improve, employ, use and otherwise deal in and with, real or personal property, or any interest therein, wherever situated.

 3. To sell,convey, lease, exchange, transfer or to otherwise dispose of, or mortgage, pledge, encumber, or create a security interest in, all or any of its property, or any interest therein, wherever situated.

 4. To make contracts, give guarnaters and incur liabilities, borrow money at such rates of intrest as the corporation may determine, issue its notes, bonds and other obligations, and secure any of its obligations by mortgage, pledge or encumbrance of, or security interest in, all or any of its property or any interest therein, wherever situated.

 5. To have and exercise all powers necessary or convenient to effect any or all of the purposes for which the corporation is formed; provided that no such power shall be exercised in a manner inconsistent with this chapter or the general laws of the commonwealth and the rules and regulations of the Dept. Public Health regarding establishment and maintainance of clinics. Continued on separate sheet (4B).

* If there are no provisions state "None".

Fenway Community Health Center, Inc. Articles of Oranization, page 2, 1972.

5. By-laws of the corporation have been duly adopted and the initial directors, president, treasurer and clerk or other presiding, financial or recording officers whose names are set out below, have been duly elected.

6. The effective date of organization of the corporation shall be the date of filing with the Secretary of the Commonwealth or if later date is desired, specify date, (not more than 30 days after date of filing.)

7. The following information shall not for any purpose be treated as a permanent part of the Articles of Organization of the corporation.

 a. The post office address of the initial principal office of the corporation in Massachusetts is:
 ~~236A Huntington Avenue, Boston, Mass., 02115~~ 16 Haviland Street, Boston

 b. The name, residence, and post office address of each of the initial directors and following officers of the corporation are as follows:

NAME	RESIDENCE	POST OFFICE ADDRESS
President: Michael A. Vance	Boston, Mass.	109 Gainsborough St. Boston, Mass. 02115
Treasurer: Penelope Simpson	Boston, Mass.	24 Phillips St. Boston, Mass. 02114
Clerk: Janet Eleanor Lister	Brighton, Mass.	21 Undine Road Brighton, Mass. 02135

Directors: (or officers having the powers of directors)

c. The date initially adopted on which the corporation's fiscal year ends is:
 Last day in December
d. The date initially fixed in the by-laws for the annual meeting of members of the corporation is:
 First Monday in December.
e. The name and business address of the resident agent, if any, of the corporation is:

IN WITNESS WHEREOF and under the penalties of perjury the above-named INCORPORATOR(S) sign(s) these Articles of Organization this 4th day of November 1972

[signatures] Norma Gaye Martin 11/4/72
[signature] November 4 1972
William Vincent Perelli 11-4-72

The signature of each incorporator which is not a natural person must be by an individual who shall show the capacity in which he acts and by signing shall represent under the penalties of perjury that he is duly authorized on its behalf to sign these Articles of Organization.

Fenway Community Health Center, Inc. Articles of Organization, page 3, 1972.

Article 4B
(continuation of Article 4)

6. To make donations, irrespective of corporate benefit, for the public
welfare or for community fund, hospital, charitable, religious, education-
al, scientific, civic or similar purposes, and in the time of war or
other national emergency in aid thereof.

Fenway Community Health Center, Inc. Articles of Oranization, page 4, 1972.

Proposals for Venereal Disease Research-Fenway Community Health Center 12/80

 The following thoughts represent some of the issues that are still not optimally clear in the management of sexually transmitted illnesses, and are areas in which I feel the Fenway Community Health Center can make an important, and in some cases unique, contribution to better comprehension and patient care. One particularly useful set of articles which helped me update my data base in this area are published in the spring 1980 issue of the Journal of Homosexuality, pages 281-333, where there are synopses of papers delivered at the Conference of Current Aspects of Sexually Transmitted Diseases, June, 1979. Another useful (and free) resource is the biannual Sexually Transmitted Diseases-Abstracts and Bibliography available from the CDC, Atlanta, GA. 30333. The projects listed below are *outlines*, sketchy by definition and I'd be more than happy to discuss details with anyone interested before,or during, the 12/14 meeting.

 Ken Mayer telephone: 232-9861 (home) 732-8611 (page #, work)

Gonorrhea

Background: 1/5 of the patients screened at the Howard Brown Memorial Clinic in Chicago had GC. About 5% of men screened at a mobile site had(+) cultures. At the tubs, asymptomatic screenees showed rates of 5% oral, 8% rectal, and 1% (+) urethral GC cultures; the latter figure contrasts with the estimate that Fiumara gives of 10% asymptomatic urethral GC in Massachusetts, so our comparative epidemiology is important in assessing how universal the Howard Brown rates are. They also found that when folks came in for VD screening that 86% of pts. with pharyngeal GC had no symptoms; 61% of pts. screened in the clinic for rectal GC denied symptoms. If we have this great a discrepancy between clinic and baths, it is worth noting. Analysis of our own gonorrhea epidemiology will enable us to answer many other questions regarding the biology of the disease and its causative organism-e.g. -what are the presenting symptoms of rectal GC, and their frequency- asymp. vs. profuse discharge, vs. pain on defecation vs. blood in the stool. the same with pharyngeal-e.g. sore throat vs. swollen glands vs. asymp. etc.

Dr. Kenneth Mayer's initial proposal for venereal disease research at
Fenway Community Health Center, page 1, December, 1980.

2. GC cont. Mayer

-how often do men and women present with disseminated gonococcal disease?

-how many of our supposedly positive GC isolates are actually meningococus, and
are the patients clinically different from those with true GC? Do any of them get'
meningococcemia? Do they respond to conventional anti-GC medication as well?
(work in this area would involve cooperation with the State Lab, which should be no prob.)

-what are the complications that our patients with GC have-e.g. epididymitis, salpingitis,
prostatitis, subsequent nonspecific urethritis, arthritis?

-what is the percentage of co-existent syphillis found in GC screening? Do these
symptomatic with GC differ from those who are asymptomatic?

-several gonococcal vaccines are being developed (see Sept. 5, 1980 issue of Science,
vol. 209, pages 1103-1106) , do we want to be involved with the clinical trials of this?

-Gonococcal prophylaxis regimes. King Holmes of U. Wash., Seattle, has found that
both minocycline and doxycycline given as single doses after multiple partner sex
may decrease the incidence of GC; this hasn't been done with large group of people.
Other drugs may do the job more cheaply and with less side effects (e.g. ampicillin),
so a clinical study is in order.

-which patients are treatment failures? do we have any penicillinase-resistant or-
ganisms or other difficult to eradicate strains (check with State Lab). If any of
our organisms have unique antibiotic sensitivities, I can arrange to have them
analyzed for free at the Brigham Microbiology Lab to see if there are any potentially
dangerous plasmids on board which could mediate an outbreak of resistant strains.

-Comparison of newer treatment regimens for gonorrhea- (1) comparison of efficacy
of the newer cephalosporins-cefmandole, cefuroxime, and cefaclor. (2) treatment
regimens for pharyngeal GC (hard to eradicate) e.g. bactrim (3) spectinomycin alone
versus spec. and penicillin for rectal GC, as some researchers are now advocating.
- rectal gram stains - how much more useful than culture in dx, of
GC proctitis.

Syphilis

-frequency of primary, secondary, tertiary? what have been the presenting symptoms
and signs? how many asymptomatic?

Dr. Kenneth Mayer's initial proposal for venereal disease research at
Fenway Community Health Center, page 2, December, 1980.

3. Syphillis (cont.) Mayer

-how many of the patients we screen have false positive tests for syphillis?

-any treatment failures, why?

-incidence of Jarisch-Herxheimer reaction?

Nonspecific Urethritis

-is the incidence of this less common among gay men than gonorrhea, and less common

in the local straight community, as Holmes found in Seattle?

-how often is it post-gonococcal?

-how effective is tetracycline at eradication? how often do people relapse and

how often are longer courses of the same drug effective at last versus changing to

another agent? Does probenecid help when txing GC in preventing NSU?—as same claim?

-Holmes found that around 50% of NCU in straights was caused by chlamydia or

ureaplasma, but that the incidence was less in gays: in cooperation with the State

Labs, we could culture for these organisms as well as enteric organisms (which

may have a higher incidence in gay men because of fucking as a mode of transmission),

to do the first definitive study of nonspecific urethritis in the gay community.

It could mean that the agent of choice for NSU would be amoxicillin, or who knows....

-how frequently are complications of nonspecific urethritis seen-e.g. arthritis,

epididymitis urethral strictures, prostatitis? Do specific bugs have predilections'

for specific problems?

Trichomoniasis

-what is the incidence of this infection among lesbians? the patterns of transmission

among gay women are not well known and deserve attention. is it seen in gay men as

a cause of nonspecific urethritis?

-there are some newer techniques which the CDC might be interested in subsidizing

to see if they are cost effective; (1) using acridine orange fluorescent microscopy

to identify the organisms on a slide (2) culturing on cysteine-peptone-liver-maltose

medium.

-comparison of various treatment regimens, e.g. single dose metronidazole vs. 5-7 day course.

Dr. Kenneth Mayer's initial proposal for venereal disease research at
Fenway Community Health Center, page 3, December, 1980.

4 Mayer

Condyloma Accuminatum

-prevalence in clinic population. patterns of illness. relationship to anal inter-
course. relationship to getting other viral infections.

-efficacy of various treatment regimens: cryo, podophyllum, bichloroacetic acid, laser,
and newer topical agents. controlled trials?

Herpes

-types of presentation. frequency of recurrence. clinical trials of various treatment
regimens; Lupidon (a German-made anti-herpes vaccine, just being tried in Europe),
methylene blue topically, influenza vaccine (reported to goose immune response against
herpes- J.B. Miller Annals of Allergy 42:295, 1979).

Enteric Diseases

Background-Dan William of the Gay Men's Health Project in NYC says that there is
a 12% asymptomatic rate of giardia and amebiasis- if this is true here and in other
major urban centers, the implications are significant. how directly is it related
to rimming versus other anal contact? (This last question has major implications
re; pt. education-may be easier to discourage rimming than screwing)
-what have been the presentations of our pts. with giardiasis and amebiasis-e.g.
blood or mucus in stool, diarrhea, malabsorption, flatulance, asymp. etc?
-where is the disease acquired? multicontact? trips to the Caribbean, Mexico, Colorodo?
-how many people relapse after a week of metronidazole? are other rxs. more effective
e.g. diodohydroxyquin?
-frequency of other enteric pathogens: salmonella, shigella, campylobacter, yersinia.

Hepatitis

-incidence? breakdown of A. vs B. vs nonA-nonB? differences in symptoms and outcomes?
relation to various anal sex acts.

-incidence of Hep B persistant (+). chronic active hepatitis incidence.

-vaccine trial versus current multi-center study of high risk Boston hospital workers.

Dr. Kenneth Mayer's initial proposal for venereal disease research at
Fenway Community Health Center, page 4, December, 1980.

-5. Mayer

Scabies and Pediculosis

-incidence. patterns of acquisition. reolution of sx's with Kwell. trial versus
newer agents, e.g. synergized pyrethin liquid, which supposedly only has to be on
the pt. for 1-2 hours.

Miscellaneous

-strategies for the management of vaginitis.

-candidiasis. success of various treatment regimens-comparison.

-hemophilus vaginalis-incidence. symptoms. comparison of treatment regimens
between metronidazole, ampicillin, and tetracycline.

-incidence of genital cytomegalovirus infection.

-bacterial etiologies of acute epididymitis.

-other rare venereal diseases: chancroid, granuloma inguinale, lymphogranuloma venereum.
do we ever see them?

Patient education

-would an intensive education in sexually transmitted dieases cause a decrease in
frequency of specific illnesses when targetted to gay people? how much teaching
in a specific course would be necessary to acause a demonstrable decrease in VD?

Computer utilization

-what ways can we think of utilizing the computer to maximize our information
retrieval network?

-the CDC might be willing to subsidize networking with them and other clinics, perhaps
also with the State Lab.

Dr. Kenneth Mayer's initial proposal for venereal disease research at
Fenway Community Health Center, page 5, December, 1980.

Fenway Community Health Center Utilization Information

Fiscal Year	# HIV-Rel. Visits	Total # of Visits	% of Visits HIV-Related	Medical Visit Rate (Medicaid)	Operating Expense	Net Patient Revenue	Other Operating Revenue	Surplus	Ending Fund Balance	Cash on Hand at Year End
1986	3,500	16,528	21.05%	38	831,579	544,714	345,650	58,785	163,865	41,262
1987	4,382	17,575	24.93%	42	1,080,632	547,191	639,821	106,380	194,823 *	142,647
1988	5,532	18,500	29.90%	50	1,454,027	756,135	1,054,370	356,478	551,301	219,415
1989	9,643	20,000	48.22%	53	2,789,186	890,854	2,122,274	223,942	775,243	346,853
1990	16,500	25,000	66.00%**	60 90 210	6,420,000 **	1,500,000 **	5,220,000 **	300,000 **	1,075,243 **	800,000 ***

* There was a prior period adj. to FB in fy87

** Projected figures

*** $797,099 on hand as of 4/4/90, including operating funds, capital reserve, subcontract funds, etc. monthly operating cash on hand has been $350,000 - $450,000 this fiscal year

Fenway Community Health Center Utilization Information, 1986–1990.

FENWAY COMMUNITY HEALTH CENTER
16 Haviland Street
Boston, Massachusetts 02115 (617) 267 - 7573

For 16 years, the Fenway Community Health Center has provided sexually transmitted disease check-ups and primary medical care to New England's gay and lesbian community. In 1981, Fenway Community Health Center saw the first patients with HIV infection in Boston. By 1983, with a growing caseload, a committee of Board members, staff and concerned volunteers formed the AIDS Action Committee which separated from the health center in 1986. Fenway Community Health Center (FCHC) continues to provide medical care, HIV testing/counseling and HIV epidemiologic research for the gay community and an increasing number of IV drug users.

In medical department visits alone, we estimate that 2,900 visits out of 12,000 annually are for HIV-related concerns. In addition, our alternative test sites provide counseling during 3,000 visits annually and our researchers track behavior influencing the spread of the epidemic during another 1,600 visits from patients and their male and female partners.

We estimate that our caseload for symptomatic HIV patients (AIDS, ARC) is 600 and that our HIV positive patients number around 2,100. There has been a rapid and dramatic shift in the severity of illness among our patients with HIV-symptomatic visits and the number of patients who are now ill. In order to combat this trend, FCHC is committed to establishing community-based medical services that are effective and cost efficient.

At the request of our patients in January we began treating eight (8) patients with aerosolized pentamadine as a prophylactic treatment to prevent reoccurance of pneumocystis pneumonia. By July, we intend to restructure our physical facility to accommodate Massachusett's first free-standing out-patient I.V. infusion and HIV treatment center to serve a capacity of 332 patients. We are seeking assistance from the Commonwealth for start-up costs and service support for this demonstration model program. To our knowledge, it will be the first free-standing out-patient HIV treatment center and should substantially reduce the cost of care as it increases the options for out-of-hospital treatment. For example, today the hospital blood centers will not infuse AIDS patients with blood products, necessitating visits to emergency rooms where patients must wait for as long as six hours to receive a one-hour transfusion at a cost of $300.-$700. for the visit alone.

The proposed HIV treatment center will administer those drugs not ordinarily or easily administered in a primary health clinic mode., i.e. other than oral or inject. While FCHC already offers AZT and aerosolized pentamadine to a limited number of patients, we have reached agreements with medicaid and the rate setting commission to proceed with structuring a new center for more intensive treatments (see attachment) The center will administer the following products and is designed to have a large ·

Fenway Community Health Center proposal for an HIV treatment center, page 1, 1987.

319

(2)

capacity for intervention with pneumocystis and can prevent frequent hospitalization for acute episodes with this opportunistic infection.

SET-UPS	NUMBER OF PATIENTS	VISITS/WEEK	NUMBER OF HRS/VISIT	PATIENT HRS/WEEK
5,200 Aerosolized Pentamdine	200	.5 One time every other week for life.	1	100
728 Pentamadine IV	2 (52)	7 (x 2 wks)	1	14
1,092 Bactrim IV	1 (26)	21 (TID) (x 2 wks)	1	21
1,092 Acyclovin	1 (52)	21 (TID) (x 1 wk)	1	21
DHPG	1	7 Daily	1	7
5,840 Amphotericin	1	7	3-8 hrs.	21 - 56=(32.5)
	332 patients @ capacity		12	219 (20%)

Annual Patient Hours $10,452.

The demonstration model will yield a mechanism for rate setting as ambulatory settings provide increased care during the epidemic. It should save costs through reduction in frequency and length of hospitalizations. It will enable cost savings by serving a population in groups that would otherwise receive one-on-one care in home care settings and should assist with long-term manpower shortages in the nursing field.

Fenway Community Health Center proposal for an HIV treatment center, page 2, 1987.

		DEPARTMENT OF HEALTH AND HUMAN SERVICES PUBLIC HEALTH SERVICE
. DATE ISSUED OCT 21 1987	2. FEDERAL CATALOG NO. 13.133	Bureau of Maternal and Child Health and Resources Development

3. SUPERSEDES AWARD NOTICE dated Aug. 31, 1987
except that any additions or restrictions previously imposed remain in
effect unless specifically rescinded.

NOTICE OF GRANT AWARD

AIDS Service Demonstration Program

4. GRANT NO. H 000073-01-1 Formerly:	5. ADMINISTRATIVE CODES BRH-08

AUTHORIZATION (Legislation/Regulation)

6. PROJECT PERIOD	Mo./ Day / Yr. From 09/01/87	Through	Mo./ Day / Yr. 09/30/90
7. BUDGET PERIOD	Mo./ Day / Yr. From 09/01/87	Through	Mo./ Day / Yr. 09/30/90

Public Health Service Act, Section 301 (42USC241)
P.L. 99-591

8. TITLE OF PROJECT (OR PROGRAM) (Limit to 53 spaces)
Metropolitan Area HIV Services

9. GRANTEE

a. Name Fenway Community Health Center

b. Organization Unit:

c. Street 93 Massachusetts Ave.

d. City Boston e. State MA f. Zip Code 02115

10. DIRECTOR OF PROJECT (PROGRAM OR CENTER DIRECTOR, COORDINATOR OR PRINCIPAL INVESTIGATOR)

NAME Orlando Dale
Last _First_ _Initial_

ADDRESS: SAME AS #9

11. APPROVED BUDGET (Excludes PHS Direct Assistance)

☒ Grand Funds Only
☐ Total project costs including grant funds and all other financial participation

a. Personal Services	$	679,631
b. Fringe Benefits		104,790
c. Consultants		
d. Travel		21,803
e. Equipment		
f. Supplies		11,090
g. Contractual		10,856
h. Patient Care		
i. .struction (A & R)		
j. .raining Costs		
k. Other		42,034
l. TOTAL DIRECT COSTS	$	870,204
m. Indirect Costs (Rate 22 % of S&W/TADC)	$	191,444
n. TOTAL APPROVED BUDGET	$	1,061,648

o. Federal Share	$ 1,061,648
p. Non-Federal Share*	$

*Must meet all matching or cost participation requirements. Subject to adjustment in accordance with PHS policy.

12. AWARD COMPUTATION FOR GRANT

a. Amount of PHS Financial Assistance (from 11.n)	$	1,061,648
b. Less Unobligated Balance From Prior Budget Periods	$	
c. Less Cumulative Prior Award(s) This Budget Period	$	1,061,648
d. AMOUNT OF THIS ACTION		~0~

13. RECOMMENDED FUTURE SUPPORT (SUBJECT TO THE AVAILABILITY OF FUNDS AND SATISFACTORY PROGRESS OF THE PROJECT).

BUDGET YEAR	TOTAL DIRECT COSTS	BUDGET YEAR	TOTAL DIRECT COSTS
a.	SEE PAGE 2	e.	
b.		f.	
c.		g.	
d.			

14. APPROVED DIRECT ASSISTANCE BUDGET (IN LIEU OF CASH)

a. Personal Services	$
b. Travel	
c. Vaccine	
d. Other	
e. TOTAL DIRECT ASSISTANCE	$

15. PROGRAM INCOME SUBJECT TO 45 CFR 74.45 SHALL BE:
a. ☒ Used to further the objectives of the legislation under which the grant was made.
b. ☐ Deducted from total project costs for the purpose of determining the net costs on which the Federal share of costs shall be based.
c. ☐ Other - See Special Conditions
d. ☐ NA

16. THIS GRANT IS SUBJECT TO THE TERMS AND CONDITIONS INCORPORATED EITHER DIRECTLY OR BY REFERENCE IN THE FOLLOWING:
a. The grant program legislation cited above.
b. The grant program regulation cited above.
c. This award notice including terms and conditions, if any, noted below under Remarks.
d. PHS Grants Administration Manual Chapters in effect as of the beginning date of the budget period.
e. PHS Grants Policy Statement in effect as of the beginning date of the budget period.
f. 45 CFR Part 74.

In the event there are conflicting or otherwise inconsistent policies applicable to the grant, the above order of precedence shall prevail.
Acceptance of the grant terms and conditions is acknowledged by the grantee when funds are drawn or otherwise obtained from the grant payment system.

REMARKS (Other Terms & Conditions Attached - ☒ Yes ☐ No)

Appropriation: 7570120

AGENCY OFFICIAL (Signature and Title) Donald C. Parks, Grants Management Officer, BMCHRD

17. ...IST NO. AIDS-PHS-	OBJ. CLASS. 41;45	18. CRS - EIN 1042510564A1		19. ORGANIZATION DESCRIPTORS:
FY-CAN	DOCUMENT NO.	SECONDARY REC. CODE	AMT. ACTION FIN. ASST.	AMT. ACTION DIR. ASST.
20. a. 7-377077 2-87	b. BRH000073A	c.	d. $1,061,648	e.
21. a.	b.	c.	d.	e.
22. a.	b.	c.	d.	e.

PHS-5152-1 (REV. 1/83) (NOTE: See reverse for payment information)

Department of Health and Human Services grant award to
Fenway Community Health Center, page 1, October, 21, 1987.

FOR PEOPLE NOT FOR PROFIT

ITEM NO.

11. Total approved budget is based on the revised budget submitted
 September 23, 1987. The budget for the first twelve months of
 the three year budget period is set out below:

11a.	Personal Service	$176,200
11b.	Fringe Benefits	27,093
11d.	Travel	5,345
11f.	Supplies	3,290
11g.	Contractual	3,264
11k.	Other	8,770
11l.	Total Direct Costs	$223,962
11m.	Indirect Costs	49,271
11n.	Total	$273,233

11m. Indirect costs - 22% of TADC

13. None. Final budget period. The final Financial Status Report for
 this project must be submitted by December 31, 1990. This report
 must agree exactly with the final report of expenditures submitted
 to the payment office as evidenced in the PMS Federal Cash Transactions
 Report (SF #272). In addition, three copies of a comprehensive project
 report must be submitted by December 31, 1990.

 DITIONS

1. The grantee must submit to this office budgets for the second and third
 12-month budget period at least 90 days prior to the start of these periods.

2. The grantee must submit to this office semi-annual performance reports
 within 30 days after the reporting period.

Failure to comply with these conditions may result in the disallowance of
grant funds.

FOR YOUR INFORMATION, THE HHS INSPECTOR GENERAL MAINTAINS A TOLL FREE TELEPHONE
NUMBER, 800-368-5779, FOR RECEIVING INFORMATION CONCERNING FRAUD, WASTE OR ABUSE
UNDER GRANTS AND COOPERATIVE AGREEMENTS. SUCH REPORTS ARE KEPT CONFIDENTIAL, AND
CALLERS MAY DECLINE TO GIVE THEIR NAMES IF THEY CHOOSE TO REMAIN ANONYMOUS.

PHS-5152-2
Rev. 8/82

Department of Health and Human Services grant award to
Fenway Community Health Center, page 2, October, 21, 1987.

WHOLISTIC THERAPIES -PROGRAM PLAN

Administration

Wholistic therapies at FCHC will include massage, acupuncture, chiropractic and polarity. The program will begin on a part-time basis using existing staff for a limited number of sessions/week (4-16 hours/staff) in massage, acupuncture and polarity. Chiropractic will be added after an appropriate affirmative action search can take place since that position will be greater than half-time.

The purpose of wholistic services at FCHC is to provide clients with a wide variety of approaches to obtaining optimal health. It will be administered (budgetary, regulatory, personnel) by the medical director with clinical oversight from Dr. Peggy Roberts, a staff physician for six years at FCHC who studied wholistic practices.

Acupuncture Program

We currently offer acupuncture detoxification in our substance abuse program. Acupuncture will serve both HIV infected people and provide treatment of non-HIV-related conditions.

1. An adjunct to the HIV-treatment center which will offer acupuncture and Chinese medical recommendations for conditions of immune system dysfunction, including Chronic Fatigue Syndrome, Epstein-Barr virus and HIV-related concerns.

2. A general medical component for non-rival related conditions (including musculo-skeletal problems, menstrual dysfunction, pain control, sports medicine, and organic or constitutionally-related complaints).

Since acupuncture is currently covered by a significant number of third party payors, this service promises to be a revenue generator for the health center. Acupuncturists in the Metropolitan Boston area routinely charge $40-75 for the initial visit and treatment, and $25-50 for return visits.

Polarity

Polarity energy balancing is hands-on body work with the goal of releasing energy blocks thus restoring the body to a natural state of pain-free balance. Polarity at the Fenway will include patients with full spectrum HIV infection, PMS, menstrual dysfunction, pain relief, stress related symptoms, pregnancy, gastrointestinal problems.

Wholistic Therapies Proposal, page 1.

Massage

Massage at the Fenway will serve patients with musculo-skeletal problems as well as stress-related symptoms. Massage has been used at the health center as referred by our physicians for the past year, particularly for HIV infected patients. This will enable expansion of the program to other clients.

For polarity and massage, patients will be charged a fee of $30 for a half-hour session and $50 for an hour session for 1st party payments.

Chiropractic

This was the first independently licensed wholistic practice in the Commonwealth. Fees for chiropractic and reimbursement systems with third party payors are still being researched.

A fee schedule of first and third party payments has been devised for the wholistic therapies program and is competitive with the Boston market place.

Space and Support Personnel

The 332 Newbury Street space is currently under lease to FCHC and will not be used by managed care at this time. It makes an ideal staff and practice office suite for this new program. The program will be able to support a receptionist/billing assistant on site.

Wholistic Therapies Proposal, page 2.

Your Department of
Public Welfare

600 Washington Street
Boston, Massachusetts 02111

Charles M. Atkins, Commissioner

March 3, 1988

Dale Orlando
Executive Director
Fenway Community Health Center
16 Haviland Street
Boston, MA 02115

Dear Ms. Orlando:

My staff and I have carefully reviewed your proposal to provide intravenous infusion therapies to Medicaid patients with HIV infections. As we understand your proposal, this service would allow the Fenway Community Health Center to provide up to five infusions simultaneously. The infusions would be performed by a Registered Nurse, with physician back-up.

As an alternative to inpatient treatment, your proposal makes excellent sense both in terms of care and cost. As a matter of policy, the Medicaid program is strongly committed to developing high quality and cost-effective alternatives to in and outpatient hospital care. We agree with you that by providing IV infusion therapy in a health center setting, we will avoid numerous unnecessary hospital stays for those patients who are otherwise-well enough to leave the hospital. We regard your proposal as entirely consistent with our policy direction.

In light of this, Medicaid will reimburse the Fenway Health Center for IV infusion therapy provided at the health center, effective March 15, 1988, given the Fenway's adherance to the clinical protocols we discussed (see Attachment).

When you are ready to begin providing this service, you will need to submit a prior approval request (Form 12) for each recipient proposed to receive this service. These requests should be submitted directly to the Health Choices High Cost Case Management Unit (Department of Public Welfare, Medicaid Division, 600 Washington Street, 5th Floor, Boston, MA, 02111, Attn: Carol Tobias). With the required clinical criteria documented, we will then approve the service for that patient, assign him/her a prior approval number, and reimburse Fenway on an individual consideration (I.C.) basis. Once you have received an approval, you will simply include the assigned prior approval number on each subsequent claim submitted on behalf of that particular patient.

Executive Office of Human Services
Commonwealth of Massachusetts

Approval for transfusion therapy performed at
Fenway Community Health Center, page 1, March 3, 1988.

-2-

Please use procedure code #033353 when billing for this service.
Reimbursement will be set at a rate established through a negotiated
budget with the Medicaid Ambulatory Reimbursement staff.

Please keep this letter in your files as documentation of our review
and approval of your proposal. If you have any questions or should
problems arise as you implement this service, please feel free to
contact Carol Tobias of my staff at 348-5510.

Sincerely,

Robert J. Master, M.D.
Medical Director
Medicaid Division

cc: Claire McIntire
 Mary Fernandez
 Russ Kulp
 Carol Tobias
 Sally Deane
 Lisa Krakow

Approval for transfusion therapy performed at
Fenway Community Health Center, page 2, March 3, 1988.

Fiscal Year 1988 Statistical Summary, page 1.

Fiscal Year 1988 Statistical Summary, page 2.

Jan - Dec 1989 Annual Report for Medical Department

Prepared by Judith Heiman on January 25, 1990

		VISITS	CLIENTS
TOTAL NUMBER OF	VISITS	11902	
	CLIENTS SEEN		4153
		VISITS	CLIENTS
GENDER DISTRIBUTION	MALE	8936	2944
	FEMALE	2966	1209
ETHNIC DISTRIBUTION	ASIAN/PACIFIC ISLANDER	26	18
	BLACK/HAITIAN	412	412
	HISPANIC	176	37
	NATIVE AMERICAN	34	2
	WHITE	4502	1591
	OTHER	29	15
HIV DISTRIBUTION	AIDS Dx	959	107
	HIV + and SYMTPOMATIC	1023	111
	HIV + and ASYMPTOMATIC	1136	219
	HIV - (AIDS ANXIOUS)	153	67
	NOT HIV RELATED	8631	3649
AGE DISTRIBUTION	UNDER 13	24	15
	13-19	112	78
	20-29	3878	1707
	30-39	5046	1556
	40-49	1770	525
	50-59	316	99
	OVER 60	756	167
GEOGRAPHIC DISTRIBUTION	FENWAY AREA	2339	867
	BOSTON	4837	1530
	128 TO BOSTON	2881	1109
	495 TO 128	832	290
	OTHER MASS	539	148
	CONNECTICUT	55	14
	MAINE	18	5
	NEW HAMPSHIRE	94	48
	RHODE ISLAND	42	23
	VERMONT	10	4
	OTHER	215	97
TOTAL NON-VISITS	DNKA'S	260	
	VOIDS (checkout only)		

Annual Report for Fenway Community Health Center's
Medical Department, page 1, January 25, 1990.

```
Program Distributions (Visits)          Primary        Seconday

     Alternative Insemination             57
     Blood Pressure                      212
     Dermatology                         485              9
     Family Planning                     119              3
     Gynecology                          328            107
     HIV Related Only                   2786
     HIV Anxiety Only                     83
     Lab Only                            537
     Massage                              60
     Nutrition                           118
     Podiatry                            165
     Primary Care                       4142            217
     STD -Initial                       1719
     STD Followup                        699
     Surgery                             312

Miscellaneous Distributions

     Where Billed                       VISITS
          Blue Cross                      2561
          Commercial                      1616
          Free Care                        139
          First Party                     5979
          Medicare                         410
          Medicaid                        1197

     Number of MAHS Consultations        ------

     Number of Speaking Dates            ------

     Number of Hosptial Followups        ------

     Other Activities
```

Annual Report for Fenway Community Health Center's
Medical Department, page 2, January 25, 1990.

FENWAY COMMUNITY HEALTH CENTER
Patients by Congressional District CY 2001

District	2001
1st John Olver	27
2nd Richard Neal	24
3rd James McGovern	100
4th Barney Frank	396
5th Martin Meehan	156
6th John Tierney	281
7th Edward J. Markey	634
8th Michael Capuano	4930
9th Stephen Lynch	1576
10th William Delahunt	340
Out of state	352
Unknown	77
	8893

Logician January 2002

Fenway Community Health Center, Patients by Congressional District, 2001.

ABOUT THE AUTHOR

Thomas Martorelli in the 1970s and today
(Photo right: Cameron Kirkpatrick)

Thomas Martorelli outs the inner workings of Fenway Health in *For People, Not for Profit,* a richly textured tale of the organization's first forty years. This narrative of Fenway's growth from a political ideal of free care for all, through its leadership in the global fight against AIDS, to its current status as an international icon of LGBT health care, is an ambitious work of dedication and love. *For People, Not for Profit,* a title inspired by the health center's early slogan, begins at the intersection of the free care and neighborhood health center movements in Boston. It continues with the heroic tale of Boston's lesbian and gay communities joining together to fight a shocking enemy. The knowledge gained in Fenway's many struggles and triumphs has helped create the largest LGBT organization in the United States today.

Tom was born to loving parents, Pasquale and Eileen (Ritchie) Martorelli, in Englewood, NJ. With his sister, Jody, and brothers Bill and Steve, he attended Dumont High School, before graduating from Princeton University and Harvard Business School. His first job title was research assistant for the Watergate Special Prosecution Force, in Washington, DC. In Boston, his work with nonprofits includes Bridge Over Troubled Waters, the Appalachian Mountain Club, the Harvard Club of Boston, and several museums.

Tom enjoys writing, cooking large meals with friends and family, traveling whenever possible, and serving on the Board of Visitors for Fenway Health. His love for Fenway began in the late 1970s, when he served as chair of its Board of Directors. He hopes readers will remember—and imagine—what a group of volunteers can accomplish together.